CELESTIAL ASPIRATIONS

Celestial Aspirations

CLASSICAL IMPULSES IN BRITISH POETRY AND ART

PHILIP HARDIE

PRINCETON UNIVERSITY PRESS

PRINCETON & OXFORD

This book is published as part of the E. H. Gombrich lecture series, cosponsored by the Warburg Institute and Princeton University Press. The lectures upon which this book is based were delivered in October 2016.

Published by Princeton University Press
41 William Street, Princeton, New Jersey 08540
6 Oxford Street, Woodstock, Oxfordshire OX20 1TR

press.princeton.edu

All Rights Reserved
ISBN 9780691197869
ISBN (e-book) 9780691233307

Library of Congress Control Number: 2021949436

British Library Cataloging-in-Publication Data is available

Editorial: Ben Tate and Josh Drake
Production Editorial: Karen Carter
Jacket/Cover Design: Pamela L. Schnitter
Production: Danielle Amatucci
Publicity: Alyssa Sanford and Charlotte Coyne

Jacket/Cover Credit: The Painted Hall depicting King William III and
 Queen Mary II, Old Royal Naval College, Greenwich, London.
 Photo by Steve Vidler / Alamy Stock Photo

This book has been composed in Arno

Printed on acid-free paper. ∞

Printed in the United States of America

10 9 8 7 6 5 4 3 2 1

CONTENTS

ILLUSTRATIONS

Color plates for figures 4.1, 5.1, 6.1, 6.4, 6.7, 6.8, 6.10, 6.16, 6.17, 6.18, 6.19, 6.20, 6.21, 6.22, 6.26, 6.27, 6.28, 6.29, 6.32, 6.33, 6.34, 6.36, and 6.37 follow page 82.

ACKNOWLEDGEMENTS

THIS BOOK is an expansion of the Gombrich Lectures on 'Celestial Aspirations: Seventeenth- and Eighteenth-Century British Poetry and Painting, and the Classical Tradition', delivered at the Warburg Institute, London, on 11–13 October 2016. I am grateful to the former director of the Warburg Institute, Peter Mack, for the invitation to give the lectures, and to the audiences at the lectures for their comments.

Materials from work in progress on the book have been delivered as papers at Corpus Christi College, Oxford; the Herbert Grierson Centre, University of Aberdeen; the Institute of Classical Studies, London; and the 2019 Meeting of the Renaissance Society of America in Toronto.

For help on the subject of British mural and ceiling painting, I am grateful to the enthusiastic members of the British Murals Network, and in particular to Lydia Hamlett, who cast an expert eye over chapter 6, and offered practical advice on securing images. Angela Leighton reassured me on what I have to say in chapter 5.

Ben Tate, my editor at Princeton University Press, the sponsor of the Gombrich Lectures, has skilfully guided the journey from initial submission of the book to publication. The criticisms and comments of the Press's readers have led to substantial reshaping and improvement of the typescript. One reader, David Quint, an old friend, unmasked himself, and has been generous with his enviable expertise in a number of the areas over which I stray in the book. My sharp-eyed and judicious copy-editor, Francis Eaves, has saved me from various *sottises*.

I am grateful to Trinity College, Cambridge, for a generous subvention towards the costs of images.

CELESTIAL ASPIRATIONS

1

Introduction

UNTIL THE INVENTION of the hot-air balloon, human beings were physically restricted in space almost entirely to the ground on which they stood. They could ascend in the direction of the heavens only by climbing mountains or other tall objects (as they could in more limited ways descend beneath the earth in chasms and caves or artificially excavated holes). But these earthly limitations could be transcended in religious belief or poetic fancy, and dreams, sleeping or waking, of flight, whether in the body or out of it, are no doubt as old as humanity, and to be found in every part of the world and in every century.

This book is focused on classical antiquity and the period in Britain reaching from the late sixteenth to the earlier part of the nineteenth century. It is a study in classical reception, centred mostly on literary history, accompanied by a substantial consideration of related phenomena in the history of art. My starting point is the observation that between the later part of the sixteenth century and the beginning of the nineteenth century the British imagination—poetical, political, intellectual, spiritual and religious—displays a pronounced fascination with images of ascent and flight to the heavens. The roots of this, and its manifestations, are various. The subject is given unity, in the first instance, by the fact that, on any reckoning, the roots of the post-classical materials lie substantially in the texts of Greek and Roman antiquity. Under this heading I include late antique Christian texts, which process specifically biblical and Christian narratives of ascent and aspiration largely through the vocabulary and imagery of non-Christian texts. My own perspective, that of a classicist with long-standing interests in early modern reception, looking forwards from antiquity, is guided, in the first instance, by the concern to trace the paths of the ancient representations of celestial aspirations through a wide body of British texts, primarily in verse, and painting, above all paintings on

ceilings, the surfaces most appropriate for images of the heavens and of ascent to the heavens.

Looking back to the classical material from the perspective of the later period, the book aims to lend cohesion to its subject by attending to the ways in which antiquity is received and transformed through the history, ideologies and aesthetics of the post-classical world. The following pages outline some of the main contexts, themes and motivations under which to consider the shaping of the particular trajectories taken by narratives and images of celestial aspiration in British history from the late sixteenth to the first part of the nineteenth century.

Science

From the time that the pre-Socratic philosopher Parmenides set out in his allegorical flying chariot, the 'flight of the mind' to the heavens and through the universe has been a recurrent figure for the quest for philosophical or scientific truth. The most famous, and the most influential, ancient example is Lucretius's praise of his revolutionary philosophical hero Epicurus, who burst through the 'flaming walls of the world' in order to traverse the boundless void, and to bring back to benighted mankind the truths about the nature of things (*On the Nature of Things* 1.62–79: see ch. 2: 36–39). Frequently imitated in later antiquity and in the Renaissance (after the rediscovery of Lucretius in 1417), this passage took on a new lease of life with the revolutionary discoveries of the new science of the seventeenth century. The new astronomy of Copernicus, Kepler and Galileo, through its reconfiguration of the heavens and through the observational revelations of the newly invented telescope, expanded still further mankind's freedom to wander through the skies, in intellect and in spirit. In Britain, the Lucretian flight of the mind is the single most important intertext for a subgenre of poems in praise of Newton's achievements in physics and astronomy, in which Newton is described as soaring through the heavens that he has mastered intellectually (see ch. 3: 149–60). On his tomb in Westminster Abbey (sculpted by Michael Rysbrack to designs by William Kent), Newton reclines under a celestial globe on which is traced the path of the comet of 1680; seated on the globe is Urania, the Muse of astronomy, and of Du Bartas and Milton, and above Urania is a star. The pyramid which forms the backdrop to the sculptural group is a symbol both of Newton's everlasting fame, and of heavenly aspiration.

Religion

Ascent to the heavens is before anything else a religious theme. Most, perhaps all, religions locate, if monotheistic their god, or if polytheistic their supreme god or most powerful gods, in the sky. The journey from the earth to the heavens is undertaken by mortal humans who undergo apotheosis; by the souls of the virtuous dead; and, in spirit while still in this life, through mystical rapture or contemplation. The question of whether these ascents are to be understood literally or figuratively is one that I shall, for the most part, leave to the side. In some cases the vertical ascent must be understood literally: for example, when the posthumous journey of the soul is to the stars, or in the taking up, before witnesses, of Christ into the heavens at the Ascension. Classical antiquity had a wide range of beliefs about the gods and about the destiny of the soul after death (including its non-survival). In antiquity, systematic theology was not a separate discipline from philosophy, and it is philosophical accounts and' representations of divinity and of the soul, particularly Platonic and Stoic, that are most easily assimilated within Christian theology; which indeed, in its late antique elaboration, owes not a little to Neoplatonism. For example, Augustine's climactic account of the mystical experience shared with his mother Monnica at Ostia, at *Confessions* 9.10.23–24, a narrative of spiritual ascent and transcendence to make contact with the life that is the Wisdom which has created all things, is punctuated by biblical allusion; but this is also a Christian version of the Neoplatonic transcendence of the mind towards supra-sensible being in Plotinus, for whom too 'life is wisdom' (*Enneads* 5.8.4.36).[1] Chapter 2 below includes a survey of a number of ancient philosophico-theological texts on the ascent of the soul, in this life or the next, that were very well known in early modern Britain. Syncretism between the Christian and the non-Christian is also found, again and again, in religious imagery. Thus, in late antique art Elijah is borne up to the sky in a chariot barely distinguishable from that of the pagan *triumphator* (Fig. 1.1), which was also the vehicle for the celestial apotheosis (*consecratio*) of the Roman emperor (Fig. 1.2).

The period of British history central to this book was one of religious upheaval and controversy, and many of the authors under consideration were deeply religious poets (to look no further than Du Bartas, Milton, Traherne

1. For commentary, see White 2019. For some discussion, see Lane-Fox 2015: ch. 26. On ascent in Augustine, see Madec 1988: cols 465–67.

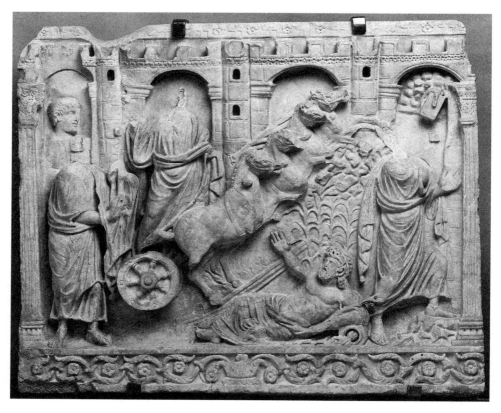

FIGURE 1.1. Ascension of Elijah, 'Sarcophage de la Remise de la Loi' (late fourth century, from St Peter's, Rome). Photo © Musée du Louvre, Dist. RMN-Grand Palais/ Anne Chauvet.

or Young). Even after the 'Glorious Revolution' of 1688, and the definitive victory of Protestantism over Roman Catholicism with the exile of James II, religion and religious controversy continued to be central concerns for poets.[2] My point of entry in the late sixteenth century is with poets whose investment in taking flight for the heavens is an expression of a militant Protestantism: Guillaume de Salluste Du Bartas and Edmund Spenser. Du Bartas's call to elevate poetry from earthly to heavenly matters, following the inspiration of Urania, the 'heavenly' Muse, will be heard later in the seventeenth century both by the republican and heterodox John Milton and by the royalist and

2. Connell 2016 presents a detailed and subtle case against a view of a progressive, Enlightenment, distancing of literary culture from religious controversy, from Milton to Pope.

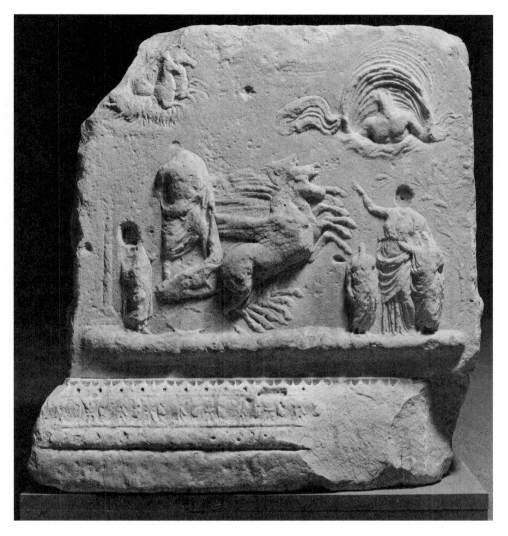

FIGURE 1.2. Apotheosis of a member of the imperial family, Belvedere Altar. Vatican City, Musei Vaticani, Museo Gregoriano Profano, inv. No. 1115. © DAI Rome, neg. 75.1286.

Anglican Abraham Cowley. Cowley's most vigorously soaring poem, 'The ex-stasie', is an adaptation of a Latin ode by the Polish Jesuit poet Casimire Sar-biewski, who enjoyed great popularity in seventeenth- and eighteenth-century England. In his Horatianizing odes, Sarbiewski undertakes repeated flights of the mind, including one in a poem in praise of his patron Pope Urban VIII. It might be misguided to look too hard for distinctive confessional variations in

the representation, in religious contexts, of flights of the mind or soul. The desire to be received in heaven above is common to all brands of Christianity. Religious lyric in the seventeenth century was fed both by meditative techniques deriving from medieval meditational treatises that also informed the Jesuit practice of Saint Ignatius's *Spiritual Exercises*, and by Protestant assumptions about the poetry of the Bible and the nature of the spiritual life.[3] These are some of the streams that flow into the sublimity of Milton's celestial aspirations, whose Protestantism is hardly compromised by the affinity of his poetry with the literature and the art of the continental baroque.[4]

Being full of the god, having the god within oneself, in Greek ἔν-θεος, whence 'enthus-iasm', leads to raptures that snatch the soul upwards in religious ecstasy. The language of religious inspiration is embedded in Greek and Roman ideas of poetic inspiration. Horace, in *Odes* 3.25, is 'full of Bacchus', and is carried away to figurative mountain-tops, as he entertains thoughts of elevating, in his poetry, the emperor Augustus to the company of Jupiter, among the stars (see ch. 2: 50). This ode inspired many later poetic raptures. In seventeenth-century England enthusiasm of the religious variety became suspect because of its association with radical religious sects during the Civil War and later. After 1688, a rehabilitation of enthusiasm took place within a Whig literary culture that also enlisted for its purposes the Miltonic sublime. A central figure here is the critic and poet John Dennis, for whom the 'enthusiastical passions' were the chief motors of poetic excellence. Dennis also sought to reform poetry by putting it to the service of religious ideas. Dennis's critical works were an important impetus for the investment in religious poetry and in the Miltonic sublime on the part of Whig poets such as Richard Blackmore, Isaac Watts, Aaron Hill, Elizabeth Singer Rowe, James Thomson and Edward Young.[5] In the 1726 Preface to 'Winter', the first of *The Seasons* to be published, Thomson pleads, '[L]et poetry, once more, be restored to her ancient truth and purity; let her be inspired from heaven, and, in return, her incense ascend thither.' Like Dennis, these poets are much given to rapturous heavenwards

3. Martz 1954 is a classic study of medieval and Counter-Reformation influences on English poetry of meditation, revised but not invalidated by Barbara Lewalski's study of a more distinctively Protestant poetics (Lewalski 1979).

4. On Milton and the baroque, see Roston 1980, and here ch. 4: 169.

5. On Whig poetics and religion, see Connell 2016: ch. 4. On Whig literary culture in general, Williams 2005 is central. On enthusiasm in eighteenth-century poetics, see Irlam 1999. On Christian poetry and the religious sublime in the eighteenth century, see Morris 1972.

flights of the mind or soul, none more so than Edward Young in the nine books of *Night Thoughts*, whose insistent religious message of the transcendence of the soul and of God's providence is driven by Young's desire to find consolation for the loss of his step-daughter, wife, and son-in-law, and by his opposition to Enlightenment criticism of Christianity. Young's enthusiastic Christianity struck a chord with John Wesley, who twice edited versions of *Night Thoughts*.[6]

Science and Religion

Science and religion come together in poems in praise of Newton. In this respect, they differ strikingly from Lucretius's praise of Epicurus, where science and religion part company when Epicurus's revelations dethrone the traditional gods from their tyranny over mankind. His flight of the mind empties the world of religion, understood as superstition. At the same time, Epicurus's reason (*ratio*) reveals the true nature of the gods, who dwell in the spaces between the plurality of worlds in a state of total serenity that is also one of total unconcern for mankind. That serenity is described with a translation of Homer's description of the windless and cloudless seat of his very interventionist gods on mount Olympus (Lucr. 3.18–22; cf. *Odyssey* 6.42–46). But in the Epicurean world the gods do not lord it over mankind from a high mountain. And, unlike Plato's divine demiurge, the Epicurean gods do not create the universe, but are themselves composed, like everything else, out of atoms, the universe's eternal material substrate.

Newton's science, by contrast, is enlisted as proof of a world created and guided by God, according to rational and universal principles. In 1692, Newton's friend Richard Bentley, the classical scholar and master of Newton's Cambridge college, Trinity, gave the first of the Boyle Lectures, endowed by the natural philosopher Robert Boyle to consider the relationship between Christianity and the new science. Bentley's title was 'A confutation of atheism'. Whatever the exact nature of Newton's own, probably heretical, religious beliefs,[7] Newtonian astronomy was one of the underpinnings of early modern British works of 'physico-theology', the use of natural science in the service of a theology that uses the argument from design. The term was coined by the natural philosopher and clergyman William Derham (1657–1735) in the

6. See James May's *ODNB* article on Edward Young.
7. See Iliffe 2017.

publication of his own Boyle Lectures as *Physico-theology: or, A Demonstration of the Being and Attributes of God from His Works of Creation* (London 1713).[8] The great outpouring of physico-theological poetry in the first half of the eighteenth century is particularly associated with Whig politics and Whig literary culture, in which an analogy is developed between the rational order of the Newtonian universe and the providential legitimacy of the constitutional monarchy established by the 1688 settlement.[9] In this poetry, the mind or soul is constantly taking flight and soaring through the spaces of the newly revealed Newtonian universe, but in the tracks of the Lucretian Epicurus, and of other classical precedents. These classical models are now combined with, and viewed through, Miltonic elevations and soarings.

The Baroque

In considering the receptivity of religious poetry to extravagant imagery of heavenwards motion, there is a further point about what might be labelled a baroque sensibility, which arguably informs all of the early modern British poetic texts on display in this book. This is a sensibility marked by an openness to, and striving for, the sublime; by a desire to reach for the unbounded and limitless; and by an emotional, and at times theatrical, exaltation and exultation. If celestial aspiration is a typical feature of the baroque, it need occasion no surprise that its expression is not regulated by narrowly confessional self-definitions: Peter Davidson has argued that 'Baroque is a cultural system which is supra-national, supra-confessional'.[10]

The importance of the category of the baroque for a wide range of arts (not just architecture) in late Stuart Britain (1660–1714) has recently been put on

8. Derham was also the author of *Astro-theology* (1714) and *Christo-theology* (1730), all three books being teleological arguments for the existence and attributes of God. On physico-theological poetry, the fullest account is Jones 1966, esp. ch. 4, 'The Triumph of Physico-Theological in Poetry'; see also Connell 2016: ch. 4. For a survey of the rise and fall of Newtonian natural theology over two centuries, see Gascoigne 1988. On physico-theology, or 'natural religion', in general in the Enlightenment, see Robertson 2020: 147–57.

9. On the religious politics of physico-theology see Connell 2016: ch. 5.

10. Davidson 2007: 13. Chapter 2, 'British Baroque', makes a strong case for recognizing that much English (and Scottish and Irish) culture of the sixteenth and seventeenth centuries should rightly be labelled 'baroque', as part of an international European (and New World) baroque, of which Latin literature of the period, with its international readership, is a central part. In the case of English literature, in both English and Latin, Davidson draws in particular on the scholarship of Mario Praz, who brought a continental eye to his subject.

display in an exhibition on 'British Baroque' at Tate Britain, which set British visual arts in the context of a European court culture.[11] In the visual arts, the story of the baroque in Britain goes back some decades earlier, with a major milestone, in the 1630s, in Rubens's ceiling for the Banqueting House in Whitehall (see ch. 6: 268–80). In Britain, the period within which baroque ceiling paintings were produced, c. 1620–c. 1720, coincides roughly with a standard periodization of the heyday of the continental baroque, from the early seventeenth century to about the 1740s. Elements of what would become the full-blown baroque are already visible in the late sixteenth century, and a major impulse to the emergence of the baroque was the Counter-Reformation, set in motion by the Council of Trent (1545–63). In poetry, I would suggest that many of the texts examined in this book show the presence of a baroque sensibility in Britain from the late sixteenth century to well into the eighteenth. In this respect, it may be argued that there is an asymmetry between the chronologies of the diffusion of baroque elements in British literature, and in British art and architecture.[12]

The Sublime

To track the celestial aspirations of poets from the late sixteenth to the nineteenth century is to follow an important strand in the history of the sublime in English poetry. The vertical axis is built into the vocabulary of the sublime: Latin *sublimis* means literally 'high, lofty, borne aloft', and the Greek title of Longinus's *On the Sublime* is Περὶ ὕψους, where ὕψος literally means 'height'.

Religious ideas have always played an important part in the experience of the sublime.[13] It is notorious that almost the only quotation of the Bible in a pagan, and (probably) non-Jewish, Greco-Roman author is Longinus's use of Genesis 1:3–9 as an example of a sublime expression of divine grandeur, immediately after quotations of the manifestations of the gods in Homer (*Sublime* 9.9): 'And God said, Let there be light: and there was light . . . And God said . . . let the dry land appear: and it was so.' This almost unique juxtaposition in pagan antiquity of the classical and biblical will become routine from Christian late antiquity onwards. In the eighteenth century, the 'ninth chapter' was the most famous part of *On the Sublime*;[14] Alexander Pope will have been well

11. See the catalogue, Barber 2020.
12. An asymmetry discussed in Praz 1964.
13. In general, see Chignell and Halteman 2012.
14. Russell 1964: xlvi.

aware of this when he composed his epitaph on Newton: 'Nature and Nature's laws lay hid in night: God said, Let Newton be! and all was light'—an epigrammatic contribution to the Newtonian sublime.

One of the most irrepressible of soaring poets, John Dennis was also an important early eighteenth-century theorist of the sublime, a good few decades before Edmund Burke. As I have already noted, Dennis is a foundational figure in the history of the eighteenth-century religious sublime. Well before Milton, the religious sublime finds major expression in Edmund Spenser and in Josuah Sylvester's translation of the French biblical poet Du Bartas. My readings of the celestial aspirations in poets of the late sixteenth and earlier seventeenth centuries are offered as further corroboration of Patrick Cheney's argument for the importance of a pre-Miltonic 'early modern sublime'.[15] Abraham Cowley, a younger contemporary of Milton, also made a plea for the re-dedication of poetry to the service of religion, and his poetic and spiritual flights, following both classical and biblical models, play an important part in the history of the seventeenth-century sublime.[16]

As well as religion, science (or natural philosophy) has been a powerful generator of the sublime, from the beginnings of Greek philosophy. For Lucretius, a part of Epicurus's heroism is his daring to pass through the whole of the boundless void of the Epicurean universe. The boundless void is an important source and subject of the Lucretian sublime, increasingly recognized as a decisive episode in the larger history of the sublime in Western culture.[17] Other ancient models of the universe operated with a closed system of celestial spheres, that was not definitively broken until the vast expansion of astronomical space with the coming of the new astronomy: what Marjorie Nicolson called 'the breaking of the circle'.[18] Sublime flights become more sublime still when they head upwards and outwards into the vast spaces of post-Galilean astronomy.

How central the idea of upwards flight is to the early modern notion of the sublime may be seen from William Marshall's title page for the first edition (in parallel Greek and Latin) of Longinus, published in England by Gerard Langbaine in 1636 (Fig. 1.3).[19] The upper half of the page consists almost entirely of

15. Cheney 2018.

16. For an attempt at a sympathetic reading of Cowley's sublime ambitions, see Hardie 2019.

17. Porter 2016: 445–54.

18. Nicolson 1950.

19. Discussed by Hamlett 2012: 204–6; Cheney 2018: 27–28.

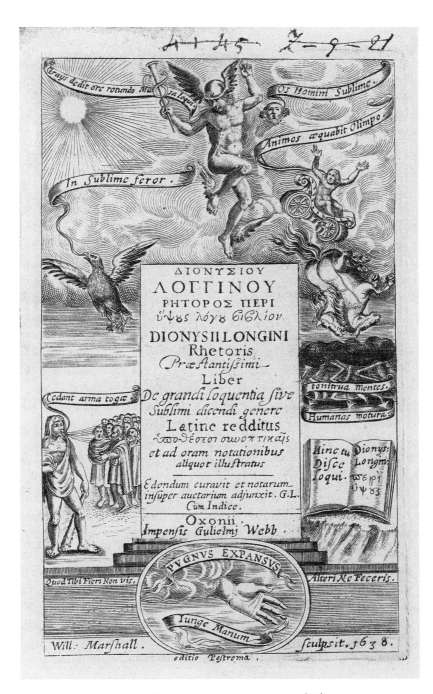

FIGURE 1.3. William Marshall, title page to Gerard Langbaine (ed.), *Dionysiou Longinou rhetoros Peri hypsous logou biblion* (Oxford, 1638). By permission of the Master and Fellows, Trinity College, Cambridge.

images of flight: at top centre, Mercury with winged helmet and sandals descends, with a scroll reading 'Graiis dedit ore rotundo Musa loqui' (The Muse granted the Greeks the power of speaking with well-rounded utterance) (Horace, *Ars poetica* 323–24); to the left an eagle flies up to the sun, with the scroll 'In sublime feror' (I am carried up on high);[20] to the right is the open-mouthed head of a man in the clouds, with the scroll 'Os homini sublime' ([Prometheus gave] man a face raised up high) (Ovid, *Met.* 1.85, from the description of the creation of 'homo erectus': see ch. 2: 46n39). Below, Phaethon and chariot and horses plunge down to earth, with the scroll 'Animos aequabit Olympo' (He will raise his spirit to the level of the heavens) (Virgil, *Aen.* 6.782), but ending in noble failure, blasted by the lightning bolts that appear in dark clouds beneath his precipitated horses, with the scroll 'Humanas motura tonitrua mentes' (Thunderclaps to shake men's minds) (Ovid, *Met.* 1.55). At the bottom of the page the open hand of God emerges from clouds, with the scrolls 'Pugnus expansus' (Open fist), and 'Iunge manum' (Join hands), an invitation to the viewer and reader to reach up to the hand of God through the vehicle of the sublime.

In sum, to trace a history of celestial aspirations in early modern Britain is to trace an important component in the history of the early modern sublime—Spenserian,[21] Marlovian, Miltonic, and on into the 'Whig sublime' of the early eighteenth century,[22] the proto-romantic poetry of Thomas Gray and Edward Young, and on to the full romanticism of Wordsworth and early Tennyson.

Power and Panegyric

In praising his hero of the spirit, Epicurus, Lucretius draws on the topics used in the praise of rulers and warriors, both in the account of Epicurus's triumphal flight of the mind in book 1 of *On the Nature of Things*, and in the proem to book 5, where Lucretius pronounces that Epicurus deserves to be called a god for his benefactions to mankind, which far exceed in utility those of the monster-slaying Hercules. In antiquity and after, Hercules, the son of the supreme god, Jupiter, and a mortal woman, Alcmene, is the archetype of the hero who, after his labours on earth, was rewarded on his death with apotheosis. In comparing

20. Cf. Seneca, *Hercules furens* 958 (Hercules predicts his own apotheosis): 'in alta mundi spatia sublimis ferar' (I shall be carried on high into the lofty spaces of the universe).

21. On the Spenserian sublime, see Cheney 2018: chs 2, 3.

22. On the 'Whig sublime', see Williams 2005: ch. 5

his hero, Epicurus, with Hercules, Lucretius engages polemically with the pan-egyrical elevation of a great man to the status of a god in the late Roman Re-public, a topos that fed into the cultic deification (*consecratio*) of the Roman emperor, beginning with the deification of Julius Caesar after his assassination in 44 BC. Apotheosis, or figurative identification with a god from the classical pantheon, became a standard part of the vocabulary of Renaissance panegyric, a metaphor for sublime and (hopefully) enduringly remembered achievement, which, understood as a metaphorical fiction, cohabited easily enough with Christian beliefs about God and the nature of the human soul. Those who so aspired might also run the risk of setting themselves up for a fall. Marlowe's pagan hero Tamburlaine hubristically imagines himself in the role of Jupiter driving his chariot through the sky. One of the many models for the bright-shining 'throne of royal state' on which Satan is seated at the beginning of book 2 of *Paradise Lost* is the Palace of the Sun at the beginning of book 2 of Ovid's *Metamorphoses*. Satan is a parodic version of a sun king, an equation of an earthly monarch with the sun-god, or with Apollo as god of the sun; an equa-tion that early modern Christian monarchs took over from antiquity (Louis XIV stands in a long tradition).[23]

It is above all (in more than one sense of the phrase) on ceiling paintings that images of apotheosis are displayed. Chapter 6 discusses a range of ceiling paintings, in classical mode, of the apotheosis or glorification of kings and great men. The heyday of these ceiling paintings reaches from the earlier part of the seventeenth century to the first decades of the eighteenth. For reasons that have to do partly with architectural and artistic fashion, this is a narrower time-frame than that of the narratives and images of celestial aspiration in poetry, which continue unchecked through the eighteenth century and into romanticism. The ceiling paintings that I shall discuss in this book use the classicizing forms of the continental and English baroque. For the most part, the imagery specific to scenes of ascent to the heavens cannot be traced di-rectly to ancient models, for the simple reason that, with the exception of some ceilings and domes in early Christian churches, very few, if any, ancient ceiling paintings or mosaics with images of ascent survived into the Renaissance. The visual iconography of ascent is perforce indebted largely to those same texts on which early modern poetry draws. This is also an area where Christian and classical imagery interact, since the continental, predominantly Italian,

23. On the continuity of sun-kingship from antiquity to Louis XIV, see Kantorowicz 1963.

imagery of royal and princely apotheosis draws largely on religious imagery, to which the Roman Catholic Counter-Reformation gave a major impetus.

States of Mind

The sensation of flying is one of liberation from constraints, physical or mental, that hem in, suppress—ground—a human consciousness. The image of flight or ascent is also frequently applied to a number of mental or spiritual conditions and emotions that escape from, or transcend, quotidian states of mind, escape from the subject's attachment to the perceptions and sensations of the world around us: desire, ecstasy, contemplation, fancy, imagination.

Erotic desire

One of the most powerful engines of heavenwards flight is erotic desire, usually of a purified and sublimated kind, and often contrasted with a kind of unpurified desire that consigns its subject to an earthbound existence, or, worse, condemns him or her to a lower inferno of lust, like Adam and Eve after the Fall in *Paradise Lost*, or like the sinner of Greek mythology Tityos, whose punishment of having his liver perpetually devoured by vultures in the underworld is allegorized by Lucretius as a figure for the unending torments of 'empty desire' in this life (Lucr. 3.984–94). In Plato's *Phaedrus*, erotic 'madness' gives the soul wings to fly upwards, enabling the flying chariot of the soul to resume its revolutions in the region above the heavens. This is a sublime image for the ascent of love that Plato elsewhere characterizes in terms that fall short of flight: the 'steps' (ἐπαναβασμοί) of the ladder of love in the speech of Diotima in the *Symposium* (211c2). The Platonic texts are the starting point for a long and rich tradition of the ascent of love in Neoplatonism and in Platonizing Christian mysticism. For example, the twelfth-century Richard of St Victor, in his contemplative work *Benjamin major*, describes the soul's amazement at the supreme beauty, producing a self-abasement from which it rebounds to rise all the higher and more swiftly through its desire for the supreme things, ravished above itself and elevated to sublime things ('tanto sublimius, tanto celerius per summorum desiderium reuerberata, et super semetipsam rapta, in sublimia eleuatur') (5.5, *Patrol. Lat.* 196:174B).[24] Platonic love and its celestial

24. Cited in Porter 2016: 22. The language used by Richard of his spiritual ravishment coincides with Virgil's narrative of the physical snatching up of Ganymede by Jupiter's eagle at *Aen.* 5.254–55: 'praepes ab Ida / sublimem pedibus rapuit Iouis armiger uncis' (see ch. 2: 72).

yearnings were put at the centre of Renaissance culture by the Florentine school of Platonism headed by Marsilio Ficino.

Modern psychology is less optimistic about the possibility of detaching the psyche from our animal instincts. Freud interpreted sexual excitement as the content of dreams of flying.[25] Involuntary ascent in flight is the result of a narrative of physical rape in the myth of the Trojan prince Ganymede's abduction to Olympus by Zeus, or the eagle of Zeus, to be the catamite (from the Etruscan form *catmite* of the Greek name *Ganumedes*) and cupbearer of the supreme god. The story of Zeus's erotic infatuation lent itself to spiritualizing allegoresis: in the *Phaedrus*, Plato transforms the traditional story of Ganymede into an account of divine love that leads to the regrowth of the wings of the soul (*Phaedr.* 255b–c). Plato stands at the start of a spiritualizing tradition that continues into the Middle Ages and Renaissance, for example in Dante's dream of being rapt by an eagle, like Ganymede, in *Purgatorio* 9, masking his actual assumption by Saint Lucy to the gate of Purgatory; and in Michelangelo's much-copied drawing of the rape of Ganymede, made for his beloved Tommaso Cavalieri.[26]

In the *Phaedrus*, sublimated sexual desire motivates the return of the lover's soul to the heights of true knowledge, to the 'Plain of Truth' (*Phaedr.* 248b6). It is a combination of love and intellectual enlightenment that enables the ascent of Dante, in the *Commedia*, from Inferno to the summit of the mountain of the Earthly Paradise in Purgatorio, and then soaring upwards through the heavens to the Empyrean. The soul of the woman Beatrice, once the object of Dante's earthly love, accompanies him on this ascent towards the final revelation. The two masculine saints who, in the fourth heaven of the sun, represent, respectively, Christ as Love and Christ as Wisdom, are Saints Francis and Dominic (*Paradiso* 11 and 12).[27] These are, as it were, the two wings that bear Dante upwards.

Petrarch's relationship with Laura in the *Rime sparse* (or *Rerum uulgarium fragmenta* [*RVF*]) is shadowed by the poet's awareness that he cannot replicate Dante's steady ascent towards God in the company of Beatrice. Petrarch frequently talks of raising himself from the ground, sometimes with reference to

25. Freud 1920, 2.10: 'Symbolism in the Dream'.

26. See Barkan 1991: 59–66 (on Dante's dream); 74–98 (on Michelangelo's drawing). Barkan questions the received opinion that Michelangelo's Ganymede is the expression of a purely Platonic love. On the ascent in Dante's *Commedia* within the tradition of Platonizing Christian mysticism, see Patten 2012.

27. Foster 1985.

Virgil's ambition at the beginning of *Georgic* 3 to find a path on which he too can raise himself from the earth (8–9: 'me . . . tollere humo'; see ch. 2: 68).[28] Love for Laura is both an incentive to take flight, and an obstacle thereto. The poet tries to reassure himself with the thought that it was love that enabled the flights of Saint Paul and Dante, at *RVF* 177.3–4: 'Love, who gives wings to the feet and hearts of his followers to make them fly up in this life to the third heaven' (Amor, ch'a'suoi le piante e i cori impenna[29] / per fargli al terzo ciel volando ir vivi)—Dante's third heaven of the planet Venus, and also the third heaven to which Paul was rapt. In the debate between the poet and Love before the tribunal of Reason in *RVF* 360, Love defends himself against the charges of the sufferings that he has brought on the poet (136–39): 'Again, and this is all that remains, I gave him wings to fly above the heavens through mortal things, which are a ladder to the Creator, if one judges them rightly' (Ancor, et questo è quel che tutto avanza, / da volar sopra 'l ciel li avea dat' ali / per le cose mortali, / che son scala al Fattor, chi ben l'estima). After her death, Laura has been raised to heaven, where the poet can, in this life, only follow her in a flight of the mind: 'I fly with the wings of thought to Heaven so often that it seems to me I am almost one of those who there possess their treasure, leaving on earth their rent veils.' (Volo con l'ali de' pensieri al cielo / sì spesse volte che quasi un di loro / esser mi par ch'àn ivi il suo thesoro, / lasciando in terra lo squarciato velo.) (*RVF* 362.1–4). In imagination he addresses Laura and asks to be brought into the presence of the Lord. But in the penultimate poem, before the concluding hymn to the Virgin Mary, who finally replaces Laura as the supreme object of love, Petrarch still regrets times past in which he was earthbound through love of something mortal: 'I go weeping for my past time, which I spent in loving a mortal thing without lifting myself in flight, though I had wings to make of myself perhaps not a base example.' (I' vo piangendo i miei passati tempi / i quai posi in amar cosa mortale, / senza levarmi a volo, abbiend'io l'ale, / per dar forse di me non bassi exempi.) (*RVF* 365.1–4).

Petrarch's *Rime* provided impetus for countless celestially aspiring imitators in the Europe-wide Petrarchism of the following centuries. For example, in France, 'the celestial flight on the wings of love for a woman was to persist well into the seventeenth century as one of the most shopworn pieces in the poet's baggage'.[30] The journey to the skies is smoother in the sixteenth-century fashion

28. See Santagata 2004 on *RVF* 360.28–29.

29. Cf. Dante, *Paradiso* 10.74: 'chi non s'impenna sì che là su voli'.

30. Ridgely 1963: 161.

for a 'spiritual Petrarchism', whose starting-point is Girolamo Malipiero's *Il Petrarcha spirituale* (Venice 1536), a Christian rewriting of the *Rime sparse* in which the success of flight to the heavens is assured by the image of Christ spreading his wings on the cross ('Sonetto 335', 7–8).[31]

Ecstasy

'Ecstasy' (ἔκστασις) literally means 'a standing outside, or apart', a state of being 'beside oneself'. The displacement to an outside may be the result of violent emotion, terror, astonishment, anger, madness; it is also the effect of sublime writings on an audience (Longinus, *Sublime* 1.4). The displacements of ecstasy need not be on the vertical axis. But certain kinds of 'ecstatic' emotion propel the soul upwards. Hermias, the late antique commentator on Plato, uses the phrase ἔκστασις καὶ μανία (ecstasy and madness) of the erotic madness in the *Phaedrus*, through which the soul ascends to the place of the gods.[32] The Neoplatonist Plotinus uses ἔκστασις of the mystical ascent of the soul to the suprarational One: 'But that other, perhaps, was not a contemplation but another kind of seeing, a being out of oneself ['ἔκστασις', although the reading is not certain] and simplifying and giving oneself over and pressing towards contact and rest and a sustained thought leading to adaptation, if one is going to contemplate what is in the sanctuary' (*Enneads* 6.9.11). In the Acts of the Apostles, Peter experiences an ecstasy in which he does not himself ascend, but is connected to what lies above through a vision of the heavens opening and a vessel descending (Acts 10:10: 'ἔκστασις'; 'mentis excessus' in the Vulgate). In the seventeenth century, Abraham Cowley's Pindaric ode 'The Exstasie' set a fashion for later seventeenth- and eighteenth-century verse ecstasies in which the soul soars to God (see ch. 3: 139–43, 147–49).

Meditation and contemplation

Spiritual or mental ascent may also be achieved through more measured alterations of consciousness, meditation and contemplation.[33] In the Middle Ages, Jacob's Ladder was standardly allegorized in terms of the ascent of the

31. Hart 1988: 153–57.
32. Lucasini and Moreschini 2012: 88.10–13.
33. On contemplative ascent, see Wallerstein 1961: ch. 8; Hawkins 1984; Madec 1988.

contemplative life,[34] an allegory of which Dante makes magnificent use in cantos 21–22 of *Paradiso*, and to which Milton alludes in *Paradise Lost* (see ch. 4: 186). The Christian ladder of contemplation has precedent in the 'steps' of the ladder of love in the speech of Diotima in Plato's *Symposium*, and in the ladder woven on the dress of the personification of Philosophy who appears to Boethius at the beginning of the *Consolation of Philosophy*; the steps of the ladder link the letter p (**p**ractical philosophy) to the letter theta (**th**eoretical philosophy).

The late medieval tradition of the 'scale of meditation' flows into both Jesuit and Protestant channels. The *scala meditatoria* laid out in Joannes Mauburnus's *Rosetum* (Zwolle 1494) exerted a strong influence on both Saint Ignatius's *Spiritual Exercises*, and on *The Arte of Divine Meditation* (London 1606) by Joseph Hall, later bishop of Exeter and Norwich, and, through Hall, on the Puritan Richard Baxter's *The Saints Everlasting Rest* (London 1650).[35] Both Hall and Baxter also acknowledge the authority of *On the Mountain of Contemplation*, an influential meditative treatise by Jean Gerson (1363–1429), chancellor of the University of Paris.[36] The image of sacred steps is also applied to devotions based on the fifteen 'Psalms of Degrees', or 'Gradual Psalms': for example, the royalist nobleman Henry Hare, first Baron Coleraine's, *La scala santa: or, A Scale of Devotions Musical and Gradual being Descants on the Fifteen Psalms of Degrees* (1681), whose frontispiece shows the steps to the Temple and Jacob's Ladder.[37]

In the eighteenth century, the dissenting Isaac Watts enjoins on his soul a calibrated ascent through contemplation, elevation on steps rather than on wings, and imposes a closure that is content to stop short of the infinite, in Hymn 58 ('The Scale of Blessedness'): 'Ascend, my soul, by just degrees, / Let contemplation rove / O'er all the rising ranks of bliss, / Here, and in worlds above' (1–4). The hymn climbs up the steps of creation, to reach Jesus, to come to a stop in the

34. On Jacob's Ladder and contemplative ascent, see Patrides 1962; Schaar 1977; and Hawkins 1984: 258 n. 8 on the image of Jacob's Ladder in the sphere of Saturn in Dante, *Paradiso* 21–22, in the context of Dante's meeting with Saint Benedict. For other examples of the image of the ladder of spiritual ascent in the Middle Ages, see Cahn 1989; Martin 1954. On the image of the ladder to heaven in non-Jewish ancient contexts, with particular reference to Manilius, *Astron.* 4.119–21, see Volk 2004 (with further bibliography); on the ladder to heaven in late antique Christian texts, see Graf 2004: 29–32.

35. Information from Martz 1954: 62–63, 331–52.

36. Martz 1954: 113.

37. See Stewart 1970: 99–100.

last stanza: 'But O what words or thoughts can trace / The blessed Three in One! / Here rest, my spirit, and confess / The Infinite unknown.'[38]

Contemplation's ascent can also be envisaged as flight, or as a ride in a flying chariot (Milton; Traherne; Young: see ch. 3: 135, ch. 4: 177 and ch. 5: 244). In the eighteenth century, lofty thoughts of a secularized Contemplation also aim high in non-religious poetry (see ch. 5: 212, 226).

Flights of fancy and imagination

In British poetry in the centuries under consideration in this book, 'flights of fancy' are more than a faded metaphor for unrealistic or fantastic ideas. Stephen Cornford, in his edition of Edward Young's *Night Thoughts*, observes that '"flight", "winging", "mounting", and "soaring" became in the middle of the eighteenth century the ideal metaphors to describe imaginative and religious aspirations.'[39] Fancy sweeps up poet and reader in vivid imaginings of flight, for example in Joseph Warton's 'Ode to Fancy' (1746), where the poet experiences a rapture comparable to that of Horace, swept away in *Odes* 3.25 by the god of ecstatic inspiration, Bacchus ('Quo me, Bacche, rapis tui / plenum?'). Warton is transported not by Bacchus, but by the personification of Fancy: 'Whence is this rage?—what spirit, say, / To battles hurries me away? / 'Tis Fancy, in her fiery car, / Transports me to the thickest war' (85–88). Here the means of transport is a flying chariot. Earlier in the poem, Fancy herself is winged: 'Whose rapid wings thy flight convey / Thro' air, and over earth and sea, / While the vast, various landscape lies / Conspicuous to thy piercing eyes' (17–20).

The view from above is enabled through Fancy's 'piercing eyes', eyes of the mind, *oculi mentis* (see ch. 2: 44), which call attention to her nature as the faculty of forming mental images of things not immediately present to the senses. 'Fancy' is a contraction of 'fantasy' (or 'phantasy'), Greek φαντασία, literally 'appearance', for which, in faculty psychology, the Latin equivalent is *imaginatio*, 'the production of images'. 'Fancy' and 'imagination' are often used interchangeably before the Romantic period.[40]

38. In Watts 1721.

39. Cornford 1989: 10.

40. For an overview of the complex history of the relationship, increasingly divergent, between the terms 'fancy' and 'imagination', see the entries by James Engell s.vv. in *The New Princeton Encyclopedia of Poetry and Poetics* (Princeton, 1993).

The non-dependence of this faculty on what is immediately present to the senses liberates the mind in untrammelled flight, very often flight in a vertical direction. David Hume thinks of imagination as something that gives the subject the illusion (only) of the unlimited ability to travel not only in space, but also in time: 'Let us chase our imagination to the heavens, or to the utmost limits of the universe; we never really advance a step beyond ourselves' (*Treatise of Human Nature* 1.2.6);[41] 'The imagination of man is naturally sublime, delighted with whatever is remote and extraordinary, and running, without control, into the most distant parts of space and time in order to avoid the objects, which custom has rendered too familiar to it.' (*Enquiry concerning Human Understanding* 12.25)[42]

Hume here makes the frequent association between imagination (or fancy) and the sublime.[43] Equally common is the association of fancy and imagination with originality, as in Henry Pemberton's account of Milton: 'Milton had a subject, which permitted his fancy to expatiate beyond the bounds of the world,[44] where the strength of his invention has formed greater and more astonishing images than any former poet, or than can be allowed to any succeeding one, whose subject confines him within the limits of human actions and powers.'[45] The language is close to Samuel Boyse's praise of Pindar's imagination, in 'Ode, on the Military Procession of the Royal Company of Archers, at Edinburgh, July 8 1734': 'Favoured by thee [Apollo], could matchless Pindar rise, / To vast imagination loose the reins! / Could, free, expatiate thro' the boundless skies, / And eternize the great Olympic scenes' (31–34).

The flights of fancy and imagination are not always valued positively, and their upwards impetus sometimes fails, or falls short of more powerful sky-reachers. For Milton, there are right and wrong ways for fancy and imagination to take flight (for detailed discussion, see ch. 4: 186–87, 189–92). For David Hume,

41. Norton and Norton 2007: 49.

42. Beauchamp 2000: 120.

43. On the importance of *phantasia* for the sublime, and in particular for the Marlovian sublime, see Cheney 2018: 131–32; at 132, '*Phantasia*, we might say, is the ultimate form of freedom, and Marlowe knew it.'

44. 'Beyond the bounds of the world' resonates with Lucretius's description of Epicurus's mental flight 'beyond the walls of the world' (see ch. 2: 36–39), a passage frequently adapted in praise of the power of Newton's mind (see ch. 3: 149–60). Henry Pemberton was best known as a physician and mathematician, a collaborator of Newton in his old age; I suspect here an association of the innovations of Milton and Newton.

45. Pemberton 1738: 155.

man's imagination, while sublime in its space- and time-travelling, also 'run[s] without control', and is opposed to 'a correct judgement'. The flying chariot of Abraham Cowley's 'The Muse' (see ch. 3: 143–45) is drawn by a numerous team, but the first two trace-horses are the opposed pair of Fancy and Judgement: 'Go, the rich chariot instantly prepare; / The Queen, my Muse, will take the air; / Unruly Fancy with strong Judgement trace'. Cowley perhaps has in mind the good and bad, obedient and disobedient, horses of the Platonic chariot of the soul (see ch. 2: 33). The strength of judgement, it is hoped, will keep in check the unruliness of fancy.

The first book of Mark Akenside's *The Pleasures of Imagination* ends with an address to the 'Genius of Ancient Greece' (566–604), and the wish to transplant Attic cultural goods to British soil (like Virgil bringing the Muses of Greece back to Italy at the beginning of the third *Georgic*, in preparation for his own lofty flight: see ch. 2: 68–69) (1.595–600[46]):

> From the blooming store
> Of these auspicious fields, may I unblamed
> Transplant some living blossoms to adorn
> My native clime: while far above the flight
> Of fancy's plume aspiring, I unlock
> The springs of ancient wisdom!

Classical learning will enable a flight higher than that of fancy. This is a vertical expression of the opposition between classical learning and native fancy in Milton's 'L'Allegro' (132–34), between 'Jonson's learned sock' and 'sweetest Shakespeare, fancy's child, / Warbl[ing] his native wood-notes wild'.

In James Thomson's 'Autumn', the poet experiences contrasting motions through the powers of Imagination and Truth, horizontal in the case of the former, vertical ('elates') in the case of the latter: 'With swift wing, / O'er land and sea Imagination roams: / Or Truth divinely breaking on his mind, / Elates his being and unfolds his powers' (1334–47).

Fancy continues to take flight even in a period when 'imagination' has become the favoured term: for example, in Leigh Hunt's (1784–1859) 'Fancy's Party. A Fragment', which takes for its epigraph the Augustan astronomical

46. The last line (604) is, 'And tune to Attic themes the British lyre', alluding to Horace's boast at *Odes* 3.30.13–14 to 'princeps Aeolium carmen ad Italos / deduxisse modos', and perhaps also to Virgil's statement at *Geo.* 2.176: 'Ascraeumque cano Romana per oppida carmen'.

didactic poet Manilius's exultant claim to wander through the sky (*Astron.* 1.13–14: see ch. 2: 45–46):

> Juvat ire per ipsum
> Aera, et immenso spatiantem vivere coelo.
> Manilius.

> We take our pleasure through the very air,
> And breathing the great heav'n, expatiate there.[47]

The free expatiation of Leigh Hunt's Fancy includes soaring movement up to the heavens and over mountain-tops (36–49):

> Now we loosen—now—take care;
> What a spring from earth was there!
> Like an angel mounting fierce,
> We have shot the night with a pierce;
> And the moon, with slant-up beam,
> Makes our starting faces gleam.
> Lovers below will stare at the sight,
> And talk of the double moon last night.
>
> What a lovely motion now,
> Smoothing on like lady's brow!
> Over land and sea we go,
> Over tops of mountains,
> Through the blue and the golden glow,
> And the rain's white fountains

The images of release from confinement and skywards soaring are also found in Leigh Hunt's friend John Keats's poem 'Fancy' (1–8):

> Ever let the Fancy roam,
> Pleasure never is at home:
> At a touch sweet Pleasure melteth,
> Like to bubbles when rain pelteth;
> Then let winged Fancy wander

47. Leigh Hunt was the author of *Imagination and Fancy, or, Selections from the English Poets, Illustrative of Those First Requisites of Their Art* (1844). On Leigh Hunt and the poetry of fancy, see Edgecombe 1994.

Through the thought still spread beyond her:
Open wide the mind's cage-door,
She'll dart forth, and cloudward soar.

Originality

Fancy and imagination take writer and reader into remote and novel regions, and both are strongly associated with originality. The same is true of flights of the mind, considered as a theme in itself. There is a light paradox in the fact that the present study of a tradition, the reception of classical themes and imagery of flight upwards and outwards, includes a tradition *of* originality, the repeated use of a stock of motifs to make a claim to be doing something new and unprecedented.

The connection between a flight into the boundless void and originality is already strong in Lucretius, who suggests an analogy between Epicurus's philosophical flight of the mind and the Callimachean untrodden paths of his own poetics. The verb *peragro* (travel over) is used both of Epicurus's trail-blazing solo journey outside the flaming walls of the world, traversing all the infinite void (1.74: 'omne immensum peragrauit'), and of the poet Lucretius's own claim to primacy in his philosophical didactic poem: 'I wander over the pathless places of the Muses, previously trodden by no foot' (auia Pieridum peragro loca nullius ante / trita solo) (1.925–30), drinking from 'untouched springs', and gathering 'new flowers . . . with which the Muses garlanded no-one's head before mine'.

Horace allusively takes Epicurus's leap into the void, when he imitates Lucretian language in his invective against the servile herd of imitators at *Epistles* 1.19.21: 'I first planted my footsteps freely in the void' (libera per uacuum posui uestigia princeps). The later Augustan poet Manilius, in turn, adapts both the Lucretian flight of Epicurus's mind, and Horace's prior imitation of that flight, to assert his own claim to poetic primacy in his astronomical didactic poem the *Astronomica*. At the beginning of the poem Manilius describes his own wanderings through the boundless heavens, in strongly Lucretian language (1.13–15: see ch. 2: 45–46). The metaphorical field for Manilius's first-time poetic endeavour is not Lucretius's trackless uplands of the Muses (Lucr. 1.926), but the heavens that are his subject-matter: 'my poetic undertaking I will owe to none of the bards, it will be nothing stolen [furtum], but my own work: in a lone chariot I soar to the heavens, in a ship of my own I sweep the sea [soloque volamus / in caelum curru, propria rate pellimus undas]' (*Astron.* 2.57–59),

combining the image of riding a chariot in the sky with the image of seafaring. Some lines later, Manilius asserts, 'Not in the crowd nor for the crowd shall I compose my song, but alone, as though borne round an empty circuit I were freely driving my chariot [uacuo ueluti uectatus in orbe liber agam currus]',[48] with none to cross my path or steer a course beside me over a common route' (2.137–40).

Milton combines flight upwards with the claim to originality at the start of *Paradise Lost*, invoking the aid of the heavenly Muse 'to my advent'rous song, / That with no middle flight intends to soar / Above the Aonian mount, while it pursues / Things unattempted yet in prose or rhyme' (1.13–16)—a claim to primacy which, famously, treads allusively in the footsteps of Ariosto: 'Cosa non detta in prosa mai, né in rima' (*Orlando furioso* 1.1.2).

In the eighteenth century, flights of originality are a repeated theme of Isaac Watts (1674–1748). For Watts, a leading dissenter, whose father had been imprisoned for non-conformity, the freedom often associated with flights into the boundless void had a particular meaning, a freedom of thought that is also a political and religious freedom, and which goes together with a freedom and originality of poetic expression, a highly Miltonic combination. In 'Free Philosophy', Watts praises his teacher, Thomas Rowe, who ran a well-known dissenting academy, for leading Watts away from 'Custom, that tyraness of fools' and from the 'shackles of the mind' (20–22, 25–29):

> Thoughts should be free as fire and wind;
> The pinions of a single mind
> Will through all nature fly:
> . . .
> A genius which no chain controls
> Roves with delight, or deep, or high:
> Swift I survey the globe around,
> Dive to the centre through the solid ground,
> Or travel o'er the sky.

In 'The Adventurous Muse', Watts invokes the Christian Muse Urania, who 'takes her morning flight / With an inimitable wing', owing nothing to the 'rules' of the French critic René Rapin. Using classical images for poetic journeying, Watts contrasts 'little skiffs' which 'along the mortal shores / With humble toil in order creep . . . Nor venture thro' the boundless deep' with 'the

48. Alluding to Horace, *Ep.* 1.19.21: 'libera per uacuum posui uestigia'.

chariot whose diviner wheels . . . unconfined / Bound over the everlasting hills / And lose the clouds below, and leave the stars behind', 'pursu[ing] an unattempted course, / Break[ing] all the critics' iron chains, / And bear[ing] to paradise the raptur'd mind.' 'Unattempted' is the first overt signal that this is in fact a poetic flight to the now immortal Milton, the subject of praise in the last thirty lines of the poem, and the object of imitation for Watts (see also ch. 5: 193–94). In the pre-Romantic era, as in classical antiquity, originality and imitation are not polar opposites

One of the founding documents for the Romantic cult of originality is Edward Young's *Conjectures on Original Composition* (1759). In his own poetry, Young is the most persistent of all cosmic voyagers (see ch. 5: 230–46). Unsurprisingly, *Conjectures* also uses the image of the flight of the mind. Young appeals to Francis Bacon in his advocacy of 'Originals':[49] 'Nor have I Bacon's opinion only, but his assistance too, on my side. His mighty mind travelled round the intellectual world; and, with a more than eagle's eye, saw, and has pointed out, blank spaces, or dark spots in it, on which the human mind never shone. . . . Moreover, so boundless are the bold excursions of the human mind, that in the vast void beyond real existence, it can call forth shadowy beings, and unknown worlds, as numerous, as bright, and, perhaps, as lasting, as the stars.' The astronomical comes into sharper focus a few sentences later: 'Originals shine, like comets; have no peer in their path; are rivalled by none, and the gaze of all.' Young perhaps has in mind in particular the original genius of Newton, famous, among other things, for his contributions to cometary science.

Celestial Aspirations and Larger Structures

The central motif of this book is a simple one: ascent from earth to the heavens. But ascent along the vertical axis frequently enters into larger patterns and systems, both in antiquity and after. A common contrast is that between a legitimate and successful ascent, and an illegitimate and unsuccessful attempt that ends disastrously in travel in the opposite direction. Major classical examples of the latter, all the subject of frequent allusion in post-classical literature and art, are the myths of the tragic failure to sustain flight of two headstrong young men—Phaethon in the chariot of his father the Sun, and Icarus on the wings crafted for him by his father Daedalus—and the myths of the

49. Bacon is contrasted here with Pope, criticized for being an imitator.

monstrously impious Titans and Giants who attempt to climb up to heaven to overthrow the Olympian gods. The latter are blasted down by Zeus's thunderbolts to a place lower than the surface of the earth, to underground prisons. Ascent and descent are deployed along the full vertical axis that reaches from the skies to the underworld, from heaven to hell. Descent, however, is not always negatively evaluated. The quest for knowledge or enlightenment may plumb the depths as well as search the heavens. Profundity, as well as altitude, is something to strive for. Sinking is the passive failure to soar, but diving is the active correlative to soaring.

The charting of the extremes of success and failure, of virtue and vice, of theological good and evil along the vertical axis often forms part of a larger moral, theological or political construction of the universe, in which order struggles against disorder. The scene is thus set for encyclopaedic texts or iconographies with ideological or theological plots. In antiquity, the classic example is Virgil's *Aeneid*, which charts the history of Rome and Roman ancestors against a cosmic backdrop, and in which the success and rewards of Roman empire are figured in terms of both horizontal and vertical expansion. The vertical thrust of the *Aeneid* is something new in Greco-Roman epic, and is determinative for much of the later tradition. Ovid responds to it, in his own idiosyncratic way, in the *Metamorphoses*, as does Dante in the *Commedia*, the great medieval 'epic' of descent and ascent, although the upwards passage through the successive spheres of the heavens in *Paradiso* often occludes the motions of flight. Soaring and sinking are, however, vividly experienced in Milton's *Paradise Lost*, an encyclopaedic epic in which moral fall and recovery from fall are recurrently mirrored in episodes of physical descent and ascent.

Periodizations and Intertextualities

These structural patterns, as well as the headings surveyed previously, could all be traced through longer histories stretching back into the Middle Ages and forward into modernity. The decision to focus on two discrete periods—classical antiquity (roughly up to the early fifth century AD, but coming as far forward as the early sixth century in the case of Boethius), and Britain roughly from the late sixteenth to the eighteenth century, but looking forward to the romanticism of the nineteenth century—inevitably has something of the arbitrary about it, and I occasionally stray into the long stretch of time that lies between. Nevertheless, my British texts and images respond for the most part to the classical models, and only intermittently to those models, both

non-Christian and Christian, as mediated through medieval texts. Milton draws on Dante, as well as the rest of the epic tradition from Homer down to the seventeenth century, but the *Commedia* is not an important influence on most of the authors discussed in this book. Of earlier English authors, Chaucer certainly is an important presence in my period, and his parodic version of a celestial ascent in *The House of Fame* is discussed briefly at ch. 2: 102.

This is also a period in English literary history given unity through its intensive and creative engagement with classical texts, of a kind that at its earlier limit was informed and concentrated by the humanism of the Renaissance, but at its latter end underwent relaxation and marginalization. While this book looks to wider frameworks of reception, it is, in the first place, a study in allusion and intertextuality. I proceed on the assumption that many of the early modern poets engage in conscious and intentional allusion to the ancient texts, as well as to earlier British (and in some cases non-British) poets, in a manner quite comparable to the proliferating chains, or 'imitative series', of intertextuality that link the ancient authors.[50] This is beyond question when it comes to classically learned, and in some cases self-annotating, authors like Milton, Cowley, Pope, Thomson, Gray and Young (university poets all, apart from Pope, who was debarred by religion). In other cases, we have to do with what had become a shared vocabulary and imagery of celestial aspiration and its associated emotions—a *koine* of rapture, ravishment and transport.

The unity of this book also depends on the claim that there *is* something cohesively British to the package of texts and images discussed. There are clear lines of intertextuality within both the textual and the visual productions of the period. Texts and images both participate in specifically British histories— literary, artistic, political, ideological. At the same time, it is important to recognize that this period in Britain, and in particular the first part of that period, was as open to continental influence as this country has ever been. This is very clearly the case with the ceiling paintings, which largely derive from, and are in dialogue with, Italian and French models, setting up tensions between continental Catholicism and British Protestantism, and activating rivalries firstly

50. Historically, allusion and intertextuality have been more central to the concerns of students of classical, especially Latin, literature (like myself) than to those of early modernists. Signs of an increasing dialogue between classicists and early modernists are the major book on imitation by Colin Burrow (Burrow 2019), and the collection edited by Burrow et al. (2021). Earlier, Ricks 2002 is a dazzling demonstration of the importance of allusion for readers of English poetry.

between British and French versions of absolutist monarchy, and subsequently between French absolutism and British constitutional monarchy. Many of the artists who painted on walls and ceilings were themselves of Italian or French origin, and brought their continental training with them to Britain. British poets were also impelled in a skywards direction by European models: for example, Spenser's Neoplatonizing ascents, James VI of Scotland's and Josuah Sylvester's translations of Guillaume de Salluste Du Bartas's sacred poems, and not least Milton, deeply read in a wide range of early modern continental authors both in the vernaculars and in Latin. Neo-Latin poetry, written for a readership not restricted by national boundaries, plays a significant part in this book: for example, the poetry of the Polish poet Casimire Sarbiewski, popular in seventeenth- and early eighteenth-century Britain. Some of the most extravagant expressions of Milton's celestial aspirations are in his own early output of Latin poetry.

Overview

Chapter 2 offers an extensive, but selective, survey, with commentary, of Greek and Latin texts, in both prose and verse, on the subject of celestial aspiration. Most of these texts were well known in the elite classical culture of Britain in the period under review. Readers who want to skip to the post-classical material may start with chapter 3, and refer back to the discussion in chapter 2 of particular ancient authors and texts, as required. The three chapters (3–5) on British poetry are organized, in general, chronologically. Chapter 3, however, takes the story to a point some decades after the death of John Milton, before chapter 4 returns to a synoptic account of celestial aspirations across the whole of Milton's poetic output. Chapter 5 then proceeds further into the eighteenth and nineteenth centuries. Throughout the book, I touch occasionally on the visual arts; chapter 6 is a sustained account of the iconography and contexts of visions of ascent to (and, in some cases, descent from) the heavens on painted ceilings.

Milton has a central role, both for his response to the earlier traditions of celestial aspiration—Christian and non-Christian; classical, medieval, early modern; British and non-British—and for his inescapable presence in the post-Miltonic material. A large number of other poets still central to the canon of English literature put in appearances, but so do a number of other poets famous in their time, but now very little read outside specialist circles. Josuah Sylvester's translation of Du Bartas's *Divine Weeks and Works* was one of the

most popular poetic works in the seventeenth century, but then plummeted into near-oblivion. Abraham Cowley, James Thomson and Edward Young all flew high in fame in their lifetimes and after, but how many read them now? A similar fate has befallen the mural and ceiling paintings of seventeenth- and early eighteenth-century palaces and stately homes, in their time the height of fashion, but now usually relegated to the sidelines in histories of British art.[51] This book has no ambition to bring about a revolution in taste, but a more modest aim is to suggest that these faded celebrities deserve continuing attention for both their literary-historical and their art-historical interest, and indeed for their aesthetic appeal. Partly for that reason, I have been generous with the quotation of texts. As a consequence, the book offers something of an anthology of passages from authors many of whom may be unfamiliar to many readers.

51. The British Murals Network is a group of art historians dedicated to the study of mural painting in Britain in the late seventeenth and early eighteenth centuries, and to the fostering of a wider interest in the subject: https://www.britishmurals.org/about-us (accessed 29 July 2021). Hamlett 2020 surveys the painting of murals in Britain from 1630 to 1730, and reconstructs contemporary ways of viewing them.

2

Classical Antiquity

THE POST-CLASSICAL Western world could draw on a wide range of ancient representations and images of flight or ascent to the heavens, whether in the body or (more usually) out of the body, whether in this life or posthumously. The discursive contexts are various: religious, philosophical, poetic, political and ideological, fictional fantasy. In this chapter, I lay the ground for the discussion of the early modern material, permeated as it is with classical allusion, by presenting a selective survey, with commentary, of these various traditions of journeying to the heavens, firstly in pre-Christian (or non-Christian) antiquity, and secondly in Christian late antiquity. The emphasis is predominantly on literary texts, some prose as well as poetry. The pre-Christian traditions will have a long afterlife in the post-antique world, sometimes mediated through or combined with ascents in biblical texts. Indeed, no small part of this history is the, often unembarrassed, coexistence of pre-Christian and Christian themes and images of celestial aspiration.

Most of these texts were very familiar to readers and writers of the Renaissance and succeeding centuries. Authors of central importance for the theme of celestial aspirations include such major figures as Plato, Cicero, Lucretius, Virgil, Horace and Ovid, all of whom would figure prominently in any history of the reception of classical literature. It is perhaps also worth noting that the texts discussed below cover a wide range of genres, including philosophical dialogue, the philosophical consolation, didactic poetry, epic, lyric, satire, the ancient novel. That is to say that the elevated and sublime theme of reaching for the heavens is by no means restricted to the higher kinds in the ancient hierarchy of genres, and this generic promiscuity, if one can put it like that, will be mirrored in the range of early modern texts discussed in succeeding chapters.

Flights of the Soul, Flights of the Mind

The ascent of the soul *post mortem* to the starry spheres above is a common belief, or hope, in the astral eschatology of the East in antiquity, a possible origin for the presence of this idea in the Greco-Roman world.[1] The idea then becomes a frequent feature of Christian representations of the destiny of the virtuous soul after death.

We will see many examples of the posthumous upwards flight of the soul. But it is possible for the human individual to experience space flight before the final separation of body and soul, whether through an 'out of the body' experience, or in imagination.[2] The 'flight of the mind' has a long and varied history, going back to early Greek religion and philosophy, and extending forward in time to the Romantic period and beyond. The flight of the mind while still in this life, in a vision of higher realities, is a cliché of ancient philosophical and mystical texts, possibly having roots in shamanistic experiences of 'psychic excursion'.[3] An early example of a mind travelling not just abroad from the body, but in lofty places, is in the proem of the pre-Socratic philosopher Parmenides's hexameter poem which laid out his account of reality. Parmenides sets out on his journey of enlightenment, on the remote path of Truth, in an allegorical chariot, guided by the Heliades, the daughters of the Sun, through the gates of Night and Day, located high in the air (Diels-Kranz 28.B1.13 'αἰθέριαι').[4] In imagination, the human philosopher follows in the tracks of the flying chariots of the Homeric gods (*Iliad* 5.748–52, Hera's chariot; 8.41–52, Zeus's). The presence of the daughters of the Sun serves to assimilate Parmenides's chariot to the chariot of the Sun, and it may be hinted that they will

1. On the soul's journey to the heavens, see Bousset 1901, on Jewish, Christian, Iranian, Babylonian and Greek (250–63) traditions; Strong 1915: 175–80.

2. There is a close parallel between ecstatic trance journeys to heaven and the journey of the soul after death: Bousset 1901: 136: 'Die Ekstase, vermoege deren man sich durch den Himmel zum hoechsten Gott erhebt, ist ja nichts anderes als seine Anticipation der Himmelsreise der Seele nach dem Tode des Menschen.'

3. Flight of the mind: see above all Jones 1926. On shamanistic psychic excursions, Bolton 1962: 121–22, on Aristeas of Proconnesus; Dodds 1968: ch. 5, 'The Greek Shamans and the Origin of Puritanism'.

4. Cerri 1999: 177, taking the Gates of Night and Day to be Hesiod's gate of Hades (*Theog.* 741), understands αἰθέριαι as 'reaching as high as the sky'; others deny the identification with Hesiod's gate and take Parmenides's Gates as a celestial gate opening on to the heights of the sky.

preserve Parmenides from the catastrophe that ensued when Phaethon attempted to drive the chariot of the Sun (see below: 81–82). Parmenides's starting point is the analogy, deeply rooted in the archaic Greek imaginary, between the movement of thought and the movement of physical bodies in space.[5] His flying chariot will have a long history, in antiquity and after, in a variety of contexts, philosophical and otherwise. For example, Parmenides's remote path of Truth may influence Pindar's statement, in a fragmentary paean, that he is driving the winged chariot of the Muses, and not travelling on a worn wagon-track.[6]

Plato and the Platonic Tradition

For Plato, the flight of the mind or of the soul is a flight away from the world of becoming, in which we are condemned to live out our life in the body. One of the *loci classici* for the flight of the mind is a passage in Plato's *Theaetetus*, 173e–174a, on the philosopher's disregard for worldly things: 'really it is only his body that has its place and home in the city; his mind, considering all these things petty and of no account, disdains them and is borne in all directions, as Pindar says (fr. 292 Snell-Maehler), "both below the earth", and measuring the surface of the earth, and "above the sky", studying the stars, and investigating the universal nature of every thing that is, each in its entirety, never lowering itself to anything close at hand.'[7] The combination of flying up into the sky with travelling underneath the earth, soaring and diving in search of lofty and deep secrets, will recur frequently, with sources both classical and biblical.[8]

5. Cerri 1999: 166–67.

6. *Paean* VIIb Snell-Maehler: see Rutherford 2001: 245–52 (accepting d'Alessio's reconstruction). On Abraham Cowley's flying Pindaric chariot, see here ch. 3: 143–44. For early modern fantasies of flying chariots and other flying machines, see Nicolson 1948: ch. 5, 'Flying Chariots'.

7. Cf. also *Theaet.* 175d for an example of the view from above (see below: 53–57): when philosophy 'lifts up' the small-minded man to larger philosophical questions, he is 'dizzied by the new experience of hanging at such a height, he gazes downward from the air [ἀπὸ ὑψηλοῦ κρεμασθεὶς καὶ βλέπων μετέωρος ἄνωθεν] in dismay and perplexity; he stammers and becomes ridiculous, not in the eyes of Thracian girls or other uneducated persons . . . but in those of all men who have been brought up as free men, not as slaves'; whereas when it comes to things that concern the ordinary man, the philosopher is at a loss, and a laughing stock, as Thales was to the Thracian serving-girl when he fell into a pit while looking up at the stars.

8. Biblical: Psalm 139:8–9 'If I ascend up into heaven, thou art there: if I make my bed in hell, behold, thou art there. If I take the wings of the morning, and dwell in the uttermost parts of the sea[.]' Of many examples, cf., e.g., Traherne, 'The Anticipation': 'My contemplation dazzles in

In the lexicon of sublimity, reaching for the depths (*bathos*) matches reaching for the heights (*hupsos*); profundity can be valued equally with elevation on the vertical axis.[9]

The most famous example of a flying chariot of the mind or soul is found in one of the several Platonic accounts of the liberation of the soul from the chains of the body, the so-called 'Palinode' of Socrates in the *Phaedrus* (243e–257b).[10] This tells of the fall of the soul from its celestial orbiting in the company of the Olympian gods. In an enormously influential image, Socrates compares the parts of the soul to a team of two horses, one noble and good, the other ugly and unruly, driven by a charioteer. The soul falls when the charioteer is unable to control the horses.

Plato also describes this fall as a loss, or shedding, of wings. The wings of the soul is another image with a long history.[11] In the *Phaedrus*, the philosophical lover's soul is able to regrow its wings when it is under the influence of the madness of erotic desire for a human beauty that reminds it of the celestial beauty that it enjoyed in a previous existence. The lover sees in the beloved boy a likeness of the god in whose company his soul had previously travelled in the heavens. Fall is followed by re-ascent to the *huperouranios topos* (place above the heavens), after the sprouting and regrowth of the wings of the soul.

The *Phaedrus* myth tells of the restoration of an original godlikeness through the ascent of the philosophical lover's soul, which sees in the beloved both a reflection of the god whose company he formerly enjoyed, and a reflection of himself, in a productive and fertile kind of narcissism. Man can ascend to the sky because he has a natural affinity with the sky and is in the likeness of the gods. The soul has a celestial origin in various ancient religious and

the end / Of all I comprehend. / And soars above all heights, / Diving into the depths of all delights' (1–4); Walter Scott, *The Antiquary* (Oldbuck to Arthur Wardour): 'But such adventures become a gallant knight better than a humble esquire,—to rise on the wings of the night-wind—to dive into the bowels of the earth' (1.13), referring facetiously to Wardour's rescue from a cliff face by an ascending chair, and his disastrous mining ventures.

9. Longinus, *Sublime*, sets out with the question of whether there is an art (*techne*) of *hupsos* or *bathos* (2.1). The text has been questioned, since this is the only time that *On the Sublime* uses *bathos* as an alternative for *hupsos* (see Russell 1964 ad loc.), but the sublimity of the abyss is well attested elsewhere: see Porter 2016: General Index s.v. 'abyss(es)'. Only much later will Alexander Pope give to 'bathos' a sense antithetical to sublime *hupsos*: see ch. 5: 215–16.

10. On the relationship between the Parmenidean and Platonic celestial chariots, see Slaveva-Griffin 2003. On the reception of the *Phaedrus* charioteer, see Yunis 2011: 25–30.

11. On which see Courcelle 1972.

philosophical accounts: the Orphics held that the soul enters the body with the breath of the wind, and that after death it may ascend to the sphere of stars.[12] The Stoics held that the soul was a part of the fiery breath that they identified with the providential deity. Virgil expresses a Platonic-Stoic point of view in his statement that the intelligent behaviour of bees is a sign that they, like all living creatures, including man, have a portion of the divine mind, a draught of aether (*Geo.* 4.220–21: 'esse apibus partem diuinae mentis et haustus / aetherios'). Thence creatures derive their vital spirits on birth, and thither they return at their death (225–27: see below: 69–70). The idea of the godlikeness of the human being, and the possibility of the ultimate arrival in heaven of men made in the image of God, are given different inflections in Christian belief.

The *Phaedrus*'s account of the enabling of ascent through a 'madness', *mania*, is the forerunner of many spiritual ascents in an abnormal state of mind, or a heightened state of emotion. In seventeenth- and eighteenth-century English literature, poetic flights of the soul in an ecstasy or rapture become something of a cliché.

The madness that elevates the soul in the 'Palinode' of Socrates is more particularly an erotic madness. In the *Symposium*, Plato uses an image for the ascent of love that falls short of flight, the 'steps' (ἐπαναβασμοί) of the ladder of love in the speech of Diotima (*Symp.* 211c2). Ladders or steps are a more appropriate image than flight when the emphasis is on the ordered or gradual nature of the ascent. This is not the only context in which flying and climbing are homologous ways of reaching for heavenly heights (see below: 54, 69).

The Platonic texts are the starting point for a long and rich tradition of the ascent of love in the Neoplatonism of both late antiquity and the Renaissance, and in Platonizing Christian mysticism. An intermittent and playful allegory of the Platonic ascent of love informs a second-century AD text, Apuleius's story of Cupid and Psyche (Apuleius, *Metamorphoses* 4.28–6.24), whose happy ending is the celestial wedding-banquet of the reunited lovers after a tale of error and misadventure.[13] The union on Olympus resolves the separation of Psyche and Cupid that occurs when she disobeys the ban on looking

12. Rougier 1959; Turcan 1959. An imaginary epigram on the tomb of Plato fittingly records the ascent to the gods of Plato's soul, *Anth. Pal.* 7.62 (anon.): '"Eagle, why do you stand on the tomb, and on whose, and why do you gaze on the starry home of the gods?" "I am an image of the soul of Plato that has flown away to Olympus; his earth-born body is in the keeping of Attic earth."'

13. Kenney 1990: 19–22.

at her husband. Woken by a drop of oil from the lamp with which Psyche reveals to herself the divine beauty of Cupid, the winged god flies away, with Psyche clinging on to his leg until she tires and falls back to earth, unable to sustain her own flight as 'a wretched hanger-on to his lofty [or 'sublime'] flight' (sublimis euectionis appendix miseranda) (5.24.1), echoing Plato's account of the soul's loss of its wings and fall to earth at *Phaedrus* 248c. Finally, Psyche is led up to the sky for the wedding feast by the flying god Mercury (6.23.5). Elevation to the heavens is the still loftier ascent that fulfils the riddling oracle at the beginning of the story, which seems to portend only evil; the oracle instructs Psyche's father to expose her 'on the peak of a high mountain' (4.33.1) as the bride for a cruel and serpentine husband, a monster who flies on wings 'above the heavens' (super aethera). But it turns out that, rather than being exposed on a lofty rock like Andromeda as prey for a monster, Psyche will be wedded to the supracelestial god of love. The Platonic colouring is partial in the Cupid and Psyche story, and the concluding banquet of the gods is described in lushly sensual terms, with the final surprise that the child of the wedded couple is Pleasure (Voluptas).

The story of Cupid and Psyche was very popular with Renaissance artists (see ch. 6: 315–16). Its undercurrent of Platonizing allegory is converted into the longing of Christian mysticism in Joseph Beaumont's long poem *Psyche, or, Loves Mysterie* (1648, 1652), which tells of Psyche's longing for union with her 'spouse', Jesus.[14] Attending Christ's ascension, Psyche attempts to follow her god, but, like Apuleius's Psyche, falls back to earth (canto 15, stanza 332): 'Then casting up to heav'n her zealous eye, / After her spouse a thousand thoughts she sent; / To whom her panting soul strove hard to fly / Upon the wings of lofty ravishment. / But when she felt her self stick still to earth, / Her breast she struck, and beat this out-cry forth.' The final scene in the poem narrates Psyche's *Liebestod*, as, dying in a ravishing ecstasy of love, she triumphantly flies 'Up to her royal spouse's marriage bed' (20.242). In her final paroxysm, and the final words of the poem, she 'With three deep sighs cried out O LOVE, and died' (20.246). Beaumont has in mind the mystical 'death' in ecstasy of Saint Teresa, which is famously represented in Bernini's near-contemporary orgasmic sculpture in Rome (of the 1640s).[15]

14. The poem has much in common with Edward Benlowes's *Theophila, or, Loves Sacrifice* (1652) (see ch. 3: 133–34): the two men lived close to each other and may have known each other.

15. Stanwood 1963.

The language in which Socrates in the *Phaedrus* speaks of the madness of love and the flight of the soul 'beyond the heavens' is marked by poeticisms and sublimity, a stylistic excess which was praised by some and criticized by others in antiquity.[16] Flights of the mind or soul, and journeys through the vastness of space are, by their nature, sublime, and they figure large in the history of the sublime from the late sixteenth to the eighteenth century, and beyond.

Lucretius

Plato's *Phaedrus* tells of a sublime flight into the immaterial world. Equally sublime is the materialist Lucretius's praise of Epicurus at the beginning of *On the Nature of Things* (Lucr. 1.62–79), a passage which draws on a range of the previous traditions of the ascent of the soul or the mind, and which is probably the most frequently imitated of any ancient text on the flight of the mind. It is also a passage that exploits a number of themes and images that are found frequently in the context of flights of the mind and of imagination (translation by Thomas Creech, 1682):

> Humana ante oculos foede cum uita iaceret
> in terris oppressa graui sub religione,
> quae caput a caeli regionibus ostendebat
> horribili super aspectu mortalibus instans,
> primum Graius homo mortalis tollere contra
> est oculos ausus primusque obsistere contra;
> quem neque fama deum nec fulmina nec minitanti
> murmure compressit caelum, sed eo magis acrem
> inritat animi uirtutem, effringere ut arta
> naturae primus portarum claustra cupiret.
> ergo uiuida uis animi peruicit et extra
> processit longe flammantia moenia mundi
> atque omne immensum peragrauit mente animoque,
> unde refert nobis uictor quid possit oriri,
> quid nequeat, finita potestas denique cuique
> quanam sit ratione atque alte terminus haerens.

16. Hunter 2012: ch. 4, 'Dionysius of Halicarnassus and the Style of the *Phaedrus*', esp. 172–78; Porter 2016: 576–94, '"Beyond the Heavens" in the *Phaedrus*'.

quare religio pedibus subiecta uicissim
obteritur, nos exaequat uictoria caelo.

(Long time men lay oppressed with slavish fear,
Religion's tyranny did domineer,
Which being placed in heaven looked proudly down,
And frighted abject spirits with her frown.
At length a mighty one of Greece began
T' assert the natural liberty of man,
By senseless terrors and vain fancy led
To slavery; straight the conquered phantoms fled.
Not the famed stories of the deity,
Not all the thunder of the threatening sky
Could stop his rising soul; through all he passed
The strongest bounds that powerful nature cast:
His vigorous and active mind was hurled
Beyond the flaming limits of this world
Into the mighty space, and there did see
How things begin, what can, what cannot be;
How all must die, all yield to fatal force,
What steady limits bound their natural course;
He saw all this, and brought it back to us.
Wherefore by his success our right we gain,
Religion is our subject, and we reign.)

In a powerful and vivid example of the common topos of the flight of the mind, Epicurus's force of mind enables him to burst through the flaming walls of the world, journeying through all the boundless void. There is paradox in traversing the entirety of that which, literally, 'cannot be measured' (is *immensum*), the boundless, but it is through this achievement that Epicurus succeeds in setting a boundary (*terminus*, literally 'boundary stone') to a rational account of the laws of nature. An opposition of, or tension between, infinity and finitude is recurrent in the long tradition of flights of the mind or soul. In Christian meditations on the incomprehensible infinity of God, the soul finds closure through immersing itself in the boundless immensity of divinity. Only infinity can satisfy the soul's endless desire for God (see ch. 3: 134–36; ch 5: 225). The Romantic artist, by contrast, yields to and is empowered by an insatiable yearning for what lies beyond; the goal that, for Tennyson's Ulysses, forever recedes (see ch. 5: 249–52).

Epicurus's mind journeys beyond ('extra') the flaming walls of the world, rather than upwards to the heavens,[17] but the vertical axis structures the framing account of his defeat of the monster Religion. At the beginning, mankind grovels on earth ('in terris') under the oppression from the heavens ('a caeli regionibus') of Religio, whose other name of Superstitio (Superstition) is etymologized in the phrase *super . . . instans* (standing over threateningly from above). Epicurus is not intimidated by thunderbolts in the heavens, as if they were wielded by a (for an Epicurean, non-existent) angry sky-god. The final result of his triumphal mental excursion of enlightenment is the inversion of the initial relationship between Religio and mankind, the former now trampled underfoot, a conventional pose for the defeated enemy, the latter brought level with the heavens.

Here, in the proem to *On the Nature of Things*, Lucretius looks back to the proem of Parmenides's philosophical didactic poem, in which the philosopher rides aloft in a chariot through the celestial gates of Night and Day, opened by Justice at the request of the daughters of the sun. In a universe where there are no cooperative divine agents, Epicurus must himself burst through 'the close-set bolts of the gates of nature'. The language of this break-out may allude to the start of a chariot race: *carceres*, literally 'prisons', is the term for the starting-gates in the Roman circus.[18] If so, Epicurus too journeys in a flying chariot.

Lucretius may also engage with the ascent of the soul of the philosopher-lover in Plato's *Phaedrus*. This is possibly one reason why he emphasizes the dimension of 'beyond', rather than 'upwards': for an Epicurean, the soul does not have a divine origin, and there can be no desire to return to a place above (and so, in a vertical dimension, 'beyond') the heavens. The Epicurean's aim is rather in this life to bring the mortal human soul into the condition of *ataraxia*, freedom from psychic disturbance, that is enjoyed by the gods in their dwelling-places between the plural worlds. This is the full extent of ὁμοίωσις θεῷ (assimilation to, being made like, god), which Plato, in the *Theaetetus*, envisages as flight from the earth to the dwelling-place of the god; 'for to flee

17. Cicero thinks of horizontal extension in his allusion to the Lucretian flight of the mind at *De nat. deor.* 1.54: 'in quam se iniciens animus et intendens ita late longeque peregrinatur' (the mind, casting and extending itself into this [boundless space], wanders so widely and so far) (see Taylor 2020: 77 n. 16).

18. Nelis 2008: 511 n. 77. There is an echo of Epicurus's bursting through the gates of nature in Virgil's description of the winds of Aeolus, pent up in their subterranean prison-house (*Aen.* 1.54: 'carcere') and roaring at the bolts on the prison-doors (56: 'circum claustra fremunt'); the winds are like horses impatient at the start of a circus race (*fremo* is used of horses).

is to become like the gods, as far as is possible' (φυγὴ δὲ ὁμοίωσις θεῷ κατὰ τὸ δυνατόν) (*Theaet.* 176b).[19] Lucretius's desire, *cupido* (Lucr. 1.72: 'cupiret'), reaches no further than to break through the gates of nature, and his ulterior ambition is to return to the world we live in, and to bring back (ibid. 75: 'refert') in triumph the Epicurean truths about nature. That Lucretius makes his choices with reference to the *Phaedrus* may be supported by reference to versions of the flight of Epicurus's mind in other Epicurean sources which do emphasize the vertical, and which do ascribe to Epicurus a strong desire, for the supreme pleasure that is enjoyed by the gods (by which is meant a state of mind in this earthly life, not a transcendental and immortal condition), in terms that come close to the Platonic account of the upwards flight of the desiring soul.[20] In the Lucretian proem, in marked contrast to the very muted *cupido* of Epicurus is the vivid picture of the goddess of love in the opening 'Hymn to Venus'—emphatically a terrestrial not a celestial, Platonic, Venus.

In later centuries, Epicurus's flight-path will be followed by many space-flights in imagination or fancy. Many of these, starting with reworkings of Epicurus's flight of the mind by Horace, Ovid and Manilius (see below: 44–47, 79–80), emphasize the vertical direction of travel as Lucretius does not.

Lucretius exploits the imagery, and more specifically Ennian imagery, of epic heroism and Roman military conquest to celebrate the achievement of an individual intellect,[21] an example of the merging of public and private, active and contemplative. There is the further implication, made explicit in the comparison, in the prologue to book 5 of *On the Nature of Things*, between the physical labours of the monster-slaying Hercules and the mental achievements of Epicurus in conquering the monsters that rage within the human breast, of a revaluation of traditional notions of heroism. Epicurus's intellectual odyssey through the universe far exceeds in its benefits for mankind the physical wanderings of Odysseus.

19. On 'ὁμοίωσις θεῷ' in Epicurus, see Warren 2000: 251–53; Erler 2002.

20. See Fowler 2002: 50–52, esp. Dionysius of Alexandria (Us. fr. 364 = Euseb. *Praep. Evang.* 14.27.9): 'Epicurus, having emerged from the universe and stepped beyond the wall that encloses the heavens [τὸν οὐράνιον ὑπερβὰς περίβολον] . . . he saw the gods in the void and blessed their luxurious lifestyle, and becoming desirous of pleasure, he calls on men to make themselves like the gods.' Warren (2000: 258 n. 65) compares this passage to Lucr. 3.14ff., and suspects an earlier Greek source, perhaps Epicurus himself. On the Platonic connections of Epicurus's flight of the mind, see also Erler 2002: 176–77.

21. Much discussed: see recently Taylor 2020: 78–82.

Freedom and Sublimity

Through his own break-out from the prison-house of unenlightenment, Epicurus also brings liberation to the rest of mankind. Victorious over an oppressive monster, he is thereby a freedom fighter. For Plato, the ascent of the soul is a journey of freedom of another kind, the liberation of the soul from the prison-house of the body. Flights of the mind or soul ('flight' in the sense of 'flying') are often flights from confinement or oppression ('flight' in the sense of 'fleeing'), flights into the freedom of the skies, an aspect of aerial imagery stressed by Gaston Bachelard in his *L'air et les songes* (1943). In a more physical fantasy, the wish for wings to escape from an intolerable or oppressive situation is a cliché of Greek tragedy. For example, the words of the Chorus in the second stasimon of Euripides's *Hippolytus*, in response to Hippolytus's violent reaction to the revelation of Phaedra's love for him (*Hippol.* 733–51): 'O that I might be within the hidden places of the steep mountains, and that there a god might make me a winged bird among the flying flocks; and that I might soar over the sea wave of the Adriatic shore and the waters of Eridanus [the Po], where into the dark-hued swell the unhappy girls in lament for Phaethon drip the amber-gleaming radiance of their tears'. The ultimate goal of their fantasy of flight is the paradise of the Garden of the Hesperides by the Pillars of Hercules in the far west.[22] The fate of Phaethon, who fell to his death from the chariot of his father the Sun, foreshadows the death of Hippolytus in an earthbound chariot out of control; Phaethon is also one of the standard examples of a failed attempt to take flight (see below: 81–82), and so a contrast to the unhindered avian flight imagined by the Chorus. In the second half of this stasimon, the Chorus think back to the ultimately disastrous sea-journey to Athens of Phaedra in her 'white-winged' Cretan ship, drawing a contrast between her real-life 'flight' and their own imagined flight, activating the frequent correspondence between travelling by sea and travelling through the air (below: 59, 75). In the Christian world, the wish for escape from danger and oppression is expressed famously in 'O for the wings of a dove', the request of the psalmist in Psalm 54:7: 'And I said: "Who will give me wings like a dove, and I will fly and be at rest?"' (et dixi 'quis dabit mihi pinnas columbae, ut uolem et requiescam?').

For the exiled Ovid, the freedom of the eyes of the mind to roam over the horizontal and vertical axes allows an escape, in imagination, at least, from

22. For other examples of the wish to become a bird in flight, see Halleran 1995, on Euripides, *Hippol.* 732–41. See also Padel 1974.

confinement in the wastes of the Black Sea to the city of Rome, Ovid's constant object of desire (*Tristia* 4.2.57–64, speaking of Augustus's triumph; translation by A. D. Melville):

haec ego summotus, qua possum, mente uidebo:
 erepti nobis ius habet illa loci;
illa per inmensas spatiatur libera terras,
 in caelum celeri peruenit illa fuga;
illa meos oculos mediam deducit in Vrbem,
 immunes tanti nec sinit esse boni;
inuenietque animus, qua currus spectet eburnos;
 sic certe in patria per breue tempus ero.

(I, banished, will see all this in my mind's eye:
 My mind can claim the sights I may not view.
Through regions measureless it freely ranges
 And reaches heaven in its rapid flight.
It draws my eyes on to the City's centre,
 Insisting they shall share in that delight.
It finds a place to see the ivory chariot—
 Thus briefly in my fatherland I'll be.)

Here, 'inmensas' (measureless) is a Lucretian touch, alluding to the mental flight through which Epicurus freed mankind from the oppression of Religion (Lucr. 1.74: 'omne immensum peragrauit mente animoque'). The verb *spatiari* (roam, range) is one often used of the free movement through unencumbered spaces (*spatia*) of the mind in intellectual or imaginative flight. In English, the compound 'expatiate' (Latin *exspatiari*), often qualified with the adverb 'freely', is much more common than 'spatiate', and becomes something of a cliché in this context.[23] The exiled Ovid's freedom to wander in space is also

23. The much rarer 'spatiate' (*OED*: first attested in in Francis Bacon) is also used of flights of the mind or soul: '[from *OED*] a1711 Thomas Ken *Psyche* v, in *Works* (1721) IV. 299 "The soul in vision seem'd from flesh unloos'd / To fly abroad, and spatiate unconfin'd." 1734 I. Watts *Reliquiae juveniles* (1789) 140 "My spirit feels her freedom . . . Exults and spatiates o'er a thousand scenes."' 'Expatiate' is associated with freedom in contexts other than space travelling: Addison, *Spectator* No. 412 (23 June 1712): 'On the Pleasures of the Imagination', on 'Greatness': 'The mind of man naturally hates every thing that looks like a restraint upon it, and is apt to fancy itself under a sort of confinement, when the sight is pent up in a narrow compass, and shortened on every side by the neighbourhood of walls or mountains. On the contrary, a spacious horizon is an image of

the freedom enjoyed by another philosopher, Pythagoras, after he had exiled himself from his native Samos because of his hatred of the tyrant Polycrates (Ovid, *Met.* 15.60–65: see below: 79).

Both the oppressive monster Religio and Epicurus's flight of liberation are fraught with sublimity. The terrifyingly indistinct features of the face of Religio looking down on us from the heavens are a key example of what Edmund Burke in his analysis of the sublime labelled 'judicious obscurity', of which other examples are Milton's personification of Death (*Paradise Lost* [*PL*] 2.666–73), the description of the fallen Lucifer in his 'excess / Of glory obscured' (1.589–99), Virgil's personification Fama and Homer's personification Eris (Strife).[24] The judiciously obscure Religio is defeated through Epicurus's sublime mental flight through the void, whose infinity holds no more terrors for him than does the indistinct shape of the monster Religio. The freedom that Epicurus achieves, for himself and for all mankind, through the defeat of Religio consequent on his mental flight through the universe, is also the freedom that is the hallmark of the sublime in the accounts of Longinus, Burke and Kant. Stephen Halliwell observes that '[t]he metaphysics of the [Longinian] sublime . . . is focused . . . on the mind's heightened awareness of its capacity to transcend the boundaries of finite, material existence, and to discover a kind of liberating infinity in its own thoughts and feelings'.[25] Burke and Kant both speak of the inhibiting effect of false, as opposed to true, religion. Burke comments that 'false religions have generally nothing but fear to support them'.[26] For Kant, 'religion internally distinguish[es] itself from superstition, [in] that the latter [does] not provid[e] a basis in the mind for reverence for the sublime, but only for fear and anxiety before the being of superior power'.[27]

liberty, where the eye has room to range abroad, to **expatiate** at large on the immensity of its views, and to lose itself amidst the variety of objects that offer themselves to its observation. Such wide and undetermined prospects are as pleasing to the fancy, as the speculations of eternity or infinitude are to the understanding.' This is not a celestial expatiation, but Addison may be thinking of the Lucretian flight of Epicurus's mind, in 'range abroad' (*peragrauit*) and 'immensity', and in the idea of an escape from narrow confinement into immensity. Byron uses the word of political freedom at *Don Juan* canto 9.26: 'he / Who neither wishes to be bound nor bind, / May still **expatiate** freely, as will I, / Nor give my voice to slavery's jackal cry.'

24. Burke 1958: 58–60, 171–72; see Hardie 2009: 93–94.

25. Halliwell 2011: 34–35.

26. Burke 1958: 70. Burke finds an example of the 'salutary fear' associated with 'true religion' in the 'diuina uoluptas . . . atque horror' (divine pleasure and dread) experienced by Lucretius at the philosophical revelation vouchsafed by Epicurus at Lucr. 3.28–30.

27. Kant 2000: 5.264. See Doran 2015: 14.

The author of the pseudo-Longinian treatise *On the Sublime*, 'Longinus' for convenience, ascribes to writers of sublime genius, as opposed to flawless mediocrities, a recognition that Nature has inspired mankind with an irresistible love (35.2: 'ἄμαχον ἔρωτα') for what is great and more divine than us. As in the *Phaedrus*, it is love that impels us to go beyond the cosmos, in a mental flight comparable in its reach to that of Lucretius's Epicurus (*Sublime* 35.3): 'Thus the whole universe is not enough for the reach of human speculation and intelligence, but our ideas often pass beyond the boundaries of that which encompasses the universe.' As a result of this natural human desire, Longinus goes on, we admire not small streams, but the Danube, the Rhine, the Ocean; not small fires, but the fires of heaven or the rivers of fire that shoot forth from Etna (35.4), a passage that was very popular in the eighteenth century.[28] It is imitated, for example, by Mark Akenside in *The Pleasures of Imagination* (1.174–83),[29] followed immediately by a flight of the mind: 'The high-born soul / Disdains to rest her heav'n-aspiring wing / Beneath its native quarry. Tired of earth . . . she springs aloft . . .' (183ff.; see ch. 5: 223). In the next chapter, Longinus says that the sublimity of writers of genius lifts them close to the greatmindedness of god (*Sublime* 36.1). Again, ascent is associated with godlikeness.

The '"flight of the mind" topos' forms a substantial entry in the index to James Porter's *The Sublime in Antiquity*. Porter sees one impulse to the topos in Homer's comparison of the speed of the goddess Hera's flight from Mount Ida to Olympus to the speed of 'the thought flashing in the mind of a man, who traversing much territory thinks of things in the mind's awareness' (*Iliad* 15.78–83).

Lucretius's image of Epicurus as a military wanderer who goes beyond the limits of the known world probably alludes to panegyric of the ambition and achievement of Alexander the Great.[30] The pseudo-Aristotelian treatise *On the Universe* (Περὶ κόσμου, *De mundo*, written at some time between 50 BC and AD 180–90), is addressed to Alexander the Great, whom the author regards, since he is the best of princes, as the most suitable student of the greatest of things, philosophy.[31] The work opens with exaltation of philosophy for its

28. The list of sublime marvels of nature coincides with a list of geographical prodigies at Lucr. 6.608–737, dependent perhaps on a shared source: see Porter 2007: 172–74.

29. Cited in Russell 1964: 167.

30. Buchheit 1971.

31. On the *De mundo* and the sublime, see Porter 2016: 473–83. On the work's sources, see Maguire 1939.

sublimity (ὕψος) and greatness (μέγεθος) in taking for its goal the contemplation of the universe. Through philosophy, the soul, taking the mind as its guide, is able to make the journey to a vision of the heavenly region. This is a journey that it is not possible to undertake in the body, as the foolish Otus and Ephialtes—the mythical Giants who tried to reach heaven by piling Pelion on Ossa—once thought. Here, as often, a distinction is made between a right and a wrong, a pious and an impious, a successful and an unsuccessful, way of reaching for the heavens. Godlikeness again reaches for divinity: the soul recognizes things that are related to it, and 'with "the soul's divine eye" it grasps things divine'. The 'eye' or 'vision of the soul' is a Platonic expression;[32] the eyes of the soul or mind, in Latin *oculi mentis*, are frequently capable of visionary flights through the universe.

The Lucretian Tradition

In the Latin version of the pseudo-Aristotelian *De mundo*, probably by Apuleius, the account of the mind's journey through the universe is coloured with allusion to the Lucretian flight of the mind of Epicurus: 'For since men cannot approach the universe and its hidden parts [penetralia] in the body, in order to leave their earthly home and look at [inspicerent] those parts, they have taken philosophy as their guide and, instructed in her discoveries, have dared to travel in spirit through the regions of the sky [animo peregrinari ausi sunt per caeli plagas]' (*praef.* 287).[33]

The Lucretian flight of the mind imprinted itself firmly on the consciousness of Latin authors much earlier than Apuleius. Traces may already be found in the inflections given by Cicero to his several accounts of the journeying of the mind or the soul from philosophical perspectives polemically opposed to Epicurean teaching on the nature of the soul (see below: 53–54, 58–59). Virgil soars, or attempts to soar, into the heavens at key points in all

32. Cf. Plato, *Rep.* 519b: 'τὴν τῆς ψυχῆς ὄψιν' (the vision of the soul); 533d: 'τὸ τῆς ψυχῆς ὄμμα' (the eye of the soul); 540a: 'τὴν τῆς ψυχῆς αὐγήν' (the bright eye of the soul); *Smp.* 219a2: 'τῆς διανοίας ὄψις' (sight of thought). 'oculi mentis': see *Thes. Ling. Lat.* 9.2, 448.35–65; compare, e.g., Cicero *Nat. deor.* 1.19: 'quibus enim oculis animi intueri potuit uester Plato fabricam illam tanti operis?' (For with what eyes of the mind was your Plato able to look at the construction of so great a work?); 2.161: 'totam licet animis tamquam oculis lustrare terram mariaque omnia' (it is possible to survey the whole earth and all the seas with our minds as if with eyes) (with Pease 1955–58 ad locc.).

33. See Harrison 2000: 185.

three of his major works, often in the track of Lucretius (see below: 63–78). Horace has an ambivalent attitude to taking flight in the Lucretian manner: he proudly follows Epicurus's launch into the void as he declares his independence as a poet (*Ep.* 1.19.21: see below: 47–48), but in *Odes* 1.28 the mental powers of the Pythagorean philosopher Archytas are of no use to him now that he is confined to a narrow grave (1–6):[34]

Te maris et terrae numeroque carentis harenae
 mensorem cohibent, Archyta,
pulueris exigui prope litus parua Matinum
 munera nec quicquam tibi prodest
aerias temptasse domos animoque rotundum
 percurrisse polum morituro

(Measurer of earth and ocean and numberless sand, Archytas, you are now confined near the Matine shore, by a little handful of dust duly sprinkled, and it profits you nothing to have probed the dwellings of air and traversed the round vault of heaven with a mind that was to die.)

Lines 5–6 recall Epicurus's flight through the universe at Lucretius 1.74: 'atque omne immensum peragrauit mente animoque'; 'mensorem' in line 2 suggests a contrast with the Lucretian *immensum*, but also reminds us that Epicurus too sets a limit to the limitless: 'finita potestas denique cuique / quanam sit ratione atque alte terminus haerens' (how a limit is fixed to the power of everything and an immovable boundary stone) (Lucr. 1.76–77). But this kind of confining is very different from the cramping of the soaring mind in the grave.

It is no surprise that Manilius, the late Augustan author of the *Astronomica*, a didactic poem on astronomy and astrology, frequently uses the image of the mind's sublime flight through the heavens.[35] Lucretius is Manilius's prime model for his sky-wandering, but the truths that Manilius brings back for his reader are those of a Stoic providentialist universe, in polemical opposition to Lucretius's Epicurean non-providentialist materialism. The Lucretian intertext is signalled through verbal echoes in the prologue to the poem: 'It is my delight [iuuat] to traverse the very air and spend my life ranging through the boundless skies [immenso spatiantem uiuere caelo], learning of the constellations

34. Hardie 2009: 54–55 (*Ep.* 1.19); 191–92 (*Odes* 1.28).

35. See Volk 2002: 225–34, 'The Heavenly Journey' (in Manilius); Landolfi 2003: ch. 1; on the Manilian sublime, see Porter 2016: 483–508.

and the contrary motions of the planets' (*Astron.* 1.13–15).[36] At the same time, for Manilius the intellectual freedom of the skies is also the poetic freedom to venture on a solitary flight through 'things unattempted', in the words of Milton. Lucretius's Epicurus was the first to undertake a tour of the universe, by implication alone; Manilius stresses his own solitary wandering with the adjective *solus*, specifically in the images of a lone chariot-ride and a lone sea-journey, at 2.58–59: 'in a lone chariot I fly to the sky, in my own ship I strike the waves', combining the images of flight and of seafaring, which is often used figuratively of space-flight; and again at 2.137–39, travelling in Horatian tracks: 'Not in a crowd, and not for the crowd, will I compose my songs, but alone, as if travelling round an empty circuit, I will freely drive my chariot [sed solus, uacuo ueluti uectatus in orbe / liber agam currus]'.[37] Manilius also follows Lucretius in the use of imagery of military conquest: '[the human being] alone stands with the citadel of his head raised high and, triumphantly directing to the stars his star-like eyes, looks ever more closely at Olympus' (stetit unus in arcem / erectus capitis uictorque ad sidera mittit / sidereos oculos propiusque aspectat Olympum) (4.905–7).[38] Here 'erectus' alludes to the common topos that mankind, *Homo erectus*, has been given an erect posture so that he can look up at the stars.[39] Man has 'starry eyes' (sidereos oculos) because man's

36. Cf. Lucr. 1.74: 'immensum'; 1.927–29: 'iuuat . . . iuuat . . .' of Lucretius's journey over the untrodden paths of the Muses.

37. Cf. Horace, *Ep.* 1.19.21: 'libera per uacuum posui uestigia primus'.

38. Manilius applies to man's intellectual and spiritual ambition language used by Virgil of Octavian's journey to the skies through military and political achievement: '**uictor**que uolentis / per populos dat iura uiamque **adfectat** Olympo' (victorious, he dispenses laws to willing nations, and sets out on a path to Olympus) (*Geo.* 4.561–62; see below: 67).

39. For the common idea that man's erect posture is given him so that he can look up at the stars see, e.g., Ovid, *Met.* 1.84–86 (Prometheus's creation of man): 'pronaque cum spectent animalia cetera terram, / os homini sublime dedit caelumque uidere / iussit et erectos ad sidera tollere uultus' (Although other animals are bent down and look at the ground, he gave man a face aloft, and told him to look at the sky and to carry his visage raised up to the stars) (for parallels see Barchiesi 2005 ad loc.); Cicero, *Leg.* 1.26: 'nam cum ceteras animantis [natura] abiecisset ad pastum, solum hominem erexit et ad caeli quasi cognationis domiciliique pristini conspectum excitauit' (for while nature had forced other animals down to seek their food, man alone she raised up, and encouraged him to gaze at the sky, as if at kindred beings and his former home); and Augustine, *City of God* 22.24. In Avitus's biblical epic *De spiritalis historiae gestis* (end of the fifth century), God, as he prepares to create Adam, says, 'So that man's nature should have a more lofty [sublimior] eminence, let him receive the gift of raising his face upright towards the sky [accipiat rectos in caelum tollere uultus]' (1.69–70; for parallels, see Hecquet-Noti 1999

origin is in the stars, according to the Stoic doctrine of the fiery nature of the soul. The journey to the heavens is a return: 'our souls return to the heaven whence they came' (in caelumque redire animas caeloque uenire) (4.887). This is the journey of like to like, the homecoming to god of the divine element in man.

Manilius is one of those classical authors, little read today, who were read quite widely in the early modern period, when scientific poetry was in fashion. Edited by Joseph Scaliger and Richard Bentley, the *Astronomica* was translated into English twice in the later seventeenth century, by Edward Sherburne,[40] and then by Thomas Creech, the translator of Lucretius.[41] Samuel Cobb praises Creech for his own flight as translator of Manilius: 'But smile, my Muse, once more upon my song; / Let Creech be numbered with the sacred throng. / Whose daring soul could with Manilius fly, / And, like an Atlas, shoulder up the sky.'[42]

Flights of the Poet. Horace

Flight is also an image for the ambition of the artist or writer. Horace uses the Lucretian launch into the void to assert his independence as a poet, in contrast to the flock of slavish imitators, 'I was the first to plant my footsteps freely through the void [libera per uacuum posui uestigia princeps], I did not place my feet in the footsteps of others . . . I was the first to reveal the iambics of

ad loc.). In the next book, Satan tempts Eve by urging her to presume too far in a heavenwards direction: 'Thrust your mind into matters on high, and stretch your erected senses towards the sky [mentemque supernis / insere et erectos in caelum porrige sensus]' (2.194–95). Milton, who had very likely read Avitus, adverts to man's erectness, before the Fall, at *PL* 7.506–10: man is created as 'a creature not prone / And brute as other creatures, but endued / With sanctity of reason, might erect / His stature, and upright with front serene / Govern the rest, self-knowing'; and in a mythological analogue, at *Comus* 51–53: Circe's 'charmed Cup / Whoever tasted, lost his upright shape, / And downward fell into a groveling swine'. Other examples of the topos: Edward Young, *Night Thoughts* 6.242–45: 'Here we stand alone; / As in our form, distinct, pre-eminent; / If prone in thought, our stature is our shame, / And man should blush his forehead meets the skies'; 9.869–72: 'Nature no such hard task enjoins: she gave / A make to man directive of his thought; / A make set upright, pointing to the stars, / As who should say, "Read thy chief lesson there".'

40. Sherburne 1675.
41. Creech 1697.
42. Cobb 1700: 23.

Paros [the poetry of Archilochus] to Latium' (*Ep.* 1.19.21–24).[43] Horace alludes in the first instance to Epicurus's mental flight through the boundless void (Lucr. 1.66–77), but he also registers the parallelism between that passage and Lucretius's own claim to primacy, as a poet writing on Epicureanism, wandering through the pathless and untrodden places of the Muses (Lucr. 1.925–27) (see ch. 1: 23).[44] Poetic success also offers the possibility of freedom from the constraints of mortality, not through the literal ascent of the soul as in Platonist and Stoic teachings about the experience of the pure and virtuous soul in the afterlife, but through the figurative flight of the poet in posthumous fame. In the closing poem of *Odes* 2, Horace uses the licence of poetic fantasy to describe his own acquisition of bird-wings as he metamorphoses, somewhat grotesquely, into a swan. In this shape he will escape death and the restraint of the grave: 'I shall not be confined by the waves of the Styx' (nec Stygia cohibebor unda) (2.20.8), and fly in fame to the remotest parts of the world. Horace draws on a long tradition in Greek lyric and elegiac poetry of images of birds, both to figure the majesty and force of poets (Pindar as eagle), and to suggest the extent of their future fame: thus the archaic Greek elegiac poet Theognis tells his friend Cyrnus that he has given him wings with which he will fly over the boundless sea, borne up effortlessly over every land, and that he will enjoy a deathless fame (Theognis 237–52 Edmonds).[45] Horace concludes *Odes* 2.20 with allusion to the interdiction on mourning in Ennius's epitaph for himself: 'Let no-one honour me with tears, or perform my funeral with weeping. Why? I fly alive over the lips of men' (nemo me dacrumis decoret, nec funera fletu / faxit. cur? uolito uiuos per ora uirum) (*Epigram* 2a, Goldberg and Manuwald 17–18). The opening image of Horace taking flight as a swan reminds the reader of the last sentence of the Ennian epigram 'uolito uiuos per ora uirum', to which Horace does not here make direct allusion, but which is echoed verbally in major statements of poetic ambition by Virgil and Ovid (see below: 68, 80).[46]

43. See Hardie 2009: 53–55.

44. See ibid.: 54–55.

45. Nisbet and Hubbard 1978: 332–33; Harrison 2017: 235–38.

46. Nick Lowe suggests to me that *Odes* 2.20.2 'per liquidum aethera' (through the liquid air) may allude to Euripides, *Phaethon* 168–70 Diggle (the Messenger reports Helios's advice to Phaethon not to drive through the Libyan *aither*): 'having no admixture of wet [κρᾶσιν ... ὑγρὰν] it will burn and destroy your chariot-wheels'. As a flying swan, Horace will avoid the fate of Phaethon.

The vertical ascent through flight of *Odes* 2.20 is part of a wider network in the first three books of Horace's *Odes*. The first poem, 1.1, ends with the statement that, if Maecenas considers Horace worthy of inclusion in the canon of great lyric poets (35: quodsi me lyricis uatibus inseres), 'I shall strike the stars with my head held high' (36: sublimi feriam sidera uertice). This humorous statement ironizes the fervency of Horace's desire to achieve sky-reaching fame, and his bid for poetic sublimity, connoted by 'sublimi', literally 'held high, aloft'.[47] The closing poem of *Odes* 3, and hence of the collection of the first three books of *Odes* as a whole, offers more nuanced assertions of the poet's pretensions to elevation: 'I have completed a monument longer-lasting than bronze' (Exegi monumentum aere perennius), and also 'set higher than the pyramids of kings' (3.30.1–2)—assertions of going beyond in both temporal and spatial dimensions. The future time during which Horace will 'grow ever-fresh in the fame of posterity' will last 'as long as the priest will climb the Capitol with the silent [Vestal] virgin—that is, as long as the Roman state lasts) (7–9). Climbing a hill, rather than taking flight, is the image of ascent here.

Horace's own ambition to touch the stars at the end of *Odes* 1.1 is inserted in a larger framework of celestial aspirations, poetic and otherwise, in the first three odes of the book. Before concluding with the poet's own ambition for the skies, *Odes* 1.1 airs the theme in relation to the temporary 'deification' of victors in the games: 'the palm of glory makes them lords of the earth and raises them to the gods' (palmaque nobilis / terrarum dominos euehit ad deos) (5–6). Horace here encapsulates a leitmotif of Pindar's epinician odes for victors in the great Greek games: that the moment of victory brings a transient approximation to divinity, a moment given a quasi-divine immortality through the fame bestowed on the victor by the praise-poet.[48] Horace's second ode works towards the equation of *princeps* and god, in the fantasy that Mercury has come down to earth in the form of Augustus, who is himself on the path to celestial apotheosis, to be achieved hopefully late in time (45: 'serus in caelum redeas', a cliché of imperial panegyric). The third ode, the propempticon to the poet Virgil (a poem 'sending him on his way' as he sets out on a

47. See Hardie 2009: 200–202.

48. On Pindar's 'divinization' of the victor and his fame, see Meister 2020: ch. 3. Horace returns to the theme in *Odes* 4.2, referring to Pindar's epinicians: 'siue, quos Elea domum reducit / palma caelestis, pugilemue equumue / dicit et centum potiore signis / munere donat' (or whether [Pindar] tells of those whom the Elean [Olympian] palm brings home as gods, whether boxer or charioteer, and bestows on them a gift worth more than a hundred statues)' (17–20).

dangerous sea-journey to Greece), works from reflections on the brazenness of the first man to launch a ship, to a general reflection on mankind's audacious and criminal breaking of boundaries, including the example of Daedalus's unnatural flight through the air, and reaching a climax in the last stanza: 'Nothing is too difficult/too steep for mortals; in our folly we aim for the sky itself, and in our wickedness we do not allow Jupiter to lay down his angry thunderbolts' (nil mortalibus ardui est: / caelum ipsum petimus stultitia neque / per nostrum patimur scelus / iracunda Iouem ponere fulmina) (37–40).[49] Addressed to Virgil, the ode comments on the celestial and divine aspirations of poets, Horace included, as well as his closest friend. Here again, journeys over the sea and through the skies are interchangeable.

In *Odes* 3.25, Horace acts out the experience of a poetic enthusiasm in which he is inspired to dangerous ventures that aspire above the condition of mortality: 'I speak of nothing small or in lowly tone, nothing mortal. Sweet is the danger' (nil paruum aut humili modo, / nil mortale loquor. dulce periculum est) (17–18). This is a poem of Bacchic rapture, beginning with the urgent question, 'Where are you carrying me off, Bacchus, filled with yourself?' (Quo me, Bacche, rapis tui / plenum?). It is the single most important ancient model for the seventeenth- and eighteenth-century fashion for a poetics of rapture and ecstasy, in which the poet is more often than not rapt, ravished, transported in an upwards direction.[50] In *Odes* 3.25, Horace does not immediately represent himself as taking off into flight: ascent is from low-lying places— *humilis* literally means 'on the ground (*humus*)', 'low-lying', and is an antonym of *sublimis*—to the mountains over which maenads range. Yet this is a poem whose poetics of ascent aims still higher: in these spaces of rapture the poet's business will be to elevate to the heavens not himself, but Caesar: 'In what caves shall I be heard practising to place Caesar's eternal glory in the stars and council of Jupiter?' (quibus / antris egregii Caesaris audiar / aeternum meditans decus / stellis inserere et consilio Iouis?) (3–6). *insero* is the verb used by Horace of his own 'enrolment' in a hall of fame at the end of *Odes* 1.1, followed immediately by his anticipation of his own expansion to the stars. The

49. Cf. the allusion to this line at *Fasti* 1.307: 'sic petitur caelum' (see below: 83).

50. For a neo-Latin imitation of the opening of *Odes* 3.25, cf. Antonius Fayius's epigram for Beza's Latin metrical versions of the Psalms (*Psalmorum Davidis . . . libri quinque*, Geneva 1579): 'Quo me, Beza rapis? caelos subuectus in altos / sidereas iam nunc te duce carpo uias' (Whither do you snatch me, Beza? Carried up into the lofty heavens, under your leadership I now journey on the paths of the stars), where the rapture is explicitly in a skywards direction.

oxymoron 'dulce periculum' (sweet danger) draws attention to the simultaneous attraction and danger of this sublime venture. The Bacchic sublime is perhaps especially hazardous, in the service of a god who can switch unpredictably from gentleness to savagery. *nil mortale loquar*: Horace may incur the penalty for presumption and pride, at the same time as he may dare to hope for immortal and sky-reaching poetic fame. His subject, a Caesar whom he will elevate to the stars, also exceeds the mortal. The political novelty of a ruler who aspires to the status of divinity may also come crashing down. The danger, then, is one that the poet shares with the *princeps*, with whom he also shares an aspiration, albeit of a different kind, to immortality. The danger is that involved in 'following the god' (sequi deum) (19). In the first instance, this is to follow Bacchus over the wild and mountainous landscape in maenadic *oreibasia* (mountain-ranging). But, in the further perspective, it is to follow Bacchus in his trajectory from earth to the heavens. Bacchus, together with Pollux, Hercules, and Romulus, is one of the mortals made gods whom Augustus will join at the banquet of the gods in *Odes* 3.3.9–16. For Horace, 'following' the god may come close to identification with the same, as indicated at the beginning of the poem, where the poet is 'full' of the god, or, in Greek, ἔνθεος (whence 'enthusiasm'). Commentators are divided as to whether the last line of 3.25, 'encircling my/his temples with green vine-leaves' (cingentem uiridi tempora pampino) refers to the god or the poet: grammatically either is possible. The impossibility of making a final judgement on that is itself a sign of the merging of man and god.[51] God, poet and *princeps* make up a trinity of celestial aspirants.

The fourth book of Horace's *Odes*, which introduces itself as the poet's unwilling return in old age to lyric poetry, refrains from the attempt to soar upwards. The only things that 'fly' in the programmatic first ode are, firstly, Venus, whom Horace beseeches to leave him be, and go off in her swan-drawn chariot—'purpureis ales oloribus' (winged with gleaming swans') (10)—to cavort with the young nobleman Paullus Maximus; and, secondly, the boy Ligurinus, desire for whom torments the ageing poet, and whose 'flying' or 'winged' form (38–39: 'uolucrem sequor / te') he is condemned to pursue in his dreams, on a horizontal plane.[52] In the next, much imitated, ode, 4.2,

51. For this point, see Hardie 2009: 221.

52. Putnam (1986: 43–47) argues that the 'uolucris Ligurinus' of *Odes* 4.1 alludes to the image of a flying swan; ibid. 51: 'The second ode of book 4 begins as the first had concluded, with a figurative use of the image of flying.'

Horace returns to the hazardous seductions of *Odes* 3.25, and warns against attempting to follow the poetic flights of Pindar, the 'Dircaean swan', whom 'many a breeze lifts up whenever he soars into the tracts of cloud' (25–27). To emulate Pindar courts the danger of suffering the fate of Icarus, who fell into the sea when he tried to fly too close to the sun, so melting the wax holding together his artificial wings. Icarus, like Phaethon, is a standard example, in antiquity and later, of the dangers of trying to fly high (see below: 83).

What is probably Horace's last word on the subject comes at the end of the *Art of Poetry*,[53] where Empedocles is the mad poet who desires divinity: 'while he longs to be accounted an immortal god' (deus immortalis haberi / dum cupit) (464–65). The desire for divinity is prompted by the same urge that is described, a few lines later as 'love for a famous/notorious death' (famosae mortis amorem) (469). For a certain kind of poet, *fama* and divinity are two sides of the same coin. Desire to be held a god as a result of his bodily disappearance leads Empedocles upwards, as far as the top of the highest mountain in the Mediterranean, Etna, into which he plunges, achieving, as far as Horace is concerned, only what would later be called 'bathos' (in Greek, literally, 'depth'), as opposed to *hypsos* ('height', or 'sublimity'). For Empedocles, the summit of Etna is not a launch-pad to join the gods in the heavens above.

Sky-Reaching Fame

The poet's aspiration to ascend in fame is a special case of the heavenwards reach and flight of fame, which goes back as far as Odysseus's self-revelation to the king of the Phaeacians at *Odyssey* 9.19–20: 'I am Odysseus, son of Laertes, who am known to all men for my cunning, and my fame [*kleos*] reaches the heavens.' Horizontal (men everywhere on the earth) and vertical (heavens) coordinates define the extent of the hero's fame. Virgil's Aeneas outdoes Odysseus's boast in his own answer to his mother Venus's disingenuous request to identify himself to her: 'I am pious Aeneas, known through fame above the sky' (sum pius Aeneas . . . fama super aethera notus) (*Aen.* 1.378–79). The monstrous personification Fama (Rumour) in *Aeneid* 4 expands rapidly to shoot up from the earth to hide her head in the clouds (4.176–77: see further below: 73–74). Virgil's model for this attribute of Fama is Homer's personification of strife (Eris), who 'at first raises herself a little, but then fixes her head in the sky, and walks on the earth' (*Iliad* 4.442–43). Longinus,

53. Assuming that the *Art of Poetry* is Horace's last work.

referring to these lines, opines that one might say that the distance from earth to heaven is 'the measure of Homer as much as of Strife' (*Sublime* 9.5). The passage in Longinus is lacunose, but the point may have been that Homer's own fame reaches the sky.[54]

Cicero and the View from Above: *Contemptus mundi*

One of the most influential ancient accounts of a journey in spirit to the heavens is Cicero's *Dream of Scipio*. This ends one of Cicero's major works of political philosophy, the *Republic*, and corresponds to the eschatological Myth of Er that concludes Plato's *Republic*, the model for Cicero's own. While the rest of Cicero's *Republic* survives only in fragments, the text of the *Dream of Scipio* was preserved in Macrobius's late antique commentary on it, and was widely read in the Middle Ages and beyond. It is the classic narrative of what in antiquity was the cliché of an ascent to the stars.[55] The question of fictionality, of whether we should believe a word of it, is evaded through the device of narrating it as a dream vision, allowing deniability in the face of scepticism.[56]

In his dream, the younger Scipio, Aemilianus, ascends to the stars. There he meets the older Scipio, Africanus, and his own biological father, Aemilius Paulus, and is enlightened on matters both political and philosophical, or, better, politico-philosophical, the two being closely entwined. The younger Scipio learns that a special place is reserved in the stars for the souls of statesmen who have served their fatherland well, but he is told that he should serve out his time on earth, and not seek prematurely to escape from the prison-house of the body and return to the starry origin of human souls. Scipio looks down from above on the nine spheres of the universe, the lowest of which is the earth, on which are visible its five zones (two frozen polar zones, and two temperate inhabitable zones separated by the intolerably hot equatorial zone), and listens to the harmony of the spheres. This vision of the spheres, with the sound of their harmony, and of the zones of the earth, Cicero will have known from two Hellenistic poems, the influential *Hermes* of the Alexandrian scholar and geographer

54. So suggests Hunter (2018: 58–60).

55. For a useful survey and anthology of passages that parallel the *Dream of Scipio*, see Festugière 1949: 441–59, 'Le Songe de Scipion'; Festugière concludes that the *Dream of Scipio* 'n'est qu'une mosaïque de lieux communs'. On Christian receptions of the *Somnium*, see Courcelle 1958 and 1967.

56. See Zetzel 1995: 223–24.

Eratosthenes, in which the god Hermes ascends to the heavens and recognizes the identity of the tuning of his lyre with the harmony of the spheres,[57] and an astronomical poem attributed to Alexander of Ephesus.

The *Dream of Scipio* is one of the best-known examples of 'the view from above', a 'perennial motif in ancient philosophic writing',[58] the view from a lofty elevation downwards through the vastness of space. This is a gaze of sovereign intellectual control, taking in the totality of the world, or even of the universe, in a single survey, the Apollonian gaze of the sun 'who sees everything' (*Iliad* 3.277 = *Odyssey* 11.109, 12.323), and the gaze of early modern cartographers, who dignify their new craft with texts in the classical tradition of the view from above (see ch. 3: 125).[59] It is also a gaze which puts into perspective the earth and the glory of the greatest earthly achievements. A similar effect may be achieved through the view from a mountain-top, from which humans, with all their ambition and self-importance, seem of no more significance than bustling ants. As often, mountain-climbing and ascents of the heavens can serve similar ends.[60] This is the perspective advocated by

57. Di Gregorio 2010. Virgil describes the Eratosthenic zones of the earth at *Geo.* 1.231–51.

58. Rutherford 1989: 155. On the 'view from above', see Rutherford 1989: 155–61; Hadot 1995: 238–50; Cosgrove 2001: 49; Williams 2012; Lovatt 2013: index s.vv. 'vertical gaze'; Koppenfels 2007: ch. 2, '*Katáskopos* oder der Blick von der Höhe', on the 'Ameisen-Perspektive' (ants' perspective). The topos of humans appearing as ants when viewed from a height continues into the age of actual manned flight: for example, the French balloonist and photographer Félix Nadar, writing about the experience of flight in a balloon in *When I Was a Photographer*: 'Finally he breathes, free from all ties with this humanity which ends up disappearing in front of his eyes, so small even in its greatest achievements—the works of giants, the labors of ants—and in the struggles and the murderous strife of its stupid antagonism. Like the lapse of times past, the altitude that takes him away reduces all things to their relative proportions, to Truth. In this superhuman serenity, the spasm of ineffable transport liberates the soul from matter' (Nadar 2015: 57–58).

59. Cosgrove 2001: 5, and passim. Cosgrove speaks of the tension in the 'Apollonian perspective' between 'an imperialistic urge to subdue the contingencies of the global surface' and 'an ironic recognition of personal insignificance set against the scale of globe and cosmos' (53).

60. Irene de Jong is working on a project on the view from the mountain, 'oroskopia'; see de Jong 2018; 2019. For an example of a close connection between the ascent of a mountain or hill, and ascent into the sky, see Milton, *Paradise Regained* 2.279–86 (after the night in which the fasting Jesus dreams of Elijah's miraculous meals in the desert): 'Thus wore out night, and now the herald lark / Left his ground-nest, high towering to descry / The Morn's approach, and greet her with his song: / As lightly from his grassy couch uprose / Our Saviour, and found all was but a dream, / Fasting he went to sleep, and fasting waked. / Up to a hill anon his steps he reared, / From whose high top to ken the prospect round.' At 1.294, Jesus had been described as 'our morning star, then in his rise'.

Lucretius in his description of the view from the lofty regions of the wise ('edita . . . sapientum templa serena') down on the follies of mankind (Lucr. 2.7–13),[61] a passage that may have been in Cicero's mind in the *Dream of Scipio*. For Cicero, there is a temporal, as well as a spatial, aspect to this: the younger Scipio is asked to reflect on the certainty of periodic universal floods and conflagrations on the earth, with the consequent futility of hoping for long-lasting, let alone eternal, glory (6.23). The lofty vantage-point of the stars not only puts human greatness in a spatial perspective, but also encourages a perspective *sub specie aeternitatis*.[62] The smallness of the earth, the perception that the Roman empire covers merely a small part, a point ('quasi punctum') on the surface of the earth, and reflection on the vulnerability of glory to periodic cosmic catastrophe, are reminders that man should always look to heavenly things, and despise human things ('haec caelestia semper spectato, illa humana contemnito') (6.20). In an uneasy tension, in the *Dream of Scipio* the journey to heaven and the view from above are at once legitimation and confirmation of the achievement of the earthly ruler, and a major impulse to what will be the Christian *contemptus mundi* (contempt of the world) tradition.

We do not have to wait for Christianity to find further examples of the use of the ascent of the soul to teach a lesson about the vanity of earthly achievement. At the beginning of book 9 of the *Civil War*, Lucan's epic on the Roman civil war, the shade of Pompey the Great, ignominiously murdered on the sands of the Egyptian shore in the previous book after the annihilation of his political and military 'greatness' at the battle of Pharsalus, frees itself from the ashes that are all that remains of his body. This is an example of a frequent kind of ascent, that of the soul after death.[63] In Lucan's Stoicizing epic, this is more

61. Closely related to the topos of the flight of the soul into higher realms: see Fowler 2002: 50–51.

62. On the temporal, as well as spatial, aspect of the lofty panoramic view of epic gods, see de Jong 2018: 27, 29. An Epicurean view from above leads to a comprehensive vision of past, present and future (citing *Iliad* 1.70, describing the prophetic reach of Calchas) at *Gnom. Vat. Epic.* 10: 'being mortal by nature and having been granted a limited time, through your discussion concerning nature you ascended to infinity and eternity, and you looked down on "the things that are, the things that will be, and the things that were previously"': for discussion, see Warren 2000: 251–53.

63. Ridgely 1963: 145 n. 16, with the example of Ronsard's 'Hymne triumphal', in *Le Tombeau de Marguerite de Valois, royne de Navarre* (1551): the queen's body is taken up by an angel to become a benign new star, and her soul continues to its eternal abode in the Empyrean.

particularly a Stoic kind of apotheosis, the return of the virtuous soul to the divinity whence it came.[64]

Pompey's soul ascends to the space between the earth's and the moon's orbits, where the dark lower air gives way to the bright upper air that can be tolerated by the 'fiery quality/virtue' (ignea uirtus) of those who have led blameless lives. There, 'after filling himself with the true light, marveling at the planets and the fixed stars, he saw the thick darkness that covers our day, and laughed at the mockery made of his headless body' (9.11–14).[65]

The great shade that is Pompey's soul flies free, unconfined by the handful of his physical ashes (2: '**nec** cinis exiguus tantam **compescuit** umbram'), like the free flight of the swan-fame into which Horace is metamorphosed in *Odes* 2.20, unconfined by the river of the underworld (8: '**nec** Stygia **cohibebor** unda'). In his birthday poem on Lucan, who had been forced to take his own life by the emperor Nero, the Flavian poet Statius transfers to the dead poet the posthumous experience of his character Pompey, imagining that Lucan too may have taken flight to the heavens, and now be riding in the airborne chariot of fame, as befits a great poet: 'But you, whether borne aloft in fame's lofty chariot through the whirling vault of heaven, the way by which rise more powerful souls, you look down on the earth and laugh at tombs' (At tu, seu rapidum poli per axem / famae curribus arduis leuatus[66] / qua surgunt animae potentiores, / terras despicis et sepulcra rides). (*Siluae* 2.7.107–10)

Boethius (c. 480–c. 524), with Augustine, is one of the chief sources for the medieval *contemptus mundi* and for the topos of the vanity of earthly glory. Imprisoned and awaiting execution, Boethius consoles himself, like Socrates nine centuries earlier, with the liberating lessons of philosophy, in the *Consolation of Philosophy*, enormously influential in the Middle Ages, and still a major text for the Renaissance, numbering among its translators Queen Elizabeth I. The mind which enjoys a good conscience is released from its earthly prison and heads for the sky, free, despising all earthly affairs. Dame Philosophy drives home the Ciceronian lesson of the futility of the pursuit of glory on the inhabitable portion of the tiny point that is the earth, seen against the vastness

64. See Brena 1999: 275–91; Narducci 2002: 337–45.

65. See Wick 2004.

66. Statius alludes to the sublime flying chariot of fame of the love elegist Propertius, speaking of his own poetry: 'quo me Fama leuat terra sublimis, et a me / nata coronatis Musa triumphat equis' (by which Fame raises me from the earth on high, and the Muse that is born of me triumphs with garlanded steeds) (3.1.9).

of the heavens (*Cons. Philos.* 2 pros. 7). In the first *metrum* of book 4, Boethius combines details of the ascent of the soul in Plato's *Phaedrus* with the tradition of the ascent of the soul in Latin poetry.[67] The *metrum* begins (1–6):

Sunt etenim pennae uolucres mihi
 quae celsa conscendant poli.
quas sibi cum uelox mens induit,
 terras perosa despicit,
aeris immensi superat globum,
 nubesque postergum uidet

(For I have rapid wings to scale the heights of the sky. When my swift mind puts them on, it looks down with hatred on the earth, it passes beyond the sphere of the boundless air, and looks back at the clouds.)

The ascent is a return to origins; once the swift mind has reached the outside of the upper air, it will remember that here is its fatherland, its *patria*. Looking back down on the earth, the repatriated mind will, like Lucan's Pompey, view the dark night that it has left behind, where fierce tyrants are seen as nothing more than exiles.

The successful ascent of the mind from earth to the supra-celestial region in the first *metrum* of book 4 of the *Consolation of Philosophy* is contrasted with the unsuccessful attempt of Orpheus to lead Eurydice on the ascent from the underworld to the upper world, the subject of the last *metrum*, 12, in book 3. After telling the story at length, the *metrum* ends with an allegorization addressed to the reader (52–58):

uos haec fabula respicit
quicumque in superum diem
mentem ducere quaeritis.
nam qui Tartareum in specus
uictus lumina flexerit,
quicquid praecipuum trahit
perdit, dum uidet inferos.

(This tale refers to you, whoever seeks to lead your mind to the daylight above. For whoever is overcome and turns his eyes back to the Tartarean

67. O'Daly 1991: 201–2; Crabbe 1981.

cave, loses whatever excellence he brings with him, while he looks on those below.)

Here is another example of a pointed contrast between successful and unsuccessful attempts to make an ascent, such as we saw in the preface to the pseudo-Aristotelian *De mundo*.

The vanity topos of the Ciceronian *Dream of Scipio* and of the Lucanian ascent of Pompey's soul has a long afterlife, continuing through the Middle Ages and beyond, with major examples in Dante, Petrarch, Boccaccio and Chaucer.[68] The teenage Mozart set the Ciceronian view from above to music in the dramatic serenade *Il sogno di Scipione* (to a libretto by Metastasio).

The Platonic-Stoic doctrine of the posthumous ascent to the stars of the virtuous soul is treated at length by Cicero elsewhere, in *Tusculan Disputations* 1.43–45. The soul escapes from the dark and damp lower air, which it swiftly bursts through to reach the upper air, hot and rarefied, whose nature it shares: this is the ascent of like to like, to the 'natural place' of the fiery soul. This is a place of freedom, the freedom for the soul, escaped from the prison-house of the body, to contemplate philosophical truth, unhindered by the desires ('cupiditates') and envyings that trouble our life in the body. At the same time, Cicero, like Plato, closely associates the ascent of the soul with desire, the insatiable desire to see the truth ('insatiabilis . . . cupiditas ueri uidendi'), a desire for knowledge that is only increased by the ease with which the place to which the soul has come makes that knowledge accessible. We have here a variation on the tension between infinity and finite goals and boundaries that emerges in the Lucretian account of Epicurus's flight of the mind (see above: 37). Cicero seems to indicate that the insatiability of the desire to see the truth will be satisfied when we arrive in the heavens, since the place itself will facilitate the acquisition of that knowledge, although the logic of the Latin might imply that the desire will never be satisfied, since the more knowledge you have, the more you will want, in an infinite regress, a celestial equivalent of the cliché about sublunary greed for money, or the insatiable appetite for food supernaturally inspired in Ovid's Erysichthon: 'the more food he sinks in his

68. Dante, *Paradiso* 22.124–38; Petrarch, *Africa* 1–2; Boccaccio, *Teseida* 11.1–3; Chaucer, *Troilus and Criseyde* 5.1.807–34. See Steadman 1972; Narducci 2001; Koppenfels 2007: ch. 2. For examples of the view from above, or 'Olympian view' (whether to provoke wonder at God's creation, or contempt for the futility of human endeavour) in sixteenth-century European literature, art and maps, see Gibson 1989: 57–59.

belly, the more he wants' (plusque cupit, quo plura suam demittit in aluum) (*Met.* 8.834).[69] As Sallust puts it in *The Conspiracy of Catiline*, 'the greed for money is always boundless and insatiable [semper infinita insatiabilis]' (11.3).

The knowledge acquired in this lofty flight is presented as a vision, and Cicero develops another analogy between seafaring and the upwards flight of the soul, giving priority, as Lucretius does, to the spiritual over the physical journey. Those who have penetrated the Bosporus, like the Argonauts, to see the Black Sea, or who have seen the Ocean through the Straits of Gibraltar, think that they have achieved something, but this is as nothing to the *spectaculum* (vision) from above of the whole earth.

Seneca the Younger

The view from above is a favourite theme of the younger Seneca.[70] A particularly grand example, and one which provided one of the models for Lucan's account of the ascent of Pompey's soul, and also for a famous passage in a poem by John Donne (see ch. 3: 132–33), forms the rousing conclusion to Seneca's *Consolation to Marcia*, on the premature death of her son Matilius (composed between AD 37 and 41). Souls which are liberated early from dealings with humans, says Seneca, more easily fly back to their source of being (23.1: 'liberati leuiores ad originem suam reuolant'). In language reminiscent both of Epicurus's flight of the mind in the proem to book 1 of Lucretius and of the view down from the 'regions of the wise' on high on the wanderings and struggles of the unenlightened at the beginning of book 2, great minds 'are eager to take their leave and break out; they chafe at this narrow existence, used as they are to wander aloft through the universe, and to look down on human existence from on high' (exire atque erumpere gestiunt, aegre has angustias ferunt, uagari per omne sublimes et ex alto adsueti humana despicere) (23.2). After

69. See Kenney 2011 ad loc. and Nisbet and Hubbard 1978 on Horace, *Odes* 2.2.13 for further parallels on the insatiability of pecuniary and erotic greed, including Horace, *Odes* 3.16.17–18: 'crescentem sequitur cura pecuniam / maiorumque fames' (as money grows, anxiety and a hunger for more accompanies it); Horace, *Ep.* 1.2.56: 'semper auarus eget' (the greedy man is always in need); Aristotle, *Pol.* 1267b4ff.: 'for the nature of desire is limitless [ἄπειρος], and the many live with the goal of satisfying it [ἀναπλήρωσιν]'; see also Mayor 1889 on Juvenal 14.139: 'crescit amor nummi quantum ipsa pecunia creuit' (the love of money grows in proportion with the growth of wealth itself).

70. See Williams 2012.

death, the soul of Matilius, no stranger in his lifetime to the view from above with the eyes of the mind, itself has soared aloft to join the souls of the blest (25.1: 'ad excelsa sublatus inter felices currit animas'), foremost among whom is his grandfather, Marcia's father, Cremutius Cordus, the historian forced to commit suicide by Tiberius's minister Sejanus. The reader's memory of the younger Scipio meeting his older relatives in Cicero's *Dream of Scipio* lends further dignity to the meeting of Matilius and Cremutius. Cremutius introduces his grandson into the secrets of nature (25.2: 'arcana naturae'), and bids him turn his gaze on the things of the earth far below ('profunda terrarum'), since there is pleasure in looking back from on high on what has been left behind ('iuuat enim ex alto relicta respicere'). The vast scale of the vertical gap between the heavens above and the earth below is matched by the freedom of the disembodied soul to wander through the immensities of both space and time: 'Throughout the free and boundless spaces of eternity they wander; no intervening seas block their course, no lofty mountains or pathless valleys or shallows of the shifting Syrtes; there every way is level, and, being swift and unencumbered, they easily are pervious to the matter of the stars and, in turn, are mingled with it' (25.3).

In a closing address to his daughter, the soul of Cremutius says that his historian's gaze can now expand from the history of a single age in a distant part of the universe (his history of the Roman Republic) to the vision of 'countless centuries, the succession and train of countless ages, the whole array of years: I may behold the rise and fall of future kingdoms, the downfall of great cities, and new invasions of the sea' (26.5). The final consolation for Marcia's loss is the thought of the common fate of all things in the universe, which Cremutius can foresee in ecstatic visions of cataclysm and ecpyrosis, surrendering joyfully to what in Cicero's *Dream of Scipio* had been an inhibition on the desire for eternal glory for earthly achievement. To be a small part of that universal ruin is itself something that Cremutius embraces: 'Then we too, the souls of the blest, who have partaken of immortality, when God decides to create the universe anew, we, amid the falling universe, shall be added as a tiny fraction to this mighty destruction, and shall be changed again into our former elements [et ipsae parua ruinae ingentis accessio in antiqua elementa uertemur]' (26.7). There is an anticipation here of the exultant descriptions in eighteenth-century poems on the Last Judgement of the colossal convulsions at the end of the world, but without the emotions of hope and fear of the Christian poets as they entertain thoughts of their own presence before the judgement seat.

Apotheosis of the Ruler

Cremutius is a virtuous Roman whose escape to the mysteries and blessedness of the heavens is an escape from the oppression of a tyrannous Roman emperor, Tiberius, and his creature, Sejanus. By the time of Cremutius's suicide in AD 25, the supposed ascent to the heavens of the deceased Roman emperor had become institutionalized with the deification of the deceased Augustus in AD 14, following the precedent of the deification of his adoptive father, Julius Caesar, in 42 BC.[71] Divus Julius and Divus Augustus were not inevitably followed into godhood by their successors. Neither Tiberius nor Caligula were granted divinity by senatorial decree, unlike Caligula's successor Claudius. Claudius's apotheosis is satirized by Seneca in the *Apocolocyntosis*, in which the dead Claudius's ascension to the celestial senate-house of Jupiter is followed by his expulsion from heaven on the motion of Augustus, and his removal down to the underworld, condemned to suffer the eternal punishment of playing his favourite game of dice using dice-boxes with holes in the bottom. From the Flavian dynasty onwards, the deification of the deceased emperor became regular, except in the case of rulers who were deposed or assassinated, or whose memory was officially condemned.

Here I will focus chiefly on the fiction of the ascent of the deified emperor to the heavens. I use the word fiction, because it is doubtful whether many, if any, educated Romans believed in the literal skywards elevation of the dead emperor's soul. It was a political and cultic fiction that yet served its purpose within the ideology and religious institutions of the Roman empire, through what might be seen as a suspension of disbelief. The fictional quality of imperial apotheosis meant that it continued to be available as a panegyrical image even in Christian centuries, when it could also merge, or be contaminated, with images of ascent from the Christian tradition (on which see below).

Works of literary fiction played a major role in the elaboration of the imagery of imperial apotheosis. Roman writers drew on precedents in the apotheoses and catasterisms of Hellenistic ruler-cult. In Theocritus 17.16–33, Ptolemy I

71. Basic bibliography on the divinity and *consecratio* of the Roman emperor: Bickermann 1929; Taylor 1931; Weinstock 1971: ch. 16, 'The Ides of March'; 356–63: 'The Ascension'; ch. 17, 'The New God'; 370–84: '*Caesaris astrum*'; Price 1987; Beard, North and Price 1998, 1: 140–49: 'Divus Julius: Becoming a God?' (typically sceptical); Koortbojian 2013; MacCormack 1981: Part 2, '*Consecratio*', an important and comprehensive discussion of late-antique imperial *consecratio* and the earlier imperial tradition, with a good selection of illustrations.

'Soter', father of the *laudandus* Ptolemy II 'Philadelphos', joins Alexander and Herakles, to whom he traced his lineage, in a symposion on Olympus, given honours equal to the gods (*homotimos*) by Zeus.[72] The last poem of Callimachus's *Aitia* (Causes) was a graceful court panegyric that narrated the origin of a new constellation in the heavens, through the elevation to the sky as a star ('catasterism', or 'stellification') of a lock of hair which Queen Berenice had cut from her head, as a votive offering for the safe return from war of her husband Ptolemy III 'Euergetes'. After being dedicated in a temple, the lock disappeared. The court-astronomer Conon conveniently discovered a new constellation, which he announced to be the catasterized lock (Callimachus, *Aitia* frr. 110–110f Harder), translated to the skies as company for the garland of Ariadne, transformed into a constellation by Ariadne's divine consort Bacchus (a metamorphosis narrated by Ovid at *Metamorphoses* 8.177–82, and *Fasti* 3.507–16; the constellation appears above the head of Ariadne in Titian's famous painting *Bacchus and Ariadne*). The Coma Berenices (Lock of Berenice) survives on the modern astronomical map of constellations. Callimachus's text survived antiquity in the Latin translation by Catullus, poem 66. 'The Lock of Berenice' is a provocative model for Virgilian and Ovidian Julian apotheoses, and a less surprising model for Alexander Pope's *The Rape of the Lock* (see ch. 5: 207–9).

In the decades preceding the apotheosis of the murdered Julius Caesar (d. 44 BC), Cicero tested the limits of ascribing divinity to the great Roman—a Pompey, a Caesar—in passages of panegyric in his oratory. The *Dream of Scipio*, written in the decade before the assassination of Julius Caesar, is also a crucial text for the development of the ideology of Roman imperial apotheosis.[73] The younger Scipio's ascent in a dream to meet Scipio Africanus and Aemilius Paulus follows a trail blazed by the first king of Rome, Romulus, whose apotheosis is introduced in the *Dream* with reference to the eclipse of the sun that occurred at the time of his disappearance: 'when the soul of Romulus made its way into [penetrauit] these very regions' (*Rep.* 6.24.3). A little later the younger Scipio asserts that he has taken to heart Africanus's lesson about the celestial rewards for those who devote themselves to the virtuous service of the state, and that he is now inspired to strive even more vigorously to follow in the footsteps of Africanus and his own father Aemilius, 'if indeed

72. Hunter 2003: 111 on the *isotheoi timai* (honours equal to the gods) that are given pictorial expression in the scene.

73. The importance for the imperial cult of the deified ruler of Cicero's explorations of the connections between human and divine has recently been brought into sharp relief by Cole 2013.

a path to enter heaven, as it were, is open to those who have served their country well' (si quidem bene meritis de patria quasi limes ad caeli aditum patet) (*Rep.* 6.26.1). The qualification of *quasi*, 'as it were', is typical of the delicacy and detachment with which Cicero handles the topic. Imperial apotheosis is more often than not a matter of 'as if'. The theme of human approximation to the divine had already been raised in the prologue to Cicero's *Republic*, when he states that 'there is nothing in which human virtue may approach more closely to the divinity of the gods than in the foundation of new cities, or in the preservation of cities founded in the past' (1.12.4). Spencer Cole notes the programmatic nature of this statement for the *Republic* as a whole: 'making connections between Rome's supreme statesmen, civic benefaction, and divinity is central to the *De re publica* both in the elaborate presentation of Romulus' apotheosis and Scipio's visionary dream of astral immortality in the coda to the dialogue.'[74]

It is above all the poets Virgil and Ovid who define and elaborate the imagery of imperial apotheosis. In what follows, I incorporate discussion of this within a unified account of patterns of ascent and descent in each poet, since, in each, ascent through apotheosis is part of a larger network of themes and images of celestial aspiration. In turn, celestial aspiration is set against the possibility of descent to or ascent from what lies beneath the earth, in an opposition, or struggle, between heaven and hell. The thematization of the vertical axis in the works of Virgil and Ovid will be vastly influential in later Latin antiquity, and then in post-antique reception.

Virgil

The three major works of Virgil, the *Eclogues*, the *Georgics* and the *Aeneid*, form a sequence that itself is characterized by a generic ascent from lower to higher, an ascent represented schematically in the medieval *rota Vergilii* (wheel of Virgil).[75] In respect of celestial aspirations, as in so many other respects, the book of pastoral poems, the georgic didactic and the epic explore similar themes, contributing to a sense that the three poems together constitute a 'super-text'. My focus will be chiefly on that section of the vertical axis that goes from earth to heaven and the stars, but the axis continues down to the

74. Cole 2013: 86; 85–103 on the *Republic*; 80–85 on the importance for the theme of the *Pro Sestio* (56 BC: possibly already under spell of Lucretius?). See also Hardie forthcoming.

75. Ziolkowski and Putnam 2008: 744–50.

underworld and its lowest depths, Tartarus. From the time of Homer, the gods have moved freely up and down the vertical axis, and they continue to do so in the *Aeneid*,[76] but Virgil's early imperial epic has a (largely) non-Homeric investment in the potential for mortals to move up the vertical axis. As well as the Homeric models, the Lucretian vision of space is of crucial importance.[77]

Eclogues

In the 'lowly' (*humilis*) genre of pastoral, the vertical axis is first introduced at 1.24–25, where Tityrus reaches for a pastoral comparison in the attempt to describe the unimaginable greatness of the city of Rome: 'but this city has raised her head as high among other cities as cypresses often do among pliant wayfaring trees'. Just how high the reach of Rome is will be revealed at *Aeneid* 8.99–100, as Aeneas approaches by river the humble pastoral settlement on the site of what will one day be Augustan Rome: 'they see buildings, which the power of Rome has now brought level with the heavens [quae nunc Romana potentia caelo / aequauit]'. That is an epic sky-reaching. A more properly pastoral vertical axis is registered at the end of the first *Eclogue*: 'and now smoke rises in the distance from the tops of farmhouse roofs, and the shadows lengthen as they fall from the high mountains' (82–83).

Three *Eclogues* at the centre of the book, 4–6, burst the strict limits of the pastoral world and of the genre of pastoral, and they explore the vertical axis in a variety of interlocking ways. *Eclogue* 4, the so-called 'Messianic eclogue', tells of the birth of a mysterious child in whose lifetime the world will revert from the current Iron Age to a paradisal Golden Age. The process starts with descent from heaven: 'now a new child is sent down from the high heavens' (iam noua progenies caelo demittitur alto) (7), accompanied by the return of Justice, or Astraea, who had fled from earth up to the skies at the end of the Golden Age, to become the constellation Virgo (6: 'iam redit et Virgo'). Ascent is implied in the last line, when the small boy is exhorted to show his

76. On the importance of the 'sublime Olympian perspective' of the vertical axis in Homer, see Porter 2016: 375–76.

77. See Hardie 2018. For a striking example of the 'view from above' in Apollonius of Rhodes, see *Argonautica* 3.164–66: Eros's view on the earth below as he flies down to shoot his arrow at Medea, a 'panorama [which] stresses Eros' universal control' (Hunter 1989: 116), and which is reflected in the supreme sky-god Jupiter's panoramic gaze on sea and earth at Virgil, *Aen.* 1.223–26.

recognition of his mother with a laugh; those who do not laugh for their mother, 'the god deems not worthy of his table, the goddess not worthy of her bed': elevation to the heavens through apotheosis (in the allusive footsteps of Hercules) is in prospect for this new baby.

Apotheosis is realized in the next *Eclogue*, 5, which contains two paired songs: Mopsus's pastoral lament for the dead Daphnis, modelled on the death of Daphnis in Theocritus's first idyll, and Menalcas's song of joy for the apotheosis of Daphnis, for which Theocritus 1 does not provide a model. Mopsus's lament ends with the epitaph to be inscribed on Daphnis's tomb: 'Daphnis in the woods was I, famed from here as far as the stars, guardian of a beautiful flock, himself more beautiful' (Daphnis ego in siluis, hinc usque ad sidera notus, / formosi pecoris custos, formosior ipse) (43–44). The vertical distance between the woods of pastoral and the stars is spanned by fame, *fama*, echoing the epic hero Odysseus's boast that his fame, *kleos*, reaches the heaven (*Odyssey* 9.20). In response, before launching into his formal song, Menalcas promises, 'I will raise your Daphnis to the stars; Daphnis will I bear to the stars [Daphninque tuum tollemus ad astra; / Daphnin ad astra feremus]: Daphnis loved me too' (51–52). 'Bearing someone to the stars' is a metaphor for praising that person, but Menalcas has in mind the literal elevation to the heavens of the soul of the dead Daphnis, who now, 'shining bright, marvels at the strange spectacle of the threshold of the heavens, and sees clouds and stars beneath his feet' (candidus insuetum miratur limen Olympi / sub pedibusque uidet nubes et sidera Daphnis) (56–57). Daphnis's view from above is not down to the earth, but to the clouds and stars, a vertiginous prospect that alludes to the effect of Epicurus's revelation of the nature of things in enabling Lucretius to see the endless void opening beneath his feet: 'But on the other hand the regions of the underworld are nowhere to be seen, although the earth is no obstacle to seeing through all things which are in operation beneath our feet [sub pedibus] throughout the void' (Lucr. 3.25–27). Menalcas also uses of the deified Daphnis the language that Lucretius had used of the 'divine' Epicurus: 'The rocks themselves, the shrubs themselves sound out the song: "a god, a god is he, Menalcas" ['deus, deus ille, Menalca!']' (*Ecl.* 5.63–64): compare *On the Nature of Things* 5.8: 'a god, a god was he, famed Memmius' (deus ille fuit, deus, inclute Memmi). For Lucretius, Epicurus's divinity is figurative; Menalcas means the real thing (within the pastoral fiction). The apotheosis of the pastoral hero Daphnis veils a reference to the recent deification of Julius Caesar as Divus Julius. The striking novelty in Rome of deifying the ruler is registered in the adjective *insuetum* in line 56: it is not only Daphnis for whom the

threshold of Olympus is 'unaccustomed'. *Eclogue* 5 is not done with its variety of ways of aspiring to the heavens: to sky-reaching fame and posthumous apotheosis is added the rocketing to the stars of cries of joy: 'the shaggy mountains themselves joyfully hurl their voices to the stars' (ipsi laetitia uoces ad sidera iactant / intonsi montes) (62–63).[78]

In the following *Eclogue*, 6, the 'Song of Silenus' on the history of the world reaches a climax with the elevation of Virgil's friend, the elegiac poet Gallus, but only as high as the summit of the mountain of poetry, Helicon. But, at the end of the poem, song reaches the skies, re-echoed to the stars: 'All the songs that of old Phoebus rehearsed, while happy Eurotas listened and bade his laurels learn by heart—these Silenus sings. The echoing valleys carry them again to the stars [pulsae referunt ad sidera ualles]' (82–84).

In the fragments of song that populate the penultimate *Eclogue*, 9, there are reprises of the sky-reachings of song, fame and apotheosis. If Varus preserves Mantua, Virgil's home-town, from land confiscations, he is promised that his name will be carried by singing swans, on high to the stars: Vare, tuum nomen . . . cantantes sublime ferent ad sidera cycni (27–29). Another snatch of song (46–49) refers to the new star that has appeared among the old, the *Caesaris astrum* (or *sidus Iulium*, 'Julian star') that signals the apotheosis of Julius Caesar, alluded to in allegory in *Eclogue* 5.

In *Eclogue* 1, the vertical axis had been opened up with reference to lofty cypresses; the last *Eclogue*, 10, concludes with a rapidly growing tree that is a correlate not of the city Roma, but of the poet's love, *amor*, for his poet-friend Gallus, 'my love for whom grows from hour to hour as fast as the green alder shoots up when spring is young' (73–74).This is followed by a self-admonition to 'rise' (75: 'surgamus'), from the shade of the tree under which the pastoral singer sits, and rise also from the lowly genre of pastoral to the higher genre of didactic.[79]

Georgics

The *Georgics* are framed by statements of the celestial aspiration of the ruler of Rome, Caesar Octavian (soon to be renamed Augustus). The opening prayer in *Georgics* 1, to the gods of farming and the countryside, concludes with a

78. On *Ecl.* 5, see Grimal 1949; DuQuesnay 1976/77; Saunders 2008: 21–30 on cosmology and catasterism; Domenicucci 1989 on the catasterism of Julius Caesar.

79. See Kennedy 1983.

foundational text in the poetic representation of imperial apotheosis (1.24–42). Virgil looks forward to Octavian's future choice of the division of the universe (earth, sea, sky or underworld) in which to locate his posthumous divinity, including the possibility that he will add himself as a star to the revolving months (32–35). The language alludes both to Catullus's account of the catasterism (stellification) of the Lock of Berenice in poem 66, and to the rising of the *sidus Iulium* in *Eclogue* 9.[80] At the end of the *Georgics*, in the so-called 'sphragis' in which the poet 'signs' his work, we find Caesar Octavian already embarked on the path to heaven, as he metaphorically wields the thunderbolt of the supreme god Jupiter, 'while great Caesar thunders in war by the deep Euphrates, and, victorious, dispenses laws among willing peoples, and pursues the path to Olympus [uiamque adfectat Olympo]' (4.560–62). This is probably to be imagined as a journey to heaven in a flying chariot.[81]

In the sphragis, Caesar's journey to Olympus is contrasted with the life-choice of the poet Virgil, content to 'flourish in the pursuits of a leisure unknown to fame' (studiis florentem ignobilis oti) (4.564). This decoupling of princely and poetic ambitions is gainsaid by the central panel of the *Georgics*: the closing sequence of book 2 and the opening sequence of book 3 together make up a complex exploration of ascents and descents, in the course of which the poet audaciously hitches his wagon to Caesar's.[82] A description of the 'Golden Age' of the farmer's existence in the present day is rounded off with a mythological allusion: when Justice left the earth, her footsteps were last seen among farmers (*Geo.* 2.473–74), alluding to the final departure from the earth of Justice (Dike) at the coming of the Bronze Age in Aratus's didactic poem on astronomy the *Phaenomena* (133–36). Justice flew up to the heavens, where

80. With *Geo.* 1.32: 'anne nouum tardis sidus te mensibus addas' (or whether you will add yourself to the slow procession of the months as a new star) compare Catullus 66.63–64 ('Lock of Berenice'): 'uuidulam a fluctu cedentem ad templa deum me / sidus in antiquis diua nouum posuit' (As I made my journey to the abodes of the gods, dripping from the spray of the sea, the goddess [Venus] placed me as a new star among the old ones); *Ecl.* 9.46–47 '"Daphni, quid antiquos signorum suspicis ortus? / ecce Dionaei processit Caesaris astrum"' ('Daphnis, why do you look up at the risings of the old stars? See, the star of Venus' Caesar has come forth.') On Virgil's allusions to the *Coma Berenices* in the *Aeneid*, see Drew Griffith 1995; Wills 1998; Hardie 2006: 34–36.

81. So Nelis 2008: 517. On the dense Lucretian echoes in these two and a half lines, see Hardie 1986: 51 with n. 42.

82. See Hardie 1986: 33–51, 'Cosmology and National Epic in the *Georgics*', reprinted in Volk 2008: ch. 8.

she can still be seen as the constellation Virgo. Aratus in turn alludes to Hesiod's prophecy that Shame (Aidōs) and Righteous Indignation (Nemesis) will leave the earth for Olympus in the still more degenerate age that will follow the age of the Race of Iron (*Works and Days* 197–200). The path to the sky is one that, in the following lines, the poet Virgil himself will attempt to follow, in a flight of the mind guided by the Muses of natural-philosophical didactic poetry, in the manner of Aratus, and of Lucretius: 'But as for me—first may the Muses, sweet beyond all things, whose holy objects I bear, smitten with a mighty love, welcome me, and show me the paths of the sky and the stars' (*Geo.* 2.475–77); 'caelique uias et sidera monstrent' could mean just 'teach me about the paths of celestial bodies and the stars', but could also mean 'show me the way to the paths of celestial bodies and the stars', on a journey to the sky. But if Virgil 'cannot reach these parts of nature' (483: 'sin has ne possim naturae accedere partis'), in the footsteps of Lucretius's Epicurus, he will be content with a life down below in the fields and valleys, a life without glory (486: 'inglorius').

Virgil makes a renewed attempt to leave the earth at the beginning of book 3, but now in the vehicle of an epic, rather than a natural-philosophical, poetic project, deploying Ennian language of immortal fame, and Lucretian language of poetic primacy. After a brief catalogue of hackneyed mythological subjects to be rejected, concluding with Pelops's chariot-race for the hand of Hippodame, the poet continues (8–11; translation by Dryden, *Georgics* 3.13–16):

> temptanda uia est, qua me quoque possim
> tollere humo uictorque uirum uolitare per ora.
> primus ego in patriam mecum, modo uita supersit,
> Aonio rediens deducam uertice Musas.[83]

> (New ways I must attempt, my grovelling name
> To raise aloft, and wing my flight to fame.
> I, first of Romans, shall in triumph come
> From conquered Greece, and bring her trophies home.)

Take-off from the earth in lines 8–9 is to be envisaged as taking place in a flying chariot, anticipating the hundred (earthbound) chariots that Virgil will cause

83. Cf. Lucr. 1.117–19: 'Ennius ut noster cecinit qui primus amoeno / detulit ex Helicone perenni fronde coronam, / per gentis Italas hominum quae clara clueret' (As our Ennius sung, who first brought down from lovely Helicon a crown of evergreen leaves, to win bright fame among the tribes of Italian peoples).

to drive in victory games in honour of Caesar at the poet's home-town of Mantua.[84] Virgil will be a purple-robed 'uictor' (17), in the likeness of the *triumphator* Caesar himself, who rode in his triumphal chariot in Rome in the triple triumph of 29 BC. Flying and mountain-climbing are alternative forms of ascent: Virgil returns to Italy bringing back the Greek Muses in triumph after ascending to the summit of mount Helicon. In *Eclogues* 5 and 6, the apotheosed Daphnis's flight to the stars is followed by the poet Gallus's elevation to the heights of Helicon.

The image of a flying chariot recurs later in *Georgics* 3 in a description of a chariot-race which has marked similarities to the poet's wish to rise up from the ground at lines 8–9: 'The flying chariot kindles in the course: / And now a-low; and now aloft they fly, / As born through air, and seem to touch the sky' (uolat ui feruidus axis; / iamque humiles iamque elati sublime uidentur / aëra per uacuum ferri atque adsurgere in auras) (3.107–9; Dryden's translation, *Georgics* 3.170–72). These chariots are taking off on a flight into sublimity: *humilis* and *sublimis* are used of the low and high styles, respectively, and *elatus*, as a participial adjective, is used in transferred senses of the greatness or sublimity of soul, mind or genius.[85]

Georgics 4 ends with Caesar's journey to Olympus. It begins with the introduction of the subject of bees, whose honey is described in the first line as 'heaven's gifts of honey from the sky' (aërii mellis caelestia dona). The bees have a particular affinity with the heavens, making as if towards their natural place when they first emerge from their hives in springtime, in a typically meaningful example of Virgilian hyperbole: 'Hence when you look up and see the swarm, just freed from the hive, sailing towards the stars in the sky [ad sidera caeli / nare], through the clear summer air, and when you marvel at the dark cloud drawn by the wind' (58–60). The remarkable gifts of the bees are evidence that they 'have a share in the mind of god, and draughts of aether' (esse apibus partem diuinae mentis et haustus / aetherios) (220–21). This claim is then generalized to the statement that all living creatures, human and animal, have their origin from the god who is immanent in the universe, and to whom all beings return, as to their home, on their bodily death: 'to him all beings thereafter return, and, when unmade, are restored; there is no place for death, but, living, they fly into the ranks of the stars, and take their place in the

84. So Nelis 2008: 513.

85. *Thes. Ling. Lat.* s.v. *effero* 5.2.151.5ff. For further discussion of these flying chariots, see Hardie 2019.

heavens on high' (scilicet huc reddi deinde ac resoluta referri / omnia, nec morti esse locum, sed uiua uolare / sideris in numerum atque alto succedere caelo) (225–27). 'uiua uolare' is another echo of Ennius's epitaph for himself (see above: 48).

The bee-keeper Aristaeus, whose hive is first wiped out as punishment for his having caused the death of Eurydice, and then restored through the miraculous procedure of *bugonia* (the spontaneous generation of bees from the carcass of a sacrificed ox), has a more special relationship to the sky and to divinity. Aristaeus is one of the gods of farming invoked in the opening prayer of *Georgics* 1. In his earthly existence, after the loss of his bees he complains to his mother, the nymph Cyrene, 'Why did you tell me to hope for the sky?' (quid me caelum sperare iubebas?) (4.325). Cyrene orders that her son be allowed access to her watery grotto, since 'it is lawful for him to touch the threshold of the gods' (fas illi limina diuum / tangere) (358–59). In the first instance this refers to her own threshold, but hints at a larger access to the gods, of the kind anticipated for the divine child at the end of the fourth *Eclogue*. A common reading of *Georgics* 4 sees in Aristaeus a figure for Octavian's restoration of Rome after the 'plague' of civil war, and in Aristaeus's 'hope for heaven' allusion to the future apotheosis of Octavian/Augustus.[86]

The Aeneid

Much of the pathos of the Homeric epics is generated by the inevitable mortality of its heroes, who strive for immortal and sky-reaching fame in the unblinking awareness that this can be their only escape from death. This is true even, and especially, of Achilles, despite his close relationship to his divine mother Thetis. The complaint of the god-to-be Aristaeus to his mother the water-nymph in *Georgics* 4 is modelled on the mortal Achilles's complaint at his treatment by Agamemnon to his mother the sea-goddess in *Iliad* 1.

The hero of the *Aeneid*, by contrast, will become a god on his death, as will heroes of future Roman history, firstly Rome's founder Romulus, and then descendants of Aeneas in the *gens Iulia* (named after Aeneas's son Iulus, or Ascanius): Julius Caesar and, in prospect, Augustus. Promises of the eventual journeys to the sky, as gods, of her son and of her distant descendant open and close the reassuring prophecy of the full span of Roman history delivered to a distraught Venus by Jupiter near the beginning of book 1 of the *Aeneid*. Seated

86. E. g., Morgan 1999.

in his panopticon at the summit of heaven and enjoying the view from above down on earth and sea (223–26), he promises his daughter, 'You will carry great-hearted Aeneas on high to the stars of the heavens' (sublimemque feres ad sidera caeli / magnanimum Aenean) (259–60); and 'Julius, whose name is passed down to him from great Iulus. In time to come, free of care, you will receive him in the sky laden with the spoils of the east; he too will be called upon in prayer' (Iulius, a magno demissum nomen Iulo. / hunc tu olim caelo spoliis Orientis onustum / accipies secura; uocabitur hic quoque uotis) (288–90).[87] Forming a ring with his opening prophecy to his daughter Venus in book 1, in his interview in the last book, 12, with his wife and sister Juno, Jupiter secures her assent to the fated inevitability of Aeneas's ascent to the heavens,: 'You yourself know, and admit that you know, that, as a god of the land, Aeneas is owed to the heavens, lifted up by fate to the stars' (indigetem Aenean scis ipsa et scire fateris / deberi caelo fatisque ad sidera tolli) (12.794–95).

When Aeneas's son Iulus/Ascanius kills his first man in battle with his bow and arrow, the god Apollo looks down from above and applauds: 'Congratulations on your newfound courage/manhood,[88] boy: this is the path to the stars, you who are the descendant of gods and ancestor of gods' (macte noua uirtute, puer, sic itur ad astra, / dis genite et geniture deos) (9.641–42). This is a promise for future generations of Romans virtuous in Rome's interest, such as the Scipiones, and a dynastic promise of actual divinity for members of the gens Iulia.

This is a path denied to Aeneas's enemy Turnus, who can at best hope for the kind of access to the heavens afforded by fame. The disguised Juturna, Turnus's sister, contrasts the glory that Turnus will win with the ignominy that confronts the Latins if they sit idly by: 'He, indeed, will ascend in fame to the gods, to whose altars he dedicates himself, and will be borne living on lips of men' (ille quidem ad superos, quorum se deuouet aris, / succedet fama uiuusque per ora feretur) (12.234–35).[89] Shortly before the end of the poem,

87. On the problem of 'which Julius?' (Julius Caesar or Augustus), see Harrison 1996. On the rhetoric of the speech of Jupiter, see O'Hara 1990: 132–63.

88. uirtus (virtue, courage), is etymologically the state of being a 'man' (uir).

89. Tarrant 2012 ad loc. compares Cicero, Cat. 3.2 '[Romulum] ad deos immortales beneuolentia famaque sustulimus' (We have raised Romulus to the immortal gods through favour and fame), a Euhemerizing formulation of the apotheosis of Romulus, narrated in Ennius's Annals; the wording resembles Geo. 4.226–27 (of the actual ascent of souls:) 'uiua uolare / sideris in numerum atque alto succedere caelo' (they fly alive to the place of a star and ascend to the lofty sky), and Ennius's epitaph for himself: 'uolito uiuus per ora uirum' (I fly living over the lips of

Aeneas taunts Turnus, 'Pray for wings on which to head for the lofty stars, or to shut yourself hidden in a hole in the ground' (opta ardua pennis / astra sequi clausumque caua te condere terra) (12.892–93). This is a sarcastic application of the Euripidean wish for escape on wings (see above: 40), sometimes paired, as here, with the polar opposite of escape beneath the earth. Ironically, Turnus will, in a manner, realise both: after his death, Turnus's city, Ardea, will be set on fire, and metamorphosed into a heron, *ardea*, whose name may be heard in *ardua*. The journey of Turnus's soul in the last line of the *Aeneid* is not upwards to the stars, but down to the shadows of the underworld: 'and with a groan his life fled indignantly down into the shadows' (uitaque cum gemitu fugit indignata sub umbras) (12.952).

The celestial destination of the great men of Rome is also presented figuratively. The anniversary funeral games for Anchises in *Aeneid* 5 contain multiple foreshadowings of Roman history. One of these is the ecphrasis of the first prize in the ship-race, a cloak embroidered with the rape of Ganymede, 'whom the swift bird that bears the arms of Jupiter snatched up on high from mount Ida in its curved talons' (quem praepes ab Ida / sublimem pedibus rapuit Iouis armiger uncis) (5.250–57). Ganymede's journey to heaven was one of those motivated by love and sexual desire, when Jupiter's eagle came down to snatch him aloft. Plato recasts the myth of Zeus and Ganymede as the model of divine *eros* in the *Phaedrus* (255c) (on the ascent of Ganymede as an expression of desire, see also ch. 6: 285n43). In the context of the ship-race in *Aeneid* 5, Virgil's Ganymede ecphrasis can be read as an allegory of the apotheosis of Romulus, the founder of Rome, as I have argued elsewhere.[90] The politico-historical coincides with the epinician (a conjunction found previously in the proem to *Georgics* 3): at the moment of his victory in the Olympian boxing-match, Pindar compares the beauty of the boy Hagesidamus to the godlike beauty of Ganymede, which impelled the love-struck Zeus to grant him immortality on Olympus (Pindar, *Olympian Odes* 10.99–105).[91]

The archery contest later in *Aeneid* 5 (485–544) is of a vertical kind. The target is a dove tied by a cord to the top of a ship's mast. One of the contestants

men) (*Epigr.* 2a Goldberg and Manuwald), echoed also at *Geo.* 3.9: 'uirum uolitare per ora'. Tarrant on 12.235 notes, 'The allusion to passages that describe lasting renown achieved through poetry may suggest that T[urnus]'s fame will be perpetuated in a way Juturna cannot foresee, through Virgil's epic.'

90. See Hardie 2002; on the Ganymede ecphrasis, see also Putnam 1998: ch. 2; on Ganymede and desire, see Barkan 1991. Ovid's account of Mars's snatching up of Romulus in his apotheosis is a figurative rape (*Met.* 14.818: 'rapinae').

91. See Meister 2020: 90.

misses the dove, but severs the cord. The next archer succeeds in hitting the bird as it flies free into the open sky: 'she fell down lifeless, leaving her life in the stars of the heavens, and bringing back as she sunk down the arrow that had pierced her' (decidit exanimis uitamque reliquit in astris / aetheriis fix-amque refert delapsa sagittam) (517–18). The language used of the dove's death, 'leaving its life' hyperbolically high 'in the stars', is reminiscent of the astral immortality of virtuous souls. Acestes, the Sicilian king, is the final ar-cher, and now with no target left, he contents himself with a display shot up into the air. His arrow miraculously catches fire and traces a fiery path through the sky, compared in a simile to a shooting star or a comet. This is one of the several prefigurations in the *Aeneid* of the 'Julian star', *sidus Iulium*, the comet whose appearance in 44 BC signalled the apotheosis of Julius Caesar, whose post-mortem *uita* is truly *in astris*.[92]

Jupiter's interview with Venus in the height of heaven in book 1 is followed by the unfolding of the story of Dido and Aeneas, in the rest of book 1 and book 4. This is a story whose stages are articulated by a series of movements down and up the vertical axis.[93] Jupiter, after concluding his prophecy of the future history of Rome with Venus's reception of Caesar in heaven (1.289–90), sends down Mercury (son of Maia) in order to ensure that the Carthaginians are welcoming to the Trojans, in a typically epic 'descent from heaven':[94] 'Maia genitum demittit ab alto' (297).

When Aeneas first catches sight of Dido's new city of Carthage, it is from the perspective of a distant 'view from above', the top of a hill from which his con-trolling gaze takes in the whole of the cityscape (1.418–38). This is a lesser version of Jupiter's imperial view from above, in the height of heaven, over the whole world earlier in book 1 (223–26). There is an analogy between mountain heights and celestial heights. Aeneas's view from above is mirrored, near the end of the story, in Dido's impotent view, from the height of the Carthaginian citadel ('arce ex summa'), of the Trojans' bustling preparations for departure from her city (4.409–10).[95] But there is no Epicurean calm detachment for Dido.

The conventional sky-reaching of fame is given monumental expression in the personification Fama (Rumour), in *Aeneid* 4, who starts off very small before shooting up to the sky: 'Timorously small at first, she soon lifts herself

92. On the Julian star, see West 1993; Williams 2003.

93. On *Aen.* 4, see Hardie 1986: ch. 6, 'Hyperbole'; 267–85 '"Theological space": The Vertical Axis. A Hyperbolical Reading of *Aeneid* 4'.

94. On which see Greene 1963.

95. On the Lucretian allusion in these 'distant views', see Hardie 2009: 160–62.

up into the air, and with her feet on the ground she hides her head in the clouds'
(parua metu primo, mox sese attollit in auras / ingrediturque solo et caput inter
nubila condit) (176–77). The appearance of this monster triggers large-scale
movements between earth and heaven. The rumours that Fama spreads about
Dido and Aeneas reach up to the throne of Jupiter, via the intermediary of the
prayers of Dido's jealous African suitor Iarbas, son of Jupiter, who complains to
his father about what he has heard through Fama. Jupiter now sends down
Mercury again, this time to order Aeneas to leave Carthage, in the grandest of
Virgilian 'descents from heaven'. On his way down to earth, Mercury pauses on
Atlas, the mountain whose head props up the sky, an anthropomorphic and
immobilized sky-reacher who guarantees the cohesion of the cosmos, in con-
trast to the chaotically disruptive and ever-mobile sky-reaching Fama. Atlas was
a Giant metamorphosed into a mountain. Fama, in Virgil's invented genealogy,
is a daughter of Earth and sister to Giants who assaulted the Olympian gods.
Fama's ascent to the sky is in the image of the unlawful attempts of Giants and
Titans to scale the heavens, a wrong way of making the journey to the sky. The
condign punishment of Titans and Giants is to be buried alive deep in the earth,
beneath mountains, or in Tartarus, the deepest pit of the underworld. There, in
Aeneid 6, we find the Titans, and the Aloidae, Otus and Ephialtes, Giants (583–
84) 'who laid violent hands on the great sky to break it down and to thrust Ju-
piter from his heavenly kingdom' , and also a mortal, Salmoneus, who falsely
claimed the honours of a god, dressing up as Jupiter and riding around in a
chariot, waving a torch as if it were the inimitable thunderbolt (585–91): a
timely reminder, perhaps, to the great men of Virgil's Rome of the risks of using
apotheosis as a political or ideological tool.[96]

The dire consequence of sky-reaching Fama's assault on Dido is that she
loses the good *fama*, the fame or reputation, by which, Dido tells Aeneas, she
thought, figuratively, to aspire to the stars: 'Because of you I have lost my sense
of shame and the good name I once had, my only hope of reaching the stars'
(qua sola sidera adibam, / fama prior) (4.321–23).[97] At the tragic climax of her
story it will not be Dido's fame, but female cries of grief, triggered by Fama's

96. This paragraph only starts to unpack the complexities and ramifications of Virgil's Fama:
for more extensive discussion, see Hardie 1986: 273–85; Hardie 2009: ch. 3, 'Virgil's *Fama* and
the Sublime'; Hardie 2012: ch. 3.

97. Cf. Drances's hyperbolical flattery of Aeneas at *Aen*. 11.124–25: 'Trojan hero, great in fame,
greater in war, with what praises might I raise you to the sky?' (o fama ingens, ingentior armis, /
uir Troiane, quibus caelo te laudibus aequem?), on which see Hardie 2012: 137–38.

propagation throughout the city of Carthage of a report of the wound inflicted by Dido on herself, that resound in the sky: 'resonat magnis plangoribus aether' (668). The final descent from heaven will be that of Iris, sent down by Juno, to cut off a lock of hair and thereby release Dido from her death-struggle. This African queen's lock of hair will not undergo catasterism, in contrast to the lock of hair of the Egyptian queen Berenice, translated to the skies. The celestial destination of the Callimachean-Catullan Lock of Berenice is reserved for Aeneas and his descendants: that is one reason why a close adaptation of the Catullan Lock's expression of regret that it has been separated from its mistress's head is, arrestingly, put in the mouth of Aeneas when he meets the shade of Dido in the underworld: 'Unwillingly, queen, I left your shore' (inuitus, regina, tuo de litore cessi) (6.460), echoing Catullus 66.39 (the lock of hair speaks): 'Unwillingly, queen, I left your head' (inuita, o regina, tuo de uertice cessi).

After the prefigurations of Roman apotheoses in the games of *Aeneid* 5, the remaining three of the central block of four books (5–8) continue to explore the upper and lower limits of the vertical axis, hell and heaven, as they relate to the Roman story. Book 6 begins with Daedalus, the legendary human being who succeeded in taking flight through technological means. His aerial flight from Crete to Cumae, in Italy, on the 'oarage of wings' (6.19: remigium alarum) corresponds to the Trojans' journey by sea, in ships that 'fly with sails' (1.224: 'mare ueliuolum'). The figurative equation of sailing on the sea and flying through the air, or through space, is one with a long history, a history registered in the modern words 'aeronaut' and 'astronaut' (literally, 'sailor in the air', 'sailor in the stars').[98] On the doors of the temple of Apollo at Cumae, Daedalus has sculpted scenes of his own story, but could not bring himself to make the image of his son Icarus, the proverbial example of failed human flight: the boy who fell because he tried to fly too high, with the result that the

98. Horace Walpole also coined the humorous 'airgonaut' (see *OED* s.v.) to refer to hot-air balloonists, 'Argonauts' who travel through the air. The classically trained Walpole perhaps remembered that in some versions, following the journey of the Argo, the ship was transformed into a heavenly constellation and translated to the heavens. On the interchangeability of flying and sailing (or swimming), see Jacob 1984: 151; Luck-Huyse 1997: 205–9, '"Fliegen" für schnelle Fortbewegung zu Wasser'; 213–15, '"Schwimmen" für "fliegen"'. Plotinus (1.6.8) alludes to Homeric sea-journeys in speaking of the Neoplatonic return of the soul to its transcendent origin, quoting 'Let us flee to the fatherland' (*Iliad* 2.140, Agamemnon's suggestion that the Greeks sail home from Troy), with further reference to Odysseus's flight over the sea from Calypso and Circe.

sun melted the wax that held his wings together.[99] At the end of book 6, Anchises shows his son the unborn souls of his descendants who will achieve godhood, including Rome's founder Romulus: 'Do you see how the father of the gods himself already marks him with his honour? See, my son, founded under his auspices, glorious Rome will make her empire equal to the world, and raise her spirit to Olympus' (uiden, ut . . . pater ipse suo superum iam signat honore? / en huius, nate, auspiciis illa incluta Roma / imperium terris, animos aequabit Olympo) (6.779–82); and Rome's 'second founder', Augustus, whose imperialist extravagations will be as heedless of limits as was the Lucretian Epicurus's flight of the mind: 'there is a land beyond the stars, beyond the paths of the year and the sun' (iacet extra sidera tellus, / extra anni solisque uias) (795–96). With this going beyond compare Lucretius 1.72–73: 'he travelled far beyond the flaming walls of the world' (extra / processit longe flammantia moenia mundi). Mapping terrestrial journeys with reference to celestial coordinates ('stars', 'paths of the year and of the sun') gives the impression that Augustus will somehow literally travel beyond the stars, beyond the signs of the zodiac and the path of the sun.

In book 7, Juno calls up the Fury Allecto from the darkness of the underworld (7.325: 'infernisque ciet tenebris') to attack the newly arrived Trojans, whose descendants, we are again reminded, are destined for the stars (the oracle of Faunus): 'Sons-in-law will come from abroad, whose blood will raise our name to the stars, and the descendants from their stock will see the whole world turning and governed under their feet, where the sun daily returning looks down on the Ocean in the west and the east' (externi uenient generi, qui sanguine nostrum / nomen in astra ferant, quorumque a stirpe nepotes / omnia sub pedibus, qua sol utrumque recurrens / aspicit Oceanum, uertique regique uidebunt) (7.98–101). The language of lines 100–101 suggests the view from above of a cosmic ruler looking down on the universe revolving beneath his feet, rather like the deified Daphnis of *Eclogue* 5, who sees clouds and stars beneath his feet (57: 'sub pedibusque uidet nubes et sidera Daphnis').

Book 8 charts the rise of Rome from a humble pastoral settlement, at the time of Aeneas's visit to Evander, to the sky-scraping city of Virgil's day: the distance travelled is measured by the narrator as the Trojan ships sail up the Tiber: 'when in the distance they see walls and a citadel and scattered houses, which Roman power has now brought level with the sky [quae nunc Romana

potentia caelo / aequauit], but then was the impoverished kingdom of Evander' (8.98–100); 'caelo aequauit' diverts to a history of Roman political and military power a phrase that Lucretius had used of the results of Epicurus's triumphal campaign of philosophical enlightenment and liberation, 'his victory brings us level with the sky' (nos exaequat uictoria caelo) (Lucr. 1.79). Evander tells Aeneas the story of the slaying of the chthonic monster Cacus by Hercules, the archetypal model for the ascent of a mortal hero to heaven as the reward for exceptional achievements. Hercules is hailed on the site of the future Rome by the priests of Mars, the Salii, as 'true offspring of Jupiter, a new glory added to the gods' (uera Iouis proles, decus addite diuis) (8.301). Before his ascent to Olympus, in his lifetime on earth Hercules had descended to the underworld and returned, one of the Labours recorded in the song of the Salii (296–97), and mirrored in the simile that compares Hercules's tearing open of the cave of Cacus to the opening of the underworld itself to the upper light (241–46).[100]

Later in book 8, as Aeneas prepares to return to the war in Latium, he acknowledges an omen in the skies that confirms his own celestial destiny: 'Olympus calls for me' (ego poscor Olympo) (533). The heavenly aspirations of his descendant Augustus are registered on the Shield of Aeneas: the *sidus Iulium*, the star of Julius Caesar, appears over his head as he goes into battle at Actium: 'patriumque aperitur uertice sidus' (681).[101] This is also Virgil's, and Augustus's, final appropriation of the catasterized Lock of Berenice: the star of Julius Caesar was a comet (κομήτης, literally 'long-haired [star]'), now seen in juxtaposition with the top of Augustus's head ('uertice'), in contrast to the unwilling separation of the Lock from the head of Berenice in Catullus 66 (39: 'inuita, o regina, tuo de uertice cessi'). In the final scene on the Shield, Augustus moves towards identification with another god, Apollo, the bright sun-god,

100. On the Lucretian allusions in the Hercules and Cacus episode, see Gildenhard 2004; Hardie 2009: 171–72.

101. This image perhaps alludes to the statue of Divus Julius in his temple in the Forum Romanum, with a star fixed to its head (Weinstock 1971: 378–79). This visual marker of apotheosis is reproduced, for example, in Luca Giordano's painting *Jupiter and the Apotheosis of the Medici*, in the Galleria di Luca Giordano (frescoed 1682–85), Palazzo Medici Riccardi, in Florence, in which six members of the Medici family are borne upwards towards Jupiter, on clouds and flying horses; two have blazing fires over their heads, perhaps an allusion to the Dioscuri, and four have multi-pointed stars, on their heads. The stars also have a more contemporary reference, to the four large moons of Jupiter, discovered in 1610 by Galileo, and dedicated to the Medici as the 'satelliti medicei'. On the *sidus Carolinum*, the star of Charles II, see ch. 5: 292–93.

on the snow-white threshold of whose newly built temple on the Palatine he sits watching his triumph: 'ipse sedens niueo candentis limine Phoebi' (8.720). Augustus is a sun-king seated in a *regia solis*, a palace of the Sun. Proximity to the sun-god will not melt his wings, in contrast to the case of Icarus, son of Daedalus who built the earlier temple of Apollo at Cumae, as narrated at the beginning of book 6. An echo of *Eclogue* 5.56 reinforces the hint of apotheosis: '[Daphnis] **cand**idus insuetum miratur **limen** Olympi' (shining bright he marvels at the strange spectacle of the threshold of the heavens): see above: 65. Like Daphnis, Augustus enjoys a view from above, looking down, like the sun from the heavens, from the Temple of Apollo on the Palatine Hill, on the conquered peoples of the world processing in the Circus Maximus below.

Ovid's *Metamorphoses*

The *Aeneid* alludes to several apotheoses, but does not narrate any circumstantially. Ovid's *Metamorphoses*, the long narrative hexameter poem that responds to the *Aeneid* in multifarious ways, narrates a whole sequence of apotheoses through which mortal heroes and rulers are transported from earth to the heavens.[102] The sequence starts in book 9 (239–72) with Hercules, the son of Jupiter whose deification after his labours on earth is a recurrent model for rulers with celestial yearnings, from antiquity onwards.[103] The process of Hercules's deification establishes a pattern for those that follow: the mortal part of his body, that which he owes to his mortal mother, is burned off on the funeral pyre, and what is left, the better part owed to his immortal father Jupiter, gains renewed strength (269: 'parte sui meliore uiget'). Jupiter then snatches him up in a four-horse chariot, anticipating the vehicle of imperial apotheosis, and carries him to the stars.

In the last two books of the *Metamorphoses*, Hercules is followed on the path to the heavens by Aeneas (14.581–608), Romulus (14.805–51) and Julius

102. On apotheoses in the *Metamorphoses* and the *Fasti*, see Lieberg 1970; Petersmann 1976; Salzman 1998; Casanova-Robin 2019; on the apotheosis of Julius Caesar, Weinstock 1971: 370–84, 'Caesaris astrum'; Flammini 1993; Pandey 2013.

103. Hercules is not the first mortal to become a god in the *Metamorphoses*: already in book 1, Io, after she is metamorphosed back from the form of a cow into human form, becomes the goddess Isis, but this further change is not accompanied by an ascent to Olympus. On Hercules's journey to the heavens, see Mühl 1958.

Caesar (15.745–851). Romulus's father Mars whisks his son up in his chariot, after reminding Jupiter of the promise that the latter had made in a council of the gods, related in Ennius's *Annals*, that Mars would take Romulus up to the skies: 'One man there will be whom you will carry up into the blue spaces of the sky' (unus erit quem tu tolles in caerula caeli) (*Met.* 14.814 = Enn. *Ann.* 54 Skutsch). Romulus's grieving wife Hersilia is then taken up into the skies by a mechanism that alludes both to the *sidus Iulium* and to the Lock of Berenice, which Virgil had already associated with the *sidus Iulium*, as well as to the omen of Lavinia's flaming hair at *Aeneid* 7.72–80:[104] 'Then a star gliding down from the heavens fell to earth; Hersilia's hair caught fire from its light, and, together with the star, she disappeared into the breezes' (ibi sidus ab aethere lapsum / decidit in terras, a cuius lumine flagrans / Hersilie crines cum sidere cessit in auras) (*Met.* 14.846–48). When Julius Caesar is assassinated, Venus snatches up his soul and carries it aloft to the stars, where it ignites and turns into a comet, flying higher than the moon. The language echoes the apotheoses of both Hercules and Romulus. In the last line of the *Metamorphoses* before the Epilogue, Ovid anticipates the day, hopefully late in time—'nostro serior aeuo' (later than our lifetime)—when Augustus too will take his place in the sky (15.870: 'accedat caelo'), an event that had already been prophesied by the Trojan seer Helenus, as reported by Pythagoras: 'the sky will be his end' (caelumque erit exitus illi) (15.449).

In the central block of the *Georgics*, Virgil had juxtaposed a divinized Caesar (who will take the central place in the temple of poetry that Virgil will build (*Geo.* 3.16: 'in medio mihi Caesar erit templumque tenebit') with a philosophical flight of the mind and a poetic take-off from the earth. In *Metamorphoses* 15, Ovid combines imperial apotheosis with philosophical and poetic ascensions in more provocative ways. In the first half of the book, Pythagoras delivers a long speech on natural philosophy, for which Lucretius's *On the Nature of Things* is one important model. Like Epicurus, Pythagoras has travelled in mind through distant parts of the sky and approached the gods (15.62–63: 'licet caeli regione remotos / mente deos adiit'). This account of the freedom of the skies comes immediately after the information that Pythagoras had gone into voluntary exile through his hatred of the tyrant of Samos, Polycrates (61–62: 'odioque tyrannidis exul / sponte erat'), seeking political freedom. In his speech, Pythagoras himself uses Lucretian language to describe the pleasure

104. See Hardie 2015 on *Met.* 14.846–48.

that he takes in his mental space travel, and in the view from above down on unenlightened mankind (147–51; Dryden's translation):

> iuuat ire per alta
> astra, iuuat terris et inerti sede relicta
> nube uehi ualidique umeris insistere Atlantis,
> palantesque homines passim et rationis egentes
> despectare procul trepidos obitumque timentes[105]

> (Pleased as I am to walk along the sphere
> Of shining stars, and travel with the year,
> To leave the heavy earth, and scale the height
> Of Atlas, who supports the heavenly weight;
> To look from upper light, and thence survey
> Mistaken mortals wandering from the way,
> And wanting wisdom, fearful for the state
> Of future things)

In the Epilogue to the poem (*Met.* 15.871–79), Ovid, possibly writing after he had been exiled to the Black Sea by Augustus in AD 8, boasts of his own skyward journey after his death, which will have power only over his body: 'yet in my better part I shall be carried, everlasting, above the lofty stars, and my name will be indestructible' (parte tamen meliore mei super alta perennis / astra ferar, nomenque erit indelebile nostrum) (875–76); 'parte meliore mei' echoes the language used previously of the apotheosis of Hercules (9.269). Ovid's 'better part' will fly *above* the stars, higher than the apotheosed souls of Julius Caesar and Augustus, higher than Pythagoras's flight of the mind. Ovid, however, does not claim the same kind of immortality as he bestows on Caesar and Augustus: his will be an elevation in fame, which will ensure him everlasting life: 'through all ages in fame I shall live' (perque omnia saecula fama . . . uiuam) (15.878–79).[106]

In the *Metamorphoses*, Ovid balances his narratives of successful flight to the heavens, through apotheosis and philosophical or poetic achievement, with stories of unsuccessful flight, in two of the most influential tales of

105. Combining allusion to the pleasure taken by Lucretius in approaching the untouched springs and flowers of the Muses at Lucr. 1.927–30 ('iuuat . . . iuuat . . .') with the view from above ('despicere'), from the lofty regions/temples ('templa') of the wise, down on the wanderings of unenlightened mankind at 2.7–13.

106. On the sky-reachings of Pythagoras and Ovid, see Hardie 1997; Wickkiser 1999; Segal 2001.

manned flight: Phaethon (*Met.* 2.1–332) and Icarus (*Met.* 8.183–235; narrated also in the *Art of Love* at 2.21–96), overreaching youths who fall to earth. Ascent is matched by disastrous descent, flight to the heavens is balanced by fall to earth, or lower still. The very first tale of a fall in the *Metamorphoses* is that of the Giants, brought low by Jupiter's thunderbolt when they attempted to assault the heavens by piling mountain on mountain to make a path to the stars (1.151–62). The defeated Giants and Titans are traditionally imprisoned under mountains, so in subterranean confinement. Ovid here, near the beginning of the *Metamorphoses*, gestures to Virgil's recurrent allusion in the *Aeneid* to gigantomachic narratives, which figure the defeat of the enemies of Rome and the victory of her sky-destined rulers.[107]

To prove to Phaethon that he really is his father, the sun-god allows him to wish for whatever he wants. Phaethon asks to be allowed to drive the chariot of his father, with disastrous consequences. Terrified by the threatening constellation of Scorpio, Phaethon loses control of the reins, and the horses run wild, plunging now high, now low, and burning up the forested mountains and rivers of the earth, until Jupiter prevents a total conflagration by blasting Phaethon with his thunderbolt, and sending him plunging headlong into the river Po. Political and poetic meanings are ready to hand. The description of the palace of the Sun (2.1–18) evokes the Palatine Temple of Apollo, the solar god, that Virgilian emblem of the power of Augustus.[108] Phaethon is a warning

107. There is a tightly scripted opposition of virtuous and gigantomachic ascents of the heavens in Statius, *Thebaid* 10. The young Menoeceus, urged on by the personification of Virtue, sacrifices himself to save the city of Thebes by hurling himself from the walls: Piety and Virtue gently bear his body down to the ground, while his soul comes into the presence of Jupiter, and 'claims for itself a pinnacle among the highest stars' (summis apicem sibi poscit in astris) (782). By contrast, the impious and monstrous Capaneus, despiser of the gods, attempts to scale the walls of Thebes, slippery with Menoeceus's blood, and is compared in a simile to the Aloidae, Otos and Ephialtes, who piled Pelion on Ossa in an assault on the Olympian gods; Capaneus challenges the gods to defend the city, and is eventually blasted by Jupiter's thunderbolt, like the Giants, and falls back only as his earthly limbs fail him. In a conscious statement of his own ambitions to lofty sublimity, Statius introduces Capaneus's attempt on the heavens with an exhortation to himself, the poet: 'astrigeros Capaneus tollendus in axes' (Capaneus must be raised to/against the starry heavens) (828). See Hardie 2009: 205–6

108. See Brown 1987; Barchiesi 2009. Berger argues (1993) that the design of Louis XIV's Louvre constituted an attempt to build the Ovidian Palace of the Sun on earth, a project stimulated by a drawing by Charles Le Brun for an unrealized ceiling painting at the chateau of Vaux-le-Vicomte, of gods and allegorical figures arranged round the Ovidian Palace of the Sun; in the centre the heraldic shield of the chateau's owner Fouquet is received by Jupiter, Mars and

to a successor who may not be able to steer the chariot of government on a steady track. The political allegory will be picked up in later centuries.[109] Phaethon's wild flight is also a poetic exercise in sublime terror, and a lesson in the dangers for an artist of aiming high. When he falls into the Po, the nymphs inscribe an epitaph on his tomb: 'Here lies Phaethon, driver of his father's chariot. If he did not control it, yet he fell in a great venture' (Hic situs est Phaethon currus auriga paterni, / quem si non tenuit, magnis tamen excidit ausis) (2.327–28). The sentiment is paralleled in an anonymous quotation cited approvingly by Longinus in *On the Sublime*: 'To make a slip in great endeavours is nevertheless a noble failure' (3.3).[110]

A metapoetic charge is also contained in the compound verb *exspatiari* (wander off track), used of the uncontrolled wandering through the skies of the horses of the sun when Phaethon attempts to drive them (*Met.* 2.202: 'exspatiantur equi'). The verb, a compound of *spatiari* (see above: 41), first found in Ovid, will have a long history, both in Latin and in the English 'expatiate', in descriptions of the free-flying mind or soul. Ovid also uses it in *Metamorphoses* 1 in the narrative of the Deluge, the destruction of the world by water that has a pendant in the near-destruction of the world by fire in the Phaethon story. There the subject is the rivers that overflow their banks, carrying off everything before them (*Met.* 1.285: 'exspatiata ruunt'). Phaethon is sent whirling on a self-destructively sublime flight, and the rushing rivers of the Flood are a Pindaric surge: Horace compares the impetus of Pindar to a 'river running down from a mountain' and overflowing its banks, and then to a swan soaring high into the clouds (*Odes* 4.2.5–8, 25–27: see above: 51–52). This is the dangerous freedom of the sublime.[111]

Saturn. Néraudau suggests (1986: 236–37) that the Palace of Versailles is a concrete realization of the Ovidian Palace of the Sun, and also of the Ovidian House of Fame (*Met.* 12.39–63). The comparison of Versailles with the Palace of the Sun is developed at length in Guillou 1963. In England, Saumurez Smith suggests (1990: 108) that the Great Hall at Castle Howard, whose dome bears a painting of the fall of Phaethon, is 'an attempt to reconstruct the Palace of the Sun, with its lofty pillars, elaborate workmanship, marble-decked, surrounded by continents and elements, presided over by Phaeton [*sic*] and Apollo'; see also Hamlett 2020: 94–95.

109. See, e.g., Duret 1988; Rebeggiani 2018: 100–109 on the importance of the myth of Phaethon to early imperial narratives of succession.

110. For an argument that Ovid's Phaethon comments on Lucretius's failed attempts at sublimity, see Schiesaro 2014.

111. Ovid's third use of *exspatiari* comes in Pythagoras's return from a digression at *Met.* 15.453–54 ('ne tamen oblitis ad metam tendere longe / exspatiemur equis') shortly before the

PLATE 1 (fig. 4.1). Andrea Sacchi, *Divine Wisdom*, Palazzo Barberini, Rome. Luisa Ricciarini / Bridgeman Images.

PLATE 2 (fig. 6.1). Pietro da Cortona, ceiling of Sala di Venere, Palazzo Pitti, Florence. Luisa Ricciarini / Bridgeman Images.

PLATE 3 (fig. 6.4). Pietro da Cortona, ceiling of Sala di Marte, Palazzo Pitti, Florence. Luisa Ricciarini / Bridgeman Images.

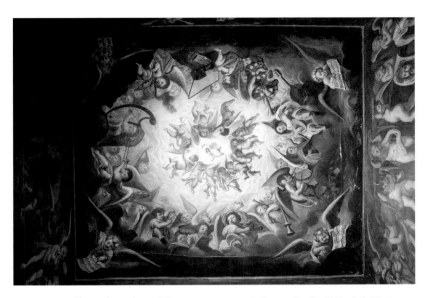

PLATE 4 (fig. 6.7). Ceiling of the Heaven Room, Bolsover Castle. © English Heritage.

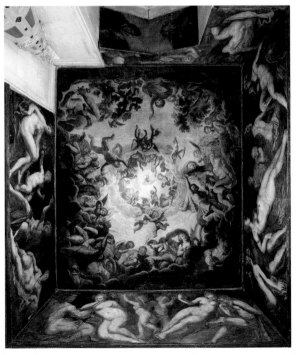

PLATE 5 (fig. 6.8). Ceiling of the Elysium Closet, Bolsover Castle. © English Heritage.

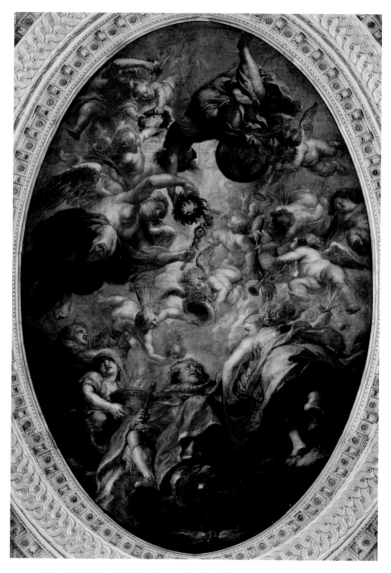

PLATE 6 (fig. 6.10). Peter Paul Rubens, *The Glorification of James I*, Banqueting House, Whitehall. © Historic Royal Palaces.

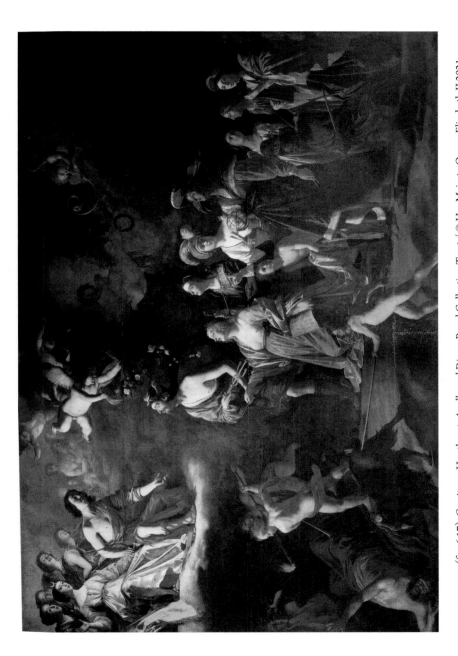

PLATE 7 (fig. 6.17). Gerrit van Honthorst, *Apollo and Diana*. Royal Collection Trust / © Her Majesty Queen Elizabeth II 2021.

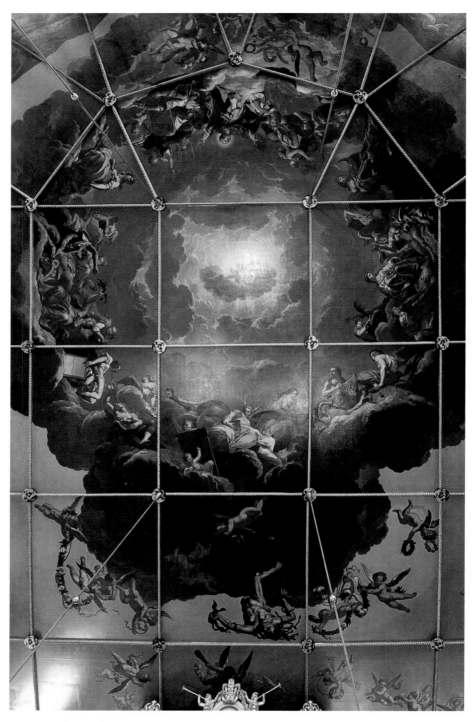

PLATE 8 (fig. 6.19). Robert Streater, *Truth Descending on the Arts and Sciences*, Sheldonian Theatre ceiling. © Photovibe/Greg Smolonski.

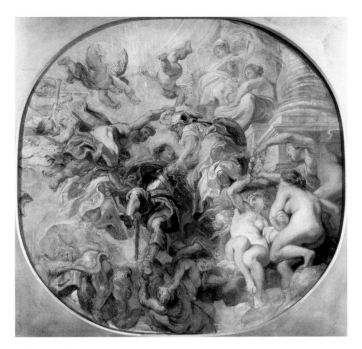

PLATE 9 (fig. 6.18). Peter Paul Rubens, sketch for *The Glorification of the Duke of Buckingham*. Bridgeman Images.

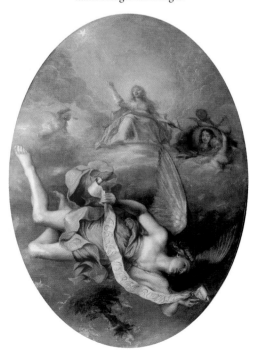

PLATE 10 (fig. 6.20). John Michael Wright, *Astraea Returns to Earth*. © Nottingham City Museums & Galleries / Bridgeman Images.

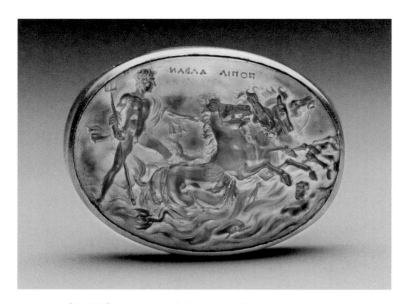

PLATE 11 (fig. 6.16). Oval gem with Octavian as Neptune, mounting a sea-chariot.
© Museum of Fine Arts, Boston.

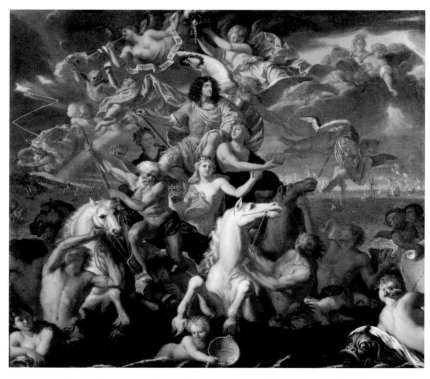

PLATE 12 (fig. 6.21). Antonio Verrio, *The Sea-Triumph of Charles II*. Royal Collection Trust
/ © Her Majesty Queen Elizabeth II 2021.

PLATE 13 (fig. 6.22). St George's Hall, Windsor, murals by Antonio Verrio (watercolour). Royal Collection Trust / © Her Majesty Queen Elizabeth II 2021.

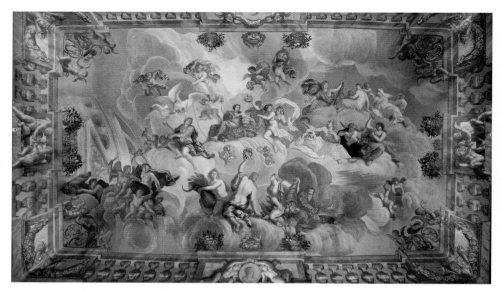

PLATE 14 (fig. 6.26). Antonio Verrio, *The Glorification of Catherine of Braganza*, Queen's Audience Chamber, Windsor. Royal Collection Trust / © Her Majesty Queen Elizabeth II 2021.

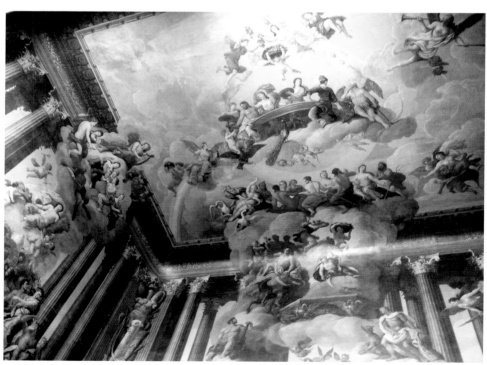

PLATE 15 (fig. 6.27). Antonio Verrio, *Banquet of the Gods*, King's Staircase, Hampton Court. © Historic Royal Palaces.

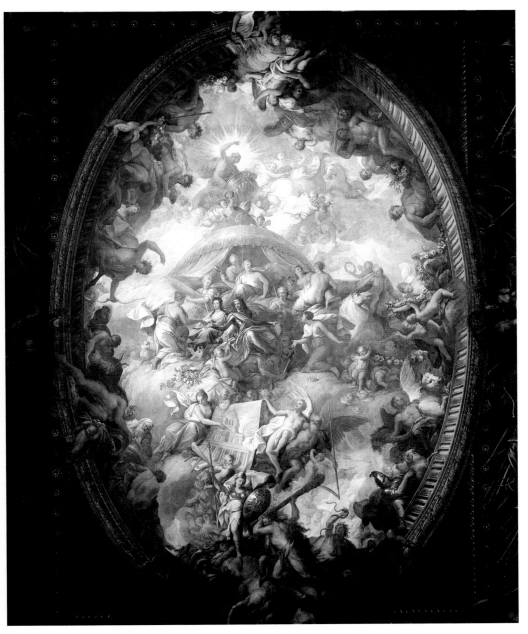

PLATE 16 (fig. 6.28). James Thornhill, *The Glorification of William and Mary*, ceiling of the Painted Hall, Greenwich. © James Brittain / Bridgeman Images.

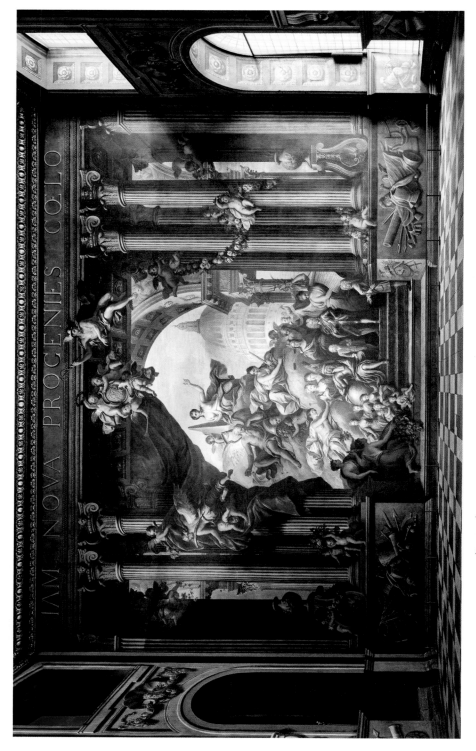

PLATE 17 (fig. 6.32). James Thornhill, the Great Front, Upper Hall, Greenwich Hospital. © James Brittain.

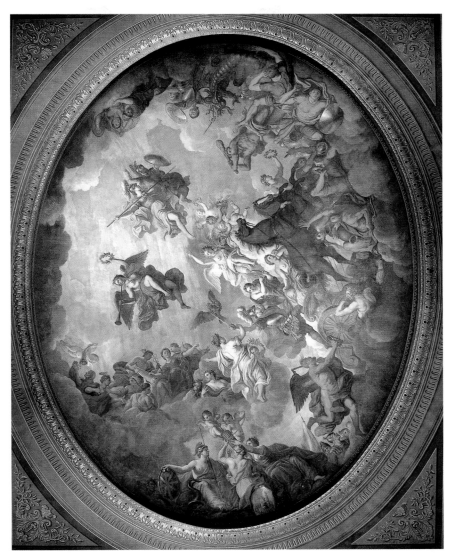

PLATE 18 (fig. 5.1). Louis Laguerre, *Allegory of Peace and War*, ceiling of the Saloon, Blenheim Palace. Bridgeman Images.

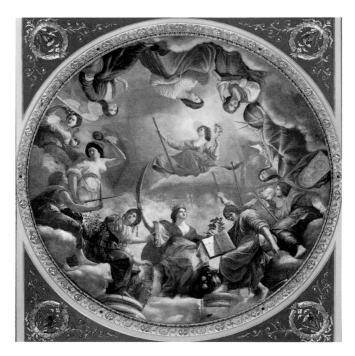

PLATE 19 (fig. 6.29). Orazio Gentileschi, *Peace Reigning over the Arts and Sciences*, originally on ceiling of the Queen's House, Greenwich. Royal Collection Trust / © Her Majesty Queen Elizabeth II 2021.

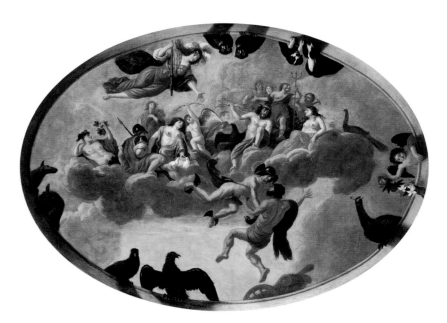

PLATE 20 (fig. 6.33). Jacob de Wet II, *The Apotheosis of Hercules*, Palace of Holyroodhouse. Royal Collection Trust / © Her Majesty Queen Elizabeth II 2021.

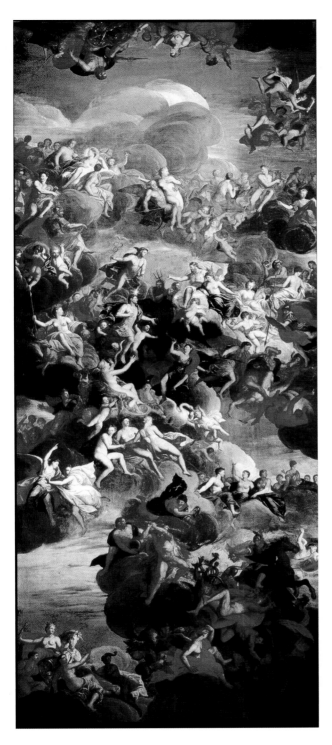

PLATE 21 (fig. 6.34). Louis Laguerre, *The Apotheosis of Julius Caesar* (ceiling in the Painted Hall, Chatsworth). © The Devonshire Collections, Chatsworth. Reproduced by permission of Chatsworth Settlement Trustees.

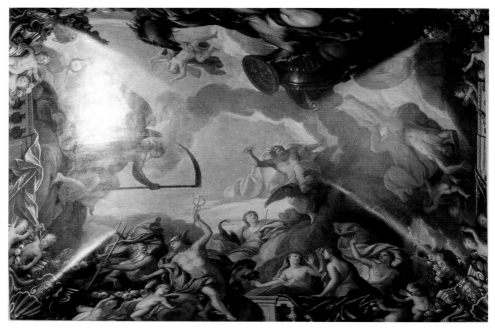

PLATE 22 (fig. 6.36). James Thornhill, *The Fall of Phaethon* (ceiling in the West Stairs, Chatsworth). © The Devonshire Collections, Chatsworth. Reproduced by permission of Chatsworth Settlement Trustees.

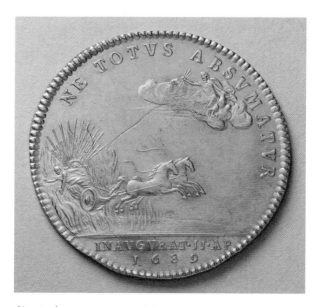

PLATE 23 (fig. 6.37). Jan Roettiers, medal commemorating the coronation of William and Mary, showing the fall of Phaethon. Royal Collection Trust / © Her Majesty Queen Elizabeth II 2021.

Icarus is the boy who fails to heed his father's instructions not to fly too high, or too low, on the artificial wings that Daedalus has made for him, lest the sun burn them, or the waves weigh them down: 'fly between the two' (inter utrumque uola) (*Met.* 8.206). Here too there are morals for the extracting: an admonition to aim for the golden mean in one's private or political life, or advice to the poet to practise a middle style, neither too lowly nor too grand.[112] Horace uses the example of Icarus to warn off the attempt to take flight in the manner of Pindar (*Odes* 4.2: see above: 52).

Ovid uses the contrast between successful and unsuccessful ways of aiming for the heavens in a programmatic passage in book 1 of the *Fasti*, the poem on the Roman religious calendar, which includes astronomical notices of the risings and settings of stars (1.295–310). Using the topos of the flight of the mind, and glancing at Lucretian and Virgilian precedents, Ovid congratulates those 'happy souls who first made it their business to know these things' and 'to scale the heavenly mansions' (inque domos superas scandere) (298). They 'raised their heads higher than the failings and homes of men', 'making heaven subject to their genius' (aetheraque ingenio supposuere suo) (306), a friendlier version of the Lucretian Epicurus's trampling of Religion underfoot (Lucr. 1.78: 'religio pedibus subiecta'). This is a path to the sky that does not incur Horace's charge of folly (*Odes* 1.3.38: 'caelum ipsum petimus stultitia'), and which avoids the impious violence of the Giants: 'this is the way to make for the sky; not by loading Ossa on Olympus and making the summit of Pelion touch the stars' (sic petitur caelum: non ut ferat Ossan Olympus, / summaque Peliacus sidera tangat apex) (*Fasti* 1.307–8).

The Celestial Aspirations of the Roman Emperor in Post-Augustan Poetry and in Art

Later Roman poets draw on the vocabulary of apotheosis and heavenwards ascent developed by Virgil and Ovid. In the proem to his epic on the civil war between Julius Caesar and Pompey, Lucan praises his imperial patron Nero by looking forward to the time, far in the future ('serus'), when Nero will head for the stars, either to wield the sceptre of Jupiter, or to mount the flaming

narrative of Hippolytus's fatal failure to control his chariot. Quintilian uses *exspatiari* of digressions and expansions in a speech.

112. For a metapoetic reading of Ovid's Daedalus and Icarus narratives, with reference also to Daedalus in Virgil and Horace, see Sharrock 1994: ch. 3, '*Amor artis*: The Daedalus Episode'.

chariot of the sun-god and circle the earth, without fear of the disaster caused when Phaethon took over the reins of the chariot of the sun (*Civil War* 1.45–59).[113] Lucan draws on Virgil's and Ovid's anticipations of the apotheosis of Augustus, respectively in the proem to the *Georgics* and the conclusion of the *Metamorphoses*, as well as on other Augustan poetic texts. Modern readers are divided as to whether to take Lucan's panegyric at face value, or as savage irony. Lucan asks Nero to take up his seat in the centre of the sky, lest the celestial axis should feel the strain of the weight should he press down on any single part of the boundless heavens. Great gods are conventionally weighty, but ancient commentators already saw in this detail an allusion to Nero's obesity.[114] If the panegyric is satirical, it belongs to a long tradition of parody and satire of celestial aspirations and flights to heaven, a tradition of debunking that so pretentious a theme inevitably called forth, as for example in the satire on the apotheosis of Nero's predecessor Claudius in the *Apocolocyntosis* (Pumpkinification) by the younger Seneca, Lucan's uncle. Lucan's verbal image of Nero in a flying chariot has a visual parallel in the purple awning stretched over the Theatre of Pompey in Rome on the occasion of Nero's reception of the Armenian king Tiridates in AD 66 (the year after Lucan's suicide), in the centre of which was the embroidered figure of Nero as the sun-god, in a flying chariot, with golden stars gleaming around him.[115] In the event Nero died ignominiously, pronounced a public enemy by the Senate: no godhood for him.

Near the beginning of the *Metamorphoses*, Ovid had made so bold as to compare the celestial palaces of Jupiter and the gods, to which the Milky Way forms the processional approach, to the Palatine, the hill in Rome on which stood the house of Augustus (*Met.* 1.168–76).[116] Later imperial panegyrists imagine themselves transported to heaven in the surroundings of the imperial

113. For the suggestion that Nero may have embraced the model of a (successful) Phaethon in his cultivation of the imagery of solar kingship, see Champlin 2003: 134–35 (following Duret 1988). An eighteenth-century drawing of a fresco in Nero's Golden House shows the nimbed Helios surrounded by Seasons, listening to the petition of Phaethon, perhaps a part of Nero's solar imagery: see Baldwin Smith 1956: 124–25, with fig. 117; for further speculation on the cosmic and solar imagery of the Golden House, see Etlin 2012: 239–43. Louis XIV was only the latest in a long line of 'sun-kings' going back to antiquity.

114. See Roche 2009: 7–9, 138–43.

115. Dio 63.6.1–2.

116. For an example of the comparison applied in praise of an early modern palace, see Louis Le Laboureur, *La Promenade de Saint-Germain, à Mademoiselle de Scudéry* (Paris 1669), invoking Ovid to describe another Milky Way that leads to the royal chateau of Saint-Germain, which

palace. Statius dines with Domitian in the new Domus Domitiana on the Pala-
tine (*Silvae* 4.2). Jupiter rejoices that the emperor is lodged in splendour equal
to that of the Capitoline Temple of Jupiter: looking up to the coffered ceiling,
you would think that you were gazing on the gilded ceiling of heaven.[117] Clau-
dian, writing three centuries later, draws on the full gamut of earlier imperial
topics of praise in his panegyrical epics on the emperor Honorius and the
regent Stilicho, poems that offered rich material for the panegyrists of the early
modern period. In the verse preface to Claudian's *On the Sixth Consulship of
Honorius* (AD 404), the poet recounts a dream in which he found himself in
the citadel of the starry heavens, presenting, at the feet of Jupiter himself, his
songs on Jupiter's triumphs over the Giants. His dream has now come true, in
the kind of 'truth' that is valid in panegyric, as he sings before the emperor
Honorius, in what he describes as 'the world's pinnacle made level with Olym-
pus' (*orbis apex aequatus Olympo*), very possibly in the Temple of Apollo on
the Palatine, adjacent to the imperial palace.[118]

The imperial cult also established a long-lasting visual vocabulary for the
ascent of the deified emperor.[119] The vehicle of ascent may be that conveyance
by now familiar to us, the flying chariot.[120] An Augustan example, the Belve-
dere Altar, shows a figure, variously identified with Julius Caesar, Augustus or
others, in a four-horse chariot riding up to the heavens, observed by a sky-god
in the top right corner (Fig. 1.2).[121] On the Antonine Altar of Ephesus, a
winged figure of Victory accompanies an emperor, probably Trajan, as he steps
on to the chariot of the sun before its departure for the sky. Septimius Severus,
shortly before his death, dreamt that he was being taken up to heaven by four
eagles and a chariot led by a winged figure (*Scriptores Historiae Augustae, Sept.
Sev.* 22.1–2). On the third-century Igel monument near Trier, the iconography
of imperial apotheosis is used in the context of private hopes for posthumous

Le Laboureur compares not just to Ovid's Palace of Jupiter, but also to the Palace of the Sun
described at the beginning of *Met.* 2 (cited in Néraudau 1986: 188). See also n. 108 above.

117. For commentary, see Coleman 1988.

118. For commentary, see Dewar 1996.

119. In general, see Strong 1915: 'Lecture 1: The Apotheosis of the Imperial Figure and Its
Influence on Design'; Cumont 1942; MacCormack 1981: Part 2, '*Consecratio*'. For an irreverent
interrogation of the iconography, see Beard and Henderson 1998.

120. See Nixon and Rodgers 1994: 209 n. 50 for bibliography on *consecratio* and ascent in the
chariot of Sol.

121. For a review of earlier identifications of the figure, arguing for a new identification, of
Nero Claudius Drusus, at his funeral in 9 BC, see Buxton 2014.

immortality, in a relief panel of the apotheosis of Hercules ascending in a chariot to be welcomed to the heavens by Minerva, the whole framed in the circle of the zodiac, with busts of wind-gods in the spandrels.[122] The late antique ivory Consecratio Diptych shows a scene of *consecratio* (deification of an emperor or other pagan figure), with two eagles taking flight from the pyre, on top of which appears the sun-god in a four-horse chariot; above two winged wind-gods bear up the *Diuus* to a waiting group of ancestors already in heaven, while in the right-hand corner, the sun-god watches behind an arc containing six signs of the zodiac (Fig. 2.1).[123] A group of reverses of the posthumous coinage of Constantine the Great shows the emperor as a charioteer on a four-horse chariot, being received into heaven by the hand of God (described by Eusebius: *Life of Constantine* 4.73); here the pagan image has entered a Christian context.

The vehicle of ascent may be a flying figure in human form. On the early imperial Grand Camée de France, the occasion for which and, correspondingly, the figures represented on which, have been variously identified, the deified imperial personage is borne up on the back of a winged figure carrying an orb,[124] to meet in the sky another family member, gone before, flying on a winged horse (Fig. 2.2).[125] On a relief in the Palazzo dei Conservatori in Rome, Sabina, wife of Hadrian, rises from her pyre, carried up by a winged female figure bearing a torch, possibly a personification of Aeternitas (or Victoria). On the base of the column of Antoninus Pius, Antoninus and his wife Faustina are carried up by a winged genius, bearing a globe with the moon, a star and the zodiac, possibly a figure of cosmic Aion, Eternity.

The eagle, the bird of Jupiter, carries aloft the deified emperor or prince on imperial gems of the first century AD. On the summit of the vault of the Arch of Titus, Titus is borne skywards by a soaring eagle (Fig. 2.3).[126] The eagle

122. Strong 1915: 222–28. Cf. the zodiac in Rubens's painting of the assassination and apotheosis of Henri IV: see ch. 6: 275.

123. St Clair argues (1964) that the emperor is Julian the Apostate; Cameron 2011: 719–28, 'The Consecratio Ivory', argues that the dead man is Symmachus, and that the iconography of imperial *consecratio* is appropriated for a private citizen.

124. Strong (1915: 69) identifies the figure as a mythical Trojan ancestor of the Julian race, from its Phrygian costume.

125. A painting of the Grand Camée was made by Rubens for Nicolas-Claude Fabri de Peiresc, who discovered the cameo in the treasury of the Sainte-Chapelle.

126. On the interwoven imagery of triumph and apotheosis on the Arch of Titus, see Norman 2009.

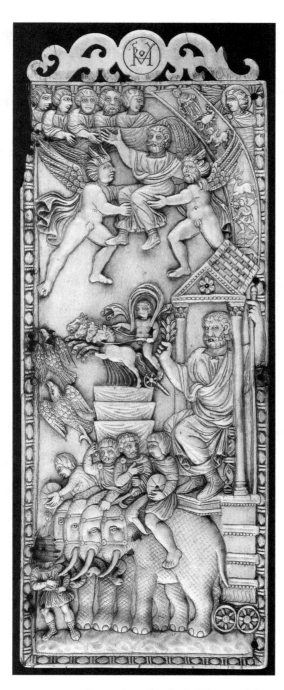

FIGURE 2.1. Scene of apotheosis, the 'Consecratio'
Diptych. © The Trustees of the British Museum.

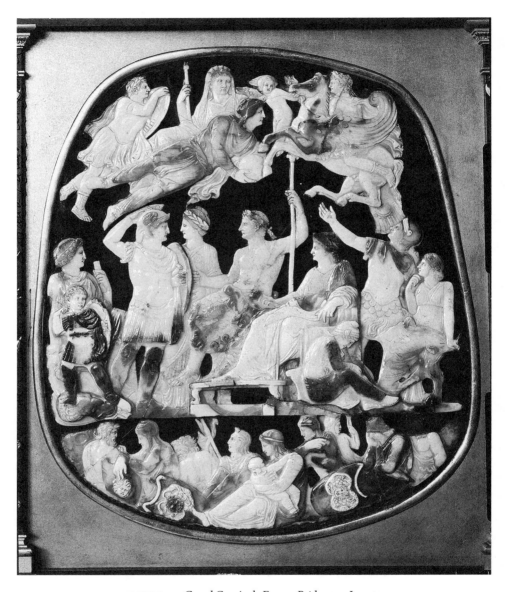

FIGURE 2.2. Grand Camée de France. Bridgeman Images.

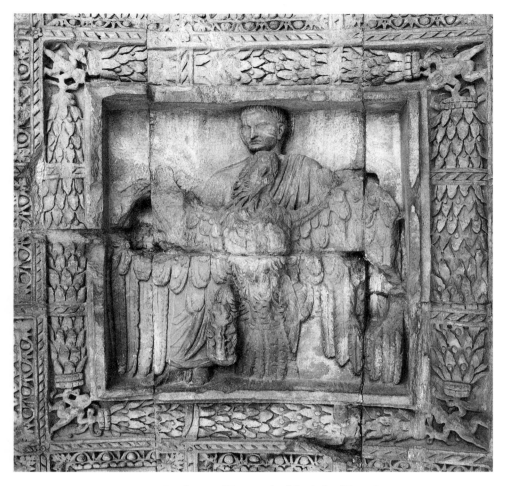

FIGURE 2.3. Apotheosis of Titus, vault of the Arch of Titus, Rome.
© DAI Rome, neg. 79.2393.

bearing up the *Diuus* is found on coins and medallions from the time of Trajan onwards.[127] This image reflects the practice of releasing an eagle to fly up from the funeral pyre of the emperor, recorded for Augustus (Dio 56.42.3) and Pertinax (Dio 74.5). The deified emperor follows in the tracks of Ganymede, rapt from earth by the eagle of Jupiter; right at the beginning of the history of the

127. MacCormack 1981: 100; Cumont 1917, on the symbolism of the eagle in scenes of the ascent of the soul and imperial *consecratio*.

deified emperor, Virgil had made the rape of Ganymede proleptic of imperial *consecratio* (see above: 72).

Biblical and Late Antique Christian Ascents

The Bible

In the Christian world, narratives and images of ascent from the Bible vie, and sometimes coalesce, with those from non-Christian sources.[128] The prophet Elijah was taken up to heaven in a chariot of fire: 'And it came to pass, as they [Elijah and Elisha] still went on, and talked, that, behold, there appeared a chariot of fire, and horses of fire, and parted them both asunder; and Elijah went up by a whirlwind into heaven' (2 Kings 2:11). Elijah ascending appears on sarcophagi from the late third century AD, riding in a four-horse chariot, in a visual schema that is based on that of imperial apotheosis (Fig. 1.1).[129] For early Christian writers such as Sedulius (*Paschal Song* [second quarter of the fifth century AD], 1.181–83), Elijah's journey in a four-horse chariot is a biblical version of the Roman triumph. This instance of the blending of the pagan and Christian will be followed by many others in the post-classical world.

A more fantastic biblical flying chariot is the inaugural vision of Ezekiel, in which the glory of God appears in the vision of a divine warrior riding in a battle chariot, drawn by four living creatures, each having four faces (those of a man, a lion, an ox and an eagle) and four wings. It is in this 'chariot of paternal deity' that the Messiah rides forth on the third day of the war in heaven in book 6 of Milton's *Paradise Lost* (6.750), in a dense combination of biblical and classical sources (see ch. 4: 183), and in which, now as a 'triumphal chariot' (881), he returns to heaven. The vision of Ezekiel is the major text for Merkabah (Chariot) mysticism, a school of Jewish mysticism that flourished in the first millennium AD and centred around experiences of ascent to heavenly palaces

128. On Hellenistic Jewish and early Christian traditions of ascent, see Segal 1980; on the traditions of ascent in Jewish and Christian apocalypses, see Himmelfarb 1993; Bremmer 2014. For a comparison of the motif of the ascent of the soul in 1 Enoch and book 1 of Lucretius, with speculation on the possible connections between the eastern (Jewish) and western (Roman) materials, see Schiesaro 2020, who locates the apocalyptic strands in *On the Nature of Things* within a wider Hellenistic 'literature of revelation'.

129. MacCormack 1981: 124–25.

and the throne of God.[130] Merkabah mysticism was accessible in the Christian *kabbalah* of Renaissance Neoplatonism, and it has been argued that Milton engages with it in the divine chariot that is the very central symbol of *Paradise Lost* (6.749–892).[131]

An unaided human attempt to reach heaven is punished in the story of the Tower of Babel (Genesis 11:3–9): 'And they said, Go to, let us build us a city and a tower, whose top may reach unto heaven; and let us make us a name, lest we be scattered abroad upon the face of the whole earth' (11:4). This project of architectural pride is also designed as a tower of sky-reaching fame.[132] As an attempt to reach heaven through a construction project, it is frequently put together, as a biblical parallel, with the classical story of the Giants piling Pelion on Ossa.[133] The bitumen (translated 'slime' in the King James Bible) that is used to bind the bricks was later interpreted by Milton as a subterranean material that bubbles up from hell: 'a black bituminous gurge / Boils out from underground, the mouth of hell; / Of brick, and of that stuff they cast to build / A city and tower, whose top may reach to heaven' (*PL* 12.41–44). Earlier in the seventeenth century, Joseph Beaumont had presented the hellish roots of the Tower in a different way: 'And then about their insolent work they fall, / And mounts of slime and brick together draw; / Unto a barbarous depth they dig, and set / In hell their heav'n-aspiring fabric's feet' (*Psyche* 16.681–84). For Beaumont, the way to heaven lies not through 'Proud dust above its earth aspir[ing] to grow' (16.708), but 'through humility's safe shady bowers' (16.696). Christ's own exaltation through self-humbling is central to a Christian inversion of the symbolic meanings of high and low.[134]

130. On Merkabah mysticism, see Scholem 1965; Halperin 1988; Karr 2017. See also Dean-Otting 1984.

131. Lieb 1999. In the ten-book 1667 edition of *Paradise Lost*, 6.762 is numerically the central line of the poem, beginning 'Ascended' (Christ into the chariot).

132. Hardie 2012: 545–46; on sky-reaching *fama*, see above.

133. E.g., in Dante, *Inferno* 31, Nembrot (Nimrod), builder of the Tower of Babel, is found together with Ephialtes among the Giants in the ninth circle.

134. Beaumont on the construction of the Christian church, empowered by the reversal of the division of tongues at the Tower of Babel by the 'cloven tongues' of fire that descended at Pentecost: 'A fabric which though its foundation here / In low and scorned humility it lays, / It mounts above the clouds in sacred pride / And in the heaven of heavens its head doth hide' (*Psyche* 16.128.3–6).

The central Christian narrative of celestial ascent is the ascension of Christ,[135] narrated most circumstantially in Acts 1:9–11 (its setting the Mount of Olives):

> And when he had spoken these things, while they beheld, he was taken up; and a cloud received him out of their sight. And while they looked steadfastly toward heaven as he went up, behold, two men stood by them in white apparel; Which also said, Ye men of Galilee, why stand ye gazing up into heaven? this same Jesus, which is taken up from you into heaven, shall so come in like manner as ye have seen him go into heaven.

Christ's ascent opens the way for other human beings, including his mother, whose bodily assumption into heaven at the end of her earthly life is narrated in apocryphal accounts. Saint Paul was uncertain whether it was in the body or out of the body that 'a man in Christ' (usually taken to be Paul) was caught up ('raptum' in the Vulgate) to the third heaven (2 Corinthians 12:2). 1 Thessalonians 4:15–17 looks forward to the Rapture of those still living at the time of the Second Coming, who will be taken up together with the resurrected dead in the clouds ('simul rapiemur cum illis in nubibus') to meet Christ. A cloud is a useful prop wherewith to effect the transition from visibility on earth to invisibility in the skies ('a cloud received him out of their sight'). In the visual arts, clouds become an indispensable element in the depiction of celestial ascents, whether as a platform for the ascending individual, as in Titian's *Assumption of the Virgin* in the church of the Frari in Venice, or to create perspective effects for the gaze directed heavenwards.[136] In terms of painting, clouds are the drapery of the heavens.

Late antique Christian literature

I move on now to Christian literature of late antiquity. In the modern classical curriculum this literature is often neglected, or put in a category of late antiquity separate from the literature and culture of earlier classical antiquity. No such hard and fast periodization existed in the Renaissance, when the Church Fathers and Christian poets of later antiquity were central authors of contemporary Christian culture.[137]

135. On the ascension of Christ, see Schrade 1928/29; Lohfink 1971, comparing Luke's narratives with Greek, Roman, Old Testament and Jewish pseudepigraphic traditions.

136. On clouds in the visual arts and the theatre, see Buccheri 2014.

137. See Vessey 2015: 117–23.

Christ's ascension is narrated in classicizing mode in the biblical epics of late antiquity, which inaugurate a tradition that goes down to Milton's biblical epic. Sedulius's *Paschal Song* is a hexameter paraphrase of the Gospels that reaches a stirring conclusion with the Ascension, labelled a 'triumph', that takes place before the reverent gaze of a crowd of the blessed: 'Carried away he disappears on high into the breezes of heaven' (aethereas euectus abit sublimis in auras) (5.425), a line that uses language found in Virgil, Ovid and Valerius Flaccus. In particular, the scene is reminiscent of Virgil's ecphrasis of the rape of Ganymede (*Aen.* 5.252–57: see above: 72), snatched aloft into the breezes ('sublimem', 'in auras') by the eagle before a crowd of, in this case dismayed, guardians. The gaze—surprised, joyful or dismayed, as it may be— of the intradiegetic spectators of an ascension invites the participation of the reader or viewer, in the visual arts: for example, that of the agitated crowd that witnesses the assumption of Titian's Virgin. Sedulius's spectators watch joyfully as the Lord travels 'above the lofty clouds, trampling with his footsteps the bright reaches of the sky' (altas / ire super nubes Dominum, tractusque coruscos / uestigiis calcare suis) (*Paschal Song* 5.429–31). The clouds come from the narrative in Acts, but readers who know their Virgil will remember the resurrected Daphnis in *Eclogue* 5 who looks in wonder at the clouds and stars beneath his feet (*Ecl.* 5.57: 'sub pedibusque uidet nubes et sidera Daphnis').[138]

Arator's versification of the Acts of the Apostles (*De actibus apostolorum*, completed 544) gives a more elaborate account of the Ascension as a novel and paradoxical triumph (1.31–41), with accompanying sound effects of crashing thunder and angelic choruses; paradoxical because, as the earthly Church Militant turns into the celestial Church Triumphant, the ruler of Olympus (*rector Olympi*, a title for Jupiter in classical poetry, now applied to Christ), who as a god descended to earth, ascends, returning to the stars, in the body of a man. The mortal flesh in which Christ is clothed is described as spoils snatched from the jaws of the black deep, from hell: a trophy which Christ now places in the citadel of light, as he raises up earthly limbs ('terrenosque erigit artus'). This entails a more comprehensive elevation of earthly flesh, since the resurrection and ascension of Christ opens the way to the general resurrection and ascent to heaven of all good Christians, as man, made originally in the image of God, is now redeemed from the effects of the Fall. This is also a triumphant overgoing of the pre-Christian idea that man has a seed of the

138. On the use of Virgilian images of celestial ascent in Christian poetry, see Fontaine 1982.

divine in him, and that, consequently, unlike beasts that go on all fours, man walks upright with his face lifted to the stars (see above: 46n39). In Ovid's formulation, 'Prometheus gave man a face held high [(Lat.) sublime] and bade him to look at the sky and raise up his countenance aloft to the stars [erectos ad sidera tollere uultus]' (where *erectos* is the participle of the verb *erigo*) (*Met.* 1.85–86).

Classical and Christian are closely interwoven in the ascents in the late antique poetry of the Christian poets Paulinus of Nola (AD 353/4–431) and Prudentius (AD 348–after 405). Paulinus celebrates the ascent to heaven of the soul of Saint Felix, to the service of whose shrine at Cimitile near Nola in Campania Paulinus devoted himself, as a 'triumph in the stars' (Poem 18, 145). A throng of the pious bear him up through the clouds, and choirs of angels meet him at the gate of heaven to bring him into the presence of God. As well as a triumph, this is also a celestial version of the *aduentus*, the ceremonial reception of an emperor or other great man on his arrival at the gates of a city.[139] At the beginning of Poem 18, Paulinus sets out to sing of the translation to heaven of his patron saint in language that combines the biblical and the Virgilian: 'through a hard journey, on a path passable to few, striving on a narrow way on high he has reached the heavenly citadel' (quod per iter durum, qua fert uia peruia paucis, / alta per arta petens superas penetrauit ad arces) (6–7); 'arta' alludes to the 'narrow way' of Matthew 7:14 ('Strait is the gate, and narrow is the way [angusta porta et arta uia], which leadeth unto life'). The 'hard journey' replicates the 'iter durum' that has led the pious Aeneas to the shade of his father in the underworld (*Aen.* 6.687–88). Felix has also journeyed to his heavenly Father. Felix has travelled to the citadel on high ('superas . . . arces') on a path passable to few. Aeneas's journey to the underworld, and his subsequent return to the world above ('superas . . . ad auras'), is something that can only be achieved by 'a few' (pauci), according to the Virgilian Sibyl (*Aen.* 6.128–31).

In another poem, 24 (891–942), Paulinus looks forward to the flight to God of the resurrected faithful at the Last Judgement, a flight of liberation from the shackles of pride and wealth that will keep the unfaithful grounded, 'stuck fast in the mire of their own dregs', too heavy for the light clouds that will bear up the pious who are 'free of the mass of things that weigh you down, and cleansed of the stain of sin' (et uos prementum mole rerum liberos / et labe puros criminum). This is a Christian version of the Platonic escape of the virtuous soul

139. See MacCormack 1981: Part 1, '*Adventus*'.

from the shackles of the body, but with the difference that the pious Christian souls will rise on high together with their resurrected bodies. This ascent is also the return of like to like, as the blessed dead are 'restored to the celestial image [in which Adam and Eve were first created], sharing the likeness of the glory of the Lord' (et ad supernam restituti imaginem, / erile conformes decus) (939–40).

The imprisoned Saint Felix's mind travels through the sky in the track of the Lucretian Epicurus in Poem 15: 'with roaming mind he wandered through the sky; though his body was chained, his free spirit preceded him in flight to the inner haunts of Christ' (spatiante polum qui mente peragrat. / seque ipsum, uincto quamuis in corpore, liber / spiritus anteuolat summi in penetralia Christi) (190–92). The verb *spatiari* had been used by Ovid and Manilius of the free flight of the mind through space (see above: 41, 45).

In Poem 27 (*Natalicium* 9), the poet Paulinus, singing of the 'birthday' of his St Felix (the anniversary of the saint's death, and hence birth into heavenly life), is taken by surprise at his own poetic flight into the lofty theme of Christ's redemption of mankind. Paulinus deploys a patchwork of Virgilian, Horatian and Ovidian passages on daring and risky flight to describe his own unaccustomed elevation, 'daring to trust myself aloft on frail wings' (ausus in excelsum fragili me credere pinna) (308),[140] before checking his swollen inspiration (320: 'tumidos flatus') and calling himself back to earth, for all that it is not possible to sing of Felix's lofty/sublime merits (323: 'meritum sublime') without at the same time praising God. This is an exercise in the Christian sublime.

Ascent to heaven is the conclusion to many of the martyr narratives in Prudentius's *Peristephanon* (On the crowns [of the martyrs]). The upward flight of the martyr's soul is an escape both from the soul's imprisonment in this fallen world, and from literal imprisonment by the persecutors, as in the case of Saint Vincent (*Perist.* 5), whose day of martyrdom (5–7) 'raised him up to heaven from the darkness of the world [ex tenebris saeculi]'. While in prison, Vincent is visited by angels, who say to him, 'Lay aside this mortal vessel, a

140. Cf. Virgil, *Aen.* 6.15: '[Daedalus] praepetibus pennis ausus se credere caelo' (daring to trust himself to the sky on swift wings); with line 311, 'super astra uolans' (flying above the stars), cf. Ovid, *Met.* 15.875–76: 'super alta . . . / astra ferar'; with line 313, 'quae me leuat aura superbum?' (What breeze lifts me up in my pride?), cf. Horace, *Odes* 4.2.25: 'multa Dircaeum leuat aura cycnum' (a great breeze bears up the Theban swan [i.e., Pindar])'; with line 317, 'acer anhelantis iuxta me spiritus intrat' (as [Nicetas] exhales, his keen breath enters me), cf. *Aen.* 5.254 (Ganymede immediately before being snatched up by the eagle): 'acer, anhelanti similis'.

fabric of earthen structure which dissolves and falls to pieces, and come in freedom to the skies' (pone hoc caducum uasculum / compage textum terrea, / quod dissipatum soluitur, / et liber in caelum ueni!) (301–4). Like an important Roman making his way through the city, Vincent's ascending soul is attended by a press of companions, in this case white-robed bands of saints: 'stipant euntem candidi / hinc inde sanctorum chori' (373–74). Souls of the blessed, angels and cherubs form a guard of honour in many paintings of ascensions: for example, again, Titian's *Assumption of the Virgin*.

Eye-witnesses to the ascent of a saint's soul lend vividness and authority: 'An attendant from the governor's household saw the heavens opening to receive the martyrs, and the illustrious three passing through the stars' (*Perist.* 6.121–23). The executioner of the spirited virgin martyr Eulalia himself sees her soul darting forth from her mouth in the shape of a snow-white dove, heading for the stars (*Perist.* 3.161–70), echoing the flight of the dove in the archery contest in *Aeneid* 5 (see above: 72–73). Prudentius draws on the fullest range of topics in the narrative of the ascent of the soul of Saint Agnes after her beheading (*Perist.* 14.91–123). Her disembodied soul darts forth, free, into the breezes, accompanied by angels. Like the Daphnis of Virgil's fifth *Eclogue*, she marvels at what she sees beneath her feet; in a view from above she sees the power and riches of the world in perspective, in the tradition that goes back to Cicero's *Dream of Scipio*, and, like Lucan's soul of Pompey, she laughs at the world's vanity. Combining the poses of the Lucretian Epicurus trampling down Superstition and of the biblical Eve bruising the head of the serpent (Genesis 3:15), Agnes tramples on 'the filthy clouds of paganism' and places her heel on the head of the Devil-serpent. She receives from God the twin crowns of martyrdom and virginity.

Even in this life, according to Saint Ambrose (c. AD 340–97), in *On Virginity* (chs 13–18), women who guard their virginity can come close to the condition of disembodiment (we might say the disembodiment of the anorexic), if they follow the urging of Saint Paul to set their affections on things above, not on things on the earth (Colossians 3:2). Going almost beyond the bounds of nature, they fly to the heavens on spiritual wings. In a flight of the mind, the soul traverses the whole world in an instant, with the freedom enjoyed by the thoughts of the wise, and soars up to the heights of divinity, unencumbered by earthly baggage. The soul cleaves to God, bearing in itself the likeness of the heavenly image ('imaginis in se referens caelestis effigiem'), as like returns to like. Ambrose adapts the image of the chariot of the soul in Plato's *Phaedrus*; now the charioteer who guides and perfects the four horses that symbolize the affections of the soul is Christ. Aware that he may seem to be borrowing the

language of pagan philosophers and poets, Ambrose asserts that it is rather the pagans who have borrowed the image of the winged chariot of the soul from Ezekiel's vision of the chariot of God, whose four animals he proceeds to allegorize as the four affections of the soul and the four cardinal virtues (as well as the more familiar symbols of the four evangelists). From the four beasts, the soul that works justice takes on the shape of the eagle, shunning earthly things and soaring to heaven, winning through justice the glory of resurrection, in keeping with the lore of the late antique bestiary the *Physiologus*, and with the Psalmist's teaching that the ageing eagle rejuvenates itself (Psalm 102:5: 'renouabitur ut aquilae iuuentus tua').[141] Ambrose then returns to the poets: the soul will travel far from the heated turmoil of the world, lest it suffer the fate of Icarus who fell to earth when the wax that held together his wings was melted by the sun.

Ambrose describes the posthumous ascent of the soul of the emperor Theodosius (d. 17 Jan. 395) in an address preached in Milan cathedral forty days after his death, before the body was sent to Constantinople.[142] Ambrose starts with the topics of the omens that foretell the death of a pre-Christian emperor, but quickly modulates into a commentary based on the exposition of biblical texts, including (§29) the biblical version of escape on the wings of a bird (Psalm 54:7): 'And I said, Oh that I had wings like a dove! for then would I fly away, and be at rest' (et dixi 'quis dabit mihi pinnas columbae, ut uolem et requiescam?'). This flight is a return of the soul to the place whence it descended to earth (§36). In heaven, Theodosius glories in the company of the saints. He meets those Christian princes who have gone before him, Constantine, Helena and Gratian. By contrast he will not meet the usurpers Maximus and Eugenius, who are now in hell. In a closing address to Theodosius's son Honorius, Ambrose contrasts the earthly triumph in which Theodosius had been expected to return to Constantinople. But now he will return in a yet more glorious *aduentus*, escorted by a host of angels and a crowd of saints (§56), as earthly triumph is converted into angelic triumph.

Very different is the narrative of the ascent of Theodosius's soul in Claudian's *On the Third Consulship of Honorius*, composed the year after the death of Theodosius (396).[143] Claudian, the author of panegyrical epics and of a mythological poem *On the Rape of Proserpina*, is another late antique author far more

141. See Hillier 1993: ch. 8, 'Aquila. The Rejuvenation of the Eagle'.

142. Liebeschuetz 2005: 174–203 for a translation of *On the Death of Theodosius I*, with introduction and notes. See also MacCormack 1981: 148–50.

143. For commentary, see Barr 1952; see also MacCormack 1981: 139–41.

familiar to Renaissance than to modern audiences.[144] *On the Third Consulship* operates entirely within the tradition of the earlier imperial ruler panegyric, whose vocabulary was established by Virgil and Ovid. Claudian combines elements of the prospective deification of Octavian in the prologue to *Georgics* 1, of Nero in the prologue to Lucan's *Civil War* and the catasterism of Julius Caesar in *Metamorphoses* 15. In resisting Nature's wish that his divinity should return to heaven, until he has handed to his son Honorius a world entirely at peace (105–10), Theodosius fulfils the conventional wish of the emperor's subjects that he should accede to godhead late in time. Theodosius's return to an original divinity can be accommodated within a Platonic-Ciceronian tradition. After entrusting his two young sons to the care of the regent Stilicho, Theodosius traces a bright path through the clouds, ascending through the planetary spheres. The doors of heaven open of their own accord, a celestial manifestation of the miracle of *Türöffnung*, and the fixed stars receive Theodosius among their number as a *nouum sidus* (172), a 'new star' in an old tradition, that being the phrase applied by Catullus to the catasterized Lock of Berenice (Cat. 66.64), by Virgil to the apotheosed Octavian (*Geo.* 1.32) and by Ovid to the comet into which the soul of Julius Caesar is transformed (*Met.* 15.749).

The apotheosis of Theodosius confirms a wider imperial and cosmic order. In his last words to Stilicho, Theodosius expresses confidence that if the gigantic monsters of myth—Typhoeus, Tityos, Enceladus—should seek to break out of their prison-houses and assault the divine order, they will fall back in the face of Stilicho (158–62), and be confined to the pagan version of hell. As the new star that is the apotheosed Theodosius orbits the world, at his rising in the east he will look on Arcadius, emperor of the eastern empire, and as he sinks to the west, on Honorius, emperor of the western empire, the two brothers who, together, serenely rule the world under their father's benevolent gaze A vision of a new Golden Age concludes with another contrast between heaven and hell, as personified Greed is left to weep in Stygian chains.

The imagery of Claudian's apotheosis of Theodosius is, as Sabina MacCormack puts it, 'an imagery of art, of culture, not . . . an imagery of cult, or religious worship'.[145] As such, it is not in conflict with the Christian beliefs and Christian cult of the court of Theodosius. Some details may indeed converge with Christian belief, such as the idea that the posthumous journey to heaven is the soul's return. Further, Theodosius's reception in the skies is not into the

144. See Cameron 1970: 'Conclusion', on the reception, largely English, of Claudian.
145. MacCormack 1981: 140.

company of the other gods of the pre-Christian pantheon. This cohabitation of an artistic and cultural pagan imaginary with Christian orthodoxy will be seen time and again in the post-classical Christian world. Claudian was read and imitated in the early modern age not least as a model for panegyric both verbal and visual.[146]

Parodic and Comic Ascents

So ambitious and pretentious a theme as the aspiration to ascend to the heavens naturally invites deflation and mockery. Aristophanic comedy provides some of the earliest surviving examples of flights to the sky. In the *Peace*, Trygaios flies up to Olympus on a dung-beetle, in order to rescue Peace and to put an end to the Peloponnesian War. This is an ascent in paratragic mode, parodying the doomed flight of Bellerophon on the winged horse Pegasus to heaven to confront the gods with their shortcomings, in Euripides's lost *Bellerophon*.[147] In the *Birds*, Peisetairos achieves his ambition of building the utopian city of Cloudcuckoo-land in the sky after he sprouts wings with the help of a magic root. Visitors to the newly built city include the dithyrambic poet Cinesias, who announces that he is 'flying up to Olympus on light wings' (1372), and asks for bird wings 'to fly on high and snatch from the clouds fresh preludes air-propelled and snowswept' (1383–85). The scene sends up, and literalizes, the bird imagery used by Greek lyric poets and dithyrambists of their own work (see above: 48).[148] Both *Peace* and *Birds* are escapist flights of fancy, in search of liberation from the intolerable circumstances of human life on earth. In the *Clouds*, Socrates is discovered in his 'thinking shop', suspended in a basket; when asked what he is doing, he replies, 'I am walking in the air [ἀεροβατῶ] and thinking about the gods', a comically literal way of realizing a flight of the mind, in a parody of contemporary 'meteorological' speculation.[149]

Some of the most influential ancient accounts of ascents to the sky are satires written by Lucian, a leading figure of the second-century AD 'Second

146. See Garrison 1975: index s.v. 'Claudian'.

147. Olson 1998: xxxii, 'Literary and Mythological Background'. On Euripides's liking for the (sublime) theme of the heavenly ascent of a mortal being, see Porter 2016: 344–50.

148. See Dunbar 1995: 664–65, 669.

149. See Festugière 1949: 445 n. 6 on the frequency in the Hellenistic period of *aerobatein, aerodromein, ouranobatein, meteoropolein*, and similar words. On Aristophanes's parody of scientific *meteorologia*, see Porter 2016: 434–43.

Sophistic'. In the *Icaromenippus*, Menippus, a third-century BC satirist and important model for Lucian's brand of satire, recounts how he flew up to the moon and beyond to the celestial home of the gods. Unable to grow wings (πτεροφυεῖν), after the manner of the philosophical lover's soul in Plato's *Phaedrus*, he followed the method of Daedalus, but, rather than constructing wings with feathers and wax, he cuts off and fits to himself whole wings of an eagle and a vulture. Menippus's motivation is to resolve the disagreements of philosophers by taking the view from above down on the earth, the view which puts into laughable perspective the rich and varied tapestry—'ποίκιλη καὶ παντοδαπή τις ἦν ἡ θέα' (It was a varied and manifold sight) (16)—of human striving.[150] From above, the cities of men seem no more significant than anthills. On the moon, Menippus comes across the singed figure of Empedocles, who has been blown up to the moon from Etna, into which, according to the story, he had jumped in order that after his disappearance it would be assumed that he had become a god (see above: 52). On being taken by Menippus for a daimon of the moon, Empedocles replies, in the words of Homer's Odysseus, 'No god am I: why liken me to them?' (*Odyssey* 16.187): a heaven-reacher who does not aspire (any longer) to divinity.

The *Icaromenippus* has a pendant in Lucian's *Charon*, in which the satirical view from above is achieved by mountain-climbing rather than flight to the heavens, a reminder of the close association of the motifs of ascending mountains and ascending to the heavens.[151] Charon, the ferryman of the dead, comes up from the underworld. Since it is not lawful for a god of the dead to enter the house of Zeus in the heavens, Hermes, the god who is able to travel up and down the vertical axis, from Hades to Olympus, arranges a lofty vantage point on a mountain-top, by piling Pelion on Ossa, effortlessly achieved by reciting the two verses (*Odyssey* 11.315–16) in which Homer narrated the doomed attempt of the sons of Aloeus to assault the gods (one of the standard mythological examples of the wrong way to try to ascend to the skies), and then for good measure adding two further mountains, Oeta and Parnassus. From this height Charon and Hermes have a view from above, down on the laughable spectacle of human activities, similar to that achieved from a loftier elevation in the *Icaromenippus*.

150. On the laughter of Lucian's views from above, see Halliwell 2008: ch. 9, 'Lucian and the Laughter of Life and Death'; 429–36: 'The View from the Moon'; 436–54: 'Other Aerial Perspectives (or Head in Clouds?)'.

151. See Jacob 1984: 150–52: 'Le motif de l'ascension sur la montagne'; 'Ménippe et les "efforts icariens"'.

The presence of Charon plays on the association between the view from above and the post-mortem perspective of a journey to the underworld as two ways to achieve a detached view of the hurly-burly of the world in which we find ourselves embroiled on earth. The *Icaromenippus* can also be paired with Lucian's *Menippus, or Nekuomanteia*, in which Menippus goes down to the underworld to find out the right way to live, by consulting the seer Teiresias instead of the conflicting and hypocritical philosophers on earth.[152] This use of both extremes of the vertical axis, underworld and heavens, as places in which to find a perspective on, and solution for, the problems of mortal existence on earth goes back to Aristophanes: in the *Birds*, Trygaeus flies to heaven to find a way of ending war on earth, but in the *Frogs* Dionysus goes down to the underworld to bring back a dead poet to advise the Athenians at a low point in the Peloponnesian War.[153]

A foundational text for science-fiction narratives of journeys to the moon and space travel is Lucian's *A True Story*, which includes an episode (1.9–29) of a ship which is carried up by a whirlwind and sails through the air, visiting the sun and the moon. Here the same vehicle sails both over the sea and through the sky, a comic literalization of the metaphor of sailing as 'flying'. This book will not trace in detail the long history of voyages to the moon, the subject of a classic study by Marjorie Nicolson.[154]

All of these works by Lucian are acutely conscious of their status as fictions, as exercises in poetic licence (taken to an extreme in the licence given to two lines of Homer to rearrange, in an instant, large-scale features of the geography of Greece). Metaphors are translated into reality: in the *Icaromenippus* Menippus's interlocutor is in suspense to hear his story of flight, μετέωρος, literally 'raised from the ground', and asks not to be left 'hanging by the ears'. Menippus's further narrating will take his companion on a mental version of the literal journey of ascent that he undertook, up to 'τὰ μετέωρα' (that is, 'the things in the heavens above', or 'astronomical phenomena'—in English, 'meteorology' has become restricted to phenomena that go no higher than the earth's atmosphere).[155] Menippus asks his companion 'to mount up to the moon in

152. See Marsh 1998: 77–83 on *Icaromenippus* as a counterpart to the *Menippus*. It is possible that both works were based on a lost work by Menippus.

153. See Branham 1989: 14 for the Aristophanic parallels for both *Icaromenippus* and *Menippus*, Trygaeus's flight to heaven on a dung beetle to rescue Eirene in *Peace*, and Dionysus's descent to Hades in *Frogs*.

154. Nicolson 1948.

155. On *meteoros* and *meteorologia*, see Capelle 1912.

fancy as best you can and share my trip' (ὡς οἷόν τε ἀναβὰς ἐπὶ τὴν σελήνην τῷ λόγῳ συναποδήμει) (§11). What for Menippus was a physical ascent, for his companion can only be a flight of fancy; but Lucian's reader knows that the whole tall story is nothing but a fantasy.

I end this section by looking forward to two post-classical examples of parodic flights, both of which were known to and exploited by English poets in the period covered by this book. My first is the parodic flight upwards in pursuit of knowledge in the second book of Chaucer's *House of Fame*.[156] After the narrator Geffrey has exited from a temple of Venus in which he has viewed images of the *Aeneid*, with particular emphasis on the doomed love of Dido for Aeneas, he finds himself in a desert from which he is carried up by an eagle. Geffrey faints, and is roused by the eagle, which gives him lessons in the science of acoustics, and would have continued with astronomical teaching, had Geffrey been receptive. The eagle carries him up to the House of Fame, located above the earth like Ovid's House of Fama (*Met.* 12.39–63). There are multiple allusions, merging pagan and Christian into one: to the winged pagan god Mercury who prompts Aeneas to leave Carthage in pursuit of Roman *gloria* (one of the meanings of *fama*); to the eagle of Saint John; to the biblical subjects of rapture, Enoch and Elijah; and to the classical Romulus and Ganymede. Chaucer also imitates the episode in Dante's *Purgatorio* (9.19–42) in which, in a dream, an eagle descends like a thunderbolt to carry Dante up to the gate of Purgatory, part of a wider pattern of allusion to the plot of the *Commedia* in Chaucer's *House of Fame*.

Ariosto, meanwhile, combines Menippean satire in the manner of Lucian with parody of Dante in the episode of Astolfo's journey to the moon in search of Orlando's lost wits, in cantos 34 and 35 of *Orlando furioso*.[157] By way of preface, I highlight three aspects of this episode that further illustrate some of the general points that have emerged in the course of this chapter: first, the deployment of the lower, as well as the higher, part of the vertical axis in a narrative of ascent; second, the combination of mountain climbing with upwards flight; and third, the strong association of ascent with the imaginary of fame.

156. Alexander Pope's *Temple of Fame* (an early work) is a rewriting chiefly of book 3 of Chaucer's *House of Fame*. See Hardie 2012: ch. 15. Pope writes his own parodies of celestial ascents: see ch. 5: 205, 207–9.

157. The following discussion is based on Hardie 2020b: 45–48. This episode in *Orlando furioso* is drawn upon by Milton (see ch. 4: 185) and Pope (see ch. 5: 207).

Astolfo's journey to the moon is the last stage in a series of ascents that col-
lectively constitute a miniature and parodic version of the journey of Dante in
the *Commedia*.[158] Canto 34 begins with Astolfo in a cave that is a version of
Inferno. The infernal associations are signalled by 'weeping and howling and
eternal lament' (34.4.6–8); 'the infernal pits' (le bolgie infernal) (5.4); and
'infernal fire' (fuoco infernal) (9.4.), whither Astolfo has chased the harpies
who plagued Prester John, and where he hears the story of the damned soul
of Lidia (34.11–43), punished for her hard-hearted and ungrateful treatment
of her lover. After making his way out of the cave, with Virgilian difficulty, and
having a Dantesque wash in a fountain, Astolfo flies on the hippogriff up to
the Earthly Paradise, where he finds a palace which is the dwelling of Saint
John. Thither the saint had been assumed, to join Enoch and Elijah. From
there, Astolfo ascends with Saint John in the chariot of Elijah to the moon.
From Inferno to Purgatorio to Paradiso; but the moon, the first heaven of
Dante's *Paradiso* (cantos 2–5) is as far as Astolfo gets in his ascent. His mission
is to recover the lost wits of Orlando, which are found in a valley on the moon.
That done, Saint John shows Astolfo a palace by a river: the palace houses the
Fates, Parcae, who spin from fleeces the threads of individual human lives, lives
which come to an end once the threads are wound on to the reel. The names
of all the finished lives are printed on metal plates, heaps of which old man
Time constantly carries away to throw into the turbulent stream of Lethe.
Around the river fly crows and vultures and other birds, which flock to carry
off the pickings of the plates, but they do not have the strength to carry them
far, and the name plates fall back into the stream. These birds, Saint John ex-
plains to Astolfo in an exegesis of the 'correspondences' (35.18.3) between
things seen on the moon and the realities of our world below, are flatterers,
buffoons, minions—in short, courtiers—who carry these names in their
mouths for a while, only to let them fall once more into oblivion. But there are
also two swans, which pick up some of the names and carry them to the temple
of Immortality on the bank of the river. A nymph, Fama, comes down to the
river to take the name plates from the swans, and affixes them to the statue of
Immortality on top of a column in the centre of the temple. The swans, Saint
John explains, are poets, birds as rare as are the two swans who rescue worthy
men from oblivion (35.23.1: 'Son, come i cigni, anco i poeti rari').

The discovery of a temple of fame and immortality on a high hill at the
zenith of Astolfo's upwards flight is the culmination of a concern with fame

158. See Quint 1977; Ascoli 1987: 264–304.

that begins in the 'underworld' cave at the beginning of canto 34. At 34.10, Astolfo promises Lidia to bring 'novella' (news) and 'fama' (report) about her to the world above, arousing in her 'the great desire' (10.6) for the same: this is a further example of the interest shown by characters in the *Inferno* for reports of themselves to be conveyed by Dante back to the world above (cf. *Inferno* 13.52–54, 28.92). On the moon, the first item mentioned in the Valley of Lost Things is 'heaps of fame . . . which, here below, long passage of time devours like the worm' (34.74.5–6); and 'fama' recurs at 76.3–8: 'He saw a mountain of swollen bladders, which seemed to contain uproar and shouting; and he knew that these were the ancient crowns of Assyria and the land of Lydia, and of the Persians and Greeks, who were once famous, and even their names are now obscure.' Ariosto himself is involved in the upwards flight of fame, in two ways. Firstly, he himself is a praise-poet. One of the fleeces that Astolfo sees in the palace of the Fates is a beautiful golden one, which Saint John tells him is that of Ippolito d'Este, Ariosto's patron, extravagant praise of whom and of Ferrara is placed on the divine lips of Saint John himself. Secondly, in tracking the ascent of Dante through versions of Inferno, Purgatorio and Paradiso, to arrive at a temple of Fame, Ariosto comments on his own aspiration to poetic achievement and poetic fame. He hopes to become another swan— Saint John does not identify the earthly poets who correspond to the two swans, but they may be Homer and Virgil—preserving from oblivion the names of men worthy of the poets, such as Ippolito d'Este.

But Astolfo ascends no higher than the moon; there is no mystic vision of the rose as a culmination of his upward flight. The immortality of fame turns out to lack the fixity and certainty of truth. In the last part of his exposition, Saint John goes on to reveal that even men of bad character can emerge living from the tomb if they know how to make friends with the god of poetry (35.24), and that Aeneas, Achilles and Hector were not such great heroes as they are made out to be by poets who have been richly rewarded by those heroes' descendants. And 'Augustus was not as saintly or as benevolent as he is trumpeted by Virgil' (Non fu sì santo né benigno Augusto / come la tuba di Virgilio suona) (26.1–2). Conversely, Dido only has a bad reputation as a 'bagascia' (whore), because Virgil was not friendly to her. Saint John, as Astolfo's guide in the ascent from the Earthly Paradise to the heavens should be playing the part of Beatrice, but it turns out that he is more of a Virgil to Astolfo-as-Dante, when he breathtakingly says that he loves poets, and 'properly so, since in your world I too was a writer'. For this, he says, he has earned what neither time nor death can take from him; the Christ whom he praised (35.29.3: 'mio

lodato Cristo') has rewarded him as he should: that is, with a deathless existence in the Earthly Paradise.

Ariosto's relativization of fame, and his demotion of transcendental gospel truth to the status of merely human, and therefore unstable, writing, have been excellently laid bare by David Quint in his discussion of the episode.[159] Even the swans in the moon no longer move in a straightforward upwards trajectory: 'The sacred swans make their way, now swimming, and now beating their wings through the air' (35.15.5–6). Flight is an option, only. One might see in these alternative modes of locomotion acknowledgement of the vagaries of poetic *fama*: Virgil tells us that Phaethon's lover Cycnus, metamorphosed into swan, ascends to the stars, but Ovid in his version 'corrects' Virgil, and says that Cycnus-as-swan does not take off into the sky, all too mindful that it was from there that Jupiter hurled his thunderbolt at Phaethon, and keeps rather to ponds, lakes and rivers.[160]

159. Quint 1983: 81–92, 'Antitype: Astolfo's Voyage to the Moon': 'The vertical dimension characteristic of epic fiction, transcending the world of human action and lending it intelligibility, has been effectively collapsed and eliminated from the Furioso' (82).

160. *Aen.* 10.189–93; *Met.* 2.367–80; 377–80: 'nor does he trust himself to the sky and to Jupiter, mindful of the fire unjustly hurled by him; he seeks out ponds and spreading lakes, and in his hatred of fire he has chosen to haunt rivers, flame's opposites'.

3

Late Sixteenth Century to the Exaltation of Newton

THIS CHAPTER SURVEYS celestial aspirations articulated in British literature, mostly in verse, over a time-span from the later sixteenth to the early eighteenth century. Strong impulses are channelled both by religious enthusiasm, and by natural-philosophical exaltation. The religious embraces the upwards rush of the assertive Protestant culture of France, England and Scotland, as well as the fashion in England, from the 1630s onwards, for imitations of the soaring neo-Latin poetry of the Roman Catholic Casimire Sarbiewski. On the natural-philosophical side, the impetus of the Lucretian tradition of mental flights into the boundless void becomes supercharged by the vastnesses of space opened up by the new astronomy of the seventeenth century. Sky-reachers may be transgressive and heterodox, as in the case of Christopher Marlowe's antiheroes, in whom is perhaps to be seen the influence of the heretical Italian philosopher Giordano Bruno. More insistent, over the course of the period here covered, is the drive to establish a symbiosis between scientific advance and Christian orthodoxy, above all in a line of poems that appropriate the Lucretian flight of the mind for celebration of Newton. This last tradition comes to take on Miltonic colouring. But this chapter sidesteps Milton, reserving a full treatment of that poet's own celestial aspirations for the following chapter.

Sylvester's *Du Bartas*, Spenser, Drayton, Marlowe, Shakespeare

On Rubens's ceiling in the Banqueting House in Whitehall, James I of England is borne up to the heavens in posthumous apotheosis (see Fig. 6.10), an early seventeenth-century example of what in later seventeenth- and early

eighteenth-century Britain will become a fashion for ceiling paintings of ascensions to, and epiphanies and triumphs in, the heavens (the subject of chapter 6). The programme of the Whitehall ceiling is dictated by the absolutist ideology of the Stuart monarchy as it had developed by the 1630s under James's successor Charles I. Yet this skywards journey is not an unfitting consummation for a king who, as the young James VI of Scotland, announced himself as 'the future patron of divine poetry in Britain'[1] with his translation of the French religious poet Saluste du Bartas's 'L'Uranie' (in *The Essayes of a Prentise*, Edinburgh 1584).[2] Du Bartas is best known in English literary history as the author of *The Divine Weeks and Works of Guillaume de Saluste, sieur du Bartas*, in the translation of Josuah Sylvester, *Sylvester's Du Bartas*.[3] Du Bartas's enormous epic-didactic poem on Genesis (published 1578–1603; Sylvester's translation was published between 1592 and 1608) narrates the Creation and Old Testament history. The work, which has now almost entirely disappeared except from the radar of literary scholars, enjoyed great popularity through the seventeenth century; Du Bartas's poetry was the central text in a Protestant literary culture shared between Huguenot France, Scotland and England. In 'L'Uranie' (one of three poems in *La Muse chrestiene*, 1574), Du Bartas transforms the classical Muse of astronomy, Urania, 'she of the heavens', into the Muse of Christian poetry. In a dream-vision, Urania urges Du Bartas to reclaim poetry from its profane misuse for the service of God, and to fly up to the heavens: in James VI's version, 'Take me for guyde, lyft up to heaven thy wing / O Salust, Gods immortals honour sing: / And bending higher Davids lute in tone / With courage seke yon endless crowne above.' This is the Urania that we find, for example, at the beginning of the second half of Milton's *Paradise Lost*, in the invocation beginning 'Descend from heav'n Urania', and perhaps also to be identified with the 'heavenly Muse' whom Milton bids 'sing' at the very beginning of the poem. Du Bartas's Urania is the Muse that, in James VI's translation, 'to the starres transports humanitie', and whose inspiration makes man transcend himself: 'For euen as humane fury maks the man, / Les than the man: So heauenly fury can / Make man pas man, and wander in holy mist, / Vpon the fyrie heauen to walk at list.' Du Bartas, and his royal translator,

1. Campbell 1935: 40.

2. See Campbell 1959: ch. 9, 'Du Bartas and King James and the Christian Muse'.

3. On the (extensive and enthusiastic) reception of Du Bartas in the Scottish and English Renaissance, see Prescott 1978: ch. 5; Campbell 1959: ch. 10, 'Du Bartas and English Poets'; Auger 2019.

Christianize Ronsard's Platonic poetic *fureur*.[4] 'Walking upon the fiery heaven' takes us back ultimately to the unfallen souls of Plato's *Phaedrus* travelling with the gods on the back of the heaven, gazing on the supra-celestial region (see ch. 2: 33).

In a passage in *The Divine Weeks and Works* celebrating the powers of man's divine soul (1.6.831–56), we read that 'though our soul live as imprisoned here / In our frail flesh, or buried (as it were) / In a dark tomb; yet at one flight she flies / From Calpe [Gibraltar] t' Imaus [a mountain range in central Asia], from the earth to skies'. The Platonic imprisonment of the soul in the tomb of the body is no impediment to the flight of the soul or mind, which rides not in a figurative chariot, but 'Much swifter than the chariot of the Sun / Which in a day about the world doth run'. The soul leaps above the clouds to learn of secrets meteorological. With a switch of image from flying to climbing steps, 'By th' air's steep stairs, she boldly climbs aloft / To the world's chambers; heaven she visits oft / stage after stage'. Finally, in the Lucretian image of going beyond the walls of the world, 'She mounts above the world's extremest wall, / Far, far beyond all things corporeal; / Where she beholds her maker face to face', viewing 'the sacred pomp of the celestial court'.

Yet, as he sets out on his vast poem, Du Bartas expresses a proper moderation of ambition in singing of God's creation (1.1.127–40):[5]

Climb they that list the battlements of heaven:
And with the whirlwind of ambition driven,
Beyond the world's walls let those eagles fly,
And gaze upon the sun of majesty:
Let other-some (whose fainted spirits do droop)

4. Revard 2001: 96–98.

5. Translating Du Bartas, *Sepmaine*, 1.105–18. The lines are perhaps echoed in Thomas Browne's *Religio medici* 1.13: 'Teach me to soar aloft, yet ever so, / When near the sun, to stoop again below. / Thus shall my humble feathers safely hover, / And, though near earth, more than the heavens discover.' For a reading of Du Bartas's middle road as steering a course between 'trying to contemplate God directly and . . . viewing the cosmos in itself rather than in its relation to God', see Banks 2008: 38. Du Bartas's middle road has a precedent in Poliziano's account of the didactic poet Hesiod (regarded in antiquity as an example of the middle style: Quintilian, *Inst.* 10.1.52), *Nutricia* 377–80 (trans. Fantazzi 2004: 134): 'At tibi Daedaleos monitus, Heliconie uates, / qui sequeris neque uentosis in nubibus alas / expandis neque serpis humi, sed praepete lapsu / ceu medium confine teris' (But [how could I praise] you, bard of Helicon, who follow the counsel of Daedalus, and neither spread your wings in the windy clouds, nor creep on the ground, but in swift flight you tread as it were a middle path.)

Down to the ground their meditations stoop,
And so contemplate on these workmanships,
That the author's praise they in themselves eclipse.
My heedful Muse, trained in true religion,
Divinely-human keeps the middle region:
Lest, if she should too high a pitch presume,
Heavens glowing flame should melt her waxen plume;
Or, if too low (near earth or sea) she flag,
Laden with mists her moisted wings should lag.

Du Bartas will emulate neither the Giants who attempted to climb up to heaven, nor the high-flying eagle which traditionally can look into the sun. He will heed the advice of the Ovidian Daedalus to his son Icarus,[6] and so avoid the fate of Icarus and Phaethon.[7] The renunciation of a flight 'beyond the world's walls' is a refusal to follow Lucretius's Epicurus 'beyond the flaming walls of the world'.[8] Du Bartas's pious caution when it comes to his own poetic ambition will be pointedly abandoned by Milton when he announces his 'advent'rous song, | That with no middle flight intends to soar / Above the Aonian mount' (*PL* 1.13–15) (see ch. 4: 179–80).

Despite Du Bartas's inaugural modesty, what Anne Lake Prescott refers to as his 'joyful rush upwards', and 'the aesthetics of levitation',[9] characterizes *The Divine Weeks and Works* as well as 'L'Uranie', and exercised a strong attraction on English, as well as Scottish, Renaissance poets. Du Bartas's soaring is singled out for praise by Phineas Fletcher in *The Purple Island* (1633): 'And that French Muse's eagle eye and wing / Hath soared to heav'n' (2.15); and by Joseph Hall (the satirist and future bishop of Norwich), in 'To Mr Josuah Sylvester, of his Bartas metaphrased' (7–16):

One while I find her, in her nimble flight,
Cutting the brazen spheres of heaven bright:
Thence, straight she glides, before I be aware,
Through the three regions of the liquid air:
Thence, rushing down, through Nature's closet-door,

6. Lines 137–40 closely follow Ovid, *Met.* 8.203–6.
7. Cf. *Met.* 2.137 (Sun to Phaethon): 'medio tutissimus ibis' (you will travel most safely in the middle region). On the metapoetics of Ovid's Daedalus and Icarus, see Sharrock 1994: ch. 3.
8. On Du Bartas and Lucretius, see Banks 2008: 47–49.
9. Prescott 1978: 208, 209.

She ransacks all her grandame's secret store:
And, diving to the darkness of the deep,
Sees there what wealth the waves in prison keep:
And, what she sees above, below, between,
She shows and sings to others' ears and eyne [eyes].

Soaring is followed by diving, in a natural pairing which goes back to Platonic and biblical models, and which is frequently found in later texts (see ch. 2: 32).

Edmund Spenser, the national poet of English Reformist Protestantism,[10] also takes flight in the tracks of Du Bartas, whose power to elevate he celebrates in his one direct reference, *Ruines of Rome* (1591): 'And after thee [Du Bellay], gins *Bartas* hie to rayse / His heauenly Muse, th' Almightie to adore' (459–60). In *The Teares of the Muses* (also of 1591) Du Bartas's own Muse, Urania, laments that those 'who scorne the school of arts diuine' put out 'th' heauenlie light of knowledge' by which we mount to a vision of the stars and spheres, and of the angels and 'Th' eternall Makers maiestie' itself.[11] Spenser concludes his own career by transporting the reader to the heavens in his *Fowre Hymnes* (1596), which fuse Christian with Platonic and Neoplatonic models of transcendence.[12] The organizing principle of the hymns, as declared in the dedication, presents the last two, 'Of heavenly love' and 'Of heavenly beauty', as the poet's 'retractation', in maturer years, of the first two, 'of earthly or naturall loue and beautie'. Spenser may allude to Urania's epiphany to Du Bartas, in 'L'Uranie', calling him from his youthful poetry on pagan subjects to sing the miracles of Scripture, to prefer the Holy Spirit to Pegasus as a vehicle to the heavens.[13] At one level, the four hymns move from the pagan classical to the Christian: the first two hymn Cupid and Venus, the second two Christ and Sapience. Beyond this simple

10. For an overview of Spenser's religion, with particular attention to *The Shepheardes Calender* and *The Faerie Queene*, see King 2001.

11. See Campbell 1959: 87–88.

12. For a recent re-evaluation of the much discussed topic of Spenser's Platonism, see Borris 2017.

13. Cheney writes (1993: 199), 'In closing his career with divine poetry, Spenser is placing himself solidly within the Augustinian-based Du Bartas movement that influenced late sixteenth-century England.' Cheney cites (after Campbell 1959: 137) Barnabe Barnes (a friend of Gabriel Harvey), *A Divine Centurie of Spirituall Sonnets* 1.1–6: 'No more lewd lays of lighter loves I sing, / Nor teach my lustful Muse abus'd to fly, / With sparrow's plumes and for compassion cry, / To mortal beauties which no succour bring. / But my Muse feathered with an angel's wing, / Divinely mounts aloft unto the sky'). Cheney 1993: 211–23 reads '*Fowre Hymnes* as a "flying tale"'.

dichotomy, what Spenser achieves in the *Fowre Hymnes* is a subsumption, or recontextualization, of the Neoplatonic love and beauty that strongly informs the first two hymns, into the transcendent, Christian, but still strongly sensual, love and beauty of the last two hymns.[14]

Throughout the four hymns there is a recurrent thrust upwards towards the heavens, with repetition of the Platonic motif of the growth of spiritual wings. This starts with the mythological account of the awakening of Love from the original Chaos, in the first hymn in the series, 'An Hymne in Honour of Loue' (64–70):

> And taking to him wings of his owne heate,
> Kindled at first from heauens life-giuing fyre,
> He gan to moue out of his idle seate,
> Weakly at first, but after with desyre
> Lifted aloft, he gan to mount vp hyre,
> And like fresh Eagle, make his hardie flight
> Through all that great wide wast, yet wanting light.

It ends with the final vision of the Beauty of Sapience, lifted up on the wings of contemplation, in 'An Hymne of Heauenly Beautie' (134–40):

> Thence gathering plumes of perfect speculation,
> To impe the wings of thy high flying mynd,
> Mount vp aloft through heauenly contemplation,
> From this darke world, whose damps the soule do blynd,
> And like the natiue brood of Eagles kynd,[15]
> On that bright Sunne of glorie fixe thine eyes,
> Clear'd from grosse mists of fraile infirmities.

This last hymn, 'arguably Spenser's most exalted fiction of sublime transport',[16] begins with a lengthy 'ladder of ascent' through 'contemplation' (22–105), as

14. McCabe 1999: xvii–xviii, 705–7; McCabe 2015: 573–74.

15. In bestiary lore, the eagle was said to test the mettle of its fledglings by making them look directly into the sun; Spenser alludes to another piece of lore, that the aging eagle rejuvenates itself with a bath and then flies upwards, a symbol of rebirth through Christian baptism, in *FQ*, 1.11.34: 'As Eagle fresh out of the Ocean waue, / Where he hath left his plumes all hoary gray, / And deckt himselfe with feathers youthly gay, / Like Eyas hauke vp mounts vnto the skies, / His newly budded pineons to assay, / And marveiles at himselfe, still as he flies: / So new this new-borne knight to battell new did rise.'

16. Cheney 2018: 97.

the soul 'mount[s] aloft by order dew' (24) from the created to the creator, via the sequence: earth; starry sky; heavens above ours; *primum mobile*; empyrean; orders of angels. (On contemplative ascent, see ch. 1: 17–19).

The move in *Fowre Hymnes* from pagan to Christian, from earthly to heavenly, is also a move upwards from unbounded and unsatisfied desire to full possession and closure. The final goal is as yet beyond the grasp of the earthly lover of 'An Hymne in Honour of Loue'. This lover (196–203)

Admires the mirrour of so heauenly light.

Whose image printing in his deepest wit,
He thereon feeds his hungrie fantasy,
Still full, yet neuer satisfyde with it,
Like Tantale, that in store doth sterued ly:
So doth he pine in most satiety,
For nought may quench his infinite desire,
Once kindled through that first conceiued fyre.

He is thus like Tantalus, and also like Ovid's tantalized Narcissus, whose store made him poor (*Met.* 3.466: 'inopem me copia fecit'), but he is also sustained by the hope that the earthly love might carry him up to the heavenly light of which it is a reflection, like the philosophical lover of Plato's *Phaedrus*. By contrast, Neoplatonic and Christian flights of the mind reach a goal, a terminus, even if that goal is itself uncircumscribed and inexpressible in human language: the Neoplatonic One or the Christian God. The last of Spenser's *Fowre Hymnes*, 'Of Heauenly Beautie', reaches a full stop: 'That still as euery thing doth vpward tend, / And further is from earth, so still more cleare / And faire it growes, till to his perfect end / Of purest beautie, it at last ascend' (44–47). The final vision is of the Beauty of Sapience, 'With whose sweete pleasures being so possest, / Thy straying thoughts henceforth for euer rest' (300–301; the last lines of the sequence of four hymns).

In contrast to the *Fowre Hymnes'* ascents of contemplation and love, the ascent to heaven of the Titaness Mutabilitie in the *Cantos of Mutabilitie* is undertaken as a bid for universal empire and in order to realise an aspiration for the honours of divinity. Mutabilitie first climbs up to the circle of the moon (*The Faerie Queene* [*FQ*] 7.6.8), and then to Jove's high palace (23). Her ascent is allusively modelled on two of the standard ancient 'wrong' ways of attempting to reach heaven. Mutabilitie is a daughter of the Titans of old who tried to overthrow Zeus, the new ruler of the universe, and her aspiration to 'rule and

dominion' is an explicit repetition of Titanomachy (2–4). She also replays elements of the story of Phaethon: the shining Palace of the Moon with its personifications of aspects of time is a double of the shining Palace of the Sun to which Phaethon travels at the beginning of Ovid's *Metamorphoses* 2. Mutabilitie threatens to knock the Moon off her chariot, as Phaethon inveigles his father the Sun into letting him take his place in his chariot. The 'lower world', suddenly plunged in darkness by the turmoil in the circle of the moon, 'Fear[s] lest Chaos broken had his chaine, / And brought againe on them eternall night' (6.14). In Ovid, the worldwide conflagration caused by Phaethon's out-of-control chariot-ride makes Earth fear a return to the primeval Chaos (*Met.* 2.298–99).[17] But, swerving from these classical models for wrongful aspirations to the heavens that end in disaster for the aspirants, Spenser resolves the quarrel between Mutabilitie and Jove through a trial held before the God of Nature, in an assembly of the gods. The trial is adjudicated in Jove's favour, yet in a manner that acknowledges that, although Mutabilitie 'all vnworthy were / Of the Heav'ns Rule; yet . . . / In all things else she beares the greatest sway' (*FQ* 7.8.1). The Titanesse Mutabilitie is 'put downe' by Nature (7.59.6), but she cannot be cast down in total defeat, like the Titans of classical antiquity or Phaethon. Her continuing wide sway will only end at the end of Christian time, at the last trump, when 'all shall changed bee [1 Corinthians 15:51], / And from thenceforth none no more change shall see' (*FQ* 7.7.59.4–5). Then (or rather when there is no 'then') 'all things [shall be] firmely stayd / Vpon the pillours of Eternity' (*FQ* 7.8.2).

The previous six books of *The Faerie Queene* are, for the most part, imagined on the horizontal axis, as befits a quest narrative, whereas Milton's *Paradise Lost* will be visualized along the vertical axis, from high to low, with many of its characters, including its narrator, moving up and down (see ch. 4).[18] But the Red Cross Knight's ascent of the Mount of Contemplation (*FQ* 1.10) is a significant vertical moment (anticipating the ascent of contemplation in 'An Hymne of Heauenly Beautie'), with a view upwards of a 'little path' leading up to the 'new Hierusalem', from which the Red Cross Knight, a Protestant Everyman, identified with the patron saint of England, Saint George, sees the likeness of Jacob's Ladder: 'The blessed Angels to and fro descend / From highest

17. For the allusions to the Phaethon story, see Cumming 1931: 243–45; see also *FQ* 5.8.40: the Souldan's out-of-control chariot-horses compared to Phaethon's flight (see Cheney 2018: 80–81).

18. See Hardie 2018: 227–28.

heauen in gladsome companee' (56.2–3).[19] This is the opposite end of the
vertical axis from the descent of Archimago's spright to an infernal House of
Morpheus in the first canto (1.1.36–44).[20] The true hermit, named 'Contemplation', is the antithesis of the false hermit Archimago, a figure for the Roman
Antichrist. The first book of *The Faerie Queene* thus plays out, in the space that
spans heaven and hell, a Christianization of Virgil's emplotment of the *Aeneid*
along the whole length of the vertical axis.

Spenser's heavenly aspiration is also registered in contexts of fame and poetry (see ch. 2: 48). It is at the centre of Patrick Cheney's important discussion
of 'Spenser's famous flight', which argues that 'Spenser relies on the avian sign
of the poet to redefine each of the four genres organizing the New Poet's Orphic career'.[21] That career is launched in *The Shepheardes Calender*. The introductory Epistle for the *Calender* by 'E. K.' declares that eclogues were devised
as means to prepare for 'greater flyght', and that 'our new Poete . . . in time shall
be hable to keepe wing with the best'.[22] In 'October', Piers encourages the
depressed Cuddie to raise his song to epic themes in a flight that spans the
extremes of the horizontal axis: 'There may thy Muse display her fluttryng
wing, / And stretch her selfe at large from East to West' (43–44). After Cuddie's response that the age of Virgil ('the Romish Tityrus'), Maecenas and
Augustus is long past, Piers comes back: 'O pierlesse Poesye, where is then thy
place? / If nor in Princes pallace thou doe sitt / . . . / Then make thee winges
of thine aspyring wit, / And, whence thou camst, flye backe to heauen apace'
(79–80, 83–84). Cuddie again declares himself unfit: 'For Colin fittes such famous flight to scanne: / He, were he not with loue so ill bedight, / Would
mount as high, and sing as soote [sweet] as Swanne' (88–90). But, in the
matter of love and flight, Cuddie is corrected by Piers: 'Ah fon, for loue does

19. Revelation 21:10, for the view from a high mountain of the celestial Jerusalem descending
from heaven. On Jacob's Ladder as an image of contemplative ascent, see ch. 1: 17–18. Cf. the
reference to Jacob's Ladder at *PL* 3.510–11 (Satan's vision): 'The stairs were such as whereon
Jacob saw / Angels ascending and descending': see ch. 4: 186. Spenser's Mount of Contemplation
is discussed by Stevens (1985: 233–45, 'Mountain Vision'), and related to Milton's 'top of speculation'
(*PL* 12.588–89).

20. Like its ultimate model, Ovid's House of Sleep (*Met.* 11.592–615), Spenser's House of
Morpheus is a version of the underworld. In *FQ* 1.5, Duessa in her chariot descends to the original underworld, the House of Pluto.

21. See Cheney 1993: 19, and Cheney 2018: 81–96 on the combination of sublimity and Neoplatonic *furor* in Colin Clout's 'famous flight'.

22. McCabe 1999: 29.

teach him climbe so hie, / And lyftes him vp out of the loathsome myre: / Such immortall mirrhor, as he doth admire, / Would rayse ones mynd aboue the starry skie' (91–94). The background to this exchange is Platonic, and more particularly the account in the *Phaedrus* of the fallen soul's growth of new wings of love on which to fly back to the place above the heavens whence it came (see ch. 2: 33).[23]

Piers's account of poetry and love is vindicated in the next eclogue, 'November', in which Colin's pastoral elegy for Dido, who 'For beauties prayse and pleasaunce had no pere' (94), ascends to gaze on her celestial afterlife in 'heauens hight' (175–79). 'November' is one of the many pastoral elegies modelled ultimately on Virgil's fifth *Eclogue*, in which the dead Daphnis is resurrected and ascends to the heavens (see ch. 2: 65).

Fame, that which the poet can promise his subjects and himself, shares golden wings with heavenly love, so further cementing Spenser's lofty, Platonizing, conception of the poet's role. 'An Hymne of Heauenlie Loue' begins, 'Love, lift me vp vpon thy golden wings, / From this base world vnto thy heauens hight' (1–2). The golden wings are shared with Fame, in the *Ruines of Time* (421–27):[24]

> But fame with golden wings aloft doth flie,
> Aboue the reach of ruinous decay,
> And with braue plumes doth beate the azure skie,
> Admir'd of base-borne men from farre away:
> Then who so will with vertuous deeds assay
> To mount to heauen, on Pegasus[25] must ride,
> And with sweete Poets verse be glorifide.

These words are in the mouth of Verlame, the personification of the vanished Roman city of Verulamium (St Albans). In the context of her despairing complaints at the inexorability of time's decay, this claim for the power of poetry to soar heavenwards and triumph over time has the air of a hyperbolic attempt

23. That the *Phaedrus* is the key Platonic text for an understanding of the *Calender's* treatment of the themes of flight and love is the argument of Borris 2017: ch. 2, 'Spenser's Phaedran *Calender*'; Borris further argues that the carriage drawn by two winged horses, and in which the May King and Queen ride, in the woodcut for 'Maye', alludes to the charioteer-image in the *Phaedrus*.

24. On the connections between love and fame, see Hardie 2012: ch. 9.

25. On Spenser's use of the myth of Pegasus, see Lascelles 1972.

at self-consolation for her fallen greatness, a shoring against the ruins brought about by mutability.[26]

After the disappearance of Verlame, the narrator of the *Ruines of Time* sees a set of visions of 'tragicke Pageants' of the destruction of things beautiful and grand. This is followed by a second set of visions (589–672), in which the transience of earthly things is transcended by the superiority of spiritual to temporal goods, in six emblematic images of the ascent to heaven of the dead poet Sir Philip Sidney. In one of these, the dying Sidney takes flight in the form of a soaring swan, with Virgilian and Horatian models (596–602):

> At last, when all his mourning melodie
> He ended had, that both the shores resounded,
> Feeling the fit that him forewarnd to die,
> With loftie flight aboue the earth he bounded,
> And out of sight to highest heauen mounted:[27]
> Where now he is become an heauenly signe;
> There now the ioy is his, here sorrow mine.

Avian metamorphosis (following in the tracks of Horace in *Odes* 2.20: see ch. 2: 48) leads to catasterism as the constellation of the Swan, in Latin *Cygnus*, whose form is reflected in the English word 'signe'. This is followed by two further catasterisms: stellification is a fitting consummation for Sidney, who took on the *persona* of 'Astrophil' (star-lover) in his *Sonnets* to 'Stella' (star), and, in his *Arcadia*, the pastoral *persona* of 'Philisides', which neatly spells 'star-lover' (Greek *phil-* + Latin *sidus*) out of the first syllables of its author's name, Phil-ip Sid-ney.[28] Sidney's skyward journey is given visual expression in an emblem in Geffrey Whitney's *A Choice of Emblemes* (1586), 'Pennae gloria perennis' (The glory of the pen is everlasting) (Fig. 3.1).[29] Spenser's heaven-ward striving is not the least important aspect of his poetic persona that joins him with Milton, who acknowledged Spenser as his 'original'—and joins him with Milton as a Protestant poet of the sublime, too.[30]

26. See Whittington forthcoming: ch. 5.

27. Cf. *Aen.* 10.193 (Cycnus metamorphosed into a swan): 'linquentem terras et sidera uoce sequentem' (leaving the earth and making for the stars as he sings).

28. For more detailed discussion, see Hardie 2020b: 40–45. On Renaissance stellification, see Fowler 1996: 65–67; see here ch. 2: 62 on the Greco-Roman tradition of catasterism.

29. Whitney 1586: 196–97. The image is taken over from Hadrianus Junius's *Emblemata* (1565) and applied to Sidney.

30. See Cheney 2018.

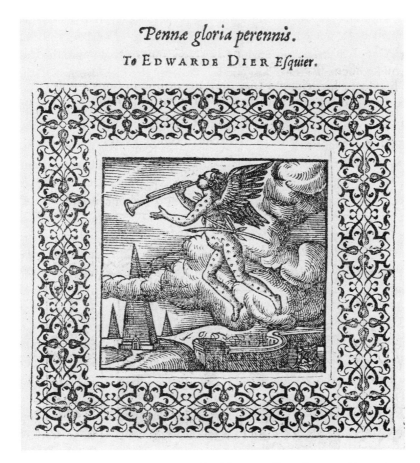

FIGURE 3.1. 'Pennae gloria perennis', emblem in Geffrey Whitney, *A Choice of Emblemes* (Leiden, 1586) 196–97. By permission of the Master and Fellows, Trinity College, Cambridge.

The ascents both of Spenser and of Saluste du Bartas's heavenly Muse, Urania, are echoed in Michael Drayton's *Endimion and Phoebe* (1595), his Neoplatonizing contribution to the genre of the Elizabethan epyllion.[31] Drayton's

31. Text in Donno 1963; commentary in Hebel 1925. Petronella 1984 reads out of the poem a consistent emplotting of three interconnected Neoplatonic themes, the four 'frenzies' (the Platonic *maniai*—'madnesses'—as systematized by Marsilio Ficino), the triad of *emanatio-raptio-remeatio*, and mystical ecstasy. Finney shows beyond reasonable doubt (1924) that Keats drew extensively on Drayton, not least in the romantic poet's accounts of Endymion's celestial

allegorization of the myth of Endymion is perhaps indebted to the version in Buchanan's *De sphaera* (see below: 124–25). Drayton translates the earthy eroticism of Shakespeare's epyllion *Venus and Adonis* (1593) into the chaste love of Endymion for the moon-goddess Phoebe (also identified with Diana). In a reworking of the comedy of errors in *Aeneid* 1, in which Venus appears to her son Aeneas disguised as a Carthaginian virgin huntress, before revealing her identity and her divinity at the end of their interview, Phoebe courts Endymion in the disguise of 'a nymph-like huntress' (159). Her advances are rebuffed by Endymion, who tells her that he is the servant of Phoebe, whom he identifies with the virginal goddess of hunting to whom he has vowed his own virginity (228–30). Despite himself, he falls in love with the disguised Phoebe. She infuses into the soul of the sleeping boy 'The fiery nature of a heavenly Muse' (508), so approximating herself to Du Bartas's Urania, and finally reveals herself as a goddess who is the polar opposite of both Virgil's and Shakespeare's Venus: 'I am no huntress, nor no nymph (quoth she) / As thou perhaps imagin'st me to be, / I am great Phoebe, Latmus' sacred queen' (632–34). Laying his head on her lap, she lifts him up on an aerial voyage, in which he first enjoys the view from above, down on to 'The earth in perfect roundness of a ball' (667), thence travelling through the regions of air and on to the sphere of the moon, from where he sees the planets and understands their astrological relationships with the signs of the zodiac. This is an ascent powered by love, and at the same time an ascent of initiation into 'heavenly secrets' (682). 'And now to him her greatest power she lent, / To lift him to the starry firmament' (719–20), followed by a descent back to earth that retains what has been won through the ascent: 'And having imped the wings of his desire,[32] / And kindled him, with this celestial fire, / She sets him down, and vanishing his sight, / Leaves him enwrapped in this true delight' (731–34). Initiation into the celestial mysteries is also initiation as a poet, and the Muses now follow Endymion wherever he pastures his flock (735ff.). Later, on an appointed day, there follows Phoebe's glorification of Endymion on top of her mountain Latmus. The two ride together, in a 'celestial coach' (880), in a combined Petrarchan Triumph of Love *and* Chastity, appropriately for the goddess of chaste desire and

flight in the company of Phoebe (for another example of Keats's celestial aspirations, see ch. 1: 22–23). See also Fowler 1996: 53–55. Endymion's flight with Phoebe was reused by Drayton in his semi-satirical *The Man in the Moone* (Hebel 1931–41, 2: 574–88).

32. Cf. Spenser, 'Hymne of Heauenly Beautie' 134–40: 'Thence gathering plumes of perfect speculation, / To impe the wings of thy high flying mynd, / Mount vp aloft through heauenly contemplation.'

her chaste lover. The epyllion debouches into numerological celebration of the divine numbers nine and three, which combine pagan and Christian symbolism (e.g., the nine Muses and the nine orders of angels). Finally, Phoebe conveys the sleeping Endymion to a shaded grove, a 'paradise', on top of Mount Latmus, 'Where from her sacred mansion next above, / She might descend and sport her with her love' (985–86). This clear mirroring of Venus's repeated enjoyment of the company of Adonis in Spenser's Garden of Adonis (*FQ* 3.6.46), in a place that leaves the reader not in the heights of a Neoplatonic heaven, but at an intermediate point where the earth meets the sky, is an oddly suspended conclusion to a poem about Neoplatonic transports of the soul. The main narrative ends on a note of deferral and unfinished business: 'Yet as a dream he thought the time not long, / Remaining ever beautiful and ever young, / And what in vision there to him befell, / My weary Muse some other time shall tell' (989–92).[33]

Endymion's celestial aspirations are a figure for Drayton's own ambitions as a poet. This is reinforced in the poem's closing address to Spenser, Samuel Daniel and Thomas Lodge, when Drayton uses the image of 'imping' (a falconry term for engrafting feathers in the wings of a bird for more powerful flight), previously applied to Phoebe's empowerment of Endymion's wings of desire, of his own flights of poetry (addressing Lodge): 'And when my Muse scarce able was to fly, / Did'st imp her wings with thy sweet poesy' (1003–4).

The rebellious attempts to scale the heavens by some of the characters in Christopher Marlowe's plays are easily read as an expression of Marlowe's own overreaching ambitions as a poet. In his classic study of Marlowe the overreacher, Harry Levin comments on the 'vertical scale' of *Doctor Faustus*, whose coordinates are 'nothing less than heaven and hell'.[34] Dr Faustus is introduced as one who has been thrown down by heaven from an Icarian flight, and has now turned to the arts of hell (1616 'B' text, Prologue 15–24, 'Chorus'):

So much he profits in divinity,
That shortly he was graced with Doctor's name,
Excelling all, and sweetly can dispute
In th' heavenly matters of theology.
Till swol'n with cunning of a self-conceit,
His waxen wings did mount above his reach,

33. Another Spenserian touch: cf. the temporary coming to harbour of 'this wearie vessell' at the end of *FQ* book 1, before setting off again 'On the long voyage' (1.12.42).

34. Levin 1961: 133.

And melting, heavens conspired his overthrow.[35]
For falling to a devilish exercise,
And glutted now with learning's golden gifts,
He surfeits upon cursed necromancy.

The Chorus after Scene 7 tells of Faustus's flights in a flying chariot, drawn by dragons like the chariots of Medea or Ceres, to learn the secrets of astronomy and cosmography ('Chorus I', 1–7):

Learned Faustus,
To find the secrets of astronomy,
Graven in the book of Jove's high firmament,
Did mount him up to scale Olympus' top,
Where sitting in a chariot burning bright,
Drawn by the strength of yoked dragons' necks,
He views the clouds, the planets, and the stars[.]

Marlowe's Tamburlaine emulates Phaethon,[36] first using his wild ride through the sky as a figure for his own career of destruction: 'As was the fame of Clymene's brain-sick son / That almost brent the axle-tree of heaven, / So shall our swords, our lances, and our shot / Fill all the air with fiery meteors' (*Tamb.* 1.4.2.49–52). Later he acts out Phaethon's chariot-ride when he enters drawn in his chariot by the kings of Trebizon and Soria: 'The horse that guide the golden eye of heaven, / And blow the morning from their nostrils, / Making their fiery gait above the clouds, / Are not so honoured in their governor / As you, ye slaves, in mighty Tamburlaine' (2.4.3.7–11). The hyperbole is ramped up when Tamburlaine imagines himself riding in triumph as the son of a god greater than the sun, Jupiter himself (2.4.3.125–32):

Then in my coach, like Saturn's royal son
Mounted his shining chariot gilt with fire.
And drawn with princely eagles through the path
Pav'd with bright crystal, and enchas'd with stars

35. On Icarian flights in sixteenth-century French poetry, see Eigeldinger 1973.

36. Levin 1961: 72, comparing the evocation by the chorus of *Gorboduc* (203–8) of Phaethon's sudden descent as the archetypal fate of tragic hero, and Shakespeare's use of the myth in *Richard II* (see below: 122); Phaethon is linked with the defeat of the Spanish Armada in James Aske, *Elizabetha triumphans* (a blank-verse pamphlet), and also in the simile of Phaethon applied to the Souldan, a figure for Philip II, in Spenser, *FQ* 5.8.40 (see n. 17 above). On the Phaethon image in *Tamburlaine*, see Reiss 1980: 116–36.

When all the gods stand gazing at his pomp,
So will I ride through Samarcanda streets,
Until my soul, dissever'd from this flesh,
Shall mount the milk-white way, and meet him there.

In this impersonation of Jupiter, Marlowe may also think of Salmoneus, who sought to simulate the thunder and lightning of Jupiter by shaking a torch as he rode in a chariot drawn by the thunderous hooves of four horses, only to be blasted by the real thunderbolt of Jupiter (Virgil, *Aen.* 6.585–94). In the last scene of the play the dying Tamburlaine uses the example of Phaethon as he advises his own son Amyras on how to guide the chariot of state (*Tamb.* 2.5.3.231–36):

As precious is the charge thou undertak'st
As that which Clymene's brain-sick son did guide,
When wandering Phoebe's ivory cheeks were scorch'd,
And all the earth, like Aetna, breathing fire.
Be warn'd by him, then; learn with awful eye
To sway a throne as dangerous as his.

Should Amyras fail to control 'these proud rebelling jades', he will meet the fate of Hippolytus, another young man whose chariot went out of control, and who was dragged and dismembered by his runaway horses. Tamburlaine aspires to apotheosis, but ascending by the doomed path of Titans or Giants, a path that seems to have fascinated Marlowe the poet.[37]

In the matter of celestial aspirations, Caroline Spurgeon draws a sharp contrast between Marlowe and Shakespeare: 'This imaginative preoccupation with the dazzling heights and vast spaces of the universe is, together with a magnificent surging upward thrust and aspiration, the dominating note of Marlowe's mind. He seems more familiar with the starry courts of heaven than with the green fields of earth, and he loves rather to watch the movements of meteors and planets than to study the faces of men. . . . [Shakespeare's] feet are firmly set upon "this goodly frame, the earth".'[38]

But it would be surprising if Shakespeare did not sometimes draw on this register of 'dazzling heights and vast spaces', and if his characters did not

37. Levin 1961: 69.
38. Spurgeon 1935: 13, 14. She cites Tamburlaine's speech at *Tamb.* 1.2.7.18–25: 'Nature . . . Doth teach us all to have aspiring minds. / Our souls, whose faculties can comprehend / The wondrous architecture of the world / And measure every wandering planet's course, / Still climbing after knowledge infinite, / And always moving as the restless spheres'.

sometimes aspire to measure the vast gap across which the poet's—Shakespeare's—gaze reaches, in Theseus's ironically dismissive words: 'The poet's eye, in a fine frenzy rolling, / Doth glance from heaven to earth, from earth to heaven' (*A Midsummer Night's Dream* 5.1.12–13).

Jonathan Bate traces the trajectory of *Antony and Cleopatra* from our 'dungy earth' to 'infinite space', in the newly emerging sense of 'space' with reference to the physical universe, the vacancy of the heavens. This new sense of space will assume increasing importance as the seventeenth century progresses. At the end of the play, Cleopatra imagines Antony getting to the heavens before her: 'I dreamt there was an Emperor Antony' (5.2.92),[39] an emperor of a new heaven. 'She follows him there in the self-apotheosis in which she imagines herself becoming "fire and air", outstripping Charmian in the race to the empyrean where it will be her "heaven to have" a "kiss" from Antony.'[40] Bate detects here the model of the apotheosis from his funeral pyre of Hercules, the archetypal heroic model for aspirations to celestial divinity, who proudly states in Jasper Heywood's translation of Seneca's *Hercules furens* (1581), 'To spaces hygh I wyll be borne of hawghtye skyes about.'[41]

Ambitions aim high and fall hard in the plays of the 'Henriad'. Richard II fails to live up to the role of a sun-king, and ends up a Phaethon: 'Down, down I come, like glistering Phaëton, / Wanting the manage of unruly jades' (*Richard II* 3.3.179–80).[42] Richard's fall and Bolingbroke's usurpation are matter of regret and resentment for one of Shakespeare's most sublime and hyperbolical heroes, the overreacher Hotspur (Harry Percy), in *1 Henry IV*. In response to the Earl of Worcester's warning of the raging torrent that Hotspur figuratively attempts to cross through his opposition to King Henry IV's demands, and in defence of his own honour, Hotspur 'imagines himself transported: his imagination travels across the horizontal coordinates of "east unto the west", "north to south", and up the vertical coordinate of the moon and down to the ocean-bottom'[43] (1.3.197–211):

39. Quotations from Shakespeare are from the RSC Shakespeare (2007).

40. Bate 2019: 221.

41. Antony's Herculean pretensions go back to Plutarch: see Pelling 1988: 123–24. On the Herculean hero in early modern English drama, see Waith 1962.

42. On the sun-king analogy in *Richard II*, see Heninger 1960; on the use of the allegory of Phaethon in this and other Shakespearian plays, see Merrix 1987.

43. Cheney 2018: 176, in the course of a revelatory discussion of the Shakespearean sublime.

HOTSPUR If he fall in, good night! or sink or swim:
 Send danger from the east unto the west,
 So honour cross it from the north to south,
 And let them grapple: O, the blood more stirs
 To rouse a lion than to start a hare!
NORTHUMBERLAND Imagination of some great exploit
 Drives him beyond the bounds of patience.
HOTSPUR By heaven, methinks it were an easy leap,
 To pluck bright honour from the pale-faced moon,
 Or dive into the bottom of the deep,
 Where fathom-line could never touch the ground,
 And pluck up drowned honour by the locks;
 So he that doth redeem her thence might wear
 Without corrival, all her dignities:
 But out upon this half-faced fellowship!

Hotspur's sense of his honour expands to fill the horizontal and vertical axes, as does Odysseus's foundational assertion of the reach of his own fame at *Odyssey* 9.19–20 (see ch. 2: 52). But Hotspur's imagination reaches still further on the vertical axis, not just up to the moon in the heavens, but down to the bottom of the unfathomable deep, in an example of the common pairing of soaring and diving (see ch. 2: 32; ch. 5: 218).[44]

Cosmic Voyaging and the New Science

The yoking of Christian and classical that we find in, for example, both Du Bartas's and Spenser's flights, is typical of much of the varied production of poetic flights to heaven in the seventeenth and eighteenth centuries. To the binary of classical and Christian should be added a third term, 'scientific'. A number of the foundational classical examples of flights of the mind are from works on natural philosophy, or science: Epicurus's odyssey through the infinite void in Lucretius, Manilius's sky-wandering exposition of astronomy and astrology and the astronomical content of Cicero's *Dream of Scipio*.

Du Bartas's cosmic voyaging in the *Premiere Sepmaine* comes towards the end of a relatively brief period, c. 1555–85, that saw a vogue for fully developed

44. For a subtle reading of the hyperbolical imagery in the context of Hotspur's characterization, and with reference to the rhetorical theory of hyperbole, see Ettenhuber 2007: 201–3.

narratives of cosmic voyages in French scientific and philosophical verse.[45] It was also in the 1550s that the Scottish George Buchanan (1506–82), tutor to James VI of Scotland and one of the greatest neo-Latin writers, began his didactic poem on cosmology and astronomy, the *De sphaera* (published 1586), which draws on a range of the topics and vocabulary of flights of the scientific mind in the classical hexameter poetry of Lucretius, Virgil, Ovid and Manilius.[46] Buchanan declares that man, confined in earthly limbs to inhabit the earth, may yet fly on high with the wings of his erect mind to view the flaming walls of his native heavens (1.73–77). It is a mark of the divine image in man that his heaven-given mind is able both to fly above the summit of the boundless sky, and to penetrate (*penetrare*) the hollow bowels of the depths of the earth (2.297–302). The poet invites his young addressee, Timoleon (the son of the Maréchal de Brissac), to 'forget your lowly cares, lift your mind up a little, and walk with me through the vast spheres of the sky' (oblitusque humiles curas, paullum erige mentem, / et mecum ingentes coeli spatiare per orbes) (1.518–19; *spatiare* is repeated at 2.4). At the beginning of book 3, Timoleon has already wandered far and wide, 'expatiated' ('late exspatiatus') (3.1) in the sky.[47] Timoleon will have no need of the waxen wings of Daedalus, or of Medea's chariot drawn by flying serpents; nor will he need to pile Pelion on Ossa to reach the stars. With the poet as guide, his mental vision will raise itself from the ground ('tollit humo sese')[48] and penetrate the vastness of the starry skies (2.1–28). Book 1 ends with an extended example of the Ciceronian,

45. See Ridgely 1963: the main texts are Jacques Peletier du Mans, *L'Amour des amours* (1555); Jean-Antoine de Baïf, *Le Premier des meteors* (1567); Edouard du Monin, *Uranologie* (1583); and Joseph du Chesne, sieur de la Violette, *La Morocosmie* (1583). At one point, du Monin paraphrases lines from the prologue of book 2 of Buchanan's *De sphaera*. See Ridgely 1963: 149 n. 22 for examples of the flight of the philosopher-poet's mind, escaping from the prison of the body, in Ronsard: e.g., the beginnings of 'Hymne de la philosophie' (1555) 21–30; 'Hymne des astres' (1555) 1–10, looking down on the clouds and stepping on the hoary shoulders of Atlas; 'L'Excellence de l'esprit de l'homme' (1559). Cf. Poliziano, *Nutricia* 34–39, for the power of the human mind to traverse and penetrate the secrets of nature (although this is not developed as a fully fledged flight of the mind); ibid. 21–22: 'the august art of poetry that carries off human minds with her to the secret recesses of the starry heavens' (humanas augusta Poetica mentes / siderei rapiens secum in penetralia caeli). See also Pantin 1995: 74–80, 'Voyages et visions célestes', with examples in Ronsard and Rabelais (75 n. 11 for further bibliography). I have not seen Keller 1974.

46. Modern edition: Naiden 1952; on Buchanan's use of classical Latin poetry, see Gee 2009.

47. On the history of *spatiari*, *exspatiari* (expatiate) in flights of the mind, see ch. 2: 41, 82.

48. Cf. Virgil, *Geo.* 3.8–9: 'temptanda uia est, qua me quoque possim / tollere humo': see ch. 2: 68.

Senecan and Boethian vanity-topos of the view from above down on the earth (see ch. 2: 53–58): if Phoebus the sun-god were to grant you control for a day of the reins that Phaethon could not control, the earth would appear no larger than a point (*punctum*) or an Epicurean atom. A selection of the lines from this epilogue is cited under the world map (*Orbis terrae compendiosa descriptio*) in Mercator's *Atlas* of 1595, tempering the pride of the map-maker in his geographical mastery with a call to the reader to reflect on the temporary nature of his dwelling-place on earth, and the need to draw forth the soul to higher and eternal things.[49]

Buchanan is no Lucretian materialist, and these mental wanderings through (*peragrare*) the skies serve to reinforce a conviction of God's providential creation of the universe (as well as to support the Ptolemaic against the Copernican system), so anticipating the 'physico-theological' poetry of the eighteenth century (see ch. 1: 7–8; ch. 5: 218). Book 5 opens with an adaptation of Lucretius's account of Epicurus's flight of the mind, and his penetration of the secrets of nature, resulting in the enduring flight of the heroes of astronomy on the wings of fame: 'But, far from the sluggish shadows of the dark underworld, glory will lift them on high and set them in the shining light, and on her swift wings will carry them through the centuries to come' (sed procul obscuri tenebris ab inertibus Orci / gloria sublimes illustri in luce reponet, / praepetibusque uehet per postera saecula pennis) (18–20).[50] The mythical Endymion, who rejects the attentions of nymphs in his infatuated devotion to the moon/Diana, turns into an astronomer when Diana comes down to earth to reciprocate his passion, and then takes him up to the heavens in her chariot to show him 'the secret recesses of her kingdom, unknown to mankind' (non nota homini penetralia regni / . . . sui) (5.179–80).[51]

49. Ramachandran 2015: 57–59. Earlier, Abraham Ortelius had used as a caption for the planisphere at the front of the 1579 edition of his *Theatrum orbis terrarum*, the first systematic atlas of the whole globe, a quotation from a Senecan example of the view of the earth from above: 'This is that pin-point that is divided with fire and sword between so many peoples! How laughable are the boundaries set by mortals!' (hoc est illud punctum quod inter tot gentes ferro et igne diuiditur! o quam ridiculi sunt mortalium termini!) (Seneca, *Nat. Quaest.* 1 *praef.* 8). In the conceit of the prefatory verses by Adophus Mekerchus to the first edition of 1570, Ortelius is taken aloft in the chariot of Apollo (the Sun), to whose vision of all the lands of the earth he is privy: see Cosgrove 2001: 2–3, 130–31.

50. The Lucretian echoes are discussed at Gee 2009: 36–41.

51. Buchanan very likely draws on the euhemeristic account of Endymion as the heroic astronomer in book 2 of the *De rebus coelestibus* of Lorenzo Bonincontri (1410–91), where

If Buchanan's cosmic expatiations do not burst the safe limits of Christian orthodoxy, the same is not true of the philosopher, cosmologist, Hermetic occultist and heretic Giordano Bruno (1548–1600), who is much given to enthusiastic philosophical flights of the mind or soul.[52] His *De gli eroici furori* (1585), written while he was in England, and dedicated to Sir Philip Sidney, uses the Platonic image of the wings of the soul, powering the flight of the *eroico furioso*, in contrast to a fall into matter symbolized by the beasts of Circe.[53]

The beginning of Giordano Bruno's *De immenso* (1591) combines Epicurus's flight of the mind in book 1 of Lucretius's *On the Nature of Things* with the revelation of the nature of things in the proem to book 3. Bruno breaks out of the prison-house of the finite Aristotelian universe into the freedom of infinite space, which he was indeed the first modern to conceptualize (*De immenso* 1.1–5, 10–14, 23–25):

> Est mens, quae uegeto inspirauit pectora sensu,
> quamque iuuat uolucres humeris ingignere plumas,
> corque ad praescriptam celso rapere ordine metam:
> unde et Fortunam licet et contemnere mortem;
> arcanaeque patent portae, abruptaeque catenae
>
> . . .
>
> intrepidus spacium immensum sic findere pennis
> exorior, neque fama facit me impingere in orbes,
> quos falso statuit uerus de principio error,
> ut sub conficto reprimamur carcere uere,
> tanquam adamanteis cludatur moenibu' totum
>
> . . .
>
> adque alios mundo ex isto dum adsurgo nitentes,

Endymion first opens up the paths on which his goddess the Moon travels: 'hic mundi moenia primus / transsiluit, magnumque deae penetrauit ad orbem . . . haec uia sublimes animos ad sidera uexit' (He first leaped across the walls of the world, and reached the sphere of the goddess . . . This is the path that carried spirits aloft to the stars.) See Haskell 1998: 508–14 on Endymion in Bonincontri and Buchanan.

52. See Sabbatino 2004: ch. 5, "'A l'infinito m'ergo'. La poesia di Bruno e il volo del moderno Ulisse'.

53. There has been much discussion of the extent of Bruno's influence on Sidney and other English poets: Frances Yates's (1936; 1943) contention of Bruno's profound influence on English poetry has been challenged by Pellegrini 1943 and Clucas 1990; see also Warnlof 1973. On Thomas Carew's use of Bruno's *Lo spaccio della bestia trionfante* (also dedicated to Philip Sidney) in his masque *Coelum Britannicum* (1634), see ch. 6: 279.

aethereum campumque ex omni parte pererro,
attonitis mirum et distans post terga relinquo.[54]

(There is the [world-]mind, which has inspired our breasts with lively sense, and which delights to plant swift wings on our shoulders, and to ravish our hearts on a lofty path to their pre-ordained goal, from which they can despise Fortune and death. The secret gates lie open, and our chains are shattered. . . . Thus, undaunted, I set out to cleave the immensity of space on my wings, and false report does not make me strike against those spheres which true error has established on false premises, so that truly we are confined in a fabricated prison, as if the universe were shut in by adamantine walls . . . and while I rise from this world to other shining worlds, I wander through all parts of the fields of heaven, leaving far behind me amazement and wonder.)

A range of other sixteenth-century Italian didactic poems in Latin also take philosophical flight in the Lucretian manner.[55] One neo-Latin text that was particularly well known in England, because it was widely taught in the early years of grammar school, both in Latin and in the English translation by Barnaby Googe (full text published in 1565), is Palingenius's moralizing didactic-epic poem *Zodiacus uitae* (which had appeared in Italy in the 1530s). In twelve books, named after the signs of the zodiac, the poem is structured as an ascent from earthly moral darkness to supra-celestial light, with a series of views from above.[56] In the opening invocation to Apollo, the poet announces that, if the god is favourable, 'I will journey to the stars, and my inspired mind will gaze on the gods on high'. In book 7 (*Libra*), the poet turns to the lofty themes of god and the immortality of the soul, and he begins by invoking the Muse to 'rise and fly on stronger wings; make for the heights, and now at last look down on lowly concerns' (surge et melioribus utere pennis: /alta pete atque humiles iamdudum despice curas) (7.1–2).

54. Bruno 1879–91, 1: 1.201–2, discussed by Haskell at 2017: 23–24.

55. See the various articles by Yasmin Haskell: 1998a, 1998b, 1999. Haskell 2016: 119 poses the question, 'So why Lucretius? Rather than a fund of (dangerous) ideas either to be refuted or endorsed, the Roman *vates* seems to represent for these poets, first and foremost, the enabling genius for taking philosophical *flight* in verse. . . . The philosophical flights of the Cinquecento Lucretian poets range from cautious Christian raptures (Paleario and Parisetti) through to bold spiritual and cosmological thought experiments (Palingenius and Bruno).'

56. Text: Chomarat 1996; on the reception of Palingenius in early modern England, and by Shakespeare, see Gillespie 2001: 407–10.

Robert Burton draws on this imagery in 'A Digression of the Air', a section of *The Anatomy of Melancholy* that contains a rapid survey of contemporary cosmological theories. Burton soars like the 'long-winged hawk': 'having come . . . into these ample fields of air, wherein I may freely expatiate and exercise myself, for my recreation, awhile rove, wander round about the world, mount aloft to those ethereal orbs and celestial spheres, and so descend to my former elements again'.[57] In his progress he will perhaps meet Lucian's Icaromenippus (see ch. 2: 100). Soaring is followed by diving, as Burton then descends into the bowels of earth, like Orpheus, Ulysses, Hercules and Lucian's Menippus.[58]

With the discoveries and theories of Copernicus, Kepler and Galileo, the astronomy of classical antiquity is decisively superseded, and early modern culture and literature respond inventively to the new science.[59] In her classic study *Voyages to the Moon*, Marjorie Hope Nicolson charts what she describes as the 'sudden emergence into popularity of the theme of cosmic flight in the 1630's'.[60] To explain this, she claims, we should turn from literary history to the history of science.

The new astronomy was certainly in the news: Ben Jonson, that most classicizing of early seventeenth-century English writers, had picked up very quickly on the latest scientific developments in his masque *Love Freed from Folly and Ignorance*, performed on 3 February 1611, a few months after news of Galileo's *Sidereus nuncius*, 'Starry Messenger', reached England. Jonson makes more extensive use of the fashionable new astronomy in his masque *News from the New World Discovered in the Moon* (7 January 1620),[61] and in his play *The Staple of News*.

In the same year as Jonson's *Love Freed*, 1611, John Donne took aim at the new science in his anti-Jesuit satire *Ignatius His Conclave*. The narrative is presented in the form of a vision, in which 'I was in an ecstasy, and "My little wandering sportful soul, guest and companion of my body"[62] had liberty to wander through all places, and to survey and reckon all the rooms, and all the volumes of the heavens'. Copernicus is one of the 'Innovators' who makes an appearance in hell, where Ignatius Loyola awaits his trial. After Ignatius has

57. Burton 1989–2000, 2: 33 (Part 2, sect. 2, memb. 3, subsec. 1) (the copy edition is 1632).
58. Ibid. 38. See Barlow 1973.
59. E.g., Reeves 2014.
60. Nicolson 1948: 21.
61. See James Knowles's 'Introduction' to *News from the New World* in Jonson 2012, 5: 425–28.
62. The emperor Hadrian's 'animula uagula blanda'.

been condemned, Lucifer wonders what to do with him, and comes up with the following idea:

> But since I may neither forsake this kingdom, nor divide it, this only rem-
> edy is left: I will write to the Bishop of Rome: he shall call Galileo the
> Florentine to him; who by this time hath throughly instructed himself of
> all the hills, woods, and cities in the new world, the Moon. And since he
> effected so much with his first glasses, that he saw the Moon, in so near a
> distance, that he gave himself satisfaction of all, and the least parts in her,
> when now being grown to more perfection in his art, he shall have made
> new glasses, and they received a hallowing from the Pope, he may draw the
> Moon, like a boat floating upon the water, as near the earth as he will. And
> thither (because they ever claim that those employments of discovery be-
> long to them) shall all the Jesuits be transferred, and easily unite and rec-
> oncile the Lunatic Church to the Roman Church; without doubt, after the
> Jesuits have been there a little while, there will soon grow naturally a hell in
> that world also: over which, you Ignatius shall have dominion, and establish
> your kingdom and dwelling there. And with the same ease as you pass from
> the earth to the moon, you may pass from the moon to the other stars,
> which are also thought to be worlds, and so you may beget and propagate
> many hells, and enlarge your empire, and come nearer unto that high seat,
> which I left at first.[63]

Galileo's discoveries of lunar features through his telescope, intellectual con-
quests, in fantasy now become a vehicle for the imperialist expansion of Jesuit
pretensions. This is envisaged as an ascent of the celestial heights from which
Lucifer had been cast down, and which will now be colonized with new hells,
forming a kind of ladder by which to climb to Lucifer's original 'high seat'. Donne
may also draw on a work of fiction by another of the revolutionary astronomers
of the period, the *Somnium* by Kepler, in which the hero Duracotus, a thinly
veiled figure of Kepler himself, travels to the moon with the aid of his mother,
who is in league with the spirits of the moon. Kepler's science-fiction fantasy is
in the tradition of Lucianic cosmic voyages (see ch. 2: 99–102), to which Donne
also alludes in *Ignatius*, within the frame of another Lucianic genre, 'Dialogues
of the Dead': that is, interviews in the underworld with dead people.[64]

63. Healy 1969: 81.

64. Nicolson 1948: 41–47 (on Kepler's *Somnium*), 49–52 (on Donne's *Ignatius His Conclave*).
Written in 1608, Kepler's *Somnium* was not published until 1634; Nicolson conjectures that

Donne satirizes the new astronomers, as well as the Jesuits. His attitude to the new science has been the subject of considerable debate. In his reading of *Ignatius*, R. Chris Hassel argues that 'Donne employs the astronomers' discoveries and the frequent disillusionment they occasioned among his contemporaries to demonstrate the futility of searching for truth when human reason is unaccompanied by faith'.[65] Hassel sees in this respect a continuity between *Ignatius*, of 1611, and 'The First Anniversary' and 'The Second Anniversary', written in 1611–12, the three works together constituting 'three steps in the process of confronting, evaluating, and dismissing consciousness'.[66]

'The First Anniversary'—'An Anatomy of the World'—anatomizes the dead body of the world now that Elizabeth Drury has left it. One manifestation of the decay and frailty of the world is the observation that 'new philosophy calls all in doubt' (205), introducing a (perhaps too) famous section that concludes ''Tis all in pieces, all coherence gone, / All just supply, and all relatïon' (213–14). Yet if this is a serious statement of the loss of certainty and order consequent on the new philosophy, it is odd that at the same time it is a symptom of the decay of the world in response to the death of Elizabeth Drury. One response has been to say that Donne did not take the new science at all seriously for itself, although he was certainly curious about its novelties, which he used for his own poetic and figurative purposes. In 'The Second Anniversary' ('Of the Progress of the Soul'), the soul of Elizabeth Drury is allowed no time to test a potential interest in astronomy as it shoots upwards from her deathbed to the presence of God, in another famous passage (179–218):[67]

> But think that death hath now enfranchised thee:
> Thou hast thy expansion now, and liberty.
> Think that a rusty piece discharged is flown

Donne may have had access to a manuscript text of the *Somnium*. On Kepler and his mother, see Rublack 2015: ch. 13, 'Kepler's Dream'. Brown thinks (2009: 55), with Healy, that it is unlikely that Donne had seen the *Somnium*, but that he draws rather on Kepler's *De stella nova*.

65. Hassel 1971: 329; see also Brown 2009.

66. Hassel 1971: 337.

67. Manley 1963, on 2.184–218, compares Donne, *Sermons* 7.71: 'my soul, as soon as it is out of my body is in heaven, and does not stay for the possession of heaven . . . till it be ascended through air, and fire, and moon, and sun and planets, and firmament, to that place which we conceive to be heaven, but without the thousandth part of a minute's stop, as soon as it issues, is in a glorious light, which is heaven'.

In pieces, and the bullet is his own,
And freely flies. This to thy soul allow:
Think thy shell broke, think thy soul hatched but now,
And think this slow-paced soul, which late did cleave
T' a body, and went but by the body's leave
Twenty perchance or thirty mile a day,
Dispatches in a minute all the way
'Twixt Heav'n and Earth: she stays not in the air,
To look what meteors there themselves prepare;
She carries no desire to know nor sense
Whether th' air's middle region be intense;
For th' element of fire, she doth not know,
Whether she passed by such a place or no;
She baits not at the Moon, nor cares to try
Whether in that new world men live, and die;
Venus retards her not, t' enquire how she
Can (being one star) Hesper and Vesper be;
He that charmed Argus' eyes, sweet Mercury,
Works not on her, who now is grown all eye;
Who if she meet the body of the Sun
Goes through, not staying till his course be run;
Who finds in Mars his camp no corps of guard,
Nor is by Jove, nor by his father barred;
But ere she can consider how she went,
At once is at and through the firmament.
And as these stars were but so many beads
Strung on one string, speed undistinguished leads
Her through those spheres as through the beads, a string,
Whose quick succession makes it still one thing:
As doth the pith, which, lest our bodies slack,
Strings fast the little bones of neck and back;
So by the soul doth death string Heaven and Earth,
For when our soul enjoys this her third birth,
(Creation gave her one, a second, grace)
Heaven is as near and present to her face,
As colours are and objects in a room
Where darkness was before, when tapers come.

Her soul is freed from the body, following both classical (Platonic) and biblical notions of its enslavement in the flesh.[68] This freedom is felt, as the flight of the mind or soul often is, as a spatial enablement, an 'expansion'.[69] Matthew Arnold will note that '[t]he love of liberty is simply the instinct in man for expansion'.[70] Elizabeth Drury's soul flies up, unrestrained, through the planetary spheres, like the soul of Theodosius in Claudian's *On the Third Consulship of Honorius* (see ch. 2: 98), but unlike, for example, Dante in his ascent through the planets in *Paradiso*, she has neither the desire (191: 'She carries no desire to know'), nor the time, to acquire knowledge about the secrets of the universe.[71] This flight of the soul is also one that the poet must undertake (219: 'This must, my soul, thy long-short progress be'), prospectively at the time of the parting of his own soul from his body, and immediately in his tracking, in imagination and through a flight of the mind, of the progress of Elizabeth Drury's soul in 'The Second Anniversary'. The implication is perhaps that Donne himself will not be much bothered about the secrets of astronomy.

Commentators compare, to the meteoric ascent of Elizabeth Drury's soul in 'The Second Anniversary', the easy and rapid ascent of the soul of Matilius in Seneca's *Consolation to Marcia* (see ch. 2: 59–60). Dying young (like Elizabeth Drury, who was dead at the age of fourteen), his soul has not had time to

68. Classical: see ch. 2: 40–42; biblical: Romans 8:21: 'Because the creature itself also shall be delivered from the bondage of corruption into the glorious liberty of the children of God'.

69. For an imitation of Donne, in which the poet at first is unable to follow the expansive soaring of the soul of the dead person, see William Habington, *The Funerals* (elegies for George Talbot, d. 1635), 'Elegy 3': 'Let me contemplate thee (fair soul) and though / I cannot track the way, which thou didst go / In thy celestial journey; and my heart / Expansion wants, to think what now thou art / How bright and wide thy glories' (text: Allott 1948). For the expansion of a scientific flight of the mind, see Henry Power, *Experimental Philosophy* (1664), 'Conclusion': 'you are the enlarged and elastical souls of the world, who . . . do make way for the springy intellect to fly out into its desired expansion' (cited in Nicolson 1950: 179–80).

70. Arnold 1879: 7.

71. Contrast Ronsard, *L'Hymne triumphal sur le trepas de Marguerite de Valois*, in which the soul of the dead queen undergoes catasterism and mounts to a point in the heavens whence the view from above allows the 'sainct Astre Navarrois' to understand a catalogue of natural questions. In one of the many English versions of Sarbiewski's flight of the mind, *Odes* 2.5 (see below: 138–39), the hymn-writer Anne Steele ('Theodosia') (1717–78) dismisses the scientist's interest in the 'lambent glories' of the skies, preferring the flight of faith to the presence of Jesus: 'Let the sons of science rove / Through the boundless fields of space, / And amazing wonders trace; / Bright worlds beyond those starry flames, / My nobler curiosity inspire' ('The Elevation' 9–13; in Fordoński and Urbański 2008: 193–96).

become weighed down by the dregs of human flesh. For such souls, the journey to the heavens is very easy. Given their freedom, they are lighter as they fly back to their origin (23.1: 'liberati leuiores ad originem suam reuolant'). Such souls chafe at the narrow constriction of the body (23.2: 'aegre has angustias ferunt'), eager, one could say, for 'expansion'. But when Matilius joins the blessed souls above, he does receive astronomy lessons from his grandfather, the martyred historian Cremutius Cordus, who initiates him into the secrets of nature (25.2: 'arcana naturae'). An interest in such knowledge is reintroduced from Donne's Senecan model in some of the imitations of Donne's 'Anniversaries':[72] for example, Ben Jonson's 'Elegie on the Lady Jane Pawlet' (1631), whose spirit is called home by angels 'to her original' (64); 'where her mortality / Became her birthday to eternity. / And now, through circumfused light, she looks / On nature's secrets, there, as her own books' (67–70).

John Donne's godson George Herbert applies Donne's image of the soul 'stringing' the spheres, like beads on a string, to the penetrating and swiftly travelling mind of the astronomer, but in a poem which points up the vanity of a human inquisitiveness that searches out everything except God, 'Vanity (1)' (1–7):

The fleet astronomer can bore
And thread the spheres with his quick-piercing mind:
He views their stations, walks from door to door,
Surveys, as if he had designed
To make a purchase there: he sees their dances,
And knoweth long before,
Both their full-eyed aspects, and secret glances.

God is the sole aim of the fervid flights of the soul in Edward Benlowes's *Theophila, or, Loves Sacrifice* (1652), composed during the Civil War by a royalist, who was 'naturally disposed toward serenity and quietness and . . . tried to remain aloof from the conflict that surrounded him'.[73] *Theophila* is 'among the poems of its time most given to levitation',[74] an unstoppable upwards surge that is recognized in the plethora of commendatory poems. William Davenant's appreciation of the heavenly flight on which *Theophila* takes the reader was perhaps heightened by the address from which he dates his 'To the author,

72. On which see Lewalski 1973: ch. 9.
73. P. G. Stanwood, *ODNB* article on Benlowes.
74. Prescott 1978: 213 (text: Saintsbury 1905).

upon his divine poem': 'TOWER [of London], May 13, 1652'. The poet himself, addressing his 'Fancy' in an introductory poem, bids her fly from earthly beauty, with its 'Darts, wing'd with fire', and rather 'Thy pinions raise with mystic fire', on a flight (of fancy) towards, rather than a flight (of escape) from earthly things. Theophila ('lover of God') tells her soul 'with love-plumes soar . . . to meet thy Spouse' ('Theophila's Love-Song', canto 4.59, 60). Benlowes acknowledges his debt to 'Noble du-Bartas . . . high-flown Trance' (3.2), and there are traces of Spenser's *Fowre Hymnes*. The progress of Elizabeth Drury's soul in Donne's 'Second Anniversary' is imitated in the poet's nocturnal vision of the 'glorified Theophila', who narrates her own 'progress', when 'Loosed from Nature's chain, / And quit from clay, I did attain, / Swift as a glancing meteor to th' aerial plain' (5.42). Theophila's soul shoots upwards through the lower air, and then through the celestial spheres and the *primum mobile*, to arrive at 'Heav'n's suburbs', with a glimpse of the purely spiritual, immaterial and immense 'Heav'n of God', inaccessible to mankind before death. 'Ocean of Joys! Who can thee fully state? / For clearer knowledge man must wait; / First shoot Death's Gulf, thy soul may then arrive thereat' (5.64). On the way up Theophila, like Elizabeth Drury, shows little interest in natural-philosophical questions:[75] 'I spare t' unlock those treasuries of snow; / Or tell what paints the rainy bow; / Or what cause thunders, lightnings, rains; or whence winds flow' (ibid.), although she does vouchsafe some curious facts, telling the poet for example that the sun 'eight-score times outbulks the earth; whose race / In four and twenty hours' space / 'Bove fifty millions of Germanic leagues does pace' (5: 49). Benlowes's *Theophila* has much in common with Joseph Beaumont's *Psyche, or, Loves Mysterie* (1648, 1652: see ch. 2: 35): Beaumont lived close to Benlowes, and the two men may have known each other.

A more harmonious cohabitation of the scientific and the religious imaginations characterizes the poetry of Thomas Traherne (1637–74). In her classic study *The Breaking of the Circle* (1950), Marjorie Hope Nicolson charts the effects on seventeenth-century poetry of the rediscovery and validation of Lucretius's exultant advocacy of the infinity of the Epicurean universe, and of the infinity of the worlds contained within it, consequent on 'the breaking of the circle of perfection' of pre-modern (non-Epicurean) models of the cosmos, through the discoveries and teachings of the new astronomy. For Nicolson, Thomas Traherne is 'the seventeenth-century climax of the poets

75. Drawing on the natural questions that the Lord poses to Job in Job 38; with 'treasuries of snow': cf. Job 38:22: 'thesauros niuis'.

of "aspiration".[76] Infinity is one of Traherne's key themes, but, in contrast to the infinity of the Epicurean material universe, this is the infinity of God and His creation, and the corresponding infinite capacity of the human soul to expand into and comprehend the infinity of divinity.[77] 'My soul a spirit infinite! / An image of the deity' ('My Spirit' 71–72): the godlikeness of man's infinite spirit paradoxically allows the satisfaction of infinite wants. 'You must Want like a GOD, that you may be Satisfied like GOD' (*Centuries of Meditations* 1.44). Traherne exultantly praises God 'For giving me desire, / An eager thirst, a burning ardent fire' ('Desire' 1–2). What he experienced at first as a 'restless longing heavenly avarice, / That never could be satisfied' (8–9)[78] is followed by the revelation of a heavenly love: 'O love! ye amities, / And friendships, that appear above the skies!' (40–41); and the realization of 'Ye high delights; / That satisfy all appetites!' (43–44). The restless heavenly avarice is revalued as 'This soaring sacred thirst, / Ambassador of bliss' (53–54). This contrast between an insatiable lower kind of desire, and a satiable higher kind, is comparable to the contrasts between the movements of the desiring soul in Spenser's 'An Hymne in Honour of Loue' and 'An Hymne of Heauenly Beautie' (see above: 112).

The 'quick and pure' soul enjoys omnipresence, which Traherne often expresses dynamically through the image of the flight of the mind, as in 'Nature', where he speaks of his secret self, his spirit, going ever 'beyond' (29–32; 71–74):

> It did encompass, and possess rare things,
> But yet felt more, and on its angel's wings
> Pierc'd through the skies immediately, and sought
> For all that could beyond all worlds be thought.
>
> But yet there were new rooms, and spaces more,
> Beyond all these, wide regions ore and ore,

76. Nicolson 1950: 173; on Traherne and the motif of ascent, see also Stewart 1970: 99–100. More recently on Traherne in his contemporary contexts, see Dodd and Gorman 2016.

77. On Traherne and infinity, see Colie 1957.

78. Cf. *Christian Ethicks* (London, 1675: 93): 'It is the glory of man, that his avarice is insatiable, and his ambition infinite, that his appetite carries him to innumerable pleasures, and that his curiosity is so endless, that were he monarch of the world, it could not satisfy his soul, but he would be curiously inquisitive into the original and end of things, and be concerned in the nature of those that are beyond the heavens. For having met with an infinite benefactor, he would not be fit for his bounty, could any finite object satisfy his desire.'

And into them my pent-up-soul like fire
Did break, surmounting all I here admire.

These are spiritual new worlds, but with a contemporary resonance in the age
of the new worlds being opened up by the advances of astronomy.

In keeping with a much older tradition, Traherne experiences these flights
of the spirit into the infinite as liberation from the narrow confines of the body,
in 'Thoughts. 1', (9–12, 61–72):

That ye are pent within my breast,
Yet rove at large from east to west,
And are invisible, yet infinite;
Is my transcendent, and my best delight.
. . .
The eye's confined, the body's pent
In narrow room: limbs are of small extent.
But thoughts are always free.
And as they're best,
So can they even in the breast,
Rove o'er the world with liberty:
Can enter ages, present be
In any kingdom, into bosoms see.
Thoughts can come to things, and view,
What bodies can't approach unto.
They know no bar, denial, limit, wall:
But have a liberty to look on all.

The infinity of God is 'the amplitude that enlargeth[79] us, and the field wherein
our thoughts expatiate without limit or restraint' (*Centuries of Meditations* 5.2).

Traherne also draws on older traditions in revaluing pagan fictions in the
context of divine love, in the sensuous imagery of 'Love' (25–35):

Why all power
Is used here
Joys down from heaven on my head to shower
And Jove beyond the fiction doth appear
Once more in golden rain to come
To Danae's pleasing fruitful womb.

79. Punning on two senses of 'enlarge': *OED* 1 'To render more spacious or extensive'; 6a
'To set at large; to release from confinement or bondage'.

His Ganymede! His life! His joy!
Or He comes down to me, or takes me up
 That I might be His boy,
And fill, and taste, and give, and drink the cup.[80]

Abraham Cowley and Casimire Sarbiewski

In the seventeenth century, classical models sit easily enough side by side with the impulses of the new astronomy. Nicolson repeats her call for a more decisive turn from literary history to the history of science with reference to Abraham Cowley: 'The change from an older to a newer kind of celestial voyage in poetry may be seen by comparing two of Cowley's poems. 'His "Dream of Elysium" is still entirely in the old tradition; the poet, rising on his "winged Pegasus" flies to an Elysium such as Cowley had found in many of the classical writers. In his "Exstasy", however, the poet, rising in whirlwind, takes off on a little cosmic voyage, using briefly many of the devices with which we have grown familiar [from the response to the new science].'[81]

However, Cowley's 'The Exstasie', one of his *Pindarique Odes* (published in his 1656 *Poems*) takes its immediate point of departure from a neo-Latin poem by the Polish Maciej Kazimierz Sarbiewski (1595–1640), 'the Sarmatian Horace', known as 'Casimire' in England, where his poems were much read and imitated in the seventeenth and eighteenth centuries.[82] Sarbiewski was a Jesuit and friend of Pope Urban VIII, the addressee of some of his poems, but this apparently did not prejudice his reception in England. He enjoyed early popularity with a coterie of royalist poets in the 1640s and 1650s, more accommodating of Counter-Reformation culture than were the Puritans, but Andrew Marvell, a mainstream Protestant, also engaged strongly with Sarbiewski's poetry. He came back into fashion from about 1683 onwards, at a time when the Catholic faction was ascendant in the English court; he further benefited

80. On the spiritual allegorization of the Ganymede myth, see ch. 2: 72.

81. Nicolson 1948: 203. Cowley's poems: Waller 1905.

82. The first publication of Sarbiewski's verse, *Lyricorum libri III*, was in 1625, augmented, in editions from 1632 onwards, as *Lyricorum libri IV, epodon liber unus, alterque epigrammatum* (Four books of lyric odes, one book of epodes, and a book of epigrams). On the English reception of Sarbiewski, see Røstvig 1954a and 1954b; Birrell 1956: 127–30; Hoyles 1971: 202–10; Kraszewski 2006; Money 2006; Fordoński and Urbański 2008; Scodel 2010: 220; Gömöri 2011; Moul 2019: 334–37. *Odes* 2.5 is included in the first edition of English translations of Sarbiewski, by George Hils (1646). The first attested English admirer of Sarbiewski is Edward Benlowes, who cites him in a work of 1636 (see Gömöri 2011: 821).

from the admiration for things Polish that followed on the Polish king Jan Sobieski's relief of Vienna from the Ottomans in 1683. An edition of his poems was published in Cambridge in 1684. Another fervent admirer of Sarbiewski was the dissenting clergyman and poet Isaac Watts, attracted by the devotional qualities of his verse. Sarbiewski also appealed to seventeenth-century poets for his praises of retreat, and, importantly for our purposes, for his flights of the mind.

One of the most influential of Sarbiewski's poems is his *Odes* 2.5, 'E rebus humanis excessus' (Departure from human affairs), in Horatian Alcaics. The ode begins, 'Humana linquo: tollite praepetem / Nubesque uentique' (I leave human things; clouds and winds, lift me up swiftly). As he flies upwards, the poet looks down over a world governed by fortune and vanity, the stage for wars and disasters man-made and natural. There are touches of Horatian flight and vision: Horace's elevation to poetic immortality in the shape of a soaring swan in *Odes* 2.20, and Horace's vision of a descending Muse in *Odes* 3.4—possibly, Horace suggests, just the delusion of a Platonic poetic madness.[83] Sarbiewski's ode owes a general debt to the ascent of the soul in the first treatise (*Poimandres*) of the *Corpus Hermeticum* (1.25–26).[84] The view from above of the folly

83. With 1, 'Humana linquo', cf. Horace, *Odes* 2.20.5: 'urbis relinquam' (I shall leave cities); with 82, 'iam iamque cerni difficilis', Horace, *Odes* 2.20.9: 'iam iam residunt'; with 77–78, 'ludor? sequaces aut subeunt latus / feruntque uenti' (Am I deceived? Or do the following winds come and bear up my body?), Horace, *Odes* 3.4.5–6: 'auditis? an me ludit amabilis / insania?' (Do you hear? Or am I deceived by a pleasing madness?) Sarbiewski also imitates Horatian flights in *Odes* 1.10, in a poem in praise of Pope Urban VIII: 'Non solus olim praepes Horatius / ibit biformis per liquidum aethera / uates . . . me Zephyris super / impune pendere, et sereno / Calliope dedit ire caelo' (A time will come when Horace will not go alone as a twy-form bard swiftly through the liquid air . . . Calliope granted me the power to hover unharmed above the breezes and to travel through the calm sky) (1–3, 6–8); and in *Odes* 4.32, recounting flight in a dream: 'pennas somnia leuibus / affigunt umeris; iamque uirentia / laetus prata superuolo . . . mox et nubibus altior, / mixtus flumineis ales oloribus, / uiuos despicio lacus, / et dulci uolucrem carmine mentior' (Dreams plant wings on my smooth shoulders; and already I joyfully fly over green meadows . . . now, even higher than the clouds, flying in the company of swans that love rivers, I look down on living lakes, and I imitate a bird in my sweet song) (3–12); later in this poem, Sarbiewski claims, in Horatian language, to take a non-Horatian flight as a poet: 'cum ter mobilibus lyram / percussi digitis, immemor, et ducis / nil sector Horatii, / sublimis liquidum nitor in aëra' (When I have thrice struck the lyre with my nimble fingers, heedless of Horace and not following him as my leader, I mount aloft into the liquid air) (19–22). On Sarbiewski's flight poems, see Olszynka 2006: 87–93.

84. Scott 1924–36, 1: 129: the soul ascends through the zones or spheres, and is successively stripped of passions and desires, until it arrives in the eighth sphere possessing its own *dunamis*

and transience of human endeavour (10: 'despecto gentes') is in a line that goes back to Cicero's *Dream of Scipio*, with many intermediaries: as the poet mounts higher and higher, the earth 'suum / uanescit in punctum' (83: 'Into its point doth vanish', in the translation of George Hils). *punctum* is the word used by the younger Scipio of the tiny extent of the Roman empire (*Rep.* 6.12.20) when viewed in the cosmic perspective; 'uanescit' refers literally to the vanishingly small size of the earth viewed from the celestial heights, but also connotes the *uanitas*, the empty vanity and vainglory of human ambition. The flight up into the aether ends in immersion in the ocean of divinity (84: 'numinis Oceanum'), an example of the frequent equation of space travel with seafaring: 'haurite anhelantem, et perenni[85] / Sarbiuium glomerate fluctu' (Swallow me up as I gasp, and engulf Sarbiewski in your eternal flood) (87–88).

Cowley's 'The Exstasie' signals the model of Casimire's ode in its first three words, 'I leave mortality', translating 'Humana linquo'—a Casimirian 'motto', itself in the manner of Horace's practice of translating the opening words of a Greek model as a 'motto'.[86] Cowley gives a nationalistic twist to the *Dream of Scipio* motif of the insignificance of the earth seen from above (8–16):[87]

How small the biggest parts of earth's proud title show!

Where shall I find the noble British land?
Lo, I at last a northern speck espy,
 Which in the sea does lie,
 And seems a grain o' the sand!

(power), and hears the 'powers' above the eighth sphere, and then mounts to god, or the Good, the *telos* for those who have *gnosis*. *Poimandres* begins with a dreamer whose bodily sensations are asleep but his 'intelligence exceedingly raised up' (μετεωρισθείσης μὲν τῆς διανοίας σφόδρα). On Milton's allusions to the *Corpus Hermeticum*, see here ch. 4: 173.

85. Cf. perhaps Horace, *Odes* 3.30.1: 'Exegi monumentum aere perennius' (I have completed a monument more long-lasting than bronze).

86. Cavarzere 1996.

87. For an earlier example of the topos of the vanity of earthly ambitions viewed from above, see the 'Catholic Puritan' William Habington (1605–54), *Funerals*, 'Elegy 3': 'Mem'ry of thy fate / Doth in me a sublimer soul create. / And now my sorrow follows thee, I tread / The milky way, and see the snowy head / Of Atlas far below, while all the high / Swol'n buildings seem but atoms to my eye. / I'm heighten'd by my ruin' (19–25); 'How small seems greatness here! How not a span / His empire, who commands the Ocean. / Both that, which boasts so much its mighty ore, / And th' other, which with pearl, hath paved its shore. / Nor can it greater seem, when this great All / For which men quarrel so, is but a ball / Cast down into the air to sport the stars' (33–39). See also n. 69 above.

For this will any sin, or bleed?
Of civil wars is this the meed?
 And is it this, alas, which we
(Oh irony of words!) do call Great Britanny?

Cowley alters the balance of his model: where Sarbiewski's poem is mostly taken up with a vision of disasters, framed by a description of the ascent, 'The Exstasie', after the first two stanzas, dwells exclusively on the upward flight, escape perhaps from depressing thoughts of the English Civil War, in which Cowley supported the king.[88] As he ascends, the poet registers the impact of the new astronomy: 'Through several orbs which one fair planet bear, / Where I behold distinctly as I pass / The hints of Galileo's glass, / I touch at last the spangled sphere' (33–36). But this is just a touch, in a poem which combines ancient and modern, classical and Christian. In the following stanza, the poet arrives at his celestial goal (41–48):

Where am I now? Angels and God is here;
An unexhausted Ocean of delight
 Swallows my senses quite,[89]
 And drowns all what, or how, or where.
Not Paul, who first did thither pass,
And this great world's Columbus was,
 The tyrannous pleasure could express.
Oh 'tis too much for Man! but let it ne're be less.

This effective adaptation of what are the closing lines in Sarbiewski's poem works the equation of celestial flight and sea voyage through a comparison between Saint Paul, 'caught up to the third heaven' (2 Corinthians 12:2), and

88. On the use of the view from above to point up the futility of earthly warfare, see Koppenfels 2007: 52–59, 'Die Demontage des martialischen Heldentums'.

89. Reworking Sarbiewski, *Odes* 2.5.83–88: 'o refusum / numinis oceanum . . . o clausa nullis marginibus freta! / haurite anhelantem, et perenni / Sarbiuium glomerate fluctu'. Sarbiewski's Latin or Cowley's English (depending on when one dates Marvell's 'The Garden'), or both, lie behind Marvell 'The Garden': 'Meanwhile the mind, from pleasures less, / Withdraws into its happiness: / The mind, that ocean where each kind / Does straight its own resemblance find; / Yet it creates, transcending these, / Far other worlds, and other seas; / Annihilating all that's made / To a green thought in a green shade' (41–48) (if there was a corresponding passage in the Latin *Hortus*, it has been lost); Smith 2003 also compares Cowley's 'The Muse': the Muse has 'a thousand worlds too of thine own . . . a New World leaps forth when Thou say'st, Let it be' (33–35). For other echoes of Sarbiewski in *Hortus*, see Moul 2019: 334–37.

another hero of modernity, Columbus, discoverer of the terrestrial New World. But the major biblical model for Cowley's flight is Elijah, whose ascent to heaven in a chariot of fire occupies the last five stanzas, and is anticipated already in the first stanza, in the line 'A Whirlwind bears up my dull feet', as 'Elijah went up by a whirlwind into heaven' (2 Kings 2:11).[90] The addition to Sarbiewski's original of an extensive passage of biblical poetry is in keeping with the larger project of the *Pindarique Odes* of combining the sacred with the secular. This project shapes the structure of the book, which opens with three classical imitations (of Pindar's second 'Olympian' and first 'Nemean' odes, and Horace, *Odes* 4.2), and closes with two biblical poems, 'The 34th Chapter of the Prophet Isaiah', and 'The Plagues of Egypt', a free composition on the biblical subject, and by far the longest poem in the book. The flight in 'The Exstasie' upwards from the earth into a biblical heaven can also be seen as a performance of Cowley's own call in the Preface to the 1656 *Poems*, in the context of presenting to the reader the four books of his biblical epic the *Davideis*, to rescue poetry from its profane employment 'either in the wicked and beggarly flattery of great persons, or the unmanly idolizing of foolish women, or the wretched affectation of scurril laughter, or at best on the confused antiquated dreams of senseless fables and metamorphoses'. This is to recover poetry out of the Devil's hands 'and to restore it to the kingdom of God, who is the Father of it', in a repetition of the call of Du Bartas's Muse Urania to re-dedicate poetry to divine subjects. Cowley took his Anglicanism seriously. But if 'The Exstasie' ends up in a biblical heaven, it does not cancel its own classical and neo-Latin debts. Cowley's 'Sacred poem', the *Davideis*, is also a thoroughly classicizing and Virgilianizing epic, just as 'classical and sacred are intermixed within almost every essay', in his *Essays*.[91]

Before mounting on high with Elijah, Cowley incorporates allusion to the Platonic ascent of desire, in the fourth stanza (33–40):

Now into' a gentle sea of rolling flame
I'm plunged, and still mount higher there,
 As flames mount up through air.
 So perfect, yet so tame,

90. A later example of an ecstatic versification of Elijah's flight up to heaven is 'The Translation of Elijah' by Elizabeth Singer Rowe, a friend and fellow poet of Isaac Watts (in Marshall 1987: 223–25).

91. Major 2020: 222.

> So great, so pure, so bright a fire
> Was that unfortunate desire,
> My faithful breast did cover,
> Then, when I was of late a wretched mortal lover.

Now, however, 'I leave mortality'. The contrast is that made by Spenser between his hymns of earthly love and beauty, composed 'in the greener times of my youth', and his hymns of heavenly love and beauty. Cowley also looks back to an earlier work of his own, his collection of love poems *The Mistress* (1647). In Spenser, earthly and Platonic-Christian impulses of desire tend to bleed into one another; Cowley (apparently) finds no difference at all between the perfection, purity and brightness of his erstwhile mortal love and what he is experiencing now. Arriving at the place of angels and god, his senses are annihilated in a paradoxically sensuous manner: 'An unexhausted Ocean of delight / Swallows my senses quite' (42–43).

The classical tradition has still more to offer for a full understanding of the kind of flight that Cowley undertakes in 'The Exstasie'. In the line 'A whirlwind bears up my dull feet', it is tempting to see a punning equivocation on bodily and metrical feet, of a kind frequently found in Ovid—and Cowley is a very Ovidian poet. Cowley's metrical feet are 'rapt' by a Pindaric inspiration that finds expression in the poem's irregular stanza form. 'The Exstasie' is one of Cowley's *Pindarique Odes, Written in Imitation of the Stile and Manner of the Odes of Pindar*. The title-page of the *Pindarique Odes* takes as its motto a line of Horace on imitating Pindar (*Ep.* 1.3.10): 'Pindarici fontis qui non expalluit haustus' (who did not blench at drinking from Pindar's fountain), and one of Cowley's Pindaric imitations is an imitation of a Horatian imitation of Pindar (Horace's *Odes* 4.2: see ch. 2: 51–52); Cowley thereby compounds the irony of Horace's declaration of Pindar's inimitability. Horace's ode begins with a statement of the folly of seeking to take Pindaric flight; in Cowley's version, 'Pindar is imitable by none; / The phoenix Pindar is a vast species alone. / Who e're but Daedalus with waxen wings could fly / And neither sink too low, nor soar too high?' Pindar's 'Laments', *Threnoi*, have the power to raise the eulogized dead to the stars: (of a 'brave young man's untimely fate') 'He bids him live and grow in fame, / Among the stars he sticks his name',[92]

92. For the phrasing here Cowley's own note refers to Horace, *Odes* 3.25.6: 'stellis inserere et concilio Iouis' (to place [praise of Augustus] among the stars and in the council of Jupiter), another Horatian ode on celestial aspirations (see ch. 2: 50). For a famous example of catasterism in a poem of praise for a 'brave young man's untimely fate', see Ben Jonson, 'To the Immortal

(32–33), imitating Horace, *Odes* 4.2.22–23: 'uiris animumque moresque / aureos educit in astra' (he raises to the stars his valour, his spirit and his golden character). Pindar himself soars up into the clouds: 'Lo, how th' obsequious wind,[93] and swelling air / The Theban swan does upward bear / Into the walks of clouds, where he does play, / And with extended wings opens his liquid way' (36–39), imitating *Odes* 4.2.25–27: 'multa Dircaeum leuat aura cycnum, / tendit, Antoni, quotiens in altos / nubium tractus' (Many a breeze lifts the swan of Dirce [a Theban spring] whenever he soars into the tracts of cloud, Antonius).

Another of Cowley's *Pindarique Odes*, 'The Muse', is an instruction to prepare the Muse's chariot, followed by an extended apostrophe of the Muse in her travels through space and time. She is more particularly the Muse of Cowley's *Pindariques*. The poem begins with an imitation of lines from Pindar's sixth Olympian, instructing the driver of the victorious mule team of Hagesias of Syracuse to yoke the mules to drive the chariot of Pindar's song. Cowley develops the metaphorical chariot in other directions (1–9):

> Go, the rich chariot instantly prepare;
>> The Queen, my Muse, will take the air;
>> Unruly Fancy with strong Judgement trace,
>>> Put in nimble-footed Wit,
>>> Smooth-paced Eloquence join with it,
>> Sound Memory with young Invention place,
>>> Harness all the winged race.
>> Let the postilion Nature mount, and let
>>> The coachman Art be set.

In his own notes to the poem, Cowley quotes the Pindaric original, and observes, '[B]y the name of Phintis he [Pindar] speaks to his own soul. O, my soul, join me the strong and swift mules together, that I may drive the chariot in this fair way.' The chariot of the soul is an image that goes back to Plato's

Memory and Friendship of That Noble Pair, Sir Lucius Cary and Sir Henry Morison' (*Underwood* 70), which equates the two with the Dioscuri, Castor and Pollux, stellified as the constellation Gemini (92–96); the poem labels itself an 'asterism' (89). Cowley remembers Jonson's 'To the Immortal Memory' in his own account of the ascent of Lucius Cary, Lord Falkland's soul on his death at the battle of Newbury (*Civil War* 3.571–84; see Hardie 2019: 77–78).

93. Cf. Sarbiewski, *Odes* 2.5.77–78: 'ludor? **sequaces** aut subeunt latus / feruntque **uenti**?' (see n. 83 above).

Phaedrus.[94] The arch 'The Queen, my Muse, will take the air'[95] tells us that this is a flying chariot; in fact it is a chariot that can go anywhere, even to places that do not exist, heterocosms, called into existence by the poet's flights of fancy, places 'Where never foot of man, or hoof of beast, / The passage pressed' (20–21).[96] Cowley continues to locate these worlds of the poetic imagination with reference to the figurative interchangeability of travel by sea and travel through the air: 'Where never fish did fly, / And with short silver wings cut the low liquid sky. / Where bird with painted oars did ne'er / Row through the trackless ocean of the Air' (22–25). Cowley's own note explains that 'fins do the same office to fish, that wings do to birds', and invokes scriptural authority for 'calling the sea the low sky'; and he gives examples of the classical metaphor of *remigium alarum* (oarage of wings) (see ch. 2: 75).[97]

These journeys of poetic fancy (on flights of fancy, see ch. 1: 19–23) are also journeys beyond, like the Lucretian Epicurus's excursion beyond the flaming walls of the world (Lucr. 1.72–73), but, unlike Epicurus, whose plurality of worlds conform to the unvarying laws of nature, the Muse calls into being a thousand worlds as an alternative creator to God: 'Nay ev'n beyond His [God's] works thy voyages are known, / Thou hast thousand worlds too of thine own. / Thou speak'st, great Queen, in the same style as He, / And a new world leaps forth when Thou say'st, Let it Be' (32–35).[98] Cowley's Muse can dive or soar through time as well as space (36–38,[99] 42–45):

94. See Revard 2001: 110.

95. I detect a moment of humour here, as if 'the queen' might wish to take the air after dinner, say. 'Take the air' in this sense goes back to the Middle Ages: *OED* s.v. *air*: '5a: e.g. 1697 T. Dilke *City Lady* ii. 18 'Never takes the air but with a fresh set of jewels'.

96. Cf. Traherne, *Centuries of Meditations* 2.90: 'For God hath made you able to create worlds in your own mind which are more precious unto Him than those which He created.'

97. At another level, Cowley seems to have in mind the paradoxical reality of 'flying fish' which do temporarily exchange water for the medium of air (*OED* citations for 'flying fish' c.1511, 1624). Cowley's 'The Muse' is an exercise in the Pindaric sublime, touched by moments of humour and grotesquerie. Pope, perhaps coincidentally, uses flying fishes as the first image in his bestiary of bathos, in *Peri Bathous, or, The Art of Sinking* (1728) on 'Flying Fishes': 'these are writers who now and then rise upon their fins, and fly out of the profound; but their wings are soon dry, and they drop down to the bottom'.

98. The Muse creates a thousand new worlds, through which she can then travel, rather than simply travelling through the thousands of worlds created by God; cf. Pope's epitaph on Newton: 'Nature and Nature's Laws lay hid in Night: / God said "Let Newton be!" and all was Light'.

99. The proximity of 'fathom'est' and 'pluck up' in these lines suggests that Cowley may remember Hotspur's soaring and diving in Shakespeare, *1 Henry IV* 1.3.204–8 (see above: 123).

Thou fathom'est the deep gulf of ages past
 And canst pluck up with ease,
 The years which Thou dost please

. . .

Nor dost thou only dive so low,
 But fly
With an unwearied wing the other way on high,
 Where Fates among the stars do grow

In his annotations Cowley does not quote, although he may have known, a fragment of Pindar quoted by Plato, on the power of human thought to dive beneath the earth and soar above the heavens in its inquiry into nature, *Theaetetus* 173e–74a (cited ch. 2: 32).

Cowley set a fashion in English for the Pindaric ode, a vehicle for poetic flights that plays a significant part in the history of the sublime in the later seventeenth and eighteenth centuries (and to which I shall return).[100] Where Cowley imitates Horace's professed lack of confidence in his ability to soar with Pindar, John Denham judges Cowley a successful imitator of Pindaric flights, in 'On Mr. Abraham Cowley his Death and Burial amongst the Ancient Poets' (1667): 'On a stiff gale (as Flaccus sings) / The Theban Swan extends his wings, / When through th' aetherial clouds he flies, / To the same pitch our swan doth rise; / Old Pindar's flights by him are reached, / When on that gale his wings are stretched.'[101]

100. On the association of Pindar and the sublime in English Pindarics, see Williams 2005: 178–80. See also Morris 1972: ch. 1, 'The Literary Origins of Religious Sublimity', including discussion of Cowley's invention of the sacred ode, crossing the Bible with Pindar, and citing Edward Benlowes, preface to *Theophila*: 'Divine Poesy is the internal triumph of the mind, rapt with St. Paul into the third heaven, where she contemplates ineffables.'

101. Denham's praise is repeated by others: Samuel Cobb (bap. 1675–1713), *Of Poetry* (on Cowley): 'Hail English Swan! for you alone could dare / With well poised pinions tempt th' unbounded Air: / And to your lute Pindaric numbers call, / Nor fear the danger of a threatened Fall' (272–75); Addison (1672–1719): *An Account of the Greatest British Poets* (1694): 'What muse but thine can equal hints inspire, / And fit the deep-mouthed Pindar to thy lyre: / Pindar, whom others in a laboured strain, / And forced expression imitate in vain. / Well-pleased in thee he soars with new delight, / And plays in more unbounded verse, and takes a nobler flight' (46–51); Thomas Sprat, 'A Pindarick Ode . . . when He Presented Cowley's Poems to Wadham College in Oxford', in *Oxford and Cambridge Miscellany Poems* (1708): 'Thy high Pindaricks soar, / Where never any wing till now could get, / And yet thy wit / Still seems as great to those who travel low'r; / Thou stand'st on Pindar's back, / And so the higher flight do'st make: / Thou art the eagle, he the wren.' (p. 109).

Cowley is the earliest of the English poets whom Isaac Watts (1674–1748) refers to with approval in 'The author's preface' to the enlarged version of his *Horae lyricae* (1709). The Latin poems include an early (1694) 'Pindarici carminis specimen',[102] addressed in gratitude to Watts's teacher at the free grammar school in Southampton, John Pinhorne. Watts reviews the Greek and Latin poets whom he read with Pinhorne, chief among whom are the 'great trio' of Homer, Virgil and Pindar.[103] He dwells at greater length on modern Latin poets, Buchanan and, at greatest length, Casimire Sarbiewski. In the first of two enraptured stanzas of irregular, 'Pindaric', metre, Watts praises the lofty flight of Casimire, and shows his erstwhile teacher how well he has read the poets: imitation of Horace's praise of Pindar, as the Theban swan metamorphoses into the Polish swan, 'Quanta Polonum leuat aura cygnum' (How mighty a breeze lifts up the Polish swan) (v. 61; cf. Horace, *Odes* 4.2.25: 'multa Dircaeum leuat aura cycnum'), is combined with imitation of Casimire's 'Humana linquo' (*Odes* 2.5): 'Humana linquens' (leaving behind human things) (v. 62). Watts is left straining his eyes in amazement as he tries to follow from afar. The stanza ends by addressing Casimire as 'O non imitabilis ales' (inimitable bird).

Cowley's 'The Praise of Pindar' begins, 'Pindar is imitable by none'. But, as Horace *does* imitate Pindar, and Cowley *does* imitate both Horace and Pindar, so, in the second, and longer, of the two stanzas, Watts's own Muse catches fire; the poet puts on starry wings and rises aloft, touching with his foot (metrical as well as physical?) the heights of Mount Sion and raising his head among the stars.[104] He now alludes to Casimire in the first person: 'longe despecto mortalia' (I look down on mortal things from afar) (77; cf. Sarbiewski, *Odes* 2.5.10: 'despecto gentes'). The view from above provokes laughter at the vanities of mortals: 'Et ridere procul fallacia gaudia secli / Terellae grandia inania' (laughing from afar at the delusive joys of the world, the weighty inanities of the little

102. 'Ad Reverendum Virum Dm. Johannem Pinhorne, fidum adolescentiae meae praeceptorem. Pindarici carminis speciem'. In the revised preface to *Horae lyricae*, Watts associates himself with the principles and practice of John Dennis, Abraham Cowley, Richard Blackmore, John Norris and John Milton.

103. The English version, by Thomas Gibbons, author of the *Memoirs of the Rev. Isaac Watts* (1780) (see Money 2006: 157), elaborates on the Latin's brief address to *Thebane uates*: 'The Theban bard my soul admires, / His tow'ring flights, his mounting fires, / The raptures of his rage.'

104. 'elato inter sidera uertice' (76): cf. Horace, *Odes* 1.1.36: 'sublimi feriam sidera uertice' (I shall strike the stars with my head held high) (see ch. 2: 49).

terrestrial globe) (79–80).[105] As the poet's breast is cleared of earthly dross, and, freed of the 'bridle' (effrenis), his mind inspired by God longs to pour forth divine song, a Christian Pindarics (in the English version, 'My soul shall her sublimest lay / To her Creator, Father, pay'). In the last lines, Watts returns to Horace's description of Pindar, who 'rushes on with numbers not bound by rules' (*Odes* 4.2.11–12: 'numerisque fertur / lege solutis'): 'Vasti sine limite numen et / Immensum sine lege Deum numeri sine lege sonabunt' (My huge measures, bound by no rule, will sound out the godhead who knows no limit, the boundless divinity governed by no rule) (97–98). The last line is a dactylic heptameter, breaking the rules of the hexameter by adding a seventh foot. At this point, the young poet's modesty is preserved, as his powers desert him, and he descends into prose, in an Icarian detumescence: 'But in the moment the Muse is promising great things her vigour fails, her eyes are dazzled with the divine glories, her pinions flutter, her limbs tremble; she rushes headlong from the skies, falls to the earth, and there lies vanquished, overwhelmed in confusion and silence.'

Cowley's 'The Exstasie', and its model, Sarbiewski's *Odes* 2.5, 'E rebus humanis excessus', prompted a whole series of imitations,[106] including the Church of England clergyman and philosopher John Norris's (1657–1711) 'The Elevation' (in *A Collection of Miscellanies*, published 1692); Thomas Parnell's (1679–1718) 'The Ecstasy' (Parnell was a friend of Pope and Swift, and one of the first 'graveyard poets'); Aaron Hill's (1685–1750) 'The Transport'; John Hughes's (1677–1720) 'The Ecstasy: An Ode' (London, 1720; Hughes, a contemporary of Isaac Watts at Thomas Rowe's dissenting academy, was also a Pindaric panegyrist of the House of Orange); and another poem, in English, by Isaac Watts, 'Strict Religion Very Rare'. Lady Mary Chudleigh (1656–1710) has two goes at *Odes* 2.5, in 'The Elevation', and 'The Song of the Three Children. Paraphras'd Casimir II 5'. In Lady Mary Chudleigh's 'Solitude',[107] the 'ecstasies of love' fire 'Those glorious beings whose exalted sense / Transcends the highest flights of human wit' (vv. 10–11). These poems are all flights of freedom, breaking loose from the 'chains of earth' (Parnell, 'The Ecstasy' 70),

105. Watts may have particularly in mind the ascent of Pompey's soul at the beginning of *Civil War* 9: 'risitque sui ludibria trunci' (14; see ch. 2: 56): Watts looks down on 'Ventosae sortis ludibrium' at v. 84. 'O curas hominum' (82) quotes Persius at *Satires* 1.1.

106. Fordoński and Urbański 2008 include eleven versions of 'E rebus humanis excessus', by ten hands.

107. From *Poems on Several Occasions* (1703).

as the soul, released from 'the confining clay' (Chudleigh, 'Solitude' v. 6) heads for its original home and native skies, journeying into an aerial ocean of serenity. The poets also experience violent emotion: ravishment, rapture, transport (both physical and mental), sacred rage (*furor*). Aaron Hill's soul feels 'rapture, involved in rapture'; he soars upwards 'Ravished! o'erwhelmed! amazed! I fly, / 'Midst pleasures, which, before, / My boldest flights of fancy never knew!' (8–10) (a contrast found elsewhere between the flight of fancy and the higher flights of divine truth: see ch. 1: 20–21). 'Peace divine' inspires Thomas Parnell with a 'wondrous love' (15–16), another example of the frequent attachment of images of flight to impulses of love and desire. Isaac Watts, as he is borne aloft, in 'Strict Religion Very Rare', has pointed out to him by a seraph a happily married pair, whose minds are given the freedom of the sky through their love, and Watts's soul sings out, 'Blest be the pow'r that springs their flight, / That streaks their path with heav'nly light, / That turns their love to sacrifice, / And joins their zeal for wings' (51–54).

John Hughes takes as epigraph for his 'The Ecstasy' two lines of Virgil, frequently quoted and imitated, in which the poet expresses his wish to be taken up to the heavens by the Muses in a journey of natural-philosophical enlightenment: 'Me vero primum dulces ante Omnia Musae / Accipiant, Coelique Vias & Sidera monstrent' (But as for me—first may the Muses, sweet beyond all things, whose holy objects I bear, smitten with a mighty love, welcome me, and show me the paths of the sky and the stars) (*Geo.* 2.475, 477).[108] Virgil's wish for initiation into the secrets of the heavens is now brought up to date for the new astronomy. In the 'Advertisement' to his poem, John Hughes declares that he has modelled his ode on Cowley's 'The Exstasie', but that 'the latter part, which attempts a short view of the heavens, according to the modern philosophy, is entirely original, and not founded on any thing in the Latin author' (referring to Sarbiewski, to whose neo-Latin poem Hughes is in some parts closer than to Cowley). The second half of Hughes's 'The Ecstasy' begins with a renewed urgency of ascent: 'Haste, clouds and whirlwinds, haste a raptured bard to raise; / Mount me sublime along the shining ways, / Where planets, in pure streams of aether driv'n, / Swim thro' the blue expanse of heav'n.' (113–16). 'Rais'd sublime on contemplation's wings', Hughes ascends through the several planets, to the Milky Way, where he catches sight of 'a pointed flame', a 'shining meteor' (170–71) climbing towards him: 'And now it

108. See Hardie 1986: 37–38; see also ch. 2: 68. The Virgilian lines are also the epigraph for Abraham Cowley's *Davideis* (see Hardie 2019: 71–72).

traverses each sphere, / And seems some living guest, familiar to the place. / 'Tis he—as I approach more near / The great Columbus of the skies I know! / 'Tis Newton's soul, that daily travels here / In search of knowledge for mankind below' (173–78). Hughes has updated Cowley's reference to Galileo with the newer science of Newton, to whom he has also transferred from Cowley's Saint Paul the comparison with Columbus. In Hughes's 'The Ecstasy', the soaring mind of Newton catches the poet's eye like a 'meteor' (171), where in Cowley's 'The Exstasie', the ascending biblical prophet Elijah 'past by the moon and planets, and did fright / All the worlds there which at this meteor gazed' (81–82).

Lucretian and Newtonian Flights of the Mind

Hughes 'The Ecstasy' is a fairly early example of an extensive subgenre of poems, in both English and Latin, in praise of the sky-soaring mind or soul of Sir Isaac Newton.[109] Poems in praise of Newton proliferate after his death in 1727, but key elements of the genre are already found in the Latin poem in hexameters by Edmond Halley (he of the comet) prefaced to the first edition of Newton's *Principia mathematica* (1687).[110] Like most of the productions of the genre, Halley's poem on Newton takes as an immediate or mediated model the passages in praise of Epicurus in Lucretius's *On the Nature of Things*, of which the most widely imitated is the description of the flight of Epicurus's mind in the proem to book 1, a template, as we have seen, for many earlier poetic accounts of the reach of the human mind inquiring into the secrets of nature. The Lucretian Newton is given plastic expression in Roubiliac's statue of him in the antechapel of Newton's Cambridge college, Trinity (installed in 1755) (Fig. 3.2). The inscription on the base of the statue, 'Qui genus humanum ingenio superauit' (Who surpassed in intellect the race of man), comes from a passage on Epicurus in *On the Nature of Things* (Lucr. 3.1043). The passage continues, 'et omnis / restinxit, stellas exortus ut aerius sol' (and quenched the light of all, as the ethereal sun once risen quenches the stars). Solar imagery is also found in eighteenth-century poems on Newton.

109. On the genre of poems in praise of Newton, see Nicolson 1946; Thomas and Ober 1989: ch. 2, 'The Sage as Hero', a survey of poems in praise of Newton; Fara and Money 2004.

110. Halley, 'In uiri praestantissimi D. Isaaci Newton opus hocce mathematico-physicum saeculi gentisque nostrae decus egregium'. On Halley's ode, see Albury 1978. On Bentley's later changes to Halley's poem to give it an even more Lucretian ring, see Fabian 1973.

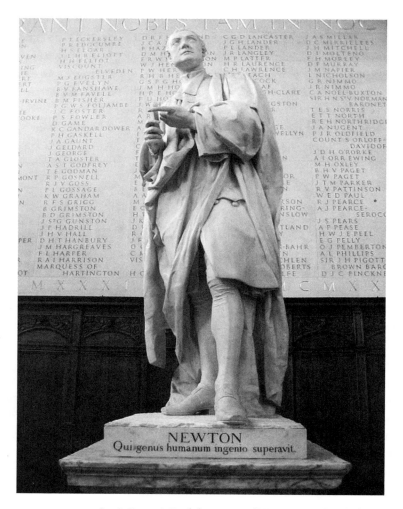

FIGURE 3.2. Louis-François Roubiliac, statue of Newton, antechapel of
Trinity College, Cambridge. By permission of the Master and Fellows,
Trinity College, Cambridge.

The deployment of Lucretius to express the ambitions of the modern
thinker finds a precedent in an earlier Cambridge philosopher, Henry More
(1614–87), with whom Newton was acquainted, and by whose thinking he
may have been influenced. More draws on Epicurus's flight of the mind in the
introductory stanzas (1–6) to his *Democritus Platonissans, or, An Essay upon
the Infinity of Worlds out of Platonick Principles* (1647), an attempt to reconcile

the Democritean infinity of worlds and Neoplatonism.[111] He introduces the reader to the 'strange sights' and 'lively forms' that 'walk in my 'boundless mind'. In stanza 5,

An inward triumph doth my soul up-heave
And spread abroad through endless 'spersed air.
My nimble mind this clammy clod doth leave,
And lightly stepping on from star to star
Swifter then lightning, passeth wide and far,
Measuring th' unbounded heavens and wasteful sky;
Ne ought she finds her passage to debar,
For still the azure orb as she draws nigh
Gives back, new stars appear, the worlds walls 'fore her fly.

The image of military triumph, and of the boundlessness of the journey,[112] are in the Lucretian tradition. The oxymoronic 'Measuring th' unbounded Heavens' reminds the reader of Horace's Lucretian Archytas, 'the measurer of the sands that lack number' (*Odes* 1.28.1–2: 'numeroque carentis harenae / mensorem': see ch. 2: 45). 'The world's walls fly' before More's soul, as they do for Lucretius at Epicurus's revelation of the nature of things (Lucr. 3.16–17: 'moenia mundi discedunt'; cf. 1.72–73), but now in an anti-Epicurean venture. These are the 'badly staid' walls of antique conceptions of nature, 'Which I in full disdain quite up will tear / And lay all ope, that as things are they may appear' (stanza 6.8–9). This is a legitimate act of vandalism, comparable to Lucretius's defence of his teaching of the inevitable final dissolution of the world against those who would accuse the Epicureans, 'who through their reasoning would demolish the walls of the world' (Lucr. 5.119: 'qui ratione sua disturbent moenia mundi'), of the impiety of the Giants in their assault on the Olympian gods.

In Halley's 1687 Latin poem, the piercing and penetrative nature of Newton's mind enables his lofty—and sublime—genius to enter the dwelling-places of the gods and to climb the heights of heaven. Halley alludes directly to Lucretian formulations of Epicurus's opening up of the hidden places of

111. See Nicolson 1950: 138–45 on Henry More and the 'aesthetics of infinity' (a main theme of Nicolson 1959), and More's 'delight in vastness'.

112. Cf. also More's 'Insomnium philosophicum' (in *Philosophical Poems*, 1647), a dream vision, in which 'I' flees from my corpse, 'Free as in open Heaven more swift than thought / In endless spaces up and down I fly' (13–14).

nature, and his revelation of philosophical truth to mankind.[113] He imitates more closely still an Ovidian passage that alludes to Lucretius's praise of Epicurus, Ovid's assertion of the legitimacy of human inquiry into celestial matters near the beginning of the *Fasti*, the poem which versifies both the Roman religious calendar and the astronomical calendar (*Fasti* 1.295–310: see ch. 2: 83). With lines 24–26 of Halley's poem, 'No longer does error oppress doubtful mankind with its darkness: the keenness of a sublime genius has allowed us to penetrate the dwellings of the Gods and to scale the heights of heaven (iam dubios nulla caligine praegrauat error, / queis superum penetrare domos atque ardua coeli / scandere sublimis genii concessit acumen), compare Ovid, *Fasti* 1.297–98: 'Happy souls, who first took thought to know these things and scale the heavenly mansions!' (felices animae, quibus haec cognoscere primis / inque domos superas scandere cura fuit!).[114] For Ovid, this is the right way to aim for the sky: not, that is, the way of the Giants who piled Pelion on Ossa to reach the stars, another example of the wrong way of trying

113. With lines 39–43, 'iam uero superis conuiuae admittimur, alti / iura poli tractare licet, iamque abdita coecae / claustra patent terrae, rerumque immobilis ordo, / et quae praeteriti latuerunt saecula mundi. / talia monstrantem mecum celebrate Camoenis' (Now indeed we are admitted as fellow diners at the banquet of the gods, and are allowed to investigate the laws of the lofty sky; now the secret bolts of the dark earth are opened up, the immovable order of nature, the things that were hidden in previous centuries of the world. Join with me in celebrating in song the man who reveals this things), compare Lucr. 1.70–71: 'effringere ut arta / naturae primus portarum claustra cupiret' (so that [Epicurus] desired to be the first to burst the fast bolts of nature's gates); 1.76–77: 'finita potestas denique cuique / quanam sit ratione atque alte terminus haerens' (on what principle each thing has its powers defined, and its deep-set boundary mark [= 'rerumque immobilis ordo']); 3.29–30: 'sic natura tua ui / tam manifesta patens ex omni parte retecta est' (thus nature by your power is laid thus visibly open, is thus unveiled on every side); 4.419: 'corpora mirando sub terras abdita caelo' (bodies hidden in that wondrous sky beneath the earth); 6.27–28 'uiam monstrauit, tramite paruo / qua possemus ad id recto contendere cursu' (he revealed the path along which by a short cross-track we might arrive at it [the *summum bonum*] in a straightforward course).

114. For an earlier example of the use of the *Fasti* passage to praise the achievements of an astronomer, see Tycho Brahe's 'Hortatory Ode' in Kepler, *Astronomia nova*: 'scandere inaccessi liceat qua culmina coeli, / et superas penetrare domos, habitacula diuum: / seu lubeat fixas, uario seu tramite motas / designare faces, cursumque situmque probare / sidereum, summi ut constent miracula Jouae' ([a path] by which we might climb the heights of the inaccessible sky, and reach into the dwelling-places above, the houses of the gods; whether our pleasure is to chart the fixed stars or those that move on a variable path, and to test the course and location of the stars, so that the wonders of supreme Jehovah are manifest) (3–7; Latin text in Seck 2018; cited in Brown 2009: 73).

to reach the heavens to set beside the failed flights of Phaethon and Icarus. Halley ends the poem by reasserting the safe limits of Newton's approach to the gods: 'Newton unlocking the archives of hidden Truth; Newton dear to the Muses; to whom pure-hearted Phoebus is present and possesses his mind with the fullness of Divinity: nor is it permitted for a mortal to come nearer to the Gods' (Newtonum clausi reserantem scrinia Veri / Newtonum Musis charum, cui pectore puro / Phoebus adest, totoque incessit numine mentem: / nec fas est propius mortali attingere Diuos) (45–48). Newton is godlike, but only in the safely figurative language of a classicizing Apollonian possession. The point is reinforced in the English translation of Halley's poem by Francis Fawkes (bap. 1720–77):[115] 'Newton, by every favouring muse inspired, / With all Apollo's radiations fired; / Newton, that reach'd th' insuperable line,[116] / The nice barrier 'twixt human and divine' ('An Eulogy on Sir Isaac Newton' 61–64). 'Apollo's radiations' suggests the rays of the sun, emanating from the sun-god.

In the *Fasti* passage on astronomers, Ovid continues, 'They brought the distant stars close to the eyes of the mind, and made the heavens subject to their genius' (admouere oculis distantia sidera mentis[117] / aetheraque ingenio supposuere suo) (1.305–6). Line 306 neutralizes Lucretius's account of Epicurus's liberation of mankind from the tyranny of Religion: 'Therefore religion in turn is cast underfoot and crushed; our victory brings us level with the sky' (quare religio pedibus subiecta uicissim / obteritur, nos exaequat uictoria caelo') (Lucr. 1.78–79). Ovid's astronomers achieve a purely intellectual domination of the *aether*, the dwelling-place of the gods to which they gain access without dethroning the previous occupants (just as, in Halley's poem, Newton's revelations gain us admission to the banquet of the gods [39]: 'iam uero superis conuiuae admittimur').

Lucretius makes polemical use of the image of Gigantomachy to vaunt the Epicurean dethroning of the traditional gods (5.110–21). He asserts, not that Epicurus was like a god, but that he *was* a god: 'For if we must speak as the acknowledged grandeur of the things itself demands, a god he was, a god, noble Memmius' (nam si, ut ipsa petit maiestas cognita rerum, / dicendum

115. 'An Eulogy on Sir Isaac Newton, Translated from the Latin of Dr Halley'. See the *ODNB* article on Fawkes by D. K. Money.

116. Perhaps alluding to Pope, *Essay on Man* 1.227–28: 'And middle natures, how they long to join, / Yet never pass the insuperable line!'

117. 'mentis' is a conjecture (Alton) for the transmitted 'nostris'.

est, deus ille fuit, deus, inclute Memmi') (5.7–8). This is not unconditional: the conditional clause 'si . . . dicendum' gives notice that this is just a manner of speaking; but it is an extravagant manner of speaking. Ovid—followed by Halley—rows back on Lucretius's defiance of conventional theology.

The later poems on Newton also take from Lucretius's account of the flight of Epicurus's mind a sense of liberation, of unfettered wandering over, expatiating through, expanding over, the expanses of the universe; a sense of the boundlessness and of the sublimity of this mental space travel. This is seen, for example, in some of Francis Fawkes's freer renderings of Halley's Latin poem: 'Before us now new scenes unfolded lie, / And heav'n appears expanded to the eye' ('An Eulogy' 7–8; Halley 5: 'intima panduntur uicti penetralia coeli'); 'O highly blest, to whom kind fate has given / Minds to expatiate in the fields of heaven!' (31–32); 'But now, admitted guests in heav'n, we rove / Free and familiar in the realms above' (53–54; Halley 39–40: 'iam uero superis conuiuae admittimur, alti | iura poli tractare licet').

What these poems are not is free-thinking, in the sense of challenging religious orthodoxy.[118] In contrast to Galileo's run-ins with the church, the scientific advances made by Newton were enlisted in the service of the argument from design, in a series of physico-theological poems (see ch. 1: 7–8) that use Lucretian imagery of flight through the boundless spaces of the universe to affirm the presence in the heavens of the Religio that Epicurus had conquered, but now in the shape of a Christian providential religion.[119]

One of the first responses to the death of Newton, published in 1727, and the best of its genre, was James Thomson's 'To the Memory of Sir Isaac Newton', the 'all-piercing sage' (23).[120] The title-page epigraph is Lucretius's description of the sublime effects on himself of the revelations delivered by Epicurus (Lucr. 3.28–30):

118. Albury, however, makes the case (1978) that Halley's Lucretianism strays towards a dangerous Epicureanism.

119. Bentley adduced Newton's system in support of belief in the deity in the first Boyle Lecture of 1692, 'A Confutation of Atheism'. Newton wrote to Bentley in 1692, 'Sir, When I wrote my treatise about our system, I had an eye upon such principles as might work with considering men, for the belief of a deity; nothing can rejoice me more than to find it useful for that purpose.'

120. See Sambrook 1986: 5: 'One could apply to Thomson's *Newton* the words that Dryden used of his own *Eleonora* (1692): "It was intended . . . not for an elegy, but a panegyric. A kind of apotheosis, indeed; if a heathen word may be applied to a Christian use".' On the (ecclesiastical) politics of Thomson's Newtonian physico-theology, see Connell 2016: ch. 5. On Thomson's sources, see McKillop 1961: 128–47; Sambrook 1986.

His ibi me rebus quaedam diuina uoluptas
percipit, atque horror; quod sic natura tua ui
tam manifesta patet ex omni parte retecta

LUCRETIUS.

Thereupon at these things a certain pleasure and shuddering seizes me,
since through your might nature has been revealed, so clearly laid open in
every part.

The poem begins, 'Shall the great soul of Newton quit this earth, / To mingle
with his stars; and every Muse, / Astonished into silence, shun the weight /
Of honours due to his illustrious name?' Note 'his stars': the stars that Newton
made his own through his scientific mastery of the laws of physics,[121] but also
hinting that his soul is at home with the stars whence it has its origin, in keep-
ing with Platonic and Stoic views of mankind's starry origins, and hinting per-
haps also at catasterism.[122] But this is a Christian firmament, where Newton's
arrival is hailed by the harps of angels, with whom the poet ambitiously aspires
to join his own song (5–11).

The poem begins, Thomson uses military imagery of Newton's intellectual conquests, as had
Lucretius in his praise of Epicurus; he makes explicit what is implicit in Lucre-
tius, the superiority of 'triumphs of the spirit'[123] to military triumphs (31–38):

And what the triumphs of old Greece and Rome,
By his diminished, but the pride of boys
In some small fray victorious! when instead
Of shattered parcels of this earth usurped
By violence unmanly, and sore deeds
Of cruelty and blood, Nature herself
Stood all subdued by him, and open laid
Her every latent glory to his view.

Lucretius's Epicurus subdues Religion (1.78: 'pedibus subiecta'), Newton, by
contrast, subdues Nature, but repeats Epicurus's 'laying open' of what was
hidden in Nature, in Thomson's Lucretian epigraph. The contrast between

121. Cf. 82: 'The Heavens are all his own'.
122. Cf. 200–201: '[thy country] glories in thy name; she points thee out / To all her sons,
and bids them eye thy star.'
123. See Buchheit 1971.

'shattered parcels of this earth' and 'all Nature' once more activates the perspectivalism of Cicero's *Dream of Scipio*.

Thomson's Newton takes off on his flight of the mind after his early gravitational calculations relating to the moon and the earth (57–65):

> Then breaking hence, he took his ardent flight
> Through the blue infinite;[124] and every star,
> Which the clear concave of a winter's night
> Pours on the eye, or astronomic tube,
> Far stretching, snatches from the dark abyss;
> Or such as further in successive skies
> To fancy shine alone, at his approach
> Blazed into suns, the living centre each
> Of an harmonious system[.]

This is a flight that follows first the unaided eye, then the eye aided by the telescope, and then, not the eyes of the mind, *oculi mentis*, as would be the case in a classical author, but fancy, imagination here elevated to burning scientific truth at Newton's approach.[125] Lucretius's Epicurus was the Greek man who first dared to raise up his eyes against the monster Religio and launch himself on a flight through the void. Newton notches up another first, doing what even Epicurus could not (76–81):

> He, first of men,[126] with awful wing pursued
> The comet through the long elliptic curve,
> As round innumerous worlds he wound his way;
> Till, to the forehead of our evening sky

124. Lucr. 1.70–71: 'effringere ut arta / naturae primus portarum claustra cupiret' (filling him with desire to be the first to burst the fast bars of nature's portals); 1.74: 'atque omne immensum peragrauit mente animoque' (and in his mind and soul he wandered through all the boundless void).

125. In contrast to the 'schools' who 'unawaken'd, dream beneath the blaze / Of truth. At once their pleasing visions fled, / With the gay shadows of the morning mix'd, / When Newton rose, our philosophic sun!' (87–90); cf. Thomson, 'Summer': 'Hence through her nourish'd powers, enlarged by thee, / She [the ennobled mind] springs aloft, with elevated pride, / Above the tangling mass of low desires, / That bind the fluttering crowd; and, angel-wing'd, / The heights of science and of virtue gains, / Where all is calm and clear; with Nature round, / Or in the starry regions, or the abyss, / To Reason's and to Fancy's eye display'd' (1736–43).

126. Lucr. 1.66: 'primum Graius homo' (It was first a man of Greece [Epicurus]). Newton showed that comets were subject to the same law of gravitation as the planets, and enabled Halley in 1682 to plot the orbit of the comet bearing his name, and to predict its return in 1758.

Returned, the blazing wonder glares anew,
And o'er the trembling nations shakes dismay.

In line 80, the participle 'returned' could be understood as referring to Newton (returning as did Epicurus from his space odyssey to 'bring back' (Lucr. 1.75: 'refert') the truth about the universe), until the following words make it clear that 'returned' goes with 'the comet'.[127] For a moment there is almost an identification of Newton with the celestial object; a few lines later he is metaphorically identified with another heavenly body: 'When Newton rose, our philosophic sun' (90).[128] John Hughes in his 1720 'The Ecstasy' also has a vision of the living Newton's soul soaring upwards as a 'shining meteor' (171). We might think of the comet that marked the apotheosis of Julius Caesar, as described by Ovid (Met. 15.844–51). Thomson sets the intellectual hero as high in the sky as a Roman emperor, 'stuck in the stars';[129] and, in the last lines of the poem, affirms Newton's claim to honours equal with royalty: buried in Westminster Abbey, Newton's 'sacred dust / Sleeps with her kings, and dignifies the scene.'

While Newton's sacred dust is enshrined in Westminster Abbey, his soul continues its sky-roaming, his natural philosophy converted to Christian hymns: 'now he wanders through those endless worlds / He here so well descried, and wondering talks, / And hymns their author with his glad compeers' (187–89). The Lucretian tension between travelling through infinity and achieving intellectual closure (see ch. 2: 37) is translated into Christian eschatology: Newton's soul, like the mind of Epicurus, 'wanders through . . . endless worlds', but at the same time it has reached its terminus, with its 'arrival on the coasts of bliss' (6). Newton may even have been metamorphosed, apotheosed, into angelic form, so that (193–99)

> mounted on cherubic wing
> Thy swift career is with the whirling orbs,

127. Edward Young equates the return of a comet with the second coming of Christ: *Night Thoughts* 4.706–16.

128. Lucr. 3.1042–44: 'ipse Epicurus obit decurso lumine uitae, / qui genus humanum ingenio superauit et omnis / restinxit, stellas exortus ut aerius sol' (Even Epicurus passed away, when his light of life had run its course, he who surpassed in intellect the race of man and quenched the light of all, as the rising ethereal sun quenches the stars).

129. Cf. Cowley's imitation of Horace, *Odes* 4.2.22–23, 'uiris animumque moresque / aureos educit in astra': 'He bids him live and grow in fame, / Among the stars he sticks his name' (see above: 142); and Young, *Night Thoughts* 9.1055–57: 'Bourbon! this wish how generous in a foe! / Wouldst thou be great, wouldst thou become a god, / And stick thy deathless name among the stars ..?' See ch. 5: 241.

Comparing things with things, in rapture lost,
And grateful adoration, for that light
So plenteous rayed into thy mind below,
From light himself; Oh, look with pity down
On humankind, a frail erroneous race!

The view from above is combined with the Lucretian and Virgilian pity of the didactic poet for his as yet unenlightened readership.[130]

Thomson returns to the model of the Lucretian flight of Epicurus's mind in book 3 of his poem *Liberty* (1735), in his praise of Pythagoras, the philosopher who came to the 'free states' of Italy, fleeing his 'native isle' (Samos) and 'a vain tyrant's [Polycrates's] transitory smile' (40–47):

His mental eye first launched into the deeps
Of boundless ether; where unnumbered orbs,
Myriads on myriads, through the pathless sky
Unerring roll, and wind their steady way.
There he the full consenting choir beheld;
There first discerned the secret band of love,
The kind attraction, that to central suns
Binds circling earths, and world with world unites.

Thomson's immediate point of departure is Ovid's description of Pythagoras's flight from tyranny in Samos and of Pythagoras's flight of the mind, introductory to the 'Speech of Pythagoras' at *Metamorphoses* 15.60–64 (see ch. 2: 79–80). Ovid there alludes to Lucretius's account of Epicurus's flight of the mind. In an example of 'window allusion', Thomson looks through the Ovidian lines to Ovid's own Lucretian model: 'first' (40) and 'boundless' (41, the Lucretian *immensum*) are not paralleled in the Ovidian passage. Newton's claim to primacy is thus qualified, and 'the kind attraction' suggests that the Pythagorean 'secret band of love' anticipates Newton's principle of gravitational attraction.[131]

When Lucretius's Epicurus returns from his flight through infinity, the terrors of the skies are neutralized. Thomson's comet returns, as predicted by Newtonian physics, and, again, 'o'er the trembling nations shakes dismay', an

130. Cf. Lucr. 2.14: 'o miseras hominum mentis, o pectora caeca' (O wretched minds of men, o blind hearts); Virgil, *Geo.* 1.41 (addressing Caesar): 'ignarosque uiae mecum miseratus agrestis' (pitying with me the rustics ignorant of the way).

131. McKillop 1942: 34–35.

example of Thomson's frequent contrast between the enlightened philosophic eye and the credulity of the ignorant crowd.[132] Comment on this is provided by a closely related passage in Thomson's 'Summer', published just a few months before the poem on Newton, in February 1727 (ll. 1706–24):[133]

Lo! from the dread immensity of space
Returning, with accelerated course,
The rushing comet to the sun descends;
And as he sinks below the shading earth,
With awful train projected o'er the heavens,
The guilty nations tremble. But, above
Those superstitious horrors that enslave
The fond sequacious herd, to mystic faith
And blind amazement prone, the enlightened few,
Whose godlike minds Philosophy exalts,
The glorious stranger hail. They feel a joy
Divinely great; they in their powers exult,
That wondrous force of thought, which mounting spurns
This dusky spot, and measures all the sky;
While, from his far excursion through the wilds
Of barren ether, faithful to his time,
They see the blazing wonder rise anew,
In seeming terror clad, but kindly bent
To work the will of all-sustaining Love.

Here the effect on the 'trembling nations' is even closer to the pre-enlightenment state of mankind in Lucretius, enslaved and enchained by superstitious fear of things that appear overhead in the sky, such as thunder and lightning: *religio* (literally something that 'binds')[134] is the noun used by Lucretius, but the near equivalent *super-stitio* is present in the etymological pun 'horribili **super** aspectu mortalibus in**stans**' (standing threateningly over mortal men with dreadful look) (Lucr. 1.65). 'Prone', in 'to mystic faith / And blind amazement prone' ('Summer' 1713–14) means 'inclined to', but also hints at

132. See Connell 2016: 195.

133. On Thomson's flights of poetic enthusiasm in *The Seasons*, see Irlam 1999: chs 4, 5.

134. Cf. 1.932: 'religionum animum nodis exsoluere pergo' (I proceed to free the mind from the bonds of religion).

the sense 'lying face downwards, prostrate'.[135] In contrast, those enlightened by 'philosophy', the natural philosophy of Newton, not the Epicurean philosophy of Lucretius, experience an irresistible upward motion, 'exalted' (1715; raised on high, *altus*), and 'exulting' (1717; literally 'leaping upwards': *exsulto*).[136] Philosophy brings them closer to the gods ('godlike minds', 'a joy divinely great'), or, rather, closer to the Christian god, whose 'all-sustaining Love' is manifested in the providential regularity of the return of comets, whose sudden and unpredicted appearance in the skies had been interpreted by the ancients as the sign of an angry and hostile divinity.

135. E.g., *OED* s.v.: '5b, 1748 S. Richardson *Clarissa* IV. xlii. 247 "This proves our spirit of the gods descent, / While that of beasts is prone and downward bent."' On bipedal man's heaven-bent gaze, see ch. 2: 46n39.

136. E.g., *OED* s.v.: '1, 1652 J. French *York-shire Spaw* iii. 36 "A fountain . . . doth at the sound of a pipe rejoicingly exult and leap up."'

4

Milton

For although a poet soaring in the high region of his fancies with his garland and singing robes about him, might without apology speak more of himself than I mean to do, yet for me sitting here below in the cool element of prose ...

JOHN MILTON, *THE REASON OF CHURCH-GOVERNMENT* (1642), BOOK 2, INTRODUCTION

IN JAMES THOMSON'S POETIC PRAISES OF NEWTON, the ancient sources are, as one would expect, in part mediated through more recent texts, not least Milton's poetry. Echoes leap out at the reader even moderately familiar with Milton, and my own reader may by now be impatient at my having skated over the Miltonic intertextuality in Thomson and some of the other authors discussed in the last chapter, as I followed Newton in his flight through the universe. Thomson hails Milton as the Muse for his own poetic flights, at 'Winter' 541–43: 'First of your kind! society divine! / Still visit thus my nights, for you reserved, / And mount my soaring soul to thoughts like yours.'

In this chapter, I take a step back in literary-historical time, and explore the celestial aspirations not just of *Paradise Lost*, but across the range of Milton's poetic output both in English and in Latin. One reason for devoting a separate chapter to a synoptic account of Milton is to point up his sustained attention to the vertical axis, with the attendant repeated launches into flight, across the whole of his poetic career, in a manner comparable to the continuity of these themes across the poetic career of Virgil (ch. 2: 63–78). Virgil's celestial aspirations had a massive influence on the post-Virgilian tradition, both antique and

post-antique, not least on Milton himself. Milton's celestial aspirations leave their traces through the following centuries of British poetry, as prominently in James Thomson as in any poet.

I start by filling in the Miltonic allusions in Thomson's praises of New-ton.[1] The clichéd penetration of Newton's mental vision is allusively enabled by the purgative power of the 'Holy Light' invoked by the blind Milton in the prologue to *Paradise Lost* 3. With lines 72–75 of 'To the Memory of Sir Isaac Newton'—'And O, beloved / Of Heaven! whose well purged penetra-tive eye / The mystic veil transpiercing, inly scanned / The rising, moving, wide-established frame'—compare *Paradise Lost* 3.51–55: 'So much the rather thou celestial light, / Shine inward, and the mind through all her powers / Irradiate, there plant eyes, all mist from thence / Purge and disperse, that I may see and tell / Of things invisible to mortal sight.' Thomson conflates the intellectual reach of Newton and Milton, and safely accommodates New-ton's scientific revelations within a Miltonic Christian world-view.[2] In lines 79–80 of Thomson's poem, 'Till, to the forehead of our evening sky / Re-turned, the blazing wonder glares anew', the comet lights up with the efful-gence of the day-star which at *Lycidas* 171: 'Flames in the forehead of the morning sky.' Milton is also present in the passage on the comet at 'Summer' 1714–19: 'the enlightened few / Whose godlike minds Philosophy exalts . . . feel a joy / Divinely great'; their 'wondrous force of thought . . . mounting spurns / This dusky spot.'[3] The enlightened few share Epicurus's superiority to superstition; but, in their philosophical exaltation they share, perhaps disturbingly, in the experiences of Satan and of those infected by Satan. Satan parodically aspires to the exaltation of the Son,[4] and plots to excite

1. On Thomson and Milton, see Griffin 1986: 179–202.

2. Lucretius is also a part of the intertextual mix, since the prologue to *Paradise Lost* 3 con-tains a number of Lucretian echoes, or at least parallels: see Hardie 2009: 266–68.

3. With 'This dusky spot', cf. *To the Memory of Sir Isaac Newton*: 'on this dim spot, where mortals toil / Clouded in dust' (13–14), alluding to Milton, *Comus*: 'the smoke and stir of this dim spot, / Which men call earth' (5–6), above which live 'those immortal shapes / Of bright aerial spirits . . . / In regions of calm and serene air' (2–4), in the masque's inaugural plotting of the vertical axis along which the moral plot of *Comus* will unfold. (Cf. also *PL* 5.266: 'A cloudy spot').

4. *PL* 2.5: 'Satan exalted sat'; 6.99–100: 'High in the midst exalted as a god / The apostate in his sun-bright chariot sat'. 'Exalt' occurs eleven times in *Paradise Lost*, elsewhere in positively evaluated contexts, as at 3.313–14: 'thy humiliation shall exalt / With thee thy manhood also to this throne'; cf. also Augustine, *City of God*: 'exaltat humilitas quae facit subditum Deo'

Adam and Eve 'With more desire to know, and to reject / Envious commands, invented with design / To keep them low whom knowledge might exalt / Equal with gods' (*PL* 4.523–26). In her Satanically inspired dream, Eve wonders 'at my flight and change / To this high exaltation' (5.89–90). In mounting and spurning this dusky spot, Thomson's enlightened few replicate the lofty, and admirable, contempt for our insignificant earth of the philosophically enlightened from Cicero's *Dream of Scipio* onwards, but they also risk the hubris of Satan as he breaks out of hell: 'At last his sail-broad vans / He spreads for flight, and in the surging smoke / Uplifted spurns the ground' (*PL* 2.927–29).[5] The experience of the enlightened few is also dangerously close to that of Adam and Eve immediately after eating the apple: 'They swim in mirth, and fancy that they feel / Divinity within them breeding wings / Wherewith to scorn the earth' (*PL* 9.1009–11).[6]

Newton is one of the non-royal, non-aristocratic, sky-soaring heroes of eighteenth-century British culture; Milton himself is the other. The two names are found linked, for example, in a poem addressed by Laetitia Pilkington

(humility elevates the heart in making it submissive to God) (14.13); on Milton's use of the paradoxes of humble exaltation, see Greene 1963: 388–90.

5. This is the only instance of 'spurn' in *Paradise Lost*. Earlier, Joseph Addison had thrillingly hinted at a Satanic ambition on the part of Milton himself in his *Account of the Greatest English Poets* (Milton): 'No vulgar hero can his muse engage, / Nor earth's wide scene confine his hallowed rage. / See! see, he upward springs, and towering high / Spurns the dull province of mortality, / Shakes heaven's eternal throne with dire alarms, / And sets the Almighty thunderer in arms' (58–63); with 'upward springs', cf. *PL* 2.1013 (Satan): 'Springs upward like a pyramid of fire' (see also ch. 5: 229). Shortly after the Lucretian passage on comets and superstition in 'Summer' (see ch. 3: 159), Thomson uses 'springs' of 'th' ennobled mind', 'enlarged' by Philosophy: 'She springs aloft, with elevated pride, / Above the tangling mass of low desires, / That bind the fluttering crowd; and, angel-winged, / The heights of science and virtue gains' (1738–41). 'Pride', even of the elevated kind, perhaps retains a trace of the Satanic. On the use of Miltonic similes for Satan in passages of 'straight description' in *The Seasons*, see Sambrook 1991: 100–101, noting the 'shadows' that they cast on Thomson's landscapes.

6. More innocent is the flight of the newly hatched and fledged birds at the creation: 'They summed their pens, and soaring the air sublime / With clang despised the ground' (*PL* 7.421–22), modelled perhaps on the flight of winged Virtue at Horace, *Odes* 3.2.21–24: 'Virtus, recludens immeritis mori / caelum, negata temptat iter uia, / coetusque uulgaris et udam / spernit humum fugiente penna' (Virtue opens a way to heaven for those who deserve not to die. She dares to take the forbidden path, spurning the vulgar throng and the dank earth with soaring wing [trans. D. West]). Milton's first birds may also be a figure for the sublime aspirations of the poet, punning on 'pens'.

(?1712–50) 'To the Reverend Dr [Stephen] Hales', a scientist regarded as second only to Newton in the eighteenth century (1–4, 43–50):[7]

> Hail, holy sage! whose comprehensive mind
> Not to this narrow spot of earth confined,
> Thro' numerous worlds can nature's laws explore,
> Where none but Newton ever trod before
>
> . . .
>
> In radiant colours truth arrayed we see,
> Confess her charms, and guided up by thee,
> Soaring sublime, on contemplation's wings,
> The fountain seek, whence truth eternal springs.
> Fain would I wake the consecrated lyre,
> And sing the sentiments thou did'st inspire!
> But find my strength unequal to a theme,
> Which asks a Milton's, or a seraph's flame.

Hales can follow Newton in his journeys through the heavens, but the poet Pilkington cannot follow Milton. The anxiety of influence experienced by post-Miltonic poets is expressed partly in terms of the inability to keep up with the sublime flights of Milton, who claims a central place in the tradition of celestial aspirations in English poetry. It is to Milton's 'soaring in the high regions of his fancies', in poetry if not in prose,[8] that I turn in this chapter. Here I consider Milton's attraction to vast and boundless spaces, both upwards towards the heavens and downwards towards hell, from the point of view of my themes of flights of the mind, ascension, and apotheosis—celestial aspirations, in short.

7. In Tucker 1996, at 88–90.

8. Amusingly, the 'seditious' qualities of Milton's prose writings are made the occasion for a contrast between his soaring poetry, and his hell-bound prose, in verses by Thomas Yalden, 'On the Reprinting Mr. Milton's Prose-Works, with His Poems Written in his *Paradise Lost*', *Oxford and Cambridge Miscellany Poems* (n.d. [1708]), p. 177: 'These sacred lines with wonder we peruse, / And praise the flights of a seraphic Muse: / Till thy seditious prose provokes our rage, / And soils the beauties of thy brightest page. / Thus here we see transporting scenes arise, / Heav'ns radiant host, and opening Paradise; / Then trembling view the dread abyss beneath, / Hell's horrid mansions, and the realms of Death' (cited in Connell 2016: 141).

The Science and Politics of the Vertical Axis

With Milton, the importance of considering the full vertical axis is paramount: movement upwards in the cosmos is always to be understood in the context of a total view of the universe, which valorizes upwards in relation to downwards, and vice versa. The point is made by Gordon Teskey:[9] 'Making poetry becomes for Milton a shamanistic art involving movement up and down on a vertical axis, or ladder, between Earth and Heaven and between Earth and Hell or, as he called them in the Latin poems, Olympus and Tartarus. In keeping with this view, he continually associates poetry with flying.' In this respect, Milton's poetic constructions are comparable to the grand ceilings which are the subject of chapter 6, in which apotheosis and ascension of the forces of virtuous order and concord are balanced against the downwards rush of the forces of disorder and discord, the outcome of cosmic struggles between good and evil. In this respect, also, Milton is a highly Virgilian poet, not least as a poet of *cosmos* and *imperium*, but the *imperium* is now the heavenly empire of the Christian god.

Milton's celestial aspirations are certainly fired in part by the intellectual developments of his day. An interest in the new astronomy of Galileo informs *Paradise Lost* at various points, most famously in the simile comparing Satan's massive shield to 'the moon, whose orb / Through optic glass the Tuscan artist views / At evening from the top of Fesole, / Or in Valdarno, to descry new lands, / Rivers or mountains in her spotty globe' (*PL* 1.287–91). The 'Tuscan artist' is Galileo, whom Milton claimed to have met when in Italy.[10] Marjorie Nicolson, wearing her hat of a historian of science, argued that Milton's imagination was stimulated by his own experience of looking through a telescope, which 'made *Paradise Lost* the first modern cosmic poem in which a drama is played against a background of interstellar space'.[11] For Nicolson, the vastly expanded universe revealed by the telescope prompted Milton's imaginative reach into the 'vast, unbounded deep'[12] of space.

But the new science is not the only thing that fired Milton's cosmic imagination. The 'vast, unbounded deep' is not just the new space revealed by the telescope, but the old space of the Lucretian boundless void. The description

9. Teskey 2015: 26.

10. *Areopagitica*, Milton 1953–82, 2: 538. For a recent discussion of the controversy over whether Milton did actually meet Galileo, see Butler 2005 ('must remain conjecture').

11. Nicolson 1956: 81; on Milton and contemporary notions of space, see also Martin 1996.

12. *PL* 10.471–72 (Satan): 'Voyaged the unreal, vast, unbounded deep / Of horrible confusion'.

of Chaos into which Satan launches himself on his flight towards the earth (*PL* 2.890–916), blazing a trail in aftertime for Epicurus (who, it turns out, was not in fact the first to break out in this way), is indebted in several particulars to Lucretius.[13] Recent work has made increasingly clear the importance of Lucretius for Milton, not least in a sensitivity to the sublimity of infinite space.[14] The affinity between Milton and Lucretius is recognized in one of the first responses to the Miltonic sublime, Andrew Marvell's 'On *Paradise Lost*', printed in the 1674 edition of the epic. In his praise of the power of Milton's mind and poetry, Marvell alludes to Lucretius's description of his reaction to the sublime cosmic vision triggered by the utterances of the divine mind of Epicurus (31–40):

> That majesty which through thy work doth reign
> Draws the devout, deterring the profane.
> And things divine thou treat'st of in such state
> As them preserves, and thee, inviolate.
> At once delight and horror on us seize,
> Thou sing'st with so much gravity and ease;
> And above human flight dost soar aloft,
> With plume so strong, so equal, and so soft.
> The bird named from that Paradise you sing
> So never flags, but always keeps on wing.

The 'delight and horror' echoes Lucretius's response to the revelation of the Epicurean universe, culminating in the vertiginous downward glance into the infinite void: 'At all this a kind of godlike delight and horror seizes me, to think that nature by your power is laid thus visibly open, unveiled on every side' (his ibi me rebus quaedam diuina uoluptas / percipit atque horror, quod sic natura tua ui / tam manifesta patens ex omni parte retecta est) (Lucr. 3.28–30).[15]

13. See Hardie 2009: 265 n. 8.

14. Hardie 2009; Norbrook 2013; Quint 2014, ch. 3, 'Fear of Falling: Icarus, Phaethon, and Lucretius'; Ellenzweig 2014.

15. The lines chosen by James Thomson for the epigraph of *To the Memory of Sir Isaac Newton*. Marvell's use of the analogy between poem and universe is complicated by his allusion to Ben Jonson's commendatory poem 'To my Chosen Friend, the Learned Translator of Lucan, Thomas May, Esquire', in which Jonson develops an analogy between poetic and cosmic disorder: see Shifflett 1998: ch. 4. Lucan's visions of the end of the world are already indebted to Lucretius, as both Milton and Marvell may have recognized. Further parallels exist between Marvell's poem and the proem to Lucretius 3: both use the image of the poet as bird; both refer

Marvell looks upwards as well, to the lofty flight of Milton's song that, in the words of the prologue to *Paradise Lost*, 'with no middle flight intends to soar / Above the Aonian mount' (1.14–15). 'Majesty' is an Anglicization of the *maiestas* (greatness), that Lucretius ascribes to Epicurus's subject-matter: 'Who is able with powerful breast to compose a song equal to the greatness of these things and equal to these discoveries?' (Quis potis est dignum pollenti pectore carmen / condere pro rerum maiestate hisque repertis?) (Lucr. 5.1–2); 'For if we must speak as the acknowledged greatness of the things itself demands, a god he was, a god, most noble Memmius' (nam si, ut ipsa petit maiestas cognita rerum, / dicendum est, deus ille fuit, deus, inclute Memmi) (7–8). Milton's flight, like that of the bird of paradise (thought to be perpetually airborne),[16] is unflagging, so achieving a sustained sublimity that will often prove beyond the powers of lesser poets (for the topos of failed flight, see ch. 5: 211–17).

Marvell stops short of calling Milton a god (that would be to risk the sin of Satan), and looks instead to the image of kingship. The 'reign' of the 'majesty' of Milton's poem challenges the majesty of kings, as Marvell acknowledges Milton's anti-royalism. This is a greatness—and sublimity—to supplant that of kings, as Epicurus's reason overthrows Religio.[17] Marvell is as alert to the politics of the Miltonic vertical axis as he is to its aesthetics.

Marvell may also have had in mind the republican reading of the Lucretian atomic system in Edmund Waller's 'To his Worthy Friend Master Evelyn upon His Translation of Lucretius', in John Evelyn, *An Essay on the First Book of T. Lucretius Carus De rerum natura* (London, 1656). Marvell's Lucretianizing

to the futility of competition on the part of other poets. At lines 33–34, Marvell writes, 'And things divine thou treat'st of in such state / As them preserves, and thee, inviolate'; at *On the Nature of Things* 3.18–24, Lucretius describes the Epicurean revelation of the inviolate dwellings of the blessed gods (note esp. 20–21: '[which] snow congealed with sharp frosts does not harm [uiolat]'); the *content* of Lucretius's theology is of course a violation of Christian truth. 'sublimis' is the epithet chosen by Ovid to characterize Lucretius in his catalogue of Greek and Roman poets at *Amores* 1.15.23.

16. Bird of Paradise: *OED* s.vv. cites, e.g., '1638 Bp. J. Wilkins *Discov. New World* (1684) i. 175 "The Birds of Paradise ... reside constantly in the air"; a1649 R. Crashaw *Carmen Deo Nostro* (1652) f. a. ijv, "With heavenly riches: which had wholly called his thoughts from earth, to live above in th' air / A very bird of paradise."'

17. Norbrook 2013 also notes the trampling underfoot of regal *maiestas* at Lucr. 5.1136–39; he observes further that Marvell's closing lines, 'Thy verse ... needs not rhyme', are immediately followed in the 1674 edition by Milton's note on 'The verse', proclaiming the 'ancient liberty recovered to heroic poem from the troublesome and modern bondage of rhyming'. Milton's blank verse flies high and free.

praise of Milton also shares the imagery of soaring flight in Waller's poem (1–6, 9–18, 21–29):[18]

> Lucretius with a stork-like fate,
> Born and translated in a state,
> Comes to proclaim in English verse
> No monarch rules the universe;
> But chance and atoms make this All
> In order democratical
>
> . . .
>
> And this in such a strain he sings,
> As if his Muse with angel's wings
> Had soared beyond our utmost sphere,
> And other worlds discovered there;
> For his immortal boundless wit
> To nature does no bounds permit;
> But boldly has removed those bars
> Of heaven, and earth, and seas and stars,
> By which they were before supposed
> By narrow wits to be inclosed
>
> . . .
>
> So vast this argument did seem,
> That the wise author did esteem
> The Roman language (which was spread
> O'er the whole world, in triumph led)
> A tongue too narrow to unfold
> The wonders which he would have told.
> This speaks thy glory, noble friend!
> And British language does commend;
> For here Lucretius whole we find[.]

Waller applies to Lucretius the terms of Lucretius's praise of Epicurus (see ch. 2: 36–37): flight beyond the bounds of our world to discover new worlds; the boundlessness of nature matched by the boundlessness of the poet's wit; liberation from the bars that imprisoned lesser wits; and the image of triumph, transferred from Epicurus's conquest of nature to the language of imperial Rome,

18. Evelyn 1656: 3, discussed by Cottegnies 2016 at 186–87. 'Stork-like' alludes to the notion that storks are only found in republics.

Latin, whose worldwide diffusion was paradoxically too narrow for Lucretius to be able to express the wonders of Epicureanism (referring to Lucretius's complaint at the poverty of the Latin language at *On the Nature of Things* 1.136–39), whereas Evelyn's English is fully adequate to convey Lucretius.

Baroque Spaces

Milton's vast cosmic spaces and the violent actions that unfold across them—the Fall of the angels and the war in heaven—have also been read in another contemporary context, as manifestations of a baroque aesthetic.[19] The expanded view out into the cosmos that resulted from the new astronomy of the sixteenth and seventeenth centuries may have contributed to the fashion for the 'boundless' ceiling frescoes of the baroque in which the eye is swept up through illusionist architecture (*quadratura*) opening up into heavenly spaces, in works by Pietro da Cortona (1596/97–1669) and his students Giovanni Battista Gaulli (1639–1709) and Andrea Pozzo (1642–1709).[20] Scholars have speculated on the impact on Milton of what he may have seen when he was in Florence, Rome and Venice during his Italian trip of 1638/39: for example, Andrea Sacchi's *Divine Wisdom* (1629–33) in the Palazzo Barberini (Fig. 4.1), or Cortona's '*Triumph of Divine Providence* (1633–39) on the ceiling of the Salone of the same.[21] Could Milton *not* have been familiar with Rubens's ceiling in the Banqueting House in Whitehall (see ch. 6: 268–75)?

19. Bottrall 1950; Roston 1980: ch. 1, 'The Baroque Vision'.

20. On ceiling paintings in Italian churches, see Poensgen 1969; England 1979.

21. Milton and baroque ceilings: see Revard 2001: 209 on a possible link between Milton's Urania and Sacchi's *Divina Sapientia* on the vault of Palazzo Barberini salotto: in February 1639 Milton was invited to a musical performance at the Palazzo Barberini; see Byard 1978: 136: 'It is almost as if Sacchi had created an emblem for *Paradise Lost* to illustrate the grandeur and immensity of Milton's theme: divinely inspired from above, Wisdom-Urania points downwards over the "vast abyss" to the "pendant world". Sacchi in his triumph painting and Milton in his poem have had the same vision'; see also the important article by Treip (1991). The palaces of Whitehall and Greenwich were both opened to the public after 1649, but Milton may have known them earlier through association with the musician Henry Lawes. Frye (1978: ch. 12, 'Infinite Space and the Paradise of Fools') reads Milton's Paradise of Fools as a *reductio ad absurdum* of ceiling paintings of apotheosis, an English example of which was the lost *Apotheosis of the Duke of Buckingham* by Rubens, satirized, together with Gerrit van Honthorst's depiction of Buckingham in the guise of Mercury in his painting of *Apollo and Diana*, after Buckingham's assassination, in the pamphlet *Felton Commended* (see ch. 6: 284–85). On Sacchi's *Divine Wisdom*, see Scott 1991: ch. 4.

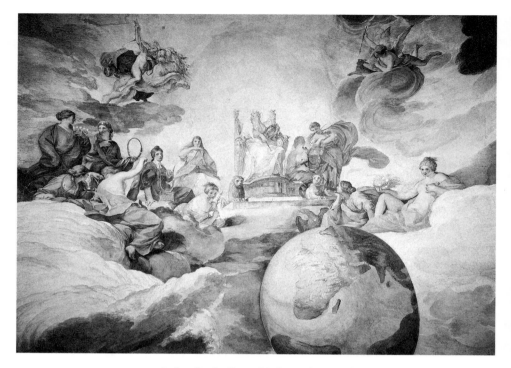

FIGURE 4.1. Andrea Sacchi, *Divine Wisdom*, Palazzo Barberini, Rome.
Luisa Ricciarini / Bridgeman Images.

Milton's Early Poetry

Milton's space explorations start early in his career.[22] A series of early satirical Latin epigrams on the Gunpowder Plot rings changes on the conceit that Guy Fawkes and the Pope were trying to blow James I up to heaven.[23] They

22. Collins 1984: 38: 'much of his early poetry was . . . concerned with . . . "ascending and descending" through supernal cosmic planes of activity'; 51: 'Milton's early cosmos was a set of spiritual planes ranging from the earthly to the divine. . . . It was, on the whole, a hopeful model of reality: the only direction one could go was up and upward flights were what his early poetry so often celebrated.' Collins also examines at length the images of fall, of Vulcan from heaven to Lemnos and of the living Amphiaraus's plunge into the underworld, applied in a double simile to the young Milton's sensations at losing sight of a beautiful girl in a crowd, at *Elegia septima* 81–84: these are anticipations of later Miltonic images of cosmic falls from heaven (Collins 1984: 43–51).

23. Date unknown, but 13.5 suggests after the death of James (27 March 1625).

combine biblical with classical allusion: the explosion would have carried the king up in a sulphureous chariot with flaming wheels, like the chariot of fire that carried up Elijah (12.5–8 Carey-Fowler, in their continuous numeration of Milton's poems).[24] The Pope's plan to use fire to send James up to the starry citadels of the sky was in revenge for the Protestant king's derision of the doctrine of purgatorial fire, without which, for a Roman Catholic, it is not possible to 'approach the house of the gods' (14). Milton tells the Pope rather to blow foul monks' cowls up to heaven that way (13).[25] On the classical side of things, the image of James's scorched shade, 'umbra perusta', going up to the aether, had the plot succeeded (still 14), is reminiscent of the charred Empedocles in Lucian's *Icaromenippus* (13), one of the Lucianic dialogues that founded the science-fiction genre of journeys to the moon (see ch. 2: 100). The space-travelling Menippus discovers Empedocles on the moon, whither he was blown after hurling himself into Etna, wishing to be taken for a god.[26] In epigram 13 (again) Milton assures the Pope that 'James has indeed gone to his kindred stars without your help, late in time [serus]'. This combines the classical idea of man's kinship with the stars with a cliché of imperial apotheosis: the wish that the ruler should only return to the heavens after a lengthy stay on earth, *serus*.[27]

A non-satirical clerical translation to the skies, in another of Milton's early Latin poems, is the lengthy description of a journey to the heavens in the mouth of the spirit of the dead bishop of Ely (Nicholas Felton, d. 5 October 1626). Beginning at line 48, 'ad astra sublimis feror' (I am carried on high to the stars), the bishop tells of his post-mortem ascent, free of the prison-house of the body, past sun and moon, the planets, the Milky Way, to the ineffable delights of heaven. He marvels at the strange swiftness of his passage (61: 'uelocitatem saepe miratus nouam'), like that of the progress of Elizabeth

24. For more detailed commentary on Milton's Latin poems, see Lewalski and Haan 2012, noting neo-Latin as well as classical parallels. On the importance of the 'translated saints', Enoch and Elijah, assumed in body and soul from earth to heaven, both for Milton's adoption of a heretical mortalism, and for his poetic imagination, see Kerrigan 1975 (a reference I owe to David Quint).

25. For the use of a satirical elevation to the skies in anti-Papist literature, compare John Donne's *Ignatius His Conclave* (1611): see ch. 3: 128–30.

26. Empedocles turns up in the Limbo of Vanity at *PL* 3.469–71.

27. See Nisbet and Hubbard 1970 on Horace, *Odes* 1.2.45: 'serus in caelum redeas'. On Milton's use, parodical and otherwise, of the classical traditions of apotheosis, see Steadman 1984.

Drury's soul in Donne's 'Second Anniversary'.[28] Biblical and classical chariots of fire allusively carry the bishop upwards: he compares himself to Elijah,[29] and, unlike Ovid's charioteer of the skies, Phaethon, who panics when he gets too close to the monsters that populate the heavens as constellations, the bishop is not afraid of the claws of Scorpio (*Met.* 2.195–200), or the sword of Orion.[30] In later works, Milton is very aware of the dangers of flying without a pilot's licence.

Milton airs his own celestial aspirations as a poet in a number of early poems in both Latin and English. In 'At a Vacation Exercise' (1628), he looks to his native language English (32–44) to

> clothe my fancy in fit sound:
> Such where the deep transported mind may soar
> Above the wheeling poles, and at heaven's door
> Look in, and see each blissful deity
> How he before the thunderous throne doth lie,
> Listening to what unshorn Apollo sings
> To the touch of golden wires, while Hebe brings
> Immortal nectar to her kingly sire:
> Then passing through the spheres of watchful fire,
> And misty regions of wide air next under,
> And hills of snow and lofts of piled thunder,
> May tell at length how green-eyed Neptune raves,
> In heaven's defiance mustering all his waves.

The English that here clothes Milton's fancy is more particularly the high-flown English of Josuah Sylvester's version of the French of Du Bartas. Milton tries on for size Sylvester's description of a flight of the mind at *Divine Weeks* 1.6.831–56 (see ch. 3: 108).[31] This is also the journey enabled, in Du Bartas's poem 'L'Uranie', by the celestial Muse Urania, who, in Sylvester's translation, 'human-kind above the poles transport[s], / Teaching their hands to touch, and eyes to

28. Cf. also Theophila's vision of the progress of her soul in Edward Benlowes, *Theophila, or, Loves Sacrifice* (1652), canto 5, xlii–lxvii: see ch. 3: 134.

29. The comparison to Elijah is closely reminiscent of a neo-Latin poem by Hieronymo Aleander, Jr, *In obitum Io. Vincentii Pinelli*, 45–52: see Lewalski and Haan 2012: 465.

30. On Milton's use of the story of Phaethon, see Kilgour 2012: 264–72, 'Falling Poets'; on Phaethon and *Paradise Lost*, see 183 below.

31. On Milton's use of Du Bartas, see Taylor 1934; Auger 2019: 189–201.

see / All th' intercourse of the celestial court' (Sylvester, *Urania, or the Heavenly Muse* 53–56). Urania is the Muse who will lead the poet up 'Into the heav'n of heav'ns' in the proem to book 7 of *Paradise Lost* (see below: 181). Milton's flight of fancy brings him into the presence of the pagan Jupiter and his court; he also swerves from Sylvester in diving down after soaring up, back down through the elements, fire, air, water. This passage of 'At a Vacation Exercise' is also very close to a prose passage in Milton's third *Prolusio*, in which he encourages his fellow students to undertake, 'as if with your eyes', a tour of the surface and depth of the earth, and of the meteorological and celestial phenomena above.[32] There Milton has his own eye on a passage by the 'thrice great Hermes' ('Il penseroso' 88), in *Corpus Hermeticum* 11.20b, presumably also a source additional to Sylvester in 'At a Vacation Exercise'. Here the full vertical axis, from heaven to hell, is not spanned, but in the line 'In heaven's defiance mustering all his waves' there is a pre-echo of Satan's mustered millions in hell, '[h]urling defiance toward the vault of heaven' in *Paradise Lost* (1.669).

In his *Elegia quinta*, 'On the Arrival of Spring' (?spring 1629), Milton describes the return of a spiritual, poetic, *furor* that proceeds in tandem with the bursting forth of sexual desire in the natural world, hinting at a fusion of the erotic and the poetic. With the epiphany of Apollo, god of poetry, 'My mind is rapt to the heights of the clear sky, and, freed from my body, I travel through the wandering clouds' (iam mihi mens liquidi raptatur in ardua caeli, / perque uagas nubes corpore liber eo) (15–20). The young poet enters the shady caves of the bards; 'The innermost sanctuaries of the gods are open to me, and my spirit gazes at what is happening in the whole of Olympus' (et mihi fana patent interiora deum, / intuiturque animus toto quid agatur Olympo). His view encompasses the depths as well as the heights of the universe, spanning the whole vertical axis: 'Dark Tartarus does not escape my eyes' (nec fugiunt oculos Tartara caeca meos).

In the defence of his poetry *Ad patrem* (variously dated from 1631 to 1645), Milton asserts that there is no clearer proof of the heavenly origin of the soul than poetry. 'When we [poets] make our way back to our celestial homeland . . . we will travel through the heavens wearing golden crowns, uniting our sweet songs to the charming voice of the lyre, to which the stars and the vaults of both hemispheres will resound' (Nos etiam patrium tunc cum repetemus Olympum, / . . . / Ibimus auratis per caeli templa coronis, / Dulcia suauiloquo sociantes carmina plectro, / Astra quibus, geminique poli conuexa sonabunt)

32. Milton 1953–82, 1: 246–47; on the Hermetic source, see Allen 1970: 14–16.

(30, 33–35). Milton combines Lucretian and Ovidian phrasing, and the classical music of the spheres, with the biblical imagery of the four and twenty elders with their golden crowns and harps in Revelation (4:4, 5:8).

In the closing lines of *Mansus*, Milton combines the motifs of the virtuous soul's posthumous journey to heaven with the post-mortem recognition of the poet's fame. His wish is that he too will find a friend such as Giovanni Battista Manso (whom he had met in Naples at the end of 1638) has been to Torquato Tasso, one who will glorify him as Manso did Tasso, and who at his death would see to his burial and perhaps make a marble bust of the dead poet, wreathing it in Venus's myrtle or Apollo's laurel. Milton concludes by imagining his own posthumous removal to the heaven, 'whither toil, purity of heart, and fiery virtue convey' (quo labor et mens pura uehunt, atque ignea uirtus) (96);[33] where, in a smiling serenity comparable to the laugh, or smile, with which the soul of Pompey looks down at his headless body in Lucan's *Civil War* (9.14; see ch. 2: 55–56), he will enjoy the view from above, looking down on the friend's services, and applaud himself, 'and smiling with complete serenity of mind, my face will be suffused with blushing radiance, and at the same time with joy will I applaud myself on heavenly Olympus' (et tota mente serenum / ridens purpureo suffundar lumine uultus / et simul aethereo plaudam mihi laetus Olympo)[34] (98–100; translations by Estelle Haan). This is a remarkable display of narcissistic self-congratulation, if we compare the applause granted by the angels to the soul of the bishop of Winchester in *Elegia tertia*: 'the heavenly ranks with their bejewelled wings applaud' (agmina gemmatis plaudunt caelestia pennis) (59).

33. Haan, in Lewalski and Haan 2012, ad loc. compares *Aen.* 6.130: 'ardens euexit ad aethera uirtus' ([those whom] blazing virtue raised to the heavens); Lucan 9.7–9: 'semidei manes . . . quos ignea uirtus / innocuos uita patientes aetheris imi / fecit, et aeternos animam collegit in orbes' (semi-divine shades, whose fiery virtue, after their blameless lives, has fitted them to endure the lower part of the aether, and has brought their souls to the eternal spheres [now joined by the soul of Pompey]); *Comus* 1018–20: 'Love virtue, she alone is free, / She can teach ye how to climb / Higher than the sphery chime.'

34. For 'mihi (sibi) plaudere', cf. Horace, *Sat.* 1.1.66–67 (a miser speaks): 'at mihi plaudo / ipse domi, simul ac nummos contemplor in arca' (But as soon as I look at the coins in my chest, I applaud myself at home); Ovid, *Met.* 6.97 (a bird-metamorphosis): 'ipsa sibi plaudat crepitante ciconia rostro' (the stork applauds itself with clattering beak). Haan compares Milton, *Prolusio* 6: 'Atque hercle non possum ego nunc quin mihi blandiuscule plaudam qui vel Orpheo, vel Amphione multo sim meo judicio fortunatior' (By Hercules I cannot stop myself from applauding myself in a somewhat flattering way, since I judge myself to be much more fortunate than Orpheus or Amphion).

A connection between the flight to heaven of the soul of the dead and the sky-reaching ambition of the poet is also engineered in Milton's two pastoral laments, *Lycidas* in English (November 1637), and *Epitaphium Damonis* in Latin (late 1639, a lament for Charles Diodati who died in August 1638). Both poems combine the motif of the resurrected pastoral hero, based on the celestial apotheosis of the dead Daphnis in Virgil's fifth *Eclogue* (see ch. 2: 65), with the pastoral poet's own heavenward ambitions and impulses. In *Lycidas*, Milton seeks to transmute the sky-reaching *fama* of Homer and Virgil (see ch. 2: 52–53) into something free of the smear of earthly fame. 'Fame is the spur that the clear spirit doth raise / (That last infirmity of noble mind) / To scorn delights, and live laborious days' (70–72). The ironic qualification of line 71 is transcended in the words of Phoebus Apollo, echoing the instructions of Apollo, god of poetry, to the pastoral poet Virgil at the beginning of *Eclogue* 6,[35] a poem that climaxes with the elevation of the poet Gallus to the heights of Mount Helicon in a poetic initiation. Milton's Phoebus speaks of a fame that is raised to the heights of the supreme god, where the mortal judgements embodied in fickle fame are elided with the immutable truths of the Last Judgement: 'Fame is no plant that grows on mortal soil / . . . / But lives and spreads aloft by those pure eyes, / And perfect witness of all-judging Jove; / As he pronounces lastly on each deed, / Of so much fame in Heav'n expect thy meed' (78, 81–84). At the end of *Lycidas*, the poet tells the shepherd to weep no more, since Lycidas is not dead. Just as the sun sinks each day in the Ocean bed, but each day rises, 'and with new spangled ore / Flames in the forehead of the morning sky: / So Lycidas sunk low, but mounted high' (170–72), elevated (permanently) to heaven through the might of the resurrected Christ.

The Latin *Epitaphium Damonis* is a lament for Milton's closest childhood friend, Charles Diodati, far closer to Milton than was Edward King, the fellow of Christ's College who wears the pastoral mask of 'Lycidas'. The *Epitaphium* is about a love which survives the grave and transcends the earthly world, and also about Milton's poetic ambition to write an epic in English, not Latin, for which he dares to hope for at least an insular, if not continental, fame (162–78). The poem closes with an ecstatic image of Damon-Diodati raised to the heavens in a Dionysiac–Christian celebration where choirs and lyres sound out in a Platonic musical-erotic *furor* (198–219; corresponding to Lycidas's ascension

35. With *Lycidas* 77, 'Phoebus replied, and touched my trembling ears', cf. Virgil, *Ecl.* 6.3–4: 'Cynthius [Apollo] aurem / uellit et admonuit' (Apollo tweaked my ear, and gave the following advice).

to the company of 'the saints above' at the end of *Lycidas*). A transition to that finale is effected through the ecphrasis, or description, of two cups given to Milton by his Italian friend Giovanni Battista Manso. Milton says he had been keeping the cups for Damon before he learned of his death. The cups in fact are artistic materializations of literary works by Manso, the *Poesie nomiche*, which included a poem on the phoenix, and the *Erocallia*, Platonic dialogues about love and beauty. Here text and image are interfused in Miltonic musings on apotheosis and flights to heaven. The ecphrastic images of phoenix and the Celestial Cupid are mythological and Platonic shadows of the transcendental reality of Damon's elevation to a biblical and Christian heaven. They are also shadows of Milton's own celestial urgings as a poet.

A connection between erotic desire and the desire for sky-reaching fame through poetic achievement is also hinted at in a rare diminutive,[36] used by Milton in the *Epitaphium* to avert envy in speaking of his epic ambitions: 'dubito quoque ne sim / turgidulus' (I am anxious lest I am a little swollen/puffed up/swollen-headed) (159–60). In a Latin letter of 23 September 1637 to Diodati (whose name is Graecized as Theodotus), Milton hesitatingly broaches his literary ambitions:

> Hear, Theodotus, but let it be in your private ear, lest I blush; and allow me for a little to speak grandly with you [apud te grandia loquar]. You ask, what am I thinking of. By the good God, immortality. And what am I doing? Growing wings and meditating flight [πτεροφυῶ, et uolare meditor]; but as yet our Pegasus raises himself on very tender pinions. Let us be humbly wise [humile sapiamus].[37]

πτεροφυῶ is the Platonic coinage used in the *Phaedrus* of the sprouting of wings in the soul inspired with an erotic madness at the sight of beauty— teething pains accompanied by itching and swelling.[38] Knowledge of this

36. The very rare *turgidulus* is found in one of Catullus's sparrow poems, Cat. 3: 'tua nunc opera meae puellae / flendo turgiduli rubent ocelli' (17–18; Lesbia weeping for the death of a winged creature!).

37. For a later example of 'humbly wise' used in the context of a celestial aspiration, cf. Henry Mackenzie (1745–1831), *The Pursuits of Happiness, Inscribed to a Friend* (1771), p. 24: 'Cease then to chase the meteor as it flies, / Be humbly happy, and be humbly wise.'

38. *Phaedrus* 251c4, 255d2. Cf. the *Phaedrus* imagery in Milton's *Of Reformation* (Milton 1953–82, 1: 520, 522): through carnal imagination, the imagination that would bring 'the inward acts of the Spirit to the outward, and customary eye-service of the body', the soul 'bated her wing apace downward: and finding the ease she had from her visible, and sensuous colleague

private text exchanged between Milton and Diodati allows us to make a link between the 'swelling' of Milton's British epic ambitions and the elevation of Damon on the wings of love as scripted in Manso's Neoplatonic dialogues.

The Platonic image of the soul's sprouting of wings is used of the flight of Contemplation, perhaps with a glance at Spenser's 'An Hymne of Heauenly Beautie' (see ch. 3: 111), at *Comus* 375–80: 'And Wisdom's self / Oft seeks to sweet retired Solitude, / Where with her best nurse Contemplation / She plumes her feathers, and lets grow her wings / That in the various bussle of resort / Were all too ruffl'd, and sometimes impair'd.' Contemplation is a soaring cherub at 'Il penseroso' 51–54: 'But first, and chiefest, with thee bring / Him that yon soars on golden wing, / Guiding the fiery-wheeled throne, / The Cherub Contemplation.'

Paradise Lost

Milton's celestial aspirations are given their freest rein in the vast cosmic spaces of *Paradise Lost*. Comparing Milton's major epic with the romance epic of Edmund Spenser, the poet whom Milton is reported to have called his 'original', Paul Hammond observes, 'Whereas *The Faerie Queene* is imagined horizontally, as befits a quest narrative, *Paradise Lost* is visualized along a vertical axis, from high to low, with many of its characters, including its narrator, moving up and down'.[39] Milton follows Virgil in exploring the heights and depths of the full vertical axis of his universe (see ch. 2: 63–78), but with a vertiginous sublimity that leaves the Roman poet trailing in his flight-path.[40] The subject of Milton's major epic is falling and ascending, a narrative in which 'the physical is always a mode of the spiritual'.[41] The spiritual fall of man is the consequence of

the body in performance of religious duties, her pineons now broken, and flagging, shifted off from her self, the labour of high soaring any more, forgot her heavenly flight'.

39. Hammond 2017: 126.

40. On the Christianization of the Virgilian vertical axis in two neo-Latin epics well known to Milton, Sannazaro's *De partu Virginis* and Vida's *Christiad*, see Hardie 2018: 223–27. Note, for example, Vida's rewriting of the plot of Virgil's epic hero in the seven-line first sentence of the *Christiad*: Vida's hero descends from heaven in order 'to lead the shades of the pious into heaven', where *Christiad* 1.7, 'manesque pios inferret Olympo', translates to the vertical Aeneas's goal on the horizontal axis, 'inferretque deos Latio' (to bring the gods into Latium) (*Aen.* 1.6).

41. Hammond 2017: 127. Hammond's chapter 12, 'Fall', discusses the imagery and allegorical meaning of falling and rising in *Paradise Lost*, and contrasts legitimate and sinful forms of aspiration. Cf. Quint 2014: 85: '[*Paradise Lost*] returns again and again to the opposition of flying and

the physical fall of the rebel angels, 'Hurled headlong flaming from the ethereal sky / With hideous ruin and combustion down / To bottomless perdition' (*PL* 1.45–47). Satan and his fellow-devils refuse to believe that they cannot 'reascend . . . and repossess their native seat' (1.633–34), but this they will no more be able to achieve than will, in later time, the Titans and Giants cast down by the Olympian gods of Greece,[42] even if, on leaving Chaos, Satan 'With fresh alacrity and force renewed / Springs upward like a pyramid of fire' (2.1012–13). Fire's proper motion is upwards, in the Aristotelian scheme of the natural places of the four elements,[43] but the analogy is now imperfect for a being who has lost his right to return to his native home above. That is the error in Moloc's earlier exhortation to his fellows to 'bethink them . . . / That in our proper motion we ascend / Up to our native seat: descent and fall / To us is adverse'(2.73–77). Moloc continues, 'The ascent is easy then' (81), misremembering the Virgilian intertext 'facilis descensus Auerno' (easy is the descent to the underworld)' (*Aen.* 6.126). A little before this, Satan may have another classical intertext in mind when he claims, 'From this descent / Celestial virtues rising, will appear / More glorious and more dread than from no fall' (*PL* 2.14–16). In Horace, *Odes* 4.4, Hannibal complains that the Romans rise stronger from defeat: 'plunge them in the deep, they come out more splendid' (merses profundo, pulchrior euenit) (65). The sequence of destruction followed by resurgence, the pattern of Roman legend and history from the time that the sack of Troy was followed by the foundation of Rome, will be repeated

falling.' On the vertical axis in Milton, see Cope 1962: ch. 3, 'Time and Space as Miltonic Symbol'; MacCaffrey 1959: ch. 3, 'Structural Patterns in *Paradise Lost*'; ch. 4, 'Scenic Structure in *Paradise Lost*'; Greene 1963: 387–95, on the imagery of height and depth, rising and falling, in *Paradise Lost*, woven 'into a fabric of multitudinous references . . . which appear on virtually every page and bind every incident of the narrative into a closer unity'; Fish 1967: 94–96, on 'relationships between physical-spatial concepts and moral ones', in words such as 'highly', 'fall', 'aspiring', 'down'; Steadman 1984: 167–89; Borris 1990.

42. On Milton's use of the classical myths of Titanomachy and Gigantomachy, see Labriola 1978.

43. For the image applied to the human spirit, cf. Richard Blackmore *Creation* 7.208–9 (the human mind): 'She moves unwearied, as the active fire, / And, like the flame, her flights to heav'n aspire'; Joseph Trapp, *Thoughts upon the Four Last Things* 3 ('Heaven'), 512–19: 'But as we see the mounting flames aspire, / To meet, and mix with elemental fire; / So souls, inspired by virtue, upwards move, / And mingle with their kindred minds above; / By their own proper motion seek the sphere / Of endless happiness, and centre there: Happy they were ev'n in themselves before; / And only heav'n's full joys can bless them more.'

in the Judaeo-Christian story; not however in the narrative of the fallen angels, but in the *felix culpa* of fallen man.[44]

The story of mankind after the Fall is one firstly of repentance and regeneration, inaugurating the eventual reversal of the Fall through an interplay of descent and ascent. At the beginning of *Paradise Lost* 11, 'Prevenient grace descending' (3) softens the hearts of Adam and Eve, with the result that their prayers become 'winged for heaven with speedier flight', and fly up to heaven they do, to arrive 'Before the Father's throne' (20).[45] Finally man will be redeemed by Christ, who, after the crucifixion, 'to the heaven of heavens . . . shall ascend / With victory' (12.451–52), so opening the way for mankind's ascent to heaven. A formulation earlier in *Paradise Lost* 12 of the ascent of Christ as cosmic ruler rewrites one of Virgil's boldest statements of the sky-reaching extent of Roman imperial power: 'he shall ascend / The throne hereditary, and bound his reign / With earth's wide bounds, his glory with the heavens' (12.369–71). Michael appropriates Jupiter's prophecy at *Aeneid* 1.287 of the destiny of a human ruler (Julius Caesar):[46] 'Whose empire Ocean, and whose fame the skies / Alone shall bound [Dryden's translation]' (imperium Oceano, famam qui terminet astris). (This is followed by Jupiter's promise to Venus that she will receive Julius in the sky.) The Virgilian line appears in its original Latin, for example, on the scroll held by Fame above the head of the king in Antonio Verrio's *The Sea-Triumph of Charles II* (c. 1674) (Fig. 6.21).

These journeys up and down the vertical axis of the cosmos are tracked by the poet himself. On to his biblical narrative of fall and ascent Milton bolts images of poetic flight and ascent that go back to classical antiquity. He proclaims his poetic ambition in the prologue, invoking the aid of the 'heavenly Muse' for his 'advent'rous song, / That with no middle flight intends to soar /

44. The text of Horace, *Odes* 4.4.65 has been questioned: Robin Nisbet (Nisbet 1995: 199) supports the reading 'clarior enitet', with may be a suggestion of the sun, and compares Milton, *Lycidas* 168: 'So sinks the day-star in the Ocean bed', in the comparison between the sun's daily sinking and rising into the morning sky and Lycidas's death and resurrection to the kingdoms of heaven: 'So Lycidas sunk low, but mounted high' (172; see above: 175).

45. Cf. George Herbert, 'Prayer (1)': 'The soul in paraphrase, heart in pilgrimage, / The Christian plummet sounding heaven and earth; / Engine against the Almighty, sinner's tower, / Reversed thunder, Christ-side-piercing spear / . . . / The milky way, the bird of Paradise' (3–6, 12): prayer spans the vertical axis, in a positive kind of gigantomachic assault on the gods.

46. On the question of whether this is the Julius assassinated in 44 BC or his adopted son Augustus, see ch. 2: n. 87.

Above the Aonian mount' (*PL* 1.6, 13–15).[47] 'With no middle flight' is a challenge to the most popular pre-Miltonic work of biblical verse narrative in English, Josuah Sylvester's translation of Du Bartas's *Divine Weekes and Works*, in which Du Bartas announces that his Muse will pursue a middle flight, obedient to Daedalus's unheeded instructions to his son Icarus (see ch. 3: 108–9). Milton, by contrast, will venture on an Icarian flight, and he will also follow Epicurus and Lucretius on flights through the immensity of space, where Du Bartas dares not go.[48]

In the invocation to 'holy Light' at the beginning of *Paradise Lost* 3, the poet reveals that he has followed Satan down to the abyss, and is now doing what Satan cannot do, 'reascend', to take his readers to the 'pure empyrean' (57) where the Father and the Son are seated (13–22):

> Thee I revisit now with bolder wing,
> Escaped the Stygian pool, though long detained
> In that obscure sojourn, while in my flight
> Through utter and through middle darkness borne
> With other notes than to the Orphean lyre
> I sung of Chaos and eternal Night,
> Taught by the heavenly Muse to venture down
> The dark descent, and up to reascend,
> Though hard and rare: thee I revisit safe,
> And feel thy sovereign vital lamp[.]

Milton registers the relief of escape from hell, and acknowledges the difficulty of reascent, but is confident in the guidance of the heavenly Muse, who plays the role of Virgil's Sibyl when facilitating Aeneas's descent to and reascent from the underworld: 'Easy is the descent to Avernus . . . But to retrace one's steps and come out to the breezes above, that is the task, that is the labour' (facilis descensus Auerno; / . . . / sed reuocare gradum superasque euadere ad auras, / hoc opus, hic labor est) (*Aen.* 6.126–29).[49] The poet is not as presumptuous as

47. And calling for a version of the wings of the dove in the following invocation of the Spirit, who (1.20–26) 'with mighty wings outspread, / Dovelike satst brooding on the vast abyss, / And mad'st it pregnant: what in me is dark / Illumine, what is low raise and support; / That to the height of this great argument / I may assert the eternal providence, / And justify the ways of God to men.'

48. On Milton's departure from Du Bartas's middle flight, see Auger 2019: 195.

49. Satan also alludes to the Virgilian lines at *PL* 2.432–33: 'long is the way / And hard, that out of hell leads up to light'. Satan gainsays Moloc's rhetoric at 2.77–81: 'Who but felt of late . . . / . . . / With what compulsion and laborious flight / We sunk thus low? The ascent is easy then.'

Moloc, who thinks that 'the ascent is easy'. Milton also travels in the company of another of Virgil's fellow-travellers, Dante, who, in the words of Saint Bernard's prayer to the Virgin at the start of the last canto of *Paradiso*, has seen the spirit-lives, one by one, from the lowest pool of the universe to the height of Paradise (with 'Escaped the Stygian pool', compare *Paradiso* 33.22–23: 'da l'infima lacuna / de l'universo infin qui').[50]

In the invocation to Urania at the beginning of the second half of the epic, Milton invokes Du Bartas's heavenly Muse, Urania.[51] Urania is asked to 'Descend from heav'n' (7.1),[52] from the heights where, in the previous book, she had been singing of the war in heaven. It is Urania, says the poet, 'whose voice divine / Following, above the Olympian hill I soar, / Above the flight of Pegasean wing' (2–4).[53] In this prologue, Milton dwells rather longer on the possibility of

50. The allusion is noted by Stevens (1985: 128–30), noting also the allusion in 'Though hard and rare' to *Inferno* 34.94–95: 'Lèvati sù . . . in piede: / la via è lunga e 'l cammino è malvagio' (Rise up on foot: the way is long and the journey is hard), shortly after Dante sees the Devil in a new light, upside down (88–90). Satan's spring upward at *PL* 2.1012–13 is turned into descent at 3.72–73: 'ready now / To stoop with wearied wings and willing feet', a deflation similar to Eve's at the end of her demonic dream (see below: 187): 'As in Dante the physical change in perspective reflects a moral one. Dante's journey up towards the stars indicates the true direction of his soul; Satan's journey down to Earth symbolizes the descent of his soul. The device of ascent being reversed into descent recurs throughout Book III' (Stevens 1985: 131).

51. On Milton's Urania and her models, see Davies and Hunter 1988; Haan 1993.

52. Translating Horace, *Odes* 3.4.1: 'Descende caelo' (addressed to another Muse, Calliope), at the beginning of the second half of Horace's Roman *Odes*. Here the descent is from the grandiose council of the Olympian gods in the previous ode, 3.3, which ends with the lyric poet Horace's self-reprimand for daring to report the speeches of gods in his small-scale measures: 'quo, Musa, tendis?' (3.3.70), echoed in Milton's reining-in of his flights of fancy in 'At a Vacation Exercise': 'But fie my wandering Muse how dost thou stray!' (53; see above: 172). But Horace, *Odes* 3.4 will take the reader up to another war in heaven, the battle between the gods and giants, Gigantomachy (a classical model for Milton's war in heaven).

53. See Fowler 1997 on *PL* 7.4 for Pegasus as an emblem for inspiration, contemplation, imagination. On Pegasus as a symbol of sky-aspiring fame, see Hardie 2012: 622–24. Natale Conti, in his *Mythologiae* (Conti 1979: 500), gives as one interpretation of the Bellerophon myth that he was an astronomer who 'ascended' into the heavens through his understanding of the power of the stars. See Quint 2014: 90 on Milton's rewriting of Pindar, *Isthmian Odes* 7.40–51, where the poet's moderate old age will not overreach like Bellerophon who aimed to enter heaven; see also Revard 2001: 113–19, on Bellerophon in Pindar and Milton; Fallon 1994. For Alexander Ross, in *Mystagogus poeticus, or, the Muses' Interpreter* (1647), Bellerophon, among a number of interpretations, is a warning against pride; but also, 'Christ is the true Bellerophon, the wisdom of God, who brought to us counsel and wisdom . . . and rides triumphantly on his Word, as on a winged horse, and by the power of his Divinity mounted up to heaven' (Glenn

failure, using the example of Bellerophon, who fell from Pegasus because of his presumption in thinking that he was a god and could fly up to Olympus (12–20):

> Up led by thee
> Into the heav'n of heav'ns I have presumed,
> An earthly guest, and drawn empyreal air,
> Thy tempering; with like safety guided down
> Return me to my native element:
> Lest from this flying steed unreined (as once
> Bellerophon, though from a lower clime)
> Dismounted, on the Aleian field I fall
> Erroneous there to wander and forlorn.

Milton attempts to exorcise the demon of presumption.[54] The presumption is not just that of a Bellerophon, but also that of an imagining of visionary flight as a temporary translation to the heavens of both body (which needs to 'draw empyreal air') and soul, in the manner of the assumed saints Enoch and Elijah.[55]

In the poem's last invocation, in book 9, Milton returns once more to his hopes and fears in the matter of poetic flight, and here depression, rather than a manic presumption, is the threat to successful flight. He refers to the 'higher argument' of his biblical epic subject: 'sufficient of itself to raise / That name [of epic], unless an age too late, or cold / Climate, or years damp my intended wing / Depressed' (43–46). 'Depressed' is spatially 'pressed down', applied to a wing, but also suggests the psychological depression of the poet.[56]

But it is with Satan that we share the most exciting experiences of flight through the oceanic immensity of Chaos and through the newly created cosmos. Satan is the great wanderer and explorer, a Ulysses, but more in the mould of Dante's Ulisse than of Homer's Odysseus. Satan's physical wanderings over the vastness of space are also an allegory of the intellectual flight of contemplation and scientific inquiry, but perverted into error by Satan's sins

1987: 262–63). Lascelles 1972 surveys the history of the positive and negative traditions of Pegasean flight, in relation to Spenser's and Milton's uses of different versions of the myth.

54. In the words of Fallon (1994: 172).

55. The connection is made by Kerrigan (1975: 164).

56. The etymological meaning of 'depress' is highlighted here by contrast with 'raise', and, through the contrast with 'erect' (literally 'raise up'), in *OED*'s first citation for *depressed*: '5a, "Brought low, . . . dejected, downcast", Robert Burton *Anatomy of Melancholy* (1621) ii. ii. vi. ii. 369 "A good orator alone . . . can comfort such as are afflicted, erect such as are depressed."'

of pride and envy.[57] As a wanderer, Satan follows in the footsteps of the heroes of Renaissance romances, Ariosto's *Orlando furioso* and Spenser's *The Faerie Queene*. In his sublime despair and fearlessness in the face of the unbounded, Satan is also a forerunner of the Romantic hero or antihero.

David Quint has demonstrated the central importance for Satan's sublime flights and falls of the two major Ovidian myths of failed flight, those of Phaethon and of Icarus; Quint also shows how these are woven into a polemic with Lucretius, in whose Epicurean and godless universe the atoms are forever falling through the boundless void.[58] With regard to the story of Phaethon, Christ is the Son who shows himself to be the true son of the Father, triumphantly driving his father's celestial chariot in the war in heaven (*PL* 6.710–12).[59] Satan, as always, is the false imitation, when he enters the battle 'High in the midst exalted as a god / The apostate in his sun-bright chariot sat / Idol of majesty divine' (99–101). Milton may have in mind the sun-kings of the seventeenth century, pretenders to divine majesty, of whom Charles II would soon be yet another (see Fig. 6.24).[60] Satan is doomed to fall even further from his sun-bright chariot than Ovid's Phaethon.[61]

Satan may not be able to reascend to his native seat, but he is capable of great flights across the boundless expanses of the void, and capable too of inducing false flights of fancy in his human victims. Cast down far deeper than had been Lucretius's unenlightened mankind before Epicurus's liberating

57. This is the argument of Borris 1990, who concludes that Satan's explorations are also of (p. 127) 'the psychic cosmos with its own luminous secrets, precipitous heights, and inchoate realms of darkness'.

58. Recent work on the *Metamorphoses* has shown how Ovid's Phaethon and Icarus episodes are already intertextual with Lucretius: on Phaethon, see Schiesaro 2014; on Icarus, see Hoefmans 1994.

59. On the possibility that Milton drew on Merkabah mysticism for this flying chariot, see Lieb 1999 (and ch. 2: 91).

60. See Quint 1993: 42, referring, for Charles and solar imagery, to Bennett 1989: 36–39, and Davies 1983: 14–19: the *Eikon basilike*'s comparison of Charles I's royal prerogative to the sun's light is attacked by Milton in *Eikonoklastes*; 'fallen' solar imagery is applied to Satan at *PL* 1.594–99, 2.488–95, 3.588–90, in contrast to Adam's unfallen understanding of the relation of the sun to God at 5.171–74: 'Thou sun, of this great world both eye and soul, / Acknowledge him thy greater'.

61. In the Oxford Restoration anthology celebrating the return of Charles II, *Britannia rediviva* (Oxford 1660), a couple of the Latin poems use the image of Phaethon's catastrophic ride for the collapse of the Protectorate, followed by the orderly succession to the reins of the chariot of the sun by Phoebus, representative in heaven of Charles on earth (information I owe to Victoria Moul).

flight of the mind, Satan and his crew have truly been struck by the thunderbolts of a supreme god (*PL* 6.858: 'thunderstruck'), which, in Lucretius's universe, are merely the fabrication of superstition. Satan breaks out of his hellish prison-house, as Epicurus burst through the bars of the gates of Nature,[62] to embark on a flight through a Chaos that corresponds to the Lucretian boundless void. When Sin opens the gates of hell, 'Before their eyes in sudden view appear / The secrets of the hoary deep, a dark / Illimitable ocean without bound' (2.890–92). Into this ocean Satan launches his cosmic flight, on 'sail-broad vans' (927). The common equation of flight with sailing has extra point when the journey is through a Chaos in which air and water are jumbled up. At first his motion is rapidly upwards: 'Uplifted [he] spurns the ground, thence many a league / As in a cloudy chair[63] ascending rides / Audacious' (929–31), only to experience a sudden failure of flight, as soaring turns into diving: 'but that seat soon failing, meets / A vast vacuity: all unawares / Fluttering his pennons vain plumb down he drops / Ten thousand fathom deep' (931–34). This downward fall (934–35: 'to this hour / Down had been falling'), replicates the original fall of the angels at the end of the war in heaven (6.864–65: 'headlong themselves they threw / Down '; 6.871–72: 'Nine days they fell; confounded Chaos roared, / And felt tenfold confusion in their fall'). Satan is saved from this unending fall only by the chances of the meteorology of Chaos, as 'The strong rebuff of some tumultuous cloud, / Instinct with fire and nitre hurried him / As many miles aloft' (2.936–38), to 'land' in the elemental confusion of 'a boggy Syrtis, neither sea, / Nor good dry land' (939–40).

Once again the ascents and descents of his characters mirror the ambitions and anxieties of the poet. Charles Martindale comments on Satan's soaring and plunging that 'Satan's suspect heroics often seem to parody Milton's own epic flights, and here his so-to-say programmatic attempts to achieve

62. *PL* 3.86–89 (God the Father and Son watching Satan's progress): 'And now / Through all restraint broke loose he wings his way / Not far off heaven, in the precincts of light, / Directly towards the new created world': cf. Lucr. 1.70–71 'effringere ut arta / naturae primus portarum claustra cupiret' (so that he first should desire to break through the close bars of the gates of nature).

63. Before reading on to 'that seat soon failing', Milton's contemporary reader might more naturally take 'a cloudy chair' to refer to a flying chariot (*OED chair*, n.2), as Satan's chaotic flight anticipates his inability to steer a celestial chariot to victory in the war in heaven. The confusion as to whether his mode of flight is like a chariot or a seat is perhaps a further aspect of the chaotic quality of Satan's journey.

Longinian *hypsos* . . . is [*sic*] constantly threatened by failure and falling.'[64] But, as Martindale says, 'Milton, while punctuating Satan's pretensions, does not himself fail the test of true grandeur'.[65] Satan's potentially endless fall is a fine example of the Miltonic sublime.

Satan eventually comes to land on the convex of the outermost sphere of the created universe (3.418–22). This corresponds to the 'summit of the arch of heaven' around which Plato's gods travel in the company of unfallen souls in the *Phaedrus*. But this is a parodic version of the place of the Platonic gods and immortal souls: they 'go out on to the back of the heavens' (ἔξω πορευθεῖσαι ἐπὶ τῷ τοῦ οὐρανοῦ νώτῳ) (*Phaedr.* 247b) to look at the 'place above the heavens' (ὑπερουράνιος τόπος), while the 'boundless continent / Dark, waste, and wild' (3.423–24) on which Satan 'walk[s] up and down' (441) is the scatological 'backside of the world' (494). In time to come, this will be the location of the Ariostan Paradise of Fools (ch. 2: 104) to which will be blown up 'all things transitory and vain' (446). These things include those fools (478–82) 'who to be sure of paradise / Dying put on the weeds of Dominic, / Or in Franciscan think to pass disguised; / They pass the planets seven, and pass the fixed, / And [the] crystalline sphere'. This is the expected, upward, direction of the cosmic flight, thwarted at the last stage: 'at foot / Of heaven's ascent' these souls are prevented from going any higher by 'A violent cross wind' that 'Blows them transverse' (487–88). That conversion of vertical into horizontal motion had already been prefigured when Satan first 'walked up and down' on that 'windy sea of land' (441, 440), where 'up and down' replaces purposeful motion up and down the vertical axis with an aimless horizontal wandering 'up and down', backwards and forwards.[66] In this passage, Milton returns to the mode of satire and parody that he had deployed in his youthful anti-papist epigrams on the Gunpowder Plot.

In this part of the poem he also engineers a large-scale contrast between right and wrong ways of ascending to heaven.[67] From this 'dark globe', Satan

64. On soaring and sinking in the context of poetic failure of flight, see ch. 5: 211–17.

65. Martindale 2012: 74.

66. *OED up and down* 2. This is also a biblical quotation: Job 1:7; 'Whence comest thou? Then Satan answered . . . From going to and fro in the earth, and from walking up and down in it.'

67. Quint 2014: 86: 'The fool's unsuccessful ascent to heaven (3.486) is opposed, as was Satan's fall, to the flight of Elijah in his chariot and his assumption as one of the "Translated saints" (3.461) together with Enoch, whose ascension, "Rapt in a balmy cloud with winged steeds", will be described at 11.706.' Simon Magus is an apocryphal example of the wrong way to attempt to fly up to heaven, narrated for example in Joseph Beaumont, *Psyche, or, Loves*

eventually sees a distant gleam, shed by a vision of a staircase rising up to heaven's gate, compared to Jacob's Ladder (3.499–515). This is a different model of ascent, by steps rather than by flying; Jacob's Ladder (Genesis 28:11–17) was standardly allegorized in the Middle Ages as the steps of the contemplative ascent to God.[68] The orderly 'Ascending by degrees magnificent' (502)[69] is in the strongest contrast to Satan's wild and digressive flights through space before he arrives on earth.[70] Satan's journey is also to be contrasted with another mode of journeying to the heavens referred to here: underneath the stairs to heaven is the water above the firmament, where Elijah arrived 'Rapt in a chariot drawn by fiery steeds' (522; cf. 11.706: '[Enoch, the other translated saint,] Rapt in a balmy cloud with wingèd steeds').

Satan and his works induce the experience of false flights of the soul in Adam and Eve. On the night of his arrival in Eden, Satan 'squat[s] like a toad, close at the ear of Eve' (4.800), working on 'the organs of her fancy', and inspiring her with false dreams, which Eve recounts to Adam the next day. She tells him that in her dream she saw an angelic figure who offered her the fruit of the tree of knowledge, saying (5.77–92):

Mysterie 10.114–19, where his fall, when Peter's prayers tear from the levitating magician his 'coach of unseen devils', is compared at 118 to the fall of Lucifer: 'So when heaven-daring Lucifer himself / Tried in the flaming face of God to fly, / His singèd wings betray the venturous elf, / And down he plunged into the misery / Of endless death.'

68. See ch. 1: 17–19. In the Dantesque ascent to God in Joseph du Chesne, sieur de la Violette's *La Morocosmie* (1583), the poet and Calliope ascend from the Milky Way by Jacob's Ladder, assisted by attendant angels, to come into the presence of the divine love, where the poet sees Christ riding in a fiery chariot like that which took Elijah to heaven, drawn by a team of four-headed winged beasts, like those seen by Ezekiel (Ridgely 1963: 159).

69. Cf. also *PL* 5.482–84 (in the course of Raphael's discourse on the cyclic movement of emanation and return): 'flowers and their fruit ... by gradual scale sublimed / To vital spirits aspire'.

70. See Moshenska 2014: 273 on the contrast between gradual, orderly ascent (*PL* 5.483: 'by gradual scale sublimed'), and Satan's explosive expansion at the touch of Ithuriel's spear: 'As when a spark ... So started up in his own shape the fiend' (4.814–19). In Moshenska's words, 'Satan is associated ... with sudden rupture and instantaneousness: he tempts Eve with the opportunity to assume in an instant a place of "high exaltation ... among the gods" (*PL* 5.90, 77)'; squatting like a toad by Eve's ear, he inspires in her 'Inordinate desires / Blown up with high conceits engendering pride' (4.808–9); the image of windy inflation in 'blown up' is abruptly turned into another kind of 'blowing up', when Satan is 'blown up' by Ithuriel's spear, taking us back to the violent ascents of the Gunpowder Plot epigrams. On Eve's dream, see Stevens 1985: ch. 5, '*Phantastike* Imagination and the Fall'.

'Taste this, and be henceforth among the gods
Thyself a goddess, not to earth confined,
But sometimes in the air, as we,[71] sometimes
Ascend to heaven, by merit thine, and see
What life the gods live there, and such live thou.'
So saying, he drew nigh, and to me held,
Even to my mouth of that same fruit held part
Which he had plucked; the pleasant savoury smell
So quickened appetite, that I, methought,
Could not but taste. Forthwith up to the clouds
With him I flew, and underneath beheld
The earth outstretched immense, a prospect wide
And various: wondering at my flight and change
To this high exaltation; suddenly
My guide was gone, and I, methought, sunk down,
And fell asleep.

Satan offers Eve a false apotheosis. In her dream, Eve experiences a 'high exaltation', with a view from above over 'the earth outstretched immense'.[72] Exaltation, an elevation both physical and psychological,[73] is rapidly followed by deflation—one might say depression[74]—at the point when, in the narrative of waking reality in the previous book, Satan, squatting by Eve's ear, is detected by Ithuriel's spear. At the moment when the toad-like Satan is figuratively 'blown up' by Ithuriel's spear, Eve suffers a sudden de-flation. In a lesson in faculty psychology, Adam explains to her that her vision is the product of 'mimic fancy',[75] not reason (5.100–13). Eve has experienced a delusive 'flight of fancy'.

71. Fowler, following Pearce, points out the syntactic ambiguity: 'as we' can go with 'ascend to heaven' as well as with 'sometimes in the air', the proper place of Satan (Ephesians 2:2: Satan 'the prince of the powers of the air').

72. Compare and contrast Adam's recollection of being taken over a landscape in a dream to Eden at 8.286–311: 'whereat I waked, and found / Before mine eyes all real, as the dream / Had lively shadowed' (309–11). In Avitus's biblical epic *De spiritalis historia gestis*, Satan, as he tempts Eve, urges her to 'thrust your mind into matters on high, and stretch your erected senses towards the sky' (2.194–95; see ch. 2: n. 39).

73. *OED* 2b: '"Elation of feeling; a state of rapturous emotion", a1513, 1707.'

74. Hinting perhaps also at sexual detumescence: cf. Milton's use of *turgidulus* (above 176).

75. Stevens 1985: 14.

This is a view from above which induces in the viewer a wondering sense of her own aggrandizement, rather than an awareness of the insignificance of mortal concerns. What Eve gazes out over might be compared with certain kinds of early modern works of art that liberate the beholder into views over 'the earth outstretched immense', or into prospects 'wide and various', such as the vast 'world landscapes' by sixteenth-century artists such as Joachim Patinir, Albrecht Altdorfer and Pieter Bruegel the Elder;[76] or, on a more limited scale, and a few decades later than Milton, the topographical bird's-eye views of palaces and country houses, with their surrounding parkland, in the engraved drawings of Leonard Knyff and Johannes Kip, images of worldly wealth and power.[77] The geographical visions of Adam in *Paradise Lost* (11.377–411) and of Christ in *Paradise Regained* (3.267–309, 4.25–89) suggest the synoptic views of the atlases of the time, which Milton seems to have known well.[78]

Milton draws on an older tradition of the view from above in Adam's self-belittling question to Raphael, after the archangel's account of Creation, at the beginning of *Paradise Lost* 8 (13–24):

> Something yet of doubt remains,
> Which only thy solution can resolve.
> When I behold this goodly frame, this world,
> Of heaven and earth consisting, and compute
> Their magnitudes, this earth, a spot, a grain,
> An atom, with the firmament compared
> And all her numbered stars, that seem to roll
> Spaces incomprehensible, (for such
> Their distance argues, and their swift return
> Diurnal) merely to officiate light
> Round this opacous Earth, this punctual spot,
> One day and night.

Adam uses the language of the view from above in the tradition of the Ciceronian *Dream of Scipio*, a vision of the insignificance of the earth seen in the immensity of space ('spot', 'grain', 'atom', 'punctual spot'). But the prelapsarian and 'erected' understanding of Adam has no need to fly up into space to see things in their proper perspective, which Adam is able to realise through a

76. Cosgrove 2001: 125–30; Gibson 1989.
77. Published in 1707 as *Britannia illustrata*: see Barber 2020: 92–93.
78. See Thompson 1919; Ramachandran 2015: 194.

mental 'computing' of 'magnitudes'. Beyond this, Adam will be satisfied with Raphael's admonitions that he leave the secrets of the heavens to God who made them, which is to say that he should not aspire to the total knowledge of one who enjoys the sovereign gaze of the view from above, as imagined in visions such as that of the *Dream of Scipio*. Adam is content to be 'lowly wise', understanding that 'heaven is for thee too high' (*PL* 8.172–73), obedient to Raphael's instruction, 'Therefore from this high pitch[79] let us descend / A lower flight, and speak of things at hand / Useful' (198–200). Adam abjures 'wandering thoughts, and notions vain' (187), criticizing the speculations of the mind and the phantasms of fancy: 'But apt the mind or fancy is to rove / Unchecked, and of her roving is no end' (188–89).

Fancy is again the culprit on the second occasion when Eve, now together with Adam, experiences a sense of taking off from the earth. This time there will be no waking into innocence. After Adam has followed Eve's lead in eating the apple (9.1004–15),

> while Adam took no thought,
> Eating his fill, nor Eve to iterate
> Her former trespass feared, the more to soothe
> Him with her loved society, that now
> As with new wine intoxicated both
> They swim in mirth, and fancy that they feel
> Divinity within them breeding wings[80]
> Wherewith to scorn the earth:[81] but that false fruit
> Far other operation first displayed,
> Carnal desire inflaming, he on Eve
> Began to cast lascivious eyes, she him
> As wantonly repaid; in lust they burn.

Fancy (but no higher faculty) deludes Adam and Eve that they are growing Platonic wings of the soul to elevate them to divinity in a shared erotic

79. *OED* s.v.: '*pitch* n. 2, 21a "The height to which a bird of prey soars before swooping down on its quarry."'

80. Parodied at 10.243–44 (Sin speaks): 'Methinks I feel new strength within me rise, / Wings growing'.

81. Cf. Horace, *Odes* 3.2.24: 'spernit humum' (see above n. 6). Cf. *PL* 2.927–29: 'At last his sail-broad vans / He spreads for flight, and in the surging smoke / Uplifted spurns the ground' (discussed above: 184).

transcendence.[82] In fact, they are falling into a very earthly lust—and something lower: 'in lust they burn' suggests hellfire. The couple go off to make love in a version of the 'sacred marriage', *hieros gamos*, of Zeus and Hera at *Iliad* 14.292–351;[83] they have allusively risen to the level of the gods, but only the false pagan gods—the kind of identification with the pagan gods that is found in royal panegyric: for example, Rubens's *Consummation of the Marriage of Henri IV and Marie de' Medici at Lyons*, in which the earthly royal couple of Henri and Marie is impersonated by Jupiter and Juno in the heavens (Fig. 4.2).[84] After their love-making, Adam and Eve suffer a severe case of post-coital *tristesse*, waking up from a sleep that has 'oppressed them' (9.1045). This is in contrast to Raphael's lesson in the Platonic ascent of love at 8.589–93: 'love refines / The thoughts, and heart enlarges, hath his seat / In reason, and is judicious, is the scale / By which to heavenly love thou mayst ascend, / Not sunk in carnal pleasure';[85] that is, an orderly ascent up the steps of love, in contrast to the disordered fancies of flight after the eating of the apple.

But fancy and imagination are not always, for Milton, negatively charged ways of taking flight.[86] The young Milton exults in his poetic flight of fancy in 'At a Vacation Exercise' (see above: 172). In the epigraph to this chapter, he also speaks without censure, and presumably self-conscious of his own celestial aspirations, of 'a poet soaring in the high region of his fancies with his garland and singing robes about him'.[87] Raphael entertains the possibility, in the moment of abjuring it, of an elevation of the imagination to a height that would not be adrift from truth and reason, as he attempts to convey to Adam the 'fight unspeakable' between Satan and Michael, in the war in heaven: 'for who,

82. So Quint 2014: 87–88.

83. For the allusion to the Iliadic seduction scene, see Fowler 1997 on *PL* 9.1027–45. The magical landscape of the Iliadic scene is alluded to, in innocent mode, in the description of the 'blissful bower' of Adam and Eve's prelapsarian love-making: see Fowler 1997 on *PL* 4.697–701.

84. There is a long tradition of comparisons to mythological marriages in wedding-songs, going back to early Greek poetry; for example, the wedding of Zeus and Hera is a mythological paradigm for the wedding of Peisetaerus and Basileia at the end of Aristophanes's *Birds* (1731–35): see Dunbar 1995: 757; Meister 2020: 48–49.

85. On these lines, see Hammond 2017: 143.

86. Hammond 2017: ch. 13, 'Fancy *and* Reason', 149–53 on fancy.

87. Milton 1931–38, 3: 235. Stevens makes the case (1985) that Milton does not renounce imagination for inspiration, using Sidney's distinction between *phantastike* and *eikastike* imagination, respectively imagination that leads to the fall, and imagination that leads to regeneration and reascent.

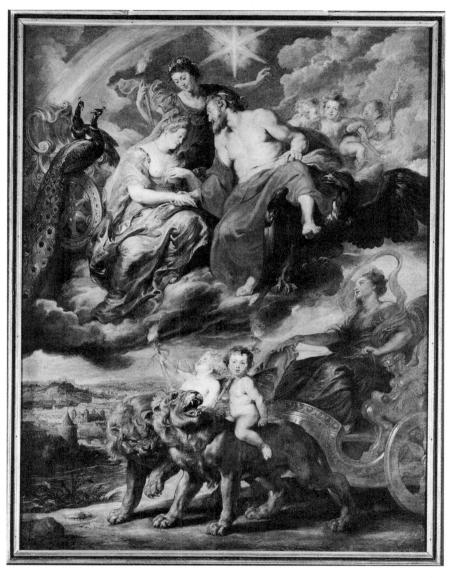

FIGURE 4.2. Peter Paul Rubens, *Consummation of the Marriage of Henri IV and Marie de'*
Medici at Lyons, from cycle on life of Maria de' Medici. Bridgeman Images.

though with the tongue / Of angels, can relate, or to what things / Liken on earth conspicuous, that may lift / Human imagination to such height / Of godlike power' (*PL* (6.297–301). The clause 'that . . . power' is ambiguous. The following words, 'for likest gods they seemed', disambiguates, revealing that the 'height of godlike power' is that of the two combatants in heaven; but before we read on we might take the 'height of godlike power' to refer to the power of human imagination, reflecting Renaissance, and anticipating Romantic, notions of the godlikeness of the creative human imagination. Milton is here perhaps daring himself to raise his own poetic imagination to a height like that of the gods.

The Adam resurrected and redeemed at the Last Judgement is launched on a flight of fancy free of any association of guilt in Thomas Newcomb's *The Last Judgment of Men and Angels. A Poem in Twelve Books: After the Manner of Milton* (London, 1723). The angel vouchsafes him a vision of the life in heaven that will be enjoyed by Adam and his just descendants after the earthly millennium: 'Scarce his voice / Had finished, when each outward sense o'erpow'rd / Adam began to feel, but still awake / In liveliest fancy; whom his steps sublime / bore thro' the' empyreal heaven and starry sky' (12.719–23). When Adam awakes, the angel comments that this flight of fancy anticipates the disembodied flight of his soul at the end of time: 'Offspring of heaven and earth, I now have led / Thy fancy, wand'ring thro' the highest joy / Thou can'st sustain, while mortal' (805–7); 'how strong / . . . / . . . will be the transport / . . . / . . . when freely thro' the sky / Clogged by no mortal weight, thy soul shall range / . . . when thy thought restrained / By nothing earthly, shall begin to rove / Thro' wide eternity' (810–21).

5

After Milton

MILTON TRACKS the upward and downward motions of his characters in his own poetic ascents and descents. This licenses later poets to re-imagine Milton's own sky-reaching flights, and also their own, and at the same time to ravish the reader in earth-defying ecstasies.[1] I have already looked at Marvell's response to *Paradise Lost*; I now turn to a later seventeenth-century text, 'Adventurous Muse', by an author already discussed in chapter 3, Isaac Watts (1674–1748), which begins, 'Urania takes her morning flight / With an inimitable wing' (see also ch. 1: 18–19).[2] The poem proceeds to snatch up the reader in a chariot of poetry to paradise. There we encounter Milton, whose 'advent'rous genius' is scarcely to be distinguished from the 'adventurous Muse' of the poem's title. Through a pastiche of Miltonic phrases, Watts vindicates Milton's audacity in presuming to ascend to the heaven of heavens (at *PL* 7.13), exploring further Milton's own equation of his poetic journeying with the journeying of his characters. Watts picks up on Marvell's themes, the sublime, and the freedom from the chains of rhyme; for the dissenting Watts, this is a philosophical and political, as well as an aesthetic, freedom.[3] His heavenly muse (32–55)

1. General bibliography on the later seventeenth- and eighteenth-century reception of Milton: Havens 1922; Griffin 1986; Shawcross 1991; Leonard 2013; Hoxby and Coiro 2016.

2. The poem first appeared in the second, enlarged, edition of *Horae lyricae* (Watts 1709: 210–13). See Pinto 1935.

3. On the 'Free Philosophy' of the dissenting academies, see Hoyles 1971: ch. 13; on Watts and the sublime, ch. 16.

Pursues an unattempted[4] course,
Breaks all the critics' iron chains,
And bears to paradise the raptured mind.

There Milton dwells: The mortal sung
Themes not presumed[5] by mortal tongue;
New terrors, or new glories,[6] shine
In every page, and flying scenes divine
Surprise the wond'ring sense, and draw our souls along.
Behold his muse sent out to explore
The unapparent deep[7] where waves of Chaos roar,
And realms of night unknown before.
She traced a glorious path unknown,
Thro' fields of heav'nly war, and seraphs overthrown,
Where his advent'rous[8] genius led:
Sov'reign she framed a model of her own,
Nor thanked the living nor the dead.
The noble hater of degenerate rhyme
Shook off the chains, and built his verse sublime,
A monument too high for coupled sound to climb.
He mourned the garden lost below;
(Earth is the scene for tuneful woe)
Now bliss beats high in all his veins,
Now the lost Eden he regains,[9]
Keeps his own air, and triumphs in unrivalled strains.

Milton's lofty strains are the equal of those of the archangel Raphael as he sings to the enraptured choir of heaven (56ff.: 'Immortal bard! Thus thy own Raphael sings . . .'). Milton himself seamlessly joins his own hymn of praise to the Son to the angels' hymn to the Father and Son, before their thrones, at *Paradise Lost* 3.410–15, so momentarily elevating himself to heaven, 'above the starry sphere' (*PL* 3.416).

4. *PL* 1.16. Watts's chariot had been preceded by Abraham Cowley's flying chariot of poetry in 'The Muse': see ch. 3: 143–44.

5. *PL* 7.13.

6. Cf. Marvell 'On *Paradise Lost*': 'At once delight and horror on us seize' (35).

7. *PL* 7.103 'unapparent deep'.

8. *PL* 1.13 'my advent'rous song'.

9. *PL* 1.4–5.

Poetic flights of the mind in the early eighteenth century are a particular hallmark of a group of Whig writers, mercilessly pilloried by the Tory Alexander Pope and his fellow Scriblerians. Yet Pope himself has an ambivalent relationship with aspirations to the skies, and was a friend of Edward Young, whose *Night Thoughts* contain some of the most ambitious mental and spiritual expatiations in the heavens to be found anywhere in English poetry, in the service of a religious message. Unrestrained mental flights are also the vehicle of a group of 'physico-theological' didactic poems, which harness explorations of the nature of things to a religious end. The unbounded sublimity of these early and mid-eighteenth-century traditions continues to fuel the aspirations of Romantic and Victorian poets.

The Whig Sublime

Isaac Watts conjoins freedom and the sublime in a single line ('Shook off the chains, and built his verse sublime'). The connection between political freedom, in the form of democracy, and the sublime is made already by Longinus (*Sublime* 44.2). Recent studies have explored the association of the transgressiveness of the sublime with the radical politics of late sixteenth- and seventeenth-century writers with republican leanings.[10] This is an association that continues into the early eighteenth century with the Whig writers and literary critics, including John Dennis (1658–1734), Joseph Addison (1672–1719) and Sir Richard Blackmore (1654–1729), a group with whose principles Isaac Watts associated himself. This group was important in developing theories of aesthetic beauty and the sublime well before Edmund Burke's (1757) *A Philosophical Enquiry into the Origins of Our Ideas of the Sublime and the Beautiful*,[11] and they were proponents and practitioners of what has been called the 'Whig sublime'.[12] Addison and Dennis were also two of the first great advocates of Milton.[13]

10. Norbrook 1999: 137–41, 212–21; Smith 1994: 125–26, 189, 203; Cheney 2009. On the continuation by Whig writers of the late seventeenth and early eighteenth centuries of the tradition of associating the sublime with liberty, see Williams 2005: ch. 5, 'The Sublime and the Liberty of Writing'.

11. Williams 2005: ch. 5. Ashfield and de Bolla 1996.

12. On which see Williams 2005: ch. 5; Cohen 1986 (Cohen claims to have invented the term); Inglesfield 1990.

13. On the importance of John Dennis, see Morris 1972: 67: 'Dennis first made Milton and Longinus the inseparable companions they became throughout the eighteenth century.' On Dennis's importance for the development of theories of the sublime in early modern England, see Doran 2015: ch. 5.

Leonard Welsted, one of the 'Whig sublime' poets, and, for his pains, one of Pope's 'dunces', translated Boileau's French version of Longinus (1712). In 'Remarks on Longinus in a letter to a friend' (Addison)[14] appended to the 1726 edition of his translation, Welsted notes (pp. 156–57):[15]

> It is undoubtedly true of Milton, that no man ever had a genius so happily formed for the sublime: he found one only theme capable enough to employ his thoughts, but he could find no language copious enough to express them.
>
> > His vigorous and active Mind was hurled[16]
> > Beyond the flaming limits of this world,
> > Into the mighty space.
>
> When I view him thus, in his most exalted flights, piercing beyond the boundaries of the universe, he appears to me as a vast comet, that for want of room is ready to burst its orb and grow eccentric.

Welsted quotes from Thomas Creech's translation of Lucretius's praise of Epicurus, but mention of comets at that time can hardly have failed to put the reader in mind of Newton. Where Newton demonstrated the regularity of the motion of comets by the law of gravity, however, Welsted's sublime Milton is in danger of flying out of control, perhaps like Milton's Satan, who 'like a comet burned, / That fires the length of Ophiucus huge' (PL 2.708–9).[17]

As well as being an important critic, John Dennis was the most extensive writer of blank verse between Milton and James Thomson, and an acclaimed practitioner of the sublime Pindaric ode. For a typical example of his aspirations to a celestial sublimity, take a passage from *Britannia Triumphans: or, A Poem on the Battel of Blenheim* (1704) (pp. 48–49):

> To such a height no mortal force can soar,
> And now the inspiration leaves my soul.
> Or if I must with feeble wings essay
> Th' etherial flight, assist y' etherial pow'rs!
> And thou the brightest angel of the sky,

14. Sambrook 2014: 26.

15. Discussed by Leonard 2013, 1: 20–21; see also 2: 716, in Leonard's discussion of Milton's universe.

16. Leonard points out that here Creech mis(over?)-translates Lucretius's 'processit' (went forth), making Epicurus coincidentally like Satan 'hurled headlong' (PL 1.45).

17. The suggestion is Leonard's (2013, 1: 21).

With whose enchanting beauties all the host
Of heav'n above, all heav'nly minds below
Are charm'd, with whom the great creator's charm'd!
Eternal Fame! Thee goddess I invoke,
For nothing without thy aid was e'er produced,
Or great or fair in earth or heav'n above,
(So the great maker willed, and made it Fate)
Descend bright goddess to my aid, descend
T' infuse a beam of thy celestial fire
Into my soul, and raise my advent'rous song.

. . .

Instruct me, goddess, for thou only know'st,
For thou with all thy hundred eyes wert by,
When stooping on thy azure wings, thou left'st
The fields of light for Blenheim's glorious field.

Dennis draws on the sky-reaching aspirations of Virgil's Fama (see ch. 2: 73–74),
but subordinates Virgil's unruly goddess to the Christian God and to the dic-
tates of divine Fate. Fame is allusively associated with the Holy Spirit invoked
by Milton as he sets out on his lofty flight at the beginning of *Paradise Lost*
(1.19–20, addressing the Spirit: 'Instruct me, for thou knowst; thou from the
first / Wast present'). Part of the great outpouring of hyperbolical poetry on
the Duke of Marlborough's victory at the battle of Blenheim (1704),[18] of which
Addison's 'The Campaign' is the best known example, Dennis's poem is the
textual equivalent of the soaring spaces of Blenheim Palace, with their ceiling
paintings: in the Great Hall, James Thornhill's *A Hero Entering the Temple of
Fame* (1716), in which the hero, Marlborough, is presented to Britannia, with
the winged Fame hovering overhead; and in the Saloon, Louis Laguerre's *Al-
legory of War and Peace* (c. 1719, referring to the Peace of Utrecht), in which the
flying figure of Peace restrains the sword-hand of Marlborough, as he steps
into a chariot whose horses seem to strain to soar skywards (Fig. 5.1).[19]

In his poetry, Dennis puts into practice his theory of poetry, according to
which 'passion . . . is the characteristical mark of poetry',[20] and more particu-
larly the 'enthusiastic', as opposed to 'vulgar', passions, of which there are chiefly

18. For a bibliography of the numerous poems in praise of Marlborough's victories at Blen-
heim, Ramillies and Oudenarde, see Horn 1975. For some discussion, see Stewart 2016.

19. On the Blenheim ceilings, see Hamlett 2020: 122–28.

20. *The Advancement and Reformation of Poetry* 1.5 (Hooker 1939: 215).

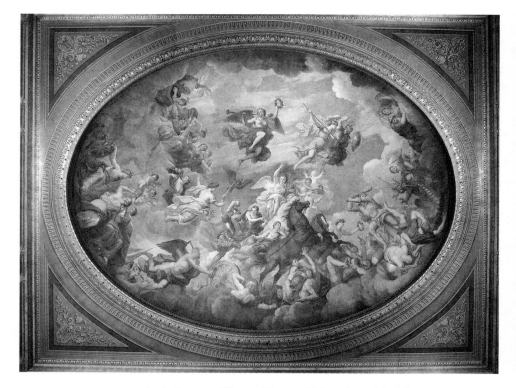

FIGURE 5.1. Louis Laguerre, *Allegory of Peace and War*, ceiling of the Saloon, Blenheim Palace. Bridgeman Images.

six: 'admiration, terror, horror, joy, sadness, desire, caused by ideas occurring to us in meditation'.[21] Dennis is much given to soaring vertically upwards in his accounts of the workings of the enthusiastic passions in poetry: for example,

> And as the reason rouses and excites the passions, the passions, as it were, in a fiery vehicle, transport the reason above mortality, which mounting, soars to the heaven of heavens, upon the wings of those very affections, that before repressed the noble efforts that it made to ascend the skies.[22]

Dennis here blends Plato's wings of *eros* and Elijah's chariot of fire. Dennis's aim was to 'restore poetry to all its greatness' by drawing on religious ideas:

21. *The Grounds of Criticism in Poetry* (Hooker 1939: 338–39).
22. *Advancement* 2.1 (Hooker 1939: 261). On the eighteenth century's conversion of (unacceptable) religious enthusiasm into (acceptable) poetic enthusiasm, see Irlam 1999; 60–79 on Dennis.

'The use of religion in poetry was absolutely necessary to raise it to the greatest exaltation, of which so noble an art is capable.' As it is, 'Poetry is miserably fallen.'[23] The imagery of heavenward flight corresponds to an 'exaltation' that restores poetry from its spiritual or moral 'fall'. This equivalence in Dennis's poetics of physical and spiritual falling and rising may be read as homage to his poetic hero Milton, for whom 'the physical is always a mode of the spiritual'.[24]

As well as in military panegyric, the lofty aspirations of the Whig sublime find expression in physico-theological didactic poetry,[25] most notably (or notoriously) borne on the 'pious wing' (7.764, from the envoi to the poem discussed below) of Sir Richard Blackmore (1654–1729). Blackmore's *The Creation. A Philosophical Poem in Seven Books* (1712) was acclaimed in its time as the English *De rerum natura*, receiving high praise from Dennis, Addison and Samuel Johnson. Blackmore sets off on a sublime Miltonic flight (1.1–19):

> No more of courts, of triumphs, or of arms,[26]
> No more of valour's force, or beauty's charms;
> The themes of vulgar lays, with just disdain,
> I leave unsung, the flocks, the am'rous swain,
> The pleasures of the land, and terrors of the main.
> How abject, how inglorious 'tis to lie
> Groveling in dust and darkness, when on high
> Empires immense and rolling worlds of light
> To range their heav'nly scenes the Muse invite.
> I meditate to soar above the skies,
> To heights unknown, thro' ways untried,[27] to rise:
> I would th' Eternal from his works assert,[28]
> And sing the wonders of creating art.
> While I this unexampled task essay,
> Pass awful gulfs, and beat my painful way,

23. *Grounds* (Hooker 1939: 328, 325).

24. Hammond 2017: 127 (cited above, ch. 4: 177). 'Exalt(ation)' is also a theologically and poetically charged word in Milton: see ch. 4: n. 4.

25. For the definition of 'physico-theology', see ch. 1: 7–8.

26. A Miltonic formula of *recusatio*: PL 9.1–3: 'No more of talk where God or angel guest / With man, as with his friend, familiar used / To sit indulgent'.

27. Cf. PL 1.16: 'Things unattempted yet in prose or rhyme.'

28. Cf. PL 1.24–25: 'That . . . / I may assert th' Eternal Providence'.

Celestial dove, divine assistance bring,
Sustain me on thy strong extended wing;
That I may reach th' Almighty's sacred throne,
And make his causeless pow'r, the cause of all things, known.

Blackmore enlists Virgil (Maro) as a predecessor in the exercise of the power of poetry to elevate to the heavens, in a passage that alludes to the heavenly origin and final destination of the bees in *Georgics* 4 (see ch. 2: 69–70): 'Maro, these wonders offered to his thought, / Felt his known ardour, and the rapture caught; / Then raised his voice, and in immortal lays ./ Did, high as heav'n, the insect nation raise' (7.194–97). He proceeds to use the Lucretian flight of Epicurus's mind against the atomic materialism of Epicurus, arguing that 'the intellectual world' of the human mind itself proclaims 'a wise creator's hand' through the mind's very ability to take flight, soaring and diving, through the universe (7.217–27):

To the remoter regions of the sky
Her swift-winged thought can in a moment fly;
Climb to the heights of heav'n, to be employed
In viewing thence th' interminable void.
Can look beyond the stream of time, to see
The stagnant ocean of eternity.[29]
Thoughts in an instant thro' the zodiac run,
A year's long journey for the lab'ring sun:
Then down they shoot, as swift as darting light,
Nor can opposing clouds retard their flight:
Thro' subterranean vaults with ease they sweep,
And search the hidden wonders of the deep.

Alexander Pope and Miltonic Skyward Ambitions

Few today read the poets of the Whig sublime, consigned to near oblivion by the success of the literary history written by Tories such as Pope, Swift and Gay.[30] Yet Pope's own engagement with themes of celestial aspiration is

29. Cf. Cowley's 'The Muse', travelling through space and time: 'And sure we may / The same too of the present say, / If past, and future times do thee obey. / Thou stop'st this current, and dost make / This running river settle like a lake' (56–60).

30. See Williams 2005.

complex. I start with *An Essay on Man* (1733–34), which has been described as a 'transliteration' of the themes of Milton's *Paradise Lost* into 'rationalistic terms', a poem of the middle flight, lacking Milton's high-flown 'magnificence'.[31] Pope insists on man's 'middle state', reminding him of his place in the great chain of being. He criticizes the soaring aspirations of pride (Satan's error): 'In pride, in reas'ning pride, our error lies; / All quit their sphere, and rush into the skies.[32] / Pride still is aiming at the blest abodes, / Men would be angels, angels would be gods' (*Essay*, Epistle 1.123–26); and 'What would this man? / Now upward will he soar, / And little less than angel, would be more; / Now looking downwards, just as grieved appears / To want the strength of bulls, the fur of bears' (173–76). The modern Englishman can learn from the untutored savage, whose hopes of a posthumous life are far humbler than the soaring pretensions of Pope's didactic addressee (99–106, 109–12):

> Lo! the poor Indian, whose untutored mind
> Sees God in clouds, or hears him in the wind;
> His soul, proud science never taught to stray
> Far as the solar walk, or milky way;[33]
> Yet simple nature to his hope has giv'n,
> Behind the cloud-topped hill, an humbler heav'n,
> Some safer world in depth of woods embraced,
> Some happier island in the watery waste
>
> . . .
>
> To Be, contents his natural desire,
> He asks no angel's wing, no seraph's fire;
> But thinks, admitted to that equal sky,
> His faithful dog shall bear him company.

This human being takes pleasure in the community of his animal, rather than aspiring to leave the beast far behind in an ascent towards the divine. He is not impelled upwards by a boundless desire, the burning love of the Seraphim.

31. See Mack 1950: lxxiii–lxxiv.

32. Gilbert Wakefield (cited in Mack 1950, on line 124) compares Horace, *Odes* 1.3.38, 'caelum ipsum petimus stultitia' (see ch. 2: 50), with Creech's translation: 'Grown giants in impiety / Our impious folly dares the sky'.

33. Mack compares Edward Young, *The Last Day* (1713) 2.369–70: 'O how Divine! to tread the Milky Way, / To the bright palace of the Lord of Day.'

Yet, the topics of the flight of the mind and celestial aspiration are emphatically present, under erasure, and through allusion, in the opening lines of the *Essay*, dedicating it to Henry St John, Lord Bolingbroke (1–16):

Awake, my St. John! leave all meaner things
To low ambition, and the pride of kings.
Let us (since life can little more supply
Than just to look about us and to die)
Expatiate free o'er all this scene of man;
A mighty maze! but not without a plan;
A wild, where weeds and flow'rs promiscuous shoot;
Or garden, tempting with forbidden fruit.
Together let us beat this ample field,
Try what the open, what the covert yield;
The latent tracts, the giddy heights explore
Of all who blindly creep, or sightless soar;
Eye Nature's walks, shoot folly as it flies,
And catch the manners living as they rise;
Laugh where we must, be candid where we can;
But vindicate the ways of God to man.

A call to a 'St. John' might prelude a flight on the wings of the eagle, the symbol of Saint John, the evangelist and supposed author of the sublime Book of Revelation. This would be to follow Chaucer lifted up to the House of Fame by an eagle, or Astolfo's flight to the moon in the company of *his* Saint John in *Orlando furioso* 34–35 (see ch. 2: 102–5), both in works with which Pope was well acquainted.[34] The words that follow, 'leave all meaner things / To low ambition', do indeed suggest that we are setting out on a lofty flight, but the continuation of line 2 adjusts the trajectory, directing a course that is below 'the pride of kings',[35] so a middle flight. An echo of a major sixteenth-century neo-Latin didactic poem on the secrets of the sky, George Buchanan's *De sphaera*

34. In the first edition, Bolingbroke is addressed as 'Laelius', the Roman statesman described by Horace as delighting in the company of the poet Lucilius in his private moments (Horace, *Sat.* 2.1.71–74); one therefore looks for a particular motivation for the change of address to 'St. John'.

35. Pride is associated with height, is lofty and haughty, goes before a fall; Latin *superbus* is from *super* (above). There is an oxymoron in associating 'pride' and 'mean'; there is perhaps a further paradox in that the original, now obsolete, sense of 'mean' *adj.* is 'occupying a middle place', as in the 'golden mean'.

(see ch. 3: 124–25), reinforces the point: 'Now, my Timoleon, set your capacious mind on greater things, and do not for ever marvel at the lowly earth; shake off ignoble concerns for mortal things, and walk with me through the vast tracts of the sky' (Iam mihi, Timoleon, animo maiora capaci / concipe, nec terras semper mirare iacentes; / excute degeneres circum mortalia curas, / et mecum ingentes coeli spatiare per oras) (*De sphaera* 2.1–4).[36] Buchanan and Timoleon are set to launch themselves on a mental journey in the sky, to which Pope does *not* invite his 'St. John'. Buchanan's *spatiare* is, however, echoed in Pope's 'expatiate free' (5), a verb often used of the liberated wandering of the flight of the mind (see ch. 1: 41), but here used of wandering on the horizontal plane, in a maze, an earthly wilderness or garden. A vertical opposition between low and high is established in lines 11–12 ('latent tracts'/'giddy heights', 'creep'/'soar'), but this is the soaring not of the poet, but of the subject of his satire, proud and presumptuous man. Pope continues to draw on Renaissance didactic verse in Latin and English: the 'latent tracts' of line 11 may look to the programmatic statement of another neo-Latin poem, the soaring Italian poet Palingenius's *Zodiacus uitae* (an epic poem that guides the reader on a journey through astronomical, moral and philosophical material, published in the 1530s, and much read in sixteenth-century English grammar schools: see ch. 3: 127): 'Meanwhile, relying on reason, I will explore the latent paths of nature, and I will open up things hidden' (interdum, fretus ratione, latentes / naturae tentabo uias, atque abdita pandam (*Zodiacus* 1.66–67).[37] Of Pope's line 12, 'Of all who blindly creep, or sightless soar', Maynard Mack notes, 'The force of the antithesis resides in the assumption that there is a mode of motion appropriate to man, which is neither creeping nor soaring, and that to depart from this is blindness in either case.' Mack cites the distinction in Sylvester's *Du Bartas* 1.1.127ff. between those who 'Climb . . . the battlements of heaven', and those who, stooping, 'the author's praise . . . in themselves eclipse'; in contrast to both, the Muse of Sylvester's *Du Bartas* 'keeps the middle region' (see ch. 3: 109). It was in pointed opposition to Du Bartas that Milton invoked the aid of the 'heavenly Muse' for his 'adventurous song, / That with no middle flight intends to soar / Above th' Aonian mount' (*PL* 1.13–15; see ch. 4: 179–80). Sylvester's *Du Bartas* also says of those ambitious of lofty flight, 'Beyond the world's walls let those eagles fly, / And gaze upon the sun of majesty' (1.1.129–30; see

36. Noted by Mack 1950, on vv. 1–5, referring to Ewart 1853.

37. The parallel is noted in the collection of parallels between *Zodiacus uitae* and *Essay on Man* in *The Publisher: Containing Miscellanies in Prose and Verse* 2 (1745) (see Mack 1950, on *Essay* 1.11).

ch. 3: 108). Maynard Mack suggests that Pope's 'sightless soar' alludes to ancient bestiary lore that only the eagle can look into the sun as it flies towards it. If so, this continues the image activated in the opening line of the eagle as the symbol of Saint John. What flies and rises is not the poet and his reader, but the figurative game-birds of folly and manners, to be shot down and snared as they attempt to take flight (Pope, *Essay* 1.13–14).

Du Bartas's 'Beyond the world's walls' alludes to the flight of the Lucretian Epicurus's mind 'extra . . . flammantia moenia mundi' (Lucr. 1.72–73). Pope himself alludes to Epicurus's flight of the mind in the next section of the *Essay on Man*: 'He, who thro' vast immensity can pierce / See worlds on worlds compose one universe / . . . / May tell why Heaven has made us as we are' (1.23–24, 28). In the Morgan manuscript version of lines 23–24, the Lucretian allusion is even more obvious: 'He who can all the flaming limits pierce / Of worlds on worlds, that form one universe.'[38] Pope will not follow the invitation to follow in Epicurus's tracks: 'Through worlds unnumbered though the God be known, / 'Tis ours to trace Him only in our own' (*Essay* 1.21–22); nor will he follow the theorist of the 'Whig sublime', John Dennis, enthusing in Lucretian-Pindaric mode over the ten thousand suns, and 'millions behind' in the heavens, in 'Part of the Te Deum Paraphras'd, in Pindarick Verse', stanza 6: 'And when our wearied eyes want further strength, / To pierce the void's immeasurable length, / Our vigorous tow'ring thoughts still further fly, / And still remoter flaming worlds descry.'[39]

38. Lord Bathurst alludes to Lucr. 1.73 in a letter to Pope sent in eager anticipation of the *Essay on Man*: 'When your mind has shot through the flaming limits of the universe, send me some account of the new discoveries', cited in Fabian 1979: 526. In one of the manuscript versions of the *Essay*, the first line begins, 'Awake my Memmius', equating Bolingbroke with Lucretius's didactic addressee. With the phrase 'flaming limits' (for Lucretius's 'flammantia moenia mundi') Leranbaum (1977: 51 n. 26) compares Rochester's 'Satyr against Reason and Mankind' (prob. before June 1674), where the clerical defender of reason against the satirist praises 'Reason, by whose aspiring influence, / We take a flight beyond material sense, / Dive into mysteries, then soaring pierce / The flaming limits of the universe, / Search heaven and hell, find out what's acted there, / And give the world true grounds of hope and fear' (66–71). Here, the Epicurean flight beyond the flaming limits of the universe reaches to a non-materialist, Augustinian and Neoplatonic spiritual realm. The satirist responds with a savage deflation of the topos of the flight of the mind, lambasting the 'thinking fools / Those reverend bedlams, colleges and schools; / Borne on whose wings, each heavy sot can pierce / The limits of the boundless universe; / So charming ornaments make an old witch fly / And bear a crippled carcass through the sky' (82–87).

39. Cited in Mack 1950, ad loc.

But, in fact, Lucretius's *On the Nature of Things* is one of the primary models for *An Essay on Man*, which draws on elements of the Lucretian didactic persona, at the same time as Pope produces an example of the 'anti-Lucretius', of which Blackmore's *Creation* is also a specimen, although of a very different kind.[40] In the 1730s, furthermore, to allude to an unnamed man who 'through vast immensity can pierce' almost inevitably also takes up a position with regard to the modern hero of Lucretian space-travel, Newton, James Thomson's 'all-piercing sage' (see ch. 3: 154).[41]

Pope also directs his satire at the celestial aspirations of contemporary ceiling painters, in his 'An Epistle to the Right Honourable Richard Earl of Burlington' (1731). Richard Boyle, third earl of Burlington was the arbiter of taste of the Palladian movement in architecture, which saw the grand mural paintings of previous decades go out of fashion (see ch. 6: 311). In Timon's villa, the visitor's soul is invited, through his ears, by the music of the service in chapel, to 'dance a jig to heaven' (141–50):

And now the chapel's silver bell you hear,
That summons you to all the pride of prayer.
Light quirks of music, broken and unev'n,
Make the soul dance upon a jig to Heav'n:
On painted ceilings you devoutly stare,
Where sprawl the saints of Verrio or Laguerre,
On gilded clouds in fair expansion lie,
And bring all paradise before your eye:
To rest, the cushion and soft dean invite,
Who never mentions Hell to ears polite.

The saints 'sprawl[ing] . . . in fair expansion' are a static equivalent to the expatiations of the sky-wandering flight of the mind.

Pope had not always been so averse to the topos of the flight of the mind. In the early *Windsor Forest* (first published 1713), he reworks the beatitudes of the end of Virgil's second *Georgic* (2.490–94: 'felix qui . . . fortunatus et ille';

40. Fabian 1979, concluding (537) that the *Essay* 'is a grand allusion to Lucretius that made of him a part of the neo-classical canon of English literature in much the same way, though not in the same manner, that Pope's translation of the Greek epics made Homer a part of this canon.' On *An Essay on Man* and Lucretius, see further Leranbaum 1977: 38–63; Hopkins 2007: 270–72; Priestman 2012: 412–14.

41. So Fabian 1979: 536–37.

see ch. 2: 68).[42] For Virgil, the alternative subjects of congratulation are the high-flying Lucretian natural philosopher, who understands the workings of stars, sun and moon, or, if that is a model of an unreachable aspiration, the man who withdraws to the protective shades of the rural landscape, and there rests content with a different kind of knowledge about the gods of the countryside. For Pope, the alternatives are the man active in the bright lights of court and politics, and the man who leads a life of retirement in the forest shades. What in Virgil are kept separate, are now combined, in keeping with the range of activities pursued in the leisure time of an eighteenth-century aristocrat or gentleman on his country estate—*both* the humbler, home-grown pursuits of rustic nature *and* sublime philosophical inquiry into the nature of things, where his soul 'expatiates' amidst the stars that are also its home, as its place of origin (for this idea see ch. 2: 33–34);[43] *Windsor Forest* (233–46, 251–56):

> Happy the man whom this bright court approves,
> His sov'reign favours, and his country loves:
> Happy next him, who to these shades retires,
> Whom nature charms, and whom the Muse inspires;
> Whom humbler joys of home-felt quiet please,
> Successive study, exercise, and ease.
> He gathers health from herbs the forest yields,
> And of their fragrant physic spoils the fields:
> With chymic art exalts the min'ral pow'rs,
> And draws the aromatic souls of flow'rs:
> Now marks the course of rolling orbs on high;
> O'er figured worlds now travels with his eye:
> Of ancient writ unlocks the learned store,
> Consults the dead, and lives past ages o'er
>
> . . .
>
> Or looks on heav'n with more than mortal eyes,
> Bids his free soul expatiate in the skies,
> Amid her kindred stars familiar roam,
> Survey the region, and confess her home!

42. On the classical theme of 'the happy man', see Røstvig 1962.

43. See Chalker 1969: 83–84. For a similar range of the humble and the elevated in the activities of an eighteenth-century aristocrat in rural retreat, see Thomson, 'Spring' 904–37, portraying George Lyttelton (also a patron of Pope) on his country estate at Hagley Park (see Chalker 1969: 121–22).

Such was the life great Scipio once admired,
Thus Atticus, and Trumbull thus retired.

It is in mock-heroic mode that Pope is most unrestrained in his handling
of themes of celestial aspiration. Allusive density characterizes his resolution
of the war of the sexes between Belinda and the Baron at the end of *The Rape of
the Lock* (1714) by the removal of the contested Lock from the earthly battle-
field through catasterism, transport to the stars: 'Some thought it mounted to
the lunar sphere, / Since all things lost on earth, are treasured there' (5.113–14):
these lines introduce an adaptation of Ariosto's Valley of Lost Things on the
moon, to which Astolfo travels in the company of Saint John in search of Or-
lando's lost wits (*Orlando furioso* 34–35: see ch. 2: 102–5). That parody of Dante's
ascent through Purgatorio and Paradiso in the *Divine Comedy* is an important
text in the history of the mock-heroic, of which *The Rape of the Lock* is a mas-
terpiece; it had been the model for Milton's Paradise of Fools (*PL* 3.444–97:
see ch. 4: 185), and Pope had read it early in life in Sir John Harington's transla-
tion, according to Joseph Spence.[44] But the surmise that the Lock had as-
cended to the moon is corrected by the Muse (5.123–32):

But trust the Muse—she saw it upward rise,
Tho' marked by none but quick, poetic eyes:
(So Rome's great founder to the heav'ns withdrew,
To Proculus alone confessed in view.)
A sudden star, it shot thro' liquid air,
And drew behind a radiant trail of hair.
Not Berenice's locks first rose so bright,
The heav'ns bespangling with dishevelled light.
The Sylphs behold it kindling as it flies,
And pleased pursue its progress thro' the skies.

'Berenice's locks' footnotes the primary classical model for a narrative about
the severance of a lock from its mistress's head, Catullus 66, 'The Lock of Ber-
enice' (*Coma Berenices*), a Latin translation of the concluding poem in Calli-
machus's *Aitia* (see ch. 2: 62). With this Greek catasterism of a woman's lock,
Pope combines two weightier, Roman, masculine apotheoses: explicitly, that
of Romulus, the credibility of which was as suspiciously dependent on the
eye-witness account of one man as credence for the ascent of Belinda's lock

44. Cited in Tillotson 1954, on 5.114ff.

rests on nothing more substantial than 'quick, poetic eyes';[45] and implicitly, that of Julius Caesar, in the version of Ovid at the end of the *Metamorphoses* (15.843–51; see ch. 2: 79). There Venus plucks the soul of Caesar from his body on his assassination and bears it up to the stars. As she does so, it catches fire, Venus lets go, and Caesar's soul soars higher than the moon, metamorphosed into the comet that appeared at his funeral games in 44 BC.[46] Etymologically, a comet is a 'hairy star' (Greek κομήτης), referring to the tail that streams from a comet. Ovid alludes to that other tale of a 'hairy star', Catullus 66, the *Coma Berenices*, in his account of the comet of Caesar; an allusion that Pope may have spotted, as he may also have seen the close parallels between Ovid's accounts of the apotheoses of Caesar and Romulus (*Met.* 14.818–28).[47]

Allusion to the Lock of Berenice continues in the list of those who will in future look up to the new star, including the 'ridiculous Star-gazer' and writer of almanacs, the virulently anti-Catholic John Partridge, taking the place of the Alexandrian astronomer Conon, who 'saw the lock from the head of Berenice shining in the lights of the heavens' (Cat. 66.7–8), but now using modern technology (137–38): 'This Partridge soon shall view in cloudless skies, / When next he looks thro' Galilæo's eyes.' *The Rape of the Lock* concludes by consoling Belinda for the loss of her 'ravish'd Hair' with the compensation of the undying 'glory' of the new star, an (unreal) astronomical glory that in the last couplet is transmuted into the kind of glory that Belinda and, even more, the poet may hope for in reality (149–50; after the death of Belinda): 'This lock, the Muse shall consecrate to fame, / And 'midst the stars inscribe Belinda's name.'[48] This is a consolation that goes back all the way to the time of

45. Reported, suspiciously, by Livy (1.16). Pope also alludes to Denham, *Cooper's Hill*: 'their [fairies', satyrs', nymphs'] airy shape / All but a quick poetic sight escape' (233–34; cited in Tillotson 1954).

46. Pope probably knew Boileau's little parody 'La Métamorphose de la perruque de Chapelain en comète' (1664): see Tillotson 1954: 116 n. 1.

47. Very Ovidian too is 'A sudden star': Ovid uses the adjective *subitus* (sudden) to refer to the product of a sudden metamorphosis: *Met.* 2.349: 'subita radice'; 5.560: 'subitis . . . pennis'; 7.372: 'subitus . . . olor'; 11.341: 'subitis . . . alis'; 13.617: 'praepetibus subitis'; the adverb *subito* often occurs in the narrative of metamorphoses.

48. Wakefield (cited in Tillotson 1954) compares Spenser, *Amoretti* 75: 'Not so, (quod I) let baser things deuize / to dy in dust, but you shall liue by fame: / my verse your vertues rare shall eternize, / and in the heuens wryte your glorious name' (9–12); and Cowley's imitation of Horace, *Odes* 4.2, 'The Praise of Pindar': 'He bids him live and grow in fame, / Among the stars he sticks his name' (32–33; see ch. 3: 142).

the Homeric heroes, who exchange their mortality in battle for undying *kleos* (fame). It is also a thoroughly Ovidian conclusion, elevating the fame achieved by the poet above the dubious celestial aspirations of Roman rulers. Caesar's comet flies higher than the moon, but the 'better part', the immortal part of Ovid, the fame of his poetry, will be carried above the lofty stars, in the boast of the Epilogue to the *Metamorphoses* (15.875–79). With the rhyme-words of the last couplet, 'fame' and 'name', Pope ends with something that goes beyond the mock-heroic, and to which *The Rape of the Lock* has since made good its claim.[49]

Soaring and Sinking

Samuel Johnson, for one, found the image of vertical aspiration as appropriate for a description of Pope's genius as Milton, and Milton's admirers, had found it for Milton's poetic flights: 'Pope had likewise genius; a mind active, ambitious, and adventurous, always investigating, always aspiring; in its widest searches still longing to go forward; in its highest flights still wishing to be higher; always imagining something greater than it knows, always endeavouring more than it can do.'[50] However, Pope took delight in parodying the sublime flights of Blackmore, Dennis, and others, the poets of the 'Whig sublime'.[51] Pope was not alone: for example, another Tory writer, George Granville, attacks poets 'Who, driven with ungovernable fire, / Or void of art, beyond these bounds aspire, / Gigantic forms, and monstrous births alone / Produce, which Nature shocked, disdains to own. / ... / Such frantic flights, are like a madman's dream, / And nature suffers, in the wild extreme' ('Concerning Unnatural Flights in Poetry' [1701]: 13–16, 57–58).[52] Granville here combines the monstrous hybrid forms denigrated by Horace at the beginning of the *Ars poetica* with the satire on the mad poet at the end (see ch. 2: 52). In his emphasis on

49. Tillotson 1954: 105: 'The external history of the poem has been one of universal fame.'

50. *Life of Pope*, in Lonsdale 2006, 4: 62.

51. See Williams 2005: 201 on 'Pope's endless parodying of the flights of Blackmore, Dennis, and others'. But Noggle argues (2001: ch. 1) that constant undercutting of Whig sublime was 'another way of expressing the unutterable nature of truly elevated thought' (as summed up by Williams 2005: 201). See also Terry 2005: ch. 3, 'Blackmore and the Low Sublime', on Blackmore as the 'sinking' poet, the 'father of the bathos, and indeed the Homer of it'. William Coward, in *Licentia poetica Discuss'd* (1709: 23–24), accuses Blackmore of having 'Clogged the brisk wings, with which he strove t' ascend'.

52. Cited in Williams 2005: 200.

the need to keep within bounds, Granville attempts to pursue a Horatian golden mean, answering an imaginary interlocutor (19–26, 41–50, 87–90):

'But poetry in fiction takes delight,
'And, mounting in bold figures out of sight,
'Leaves truth behind in her audacious flight:
'Fables and metaphors that always lie,
'And rash hyperboles that soar so high,
'And every ornament of verse must die.'
Mistake me not; no figures I exclude,
And but forbid intemperance, not food.

. . .

Hyperboles, so daring and so bold,
Disdaining bounds, are yet by rules controlled:
Above the clouds, but still within our sight,
They mount with truth, and make a tow'ring flight;
Presenting things impossible to view,
They wander thro' incredible to true:
Falsehoods thus mixed, like metals are refined,
And truth, like silver, leaves the dross behind.
Thus poetry has ample space to soar,
Nor needs forbidden regions to explore[.]

. . .

First Mulgrave rose, Roscommon next, like light,
To clear our darkness, and to guide our flight;
With steady judgment, and in lofty sounds,
They gave us patterns, and they set us bounds.

The section on hyperboles reads as another sanitized version of Virgil's hyperbolical and sky-reaching Fama, who hides her head in the clouds while her feet are still on the ground, and who mingles fictions with falsehoods (see ch. 2: 73–74). But one is left with the sense of hyperbole denatured, the 'over-reacher' in chains, a contradiction in terms, if one rephrases line 42 as 'Disdaining bounds, but yet rule-bound'. This is hyperbole minus the thrill of the sky-soaring sublime.[53]

53. For a defence of hyperbole's decorousness as a figure of the sublime, see Ettenhuber 2007; for a 'hyperbolical reading' of *Aen.* 4 which shows just why Virgil's sky-reaching Fama is at home in that book, see Hardie 1986: 267–85.

The Tory writers' attacks on the ungrounded flights of the Whig sublime exploit the anxiety of those writers themselves as to their ability to sustain their ambitions, an anxiety with a long history. The poet inspired and transported by the mysteries and secrets of Nature and God soars and dives, ranging freely over the full vertical axis. But high-flying comes with its risks. A Phaethon, an Icarus, or a Satan, ends up falling, rather than diving, because of a failure to control the technology of flight, or because of adverse meteorological or astronomical conditions, or because of misguided ambition and pride. Phaethon, Icarus and Satan suffer from a lack of self-awareness. Others who fancy that they are uplifted on the wings of their sublime art may unwittingly sink and become the objects of ridicule, because they deceive themselves as to the nature of their raptures, transports, ecstasies. This is the point at which *hypsos*, 'height, sublimity', crashes down in bathos, literally 'depth'. Others, more self-aware, who aspire to figurative flights of philosophy and poetry may end up grounded because of a confessed inability to sustain the effort.

The topos of the failure of mental flight goes back at least as far as Virgil's admission at the end of the second *Georgic* that he may not be capable of a Lucretian-Aratean flight through the universe, and instead may have to content himself with a life unknown to fame amidst the rivers and valleys of an idealized landscape (*Geo.* 2.475–89: see ch. 2: 68). A Roman author of the Neronian period, Columella, who included in his prose treatise on agriculture a book in didactic hexameters on horticulture in a highly Virgilian (and Lucretian) vein, recalls himself from a sublime but over-ambitious flight in a chariot of poetry, in which he has launched himself to sing of the springtime sacred marriage of the sky-god Jupiter and Mother Earth. Instead he confines himself to the narrower earthbound circuit of the slender poetry befitting the tree-pruner and vegetable gardener (*De re rustica* 10.215–19):

> sed quid ego infreno uolitare per aethera cursu
> passus equos audax sublimi tramite raptor?
> ista canit, maiore deo quem Delphica laurus
> impulit ad rerum causas et sacra mouentem
> orgia naturae secretaque foedera caeli.

> (But why am I carried away on a lofty path, boldly allowing my horses to fly unbridled through the air? That is a theme for one whom the Delphic laurel has moved with inspiration more divine to sing of the causes of things, treating of the sacred rites of nature and the secret laws of the heavens.)

The late antique Christian poet Paulinus of Nola, surprised by his own sublime flight into lofty matters of divinity, calls himself back to earth (Poem 27.307–22: see ch. 2: 95).

The Virgilian sequence at the end of *Georgics* 2 is a close model for James Thomson's 'Autumn', addressing Nature (1352–53, 1355, 1365–69):

> Snatch me to heaven; thy rolling wonders there,
> World beyond world, in infinite extent,
>
> . . .
>
> Shew me . . .
>
> . . .
>
> But if to that unequal, if the blood,
> In sluggish streams about my heart, forbid
> That best ambition; under closing shades,
> Inglorious, lay me by the lowly brook,
> And whisper to my dreams[.][54]

Virgil is perhaps mediated through Thomson in the youthful Joseph Warton's *The Enthusiast: or, the Lover of Nature* (composed 1740), which invokes, 'in cloudless nights', 'Old Midnight's sister Contemplation sage / . . . / To lift my soul above this little earth, / This folly-fettered world: to purge my ears, / That I may hear the rolling planet's song, / And tuneful turning spheres' (200, 207–10). But this celestial aspiration may not be realized, and the poet may have to find recreation in low-lying places (210–13): 'if this debarred, / The little fays that dance in neighbouring dales, / Sipping the night-dew, while they laugh and love, / Shall charm me with aërial notes.'

The would-be imitator of Pindar may fail to match the wing-power of his poetic hero, as Horace warns in *Odes* 4.2 (see ch. 2: 52).[55] The neo-Latin poet Sarbiewski manages a controlled descent from a potentially disastrous flight at the end of a soaring ode in praise of Pope Urban VIII (*Odes* 1.10).[56]

54. 'if the blood, In sluggish streams about my heart, forbid' virtually translates *Geo.* 2.484: 'frigidus obstiterit circum praecordia sanguis'; 'inglorious' = *Geo.* 2.486 'inglorius'.

55. Spenser protests at his recurrent failure to take flight at the beginning of second of the *Mutabilitie cantos*, but calls on the 'greater Muse' to enable him to overcome this moment of *recusatio*: 'Ah! whither doost thou now thou greater Muse / Me from these woods and pleasing forrests bring? / And my fraile spirit (that dooth oft refuse / This too high flight, vnfit for her weake wing) / Lift vp aloft, to tell of heauens King' (*FQ* 8.7.1–5).

56. On this poem, see also ch. 3: n. 83.

Sarbiewski's poetic afflatus has led him to dwell at length on the pope's post-humous accession to the heavens, late in time, it is hoped, in an example of a standard ancient topos of imperial panegyric (see ch. 2: 49). The papal panegyric concludes with a stanza looking forward to Urban's triumphal return, laden with trophies and years, to the 'golden Capitol of the stars' (77–80). At this point, conscious perhaps of the impropriety of attempting to rival the pope's skyward trajectory in his own flight as a Horatian swan through the liquid ether (1ff.), the poet calls on the Muse to relieve him of the Horatian wings that he had put on at the beginning of the poem (81–84):

> Quo, Musa, uatem, non memor Icari,
> tollis relapsurum? his potius grauem
> depone ripis, et dolosas
> deme humeris digitisque plumas.[57]

(Whither, Muse, unmindful of Icarus, do you carry your bard, heading for a fall back to earth? Lay down his heavy body instead on these banks, and remove the treacherous feathers from his shoulders and fingers.)

The poet ends by asking to be allowed to slumber lazily on the banks of the Tiber.

Flights inspired by religious rapture fail because of the embodied mortal's inability to reach up to God. Falling back is also a convenient way of imposing poetic closure. This is a recurrent device, for example, in the poetry of Isaac Watts. In Watts's 'To Mr T. Bradbury. Paradise' (1708), the strain on the mortal frame imposed by the attempted ascent towards Paradise leads to the breaking of a dream vision (73, 75–76, 81–86):

> And now my tongue . . .
>
> . . .
>
> Attempts th' unutterable name,
> But faints confounded by the notes divine
>
> . . .
>
> Th' immortal labour strained my feeble frame,
> Broke the bright vision, and dissolved the dream;
> I sunk at once and lost the skies:

57. 'Quo Musa uatem' points to Horace, *Odes* 3.25: 'Quo me, Bacche, rapis . . . ?' (see ch. 2: 50–51); for Icarus, cf. Horace, *Odes* 2.20.13; 4.2.1–4.

> In vain I sought the scenes of light
> Rolling abroad my longing eyes,
> For all around them stood my curtains and the night.

In one of Watts's major exercises in Pindarics, 'Two Happy Arrivals, Devotion and the Muse', Pindaric song itself is inadequate to the heights of Christian religion, and eventually the Christian poet's own powers give out. The Muse first outstrips Virtue and Piety in her ascent, but is then overtaken by the flight of Devotion, helped upwards by Religion 'descending down': 'Now the swift transports of the mind / Leave the fluttering muse behind, / A thousand loose Pindaric plumes fly scatt'ring down the wind' (90–92). Finally, the poet's mortal strength droops (95–101):

> The feeble pow'rs that nature gave
> Faint, and drop downward to the grave;
> Receive their fall, thou treasurer of death;
> I will no more demand my tongue,
> Till the gross organ well refin'd
> Can trace the boundless flights of an unfettered mind,
> And raise an equal song.

Abigail Williams notes of the early eighteenth-century 'Whig sublime' that it 'is characterized by the professions of linguistic inadequacy that accompanies the flight of imagination, and the need to describe "something too great for utterance"'.[58] An example from one of the most popular poems of the time is Charles Montagu (later earl of Halifax)'s *Epistle to Dorset*, a panegyric on William III's victory over James II at the Battle of the Boyne in 1690 (p. 8):

> My spirits shrink, and will no longer bear;
> Rapture and fury carried me thus far
> Transported and amazed,
> That rage once spent, I can no more sustain
> Your flights, your energies, and tragic strain,
> But fall back to my nat'ral pace again.[59]

58. Williams 2005: 195.

59. Ibid.; and 51–52, on Tory satire on descent and the false sublime in Whig 'enthusiasm'. For another example, see Thomas Parnell 'The Ecstasy' (64–74): 'But ah what's this? And where is all my heat, / What interruption makes my joy retreat . . . ?', dragged down again by 'these chains of earth'.

It is hard to overlook the sexual overtones of the language here ('shrink', 'spent', 'fall back'), an eroticized imagery which can be unembarrassedly overt, as in John Dennis's comment that the sublime is 'an invincible force, which commits a pleasing rape upon the very soul of the reader'.[60] Another example from a writer associated with Whig circles, and who was also one of Alexander Pope's 'dunces', comes at the conclusion of John Ozell's translation (1708) of Boileau's mock-epic *Le Lutrin* (1674).[61] The poet breaks off, as he expresses his inability to 'sing the man' Aristus, who finally resolves the dispute over the lectern:

> Still burns the Muse to speak the hero's praise;
> And with thy name immortalize her lays.
> But when she measures the transcendent height,
> Her feeble wings decline the dangerous flight.
> The trembling sounds are dashed upon her tongue,
> And admiration interdicts her song.

The failed flight image here is an addition to the devices by which Boileau extricates himself from the task of writing through to its conclusion a work which he confesses, in his 'Au lecteur' of the 1674 edition, to having left 'imparfait'.

In the context of a mock epic, published just four years before the first publication (1712) of Pope's *The Rape of the Lock* (for which Boileau's *Le Lutrin* was an important model), the use of the topos is hardly without irony. That this is so is an indication of the partiality with which the clichéd professions by Whig poets of inadequacy in sustaining sublime flight were seized upon as a target for the satire of the Tory Scriblerians (Pope, Swift and the like), in, for example, Pope's *Peri Bathous, or, The Art of Sinking in Poetry* (1727).[62] Earlier, in *A Tale of a Tub* (1704), Swift had satirized radical Dissenters as 'Aeolists' (adherents of Aeolus, god of winds, claiming the afflatus of divine inspiration): 'his first flight of fancy commonly transports him to ideas of what is most perfect, finished, and exalted, till, having soared out of his own reach and sight, not well perceiving how near the frontiers of height and depth border upon each other, with the same course and wing he falls down plump into the lowest

60. Cited in Williams 2005: 191; cf. also Fitzgerald 1987: 92–93 (see n. 90 below). On the imagery of rape, rapture, abduction, ravishment in Thomson's *The Seasons*, see Irlam 1999: 123.

61. On Ozell, see Abigail Williams's article in *ODNB*; on his relations with Pope, see Sutherland 1953: 450–51.

62. Williams 2005: 196.

bottom of things' (§8).[63] Swift's airing of possible reasons for this includes 'whether fancy, flying up to the imagination of what is highest and best, becomes over-short, and spent, and weary, and suddenly falls, like a dead bird of paradise, to the ground'.[64] This 'Icarian pattern'[65] is also exemplified in a satirical passage of Pope's *Essay on Man* (2.19–30):[66]

> Go, wondrous creature! mount where science guides,
> Go, measure earth, weigh air, and state the tides;
> Instruct the planets in what orbs to run,
> Correct old time, and regulate the sun;
> Go, soar with Plato to th' empyreal sphere,
> To the first good, first perfect, and first fair;
> Or tread the mazy round his followers trod,
> And quitting sense call imitating God;
> As Eastern priests in giddy circles run,
> And turn their heads to imitate the sun.
> Go, teach Eternal Wisdom how to rule -
> Then drop into thyself, and be a fool!

One of the leading literary men with whom Pope repeatedly clashed was the dramatist, poet, essayist and projector Aaron Hill (1683–1750). Pope satirized what he saw as Hill's inability to sustain either the soaring or the diving of the sublime style. Aaron Hill is present by initials in both *Peri Bathous* and *The Dunciad* (1728).[67] In *Peri Bathous*, he is one of the 'flying fishes', 'writers who now and then rise upon their fins, and fly out of the profound; but their wings are soon dry, and they drop down to the bottom' (6).[68] In *The Dunciad*, Hill features as one of the competitors in the mud-diving contest, for writers 'who the most in love of dirt excel' (2.283–86). Pope cattily labelled his inclusion of Hill an 'oblique panegyric'. A few lines earlier, Pope ascribes to John Dennis a fate similar to that of Swift's Aeolists (Dennis dives into the mud of

63. On flights of fancy, see ch. 1: 19–23.

64. Marvell had compared Milton's successful flight of sublimity to that of the bird of paradise: see ch. 4: 167.

65. See Clark 1970: ch. 2 on the 'Icarian pattern' in *A Tale of a Tub*, and in Pope's *Peri bathous*.

66. The movement of this passage is reminiscent of Horace's Archytas ode, 1.28, contrasting the flight of Archytas's mind with his present constriction in the tomb by a handful of dust (see ch. 2: 45). That parallel is noted by Maynard Mack, ad loc, along with others (in Augustine, Erasmus, Boileau) which do not apply the topos of the flight of the mind.

67. Line-numbering is from the 1728, not the expanded 1743, *Dunciad*.

68. See ch. 3: 144 on Cowley's flying fish.

the Fleet): 'He . . . climbed a stranded lighter's height, / Shot to the black abyss, and plung'd down-right. / The senior's judgment all the crowd admire, / Who but to sink the deeper, rose the higher' (275–78).

Yet the catastrophic failure of flight could itself be productive of sublime effects. The thrill of flirting with dangerous and sublime flights may have something to do with the fashion in English country houses of the early eighteenth century for ceiling paintings on the subject of Phaethon, whether the scene in which Phaethon makes his request to his father the sun to drive his chariot, or the fall of Phaethon (see ch. 6: 316–18).[69] Longinus had quoted a fragment of Euripides's *Phaethon* (*Sublime* 15.4), and enthused, 'Would you not say that the soul of the writer enters the chariot at the same moment as Phaethon and shares in his dangers and in the rapid flight of his steeds? For it could never have conceived such a picture had it not been borne in no less swift career on that journey through the heavens.'

Flying through the Eighteenth Century

The sharp pens of the Scriblerians failed to deter a series of younger poets in the eighteenth century from continuing to launch themselves on lofty flights. It may not, however, be coincidental that a number of these are poets much read in their day but who have now fallen out of fashion (Thomson, Akenside, Young). At the end of this chapter, I shall pursue the story as far as Wordsworth and Tennyson, poets who still claim their undisputed places in the canon.

I have already discussed several passages from the poetry of James Thomson, the *éclat* of whose fame continued to the end of the eighteenth century and beyond, as attested in a well-known anecdote about Coleridge.[70] A Newtonian physico-theology motivates a number of rapturous poetic flights in *The Seasons*: for example, in the concluding lines of 'Autumn' (first published 1730), which rewrites a famous passage in Virgil's *Georgics* (2.475–89: see ch. 2: 68), and of which I cite the first part (1352–66; on the last part see above: 212):

> Oh Nature! all-sufficient! over all!
> Enrich me with the knowledge of thy works!
> Snatch me to Heaven; thy rolling wonders there,

69. See Hamlett 2012: 204 with n. 57.

70. William Hazlitt recounts that on a trip with Coleridge to Linton, Coleridge saw a shabby copy of *The Seasons* lying on the window-seat of an obscure country alehouse, and exclaimed, 'That is true fame!' (Hazlitt 'Lecture on Thomson and Cowper' [1818], in Howe 1930, at 88).

World beyond world, in infinite extent,
Profusely scattered o'er the blue immense,
Show me; their motions, periods, and their laws
Give me to scan; through the disclosing deep
Light my blind way: the mineral strata there;
Thrust, blooming, thence the vegetable world;
O'er that the rising system, more complex,
Of animals; and higher still, the mind,
The varied scene of quick-compounded thought,
And where the mixing passions endless shift;
These ever open to my ravished eye;
A search, the flight of time can ne'er exhaust!

The 'infinite extent' of worlds, and the 'immense' is the new astronomy filtered through Lucretius, rather than Virgil. The familiar binary of diving into the 'deep', after soaring in heaven, here introduces a multi-term ascent through the Great Chain of Being, from mineral, through vegetable and animal, to the human mind.

Thomson gave a powerful impulse to a group of 'physico-theological'[71] descriptive poems and 'excursions' of the 1720s to 1740s. David Mallet's (formerly Malloch, 1701/2?–65) was a close friend and compatriot of Thomson, in emulation of whose *Seasons*, and more particularly 'Summer', he wrote *The Excursion* (1728).[72] This begins with the invocation of 'Fancy' (the psychological faculty often associated with flights of the mind (see ch. 1: 19–23), and one of the 'Genii' who will be invoked by Mark Akenside at the beginning of *The Pleasures of Imagination*). Mallet's Fancy travels over both the horizontal and vertical axes: 'with me range earth's extended space, / Surveying Nature's works; and thence aloft, / Spread to superior worlds thy bolder wing, / Unwearied in thy flight' (*Excursion* [1728], p. 10); 'O'er her [Nature's] ample breast, / O'er sea and shore, light Fancy speeds along, / Quick as the darted beam, from pole to pole, / Excursive traveller' (p. 27). Fancy is the 'excursive

71. On the term, see ch. 1: 7–8.

72. Mallet 1728, reprinted in *Poems on Several Occasions* (London, 1762). In his 'Advertisement', Mallet both apologises for the lack of 'unity and regularity of design', and parades the freedom thereby afforded to the flights of his fancy, or imagination: 'I hope it may be forgiven to a young author, who, from want of skill and experience in his art, may sometimes find it necessary, in a first performance, to indulge a freer and more unconfined range of imagination.'

traveller' of *The Excursion*, her ex-tended ex-cursions matching the ex-patiations of other free-flying minds (see ch. 2: 41–42). The two books mount from earth to the heavens, and finally to God, measuring the full vertical axis in contemplation of the volcano, whose smoke ascends to the sun, and offering to imagination a vertiginous downward gaze into a figurative hell which evokes the Aetnean and Typhoean fires and uproar of the landscape of Satan and the fallen angels in books 1 and 2 of *Paradise Lost* (*Excursion*, p. 42):

> The dread volcano, from whose sulphurous pit,
> Store-house of fire, ascends eternal smoke,
> A dusky column height'ning to the sun!
> Imagination's eye looks down dismayed
> The steepy gulf, pale-flaming and profound,
> With hourly tumult vexed, but now incensed
> To sevenfold fury. First, discordant sounds,
> As of a clamouring multitude enraged,
> The dash of floods, and hollow howl of winds,
> Rise from the distant depth where uproar reigns.

With book 2 of *The Excursion*, the poet ascends with his Muse from the earth to the skies, attaining a vision of the serene and cloudless ether that evokes the revelation to Lucretius of the bright 'aether' of the abodes of the gods, at *On the Nature of Things* 3.18–22 (*Excursion*, p. 50):

> To those bright climes, awak'ning all the Powers,
> And rising to a nobler flight, the Muse
> Ambitious soars, upborn throe tracts of air;
> A path the vulture's eye hath not beheld,
> Nor foot of eagle trod. And as I mount,
> The fluid ether flies approach, observ'd
> Remote, translucent, without loud serene.
> Glorious expansion! by th' Almighty spread,
> Whose limits who hath seen!

The physico-theology of the poem bubbles over in the elevation of reason through enthusiastic passion, obedient to John Dennis's prescriptions on the role of the passions in poetry (p. 59):

> Beauteous appearance! by th' Almighty's hand
> Peculiar fashioned.—Thine those noble works,

> Great, universal ruler! earth and heaven
> Are thine, spontaneous offspring of thy will,
> Seen with transcendent ravishment sublime,
> That lifts the soul to Thee! a holy joy,
> By reason prompted, and by reason swelled
> Beyond all height; for Thou art infinite!
> Thy virtual energy, the frame of things
> Pervading actuates: as at first thy hand
> Diffused thro' endless space this limpid sky,
> Vast ocean without storm, where these huge globes
> Sail undisturb'd, a rounding voyage each[.]

As often, the vastness of space is presented as an ocean, flying equated with sailing. This passage leads on, inevitably, to a paragraph in praise of Newton, indebted to Thomson's poem in his honour: Newton 'whose towering thought, / In her amazing progress unconfined, / From truth to truth ascending, gained the height / Of science', first revealing the divinely established law of gravity. Liberated by death, Newton's disembodied mind now flies higher still, privy to the ultimate vision (p. 61):

> Now beyond that height,
> By death from frail mortality set free,
> A pure intelligence, he wings his way
> Thro' wondrous scenes, new-opened in the world
> Invisible, amid the general quire
> Of saints, and angels, rapt with joy divine,
> Which fills, o'erflows, and ravishes the soul!
> His mind's clear vision from all darkness purged,
> For God himself shines forth immediate there
> Thro' these eternal climes, the frame of things,
> In its ideal harmony, to him
> Stands all revealed.

The poem ends with contemplation of the 'immortal natures' of the guardian angels who watch over and guide mortals in various ways, the last of which is to inspire the soul (pp. 73–74),

> born aloft,
> Fired with ethereal ardor, to survey
> The circuit of creation, all those suns

With all their worlds: and still from height to height,
By things created rising, last ascend
To that first cause, who made who governs all,
Fountain of being, self-existent power,
All-wise, all-good, who from eternal age
Endures, and fills th' immensity of space,
That infinite diffusion, where the mind
Conceives no limits; undistinguished void,
Invariable, where no landmarks are,
No paths to guide imagination's flight.

Where Epicurus's flight of the mind revealed an infinity of matter devoid of transcendental deity, for Mallet the immensity of space is filled with the infinity of God. Where for Lucretius the pathless places of the Muses (Lucr. 1.926: 'auia Pieridum . . . loca') offer fresh ground for new explorations, for Mallet, in the last two lines of the poem, the absence of landmarks and paths brings an end to the flight of imagination that began with the invocation to 'Fancy', the first word of the poem. The undistinguished immensity of space finally cancels the invitation to wander over pathless places of a more pastoral, and less elevated, landscape that had been issued in the opening invocation to Fancy, 'Thou whose mighty will / Peoples with airy shapes the pathless vale, / Where pensive meditation loves to stray.'

Mark Akenside's (1721–70) The Pleasures of Imagination (1744)[73] is a philosophical didactic poem, in three books, on the powers of imagination, as that faculty acts as the interface between the human mind and nature, and gives rise to the imitative arts of painting and sculpture, and the linguistic art of poetry, an art detached from direct imitation of nature, but still having as an important goal the expression of the objects of imagination. Akenside's immediate point of departure is Addison's Spectator essays (nos 411–21, of 1712) on the 'Pleasures of the Imagination'. Akenside's imagination is comparable to the power of the demiurge (3.398–405), or to the animating art of Prometheus (410–12). This is also a poem about God's self-revelation in Nature, and in that respect Akenside self-consciously seeks a loftier flight than does Pope in his Essay on Man.[74] After

73. Edited by Robin Dix (1996). The Pleasures of Imagination was completely rewritten as The Pleasures of the Imagination, left incomplete at Akenside's death.

74. Sitter notes (1982: 161) that, in contrast to Pope's Essay, in both Young's Night Thoughts and Akenside's Pleasures, 'unbounded ambition, the desire to "soar", is treated approvingly rather than ironically'. On Akenside's Miltonic aetherial flights, see Griffin 1986: 111.

the prologue, the main body of the poem begins not with the 'scene of Man' (*Essay on Man* 1.5), but with heaven (*Pleasures* 1.56–57) 'From heav'n my strains begin; from heav'n descends / The flame of genius to the human breast'. That is the starting point of Milton's invocation at the beginning of the second half of *Paradise Lost*: 'Descend from heav'n Urania', with whose aid the poet will soar 'above the Olympian hill . . . / Above the flight of Pegasean wing' (*PL* 7.1).

In his prologue, Akenside claims a Miltonic kind of novelty: 'Oft have the laws of each poetic strain / The critic-verse employed; yet still unsung / Lay this prime subject' (1.31–33). 'High Parnassus' is not to be conquered 'By dull obedience and by creeping toil / Obscure' (35–36). Rather, 'Nature's kindling breath / Must fire his chosen genius; nature's hand / Must string his nerves, and imp his eagle-wings / Impatient of the painful steep, to soar / High as the summit' (37–41)—the eagle-wings that Pope does not request from his Saint John. The prologue ends with a close adaptation of Lucretius's account of the love of the Muses that impels him to roam over their pathless haunts (Lucr. 1.922–30, cited in full by Akenside in a note), a signal of Akenside's allegiance to the Lucretian didactic tradition, and also of the poem's affinity with Mallet's *The Excursion*.[75] Where Lucretius is inspired (just) by 'love of the Muses', Akenside is driven to explore by 'the love / Of nature and the muses' (48–49). Here 'nature' is at once an allusion to the subject of Lucretius's *On the Nature of Things* and anticipation of the very different kind of 'nature' that will be the subject of this poem: a non-materialist nature that is the unfolding of God's 'unfathomed essence'. Where Lucretius emphasizes the novelty of his untrodden paths, Akenside plays up the hidden and secret quality of what he explores, looking to 'shade my temples with unfading flow'rs / Culled from the laureate vale's profound recess, / Where never poet gained a wreath before' (53–55); a deep place, in contrast both to 'high Parnassus' and to the heaven from which his strains begin in the very next line.

Akenside names three sources of the primary pleasures of the imagination: the sublime, the wonderful, and the fair (corresponding to Addison's the great, the new, and the beautiful: *Spectator* no. 412, 23 June 1712). The sublime is the occasion for an extended and exhilarating flight of 'the high-born soul' through the cosmos, a flight that sweeps through the tradition of the Lucretian flight of the mind, by this date mediated through a line stretching back through Pope, Thomson and Milton (*Pleasures* 1.151–221), combining it with paraphrase

75. On Akenside's use of the Lucretian model, see Dix 1996: 20–21.

of a passage of Longinus, 'very popular in the eighteenth century',[76] contrasting wondrously great rivers with small streams, the fires of the heavens with a little flame kindled by humans (Longinus, *Sublime* 35.4): 'Who but rather turns / To heaven's broad fire his unconstrained view, / Than to the glimmering of a waxen flame? / . . .' (*Pleasures* 1.174ff. [to 183]).

The section begins with the question, 'Say why was man so eminently raised / Amid the vast creation' (151–52), an example of the *Homo erectus* topos which contrasts bipedal man's face raised to the heavens with the four-footed beasts' eyes fixed on the ground.[77] Man 'dart[s] his piercing eye' through life and death, 'With thoughts beyond the limit of his frame' (153–54): Lucretius's 'extra' (beyond), is defined here with reference to the boundaries of the microcosm, man, but it is God's purpose to send man forth 'as on a boundless theatre' (157), into the 'immense of being' (211). This is a journey into freedom, in which the mind proudly and boldly disdains what would keep it in thrall to earthly powers. The mind is 'impatient to be free, / Spurning the gross control of wilful might; / Proud of the strong contention of her toils; / Proud to be daring' (171–74). The soul 'exalts' (158) and 'exults' (198), and is 'amazed' (201).

There are touches of the flight through Chaos towards Eden of Milton's Satan, who likewise 'spurns the ground' (*PL* 2.929).[78] Satan is buffeted and thrown around by the stormy confusion of Chaos, but 'the high-born soul['s] . . . heaven-aspiring wing' (183–84) harnesses the energies of the storm to her own progress (185–90):

> Tired of earth
> And this diurnal scene, she springs aloft
> Through fields of air; pursues the flying storm;
> Rides on the vollied lightning through the heavens;
> Or, yoked with whirlwinds and the northern blast,
> Sweeps the long tract of day.

The high-born soul is as much at ease with this meteorological energy as is the unfallen angel to whom Joseph Addison, in famous lines, compares the

76. Russell 1964: 167. On the sources for this 'cosmic voyage', see Dix 1996: 443–44; for discussion, see Sitter 1982: 134–36.

77. See ch. 2: n. 39; picked up at 1.537–40: 'For of all / Th' inhabitants of earth, to man alone / Creative wisdom gave to lift his eye / To truth's eternal measures.'

78. Sitter (1982: 135) 'catches the beginnings of a "romantic" reading of Satan' in Akenside (Griffin, 1986: 111, thinks perhaps too readily).

sovereign actions of 'Marlbro's mighty soul' at the battle of Blenheim, in 'The Campaign, Poem, to His Grace the Duke of Marlborough' ([1705] 292–97):

> So when an angel by divine command
> With rising tempests shakes a guilty land,
> Such as of late o'er pale Britannia past,
> Calm and serene he drives the furious blast;
> And, pleased th' Almighty's orders to perform,
> Rides in the whirlwind, and directs the storm.

A few lines later, Akenside transfers the imagery of Lucretius's 'quiet abodes' (sedes quietae) of the Epicurean gods in the spaces between the plurality of worlds (Lucr. 3.18–22) to unspecified 'happy spirits', and combines it with up-to-date astronomical speculation (*Pleasures* 1.201–6):

> Now amazed she views
> The empyreal waste, where happy spirits hold,
> Beyond this concave heaven, their calm abode;
> And fields of radiance, whose unfading light
> Has travelled the profound six thousand years,
> Nor yet arrives in sight of mortal things.

Akenside notes on 'Whose unfading light, &c.', that '[i]t was a notion of the great Mr. Huygens, that there may be fixed stars at such a distance from our solar system, as that their light should not have had time to reach us, even from the creation of the world to this day'. Newton is also allusively present when the soul 'darts her swiftness up the long career / Of devious comets' (196–97), one of several echoes of Thomson's passage on comets in 'Summer'.

Like Lucretius, when the vision of the Epicurean universe opens up to him at the beginning of On the Nature of Things 3, Akenside's high-born soul looks both upwards and downwards. Soaring (190) is followed by a precipitous plunge that hints at the vertiginous fall of a Phaethon,[79] but ends as a dive into the ocean of being, a homecoming (207–11):

> Even on the barriers of the world untired
> She meditates the eternal depth below;
> Till half recoiling, down the headlong steep

79. On *praeceps* (headlong) as a term for a sublimity that risks failure, see Hardie 2009: 215–16, 226.

She plunges; soon o'erwhelm'd and swallowed up
In that immense of being. There her hopes
Rest at the sated goal.

This is the climax of Abraham Cowley's flight of the mind in 'The Exstasie':
'Where am I now? Angels and God is here; / An unexhausted ocean of delight /
Swallows my senses quite, / And drowns all what, or how, or where' (41–44; see
ch. 3: 142). As often in this kind of philosophical tour of the universe, infinitude
is balanced against finitude: the soul is plunged into the immense, but also
comes to rest 'at the sated goal'. Some lines later, that tension is pointed in the
oxymoron 'infinite perfection': God, man's maker, has ordained that the soul
should not find enjoyment in passing pleasures, renown, or power, but should
rather 'Thro' all the ascent of things enlarge her view, / Till every bound at length
should disappear, / And infinite perfection close the scene' (1.219–21).[80]

Lorna Clymer, in a discussion of what she terms the early eighteenth-
century 'soaring muse', speaks of 'a sublime of limitation' in physico-theological
poems, as opposed to the unlimited, Longinian and Burkean brand of the
sublime.[81] That limitation is clearly visible in Jane Brereton's (1685–1740) lines
on the bust of Newton, in 'On the Bustoes in the Royal Hermitage' (1733) (the
Hermitage being Queen Caroline's in the gardens of Richmond Lodge):[82]
'Sublimely on the wings of knowledge, [he] soars; / Th' establish'd order of
each orb unfolds, / And th' omnipresent God, in all, beholds. / . . . / If to the
dark abyss, or bright abode / He points; the view still terminates in God' (37–
42). But in many of these philosophical tours of the universe there is felt the
frisson of opening the mind to the unsettling thrill of the boundless, before
coming home safely to the reassuring presence of the Christian God, an un-
stable combination that is not unlike the tightrope walked by Lucretius over
the abyss of the infinite void.

Akenside's cosmic flight of imagination is also a moral ascent, in which 'the
omnipotent' sends man forth 'As on a boundless theatre, to run / The great
career of justice; to exalt / His generous aim to all diviner deeds' (157–59).

80. Cf. Spenser, 'Hymne of Heauenly Beautie' 104–5: 'How then can mortall tongue hope
to expresse, / The image of such endlesse perfectnesse?' Etymologically 'endlesse perfectnesse'
is an oxymoron, since 'perfect(ness)' is from Latin *perficio* (bring to an end or conclusion);
'infinite . . . close' is another oxymoron (the phrase is changed to 'fill the scene' in the 1772 *The
Pleasures of the Imagination*).

81. Clymer 2005: 33.

82. Quoted in Fairchild 1939 at 325.

Mountain-climbing is again combined with the image of flight, as 'the voice / Of truth and virtue, up the steep ascent / Of nature, calls him to his high reward, / The applauding smile of heaven' (163–66). The allusion is to Prodicus's Choice of Hercules, between the primrose path of Pleasure, and the steep path to the summit of Virtue, a favourite parable in the mid-eighteenth century, and reworked at greater length in book 2 of *The Pleasures of Imagination*, in Harmodius's vision of the competing claims of Euphrosyne ('Mirth', 'Pleasure') and Virtue.[83]

The mountain as an image of an ascent both intellectual and moral, with allusion to another much imitated passage of Lucretius, occurs in a poem almost exactly contemporary with Akenside's *The Pleasures of Imagination*, Thomas Warton's *The Pleasures of Melancholy* ('Written in 1745, the Author's 17th year'), in which contemplation is the means of elevation (see ch. 1: 17–19). The poem opens with an invocation (1–6):

> Mother of musings, Contemplation sage,
> Whose grotto stands upon the topmost rock
> Of Teneriffe; 'mid the tempestuous night
> On which, in calmest meditation held,
> Thou hear'st with howling winds the beating rain
> And drifting hail descend[.]

The debt to the famous opening of book 2 of Lucretius's *On the Nature of Things* is put beyond doubt in lines 10–16:

> while murmurs indistinct
> Of distant billows soothe thy pensive ear
> With hoarse and hollow sounds; secure, self-blest,
> There oft thou listen'st to the wild uproar
> Of fleets encount'ring, that in whispers low
> Ascends the rocky summit, where thou dwell'st
> Remote from man, conversing with the spheres!

Compare Lucretius 2.1–2 ('Suaue mari magno . . .'): 'Sweet it is, when winds stir up the surface of the great sea, to watch from land the great travail of another'. The rocky summit of sky-reaching Tenerife (cf. *Paradise Lost* 4.987–88) is an Epicurean elevation, a version both of Lucretius's 'lofty regions of the wise' (Lucr. 2.8: see ch. 2: 55), and, in the phrase 'remote from man', of the

83. Bibliography: Sitter 1982: 91 n. 20.

calm dwelling-places of the gods, far removed from human concerns (Lucr. 2.648).

Thomas Gray uses Milton's sublime flight in more complicated ways, to comment on his own poetic ambitions and anxieties, in 'The Progress of Poesy. A Pindaric Ode' (1751–54). The ode opens with a call to the Aeolian lyre to awake, followed by water imagery of poetry's progress from 'Helicon's harmonious springs', in the form first of the 'mazy progress' of '[a] thousand rills'; then of a rich stream winding along, 'Deep, majestic, smooth, and strong, / Through verdant vales and Ceres' golden reign'; and finally 'rolling down the steep amain / Headlong, impetuous, see it pour: / The rocks and nodding groves rebellow to the roar' (10–12). Gray alludes to Horace's description of Pindar as a river in spate hurtling down from a mountain: 'monte decurrens uelut amnis, imbres / quem super notas aluere ripas, / feruet immensusque ruit profundo / Pindarus ore' (*Odes* 4.2.5–8); in Cowley's imitation, 'The Praise of Pindar', 'Like a swoll'n flood from some steep mountain pours along, / The ocean meets with such a voice / From his enlarged mouth, as drowns the ocean's noise' (9–11; see ch. 2: 52; ch. 3: 142–43). Horace's *Odes* 4.2 begins, however, not with a gravity-powered plunge, but with the image of the sublime flight of the 'Dircaean swan', from which the poet warns off would-be imitators of Pindar. Gray transfers the dangerous flight to Milton, in the third antistrophe (95–106):

> Nor second [to Shakespeare] he, that rode sublime
> Upon the seraph-wings of Ecstasy,
> The secrets of the abyss to spy.[84]
> He passed the flaming bounds of place and time:[85]
> The living throne, the sapphire-blaze,[86]
> Where angels tremble while they gaze,
> He saw; but blasted with excess of light,[87]
> Closed his eyes in endless night.

84. Milton, *PL* 4.935–37: 'I therefore, I alone first undertook / To wing the desolate abyss, and spy / This new created world.'

85. Gray gives as his source Lucr. 1.73–74.

86. Gray gives as his source Ezekiel 1:20, 26, 28: 'For the spirit of the living creature was in the wheels—And above the firmament, that was over their head, was the likeness of a throne, as the appearance of a sapphire-stone.—This was the appearance of the glory of the Lord.'—a passage imitated by Milton at *PL* 6.750–59.

87. Cf. *PL* 1.593–94: 'excess / Of glory obscured'; 3.380: 'Dark with excessive bright'.

Behold, where Dryden's less presumptuous car,[88]
Wide o'er the fields of glory, bear
Two coursers of ethereal race,
With necks in thunder clothed, and long-resounding pace.[89]

Milton 'rides sublime' in a combination of biblical, Lucretian and Miltonic language. The 'seraph-wings of ecstasy' perhaps footnotes Gray's debt to Cowley's Pindaric ode 'The Exstasie'. Milton succeeds in voyaging beyond the bounds, but his ex-cursion leads to an ex-cess of light that leaves him blinded, 'blasted' as if by one of the thunderbolts that cast down the excessive Giants.[90] In his own annotations, Gray refers to Homer's Demodocus, for whom the Muse 'had mingled good and evil in her gifts, robbing him of his eyes but granting him the gift of sweet song' (*Odyssey* 8.63–64).[91] But we might think rather of the bard Thamyris in the *Iliad* (2.594–600), who hoped with his singing to defeat the Muses;[92] they in their anger 'maimed' (blinded, in one version) him and took away his powers of song and lyre-playing. Milton has presumed too far, incurring a fate that will be avoided by Dryden in his 'less presumptuous car'.[93] Gray looks back to Milton's anxiety that in his

88. Cf. *PL* 7.13–14: 'Into the heav'n of heav'ns I have presumed, / An earthly guest'.

89. Cf. Virgil, *Aen.* 7.280–81: 'geminosque iugales / semine ab aetherio, spirantes naribus ignem' (two yoke-mates of ethereal seed, breathing fire from their nostrils); Dryden, *Aeneid* 8.51, translates 'semine ab aetherio' as 'Undoubted offspring of ethereal race'. In Gray's poem, Dryden enters his own chariot-race, hoping to win poetic glory.

90. Fitzgerald notes (1987: 92–93) that in Gray, Milton's flight is modelled on those of Milton's Satan and of Epicurus; and that the passage is 'violently sexual, and it culminates accordingly in a post-coital fall'. Griffin (1986: 39) reads this in the light of the eighteenth century's anxiety about writing a literary history that traced a convincing line from Milton to itself—now no 'daring spirit wakes . . . the lyre divine'. Griffin also cites Gray's 'Stanzas to Mr Bentley': 'not to one in this benighted age / Is that diviner inspiration given, / That burns in Shakespeare's or in Milton's page, / The pomp and prodigality of heaven' (17–20).

91. On Demodocus and the link between blindness and poetry, see Buxton 1980: 27–30. Gray may also have in mind the story that Homer conjured up the shade of Achilles, and was blinded by the overpowering splendour of his divinely forged armour, with its shield bearing an image of the universe: the story is narrated in Poliziano's *Ambra* (260–85) (Fantazzi 2004: 86), and reported by Pope, in his *Essay on Homer* (in Mack 1967 at 31).

92. The story is also told of Demodocus: schol. Ovid, *Ibis* 272. At *PL* 3.32–35, Milton remembers 'Blind Thamyris and blind Maeonides [Homer] . . . equalled with me in fate'.

93. For more presumptuous accounts of Dryden's poetic flight, in the slipstream of Virgil, see Richard Flecknoe's panegyrical epigram on Dryden, in *Epigrams Made at Several Times upon Several Occasions* (1673): 'Dryden the Muses' darling and delight, / Than whom none ever flew

attempt to take flight he might suffer the fate of Bellerophon;[94] the image of
a heroically transgressive poet is echoed at the end of Gray's 'The Bard':
'headlong from the mountain's height / Deep in the roaring tide he plunged
to endless night';[95] and in both places there is more than a touch of the
proto-Romantic. Gray could also look back to Joseph Addison for the hint of
a Gigantomachic or Satanic Milton, in Addison's 'An Account of the Greatest
English Poets' (58–63):[96]

> No vulgar hero can his muse engage,
> Nor earth's wide scene confine his hallowed rage.
> See! see, he upward springs,[97] and towering high
> Spurns the dull province of mortality,
> Shakes heaven's eternal throne with dire alarms,
> And sets the Almighty thunderer in arms.

In the third and final epode, Gray looks to take flight himself, but, as a lyric
poet, he is a Horace, who feels himself inferior to the soaring flight of the
Theban eagle, Pindar, 'Sailing with supreme dominion / Through the azure
deep of air' (116–17).[98] Yet in a counter-surge of confidence he will rise, but
into a qualified form of the boundless: 'Yet shall he mount and keep his distant

a braver flight', contrasted with creeping 'reptiles of Parnassus', 'water-poets, who have gone /
No farther than to' th' fount of Helicon', 'airy ones, whose Muse soars up / No higher than to
mount Parnassus' top. / Whils't thou with thine does seem t' have mounted higher / Than him
who fetched from heaven celestial fire, / And dost as far surpass all others, as / The fire all other
elements does surpass' (p. 77); John Dennis, 'To Mr. Dryden, upon His Translation of the Third
Book of Virgil's Georgics' (in Select Works, 1718): 'While mounting with expanded wings, / The
Mantuan swan unbounded heav'n explores; / While with seraphic sounds he tow'ring sings, /
Till to divinity he soars; / mankind stands wond'ring at his flight, / Charmed with his music
and his height, / Which both transcend our praise; / Nay gods incline their ravished ears, / And
tune their own harmonious spheres / To his melodious lays. / Thou, Dryden, canst his notes
recite, / In modern numbers, which express / Their music and their utmost might; / Thou
wond'rous poet, with success, / Canst emulate his flight.' (stanza 1: pp. 19–22).

94. On Milton and Bellerophon, see ch. 4: 182.

95. Gray said at an early stage of composing 'The Bard', 'I felt myself the bard'.

96. For a similar characterization of Milton's sublimity, see Samuel Cobb, *Poetae Britannici*
(London, 1700): 'Milton! whose Muse kisses th' embroidered skies, / While earth below grows
little as she flies. / Thro' trackless air she bends her winding flight, / Far as the confines of retreat-
ing light' (407–10).

97. *PL* 2.1013 (Satan): 'Springs upward like a pyramid of fire'.

98. The image of *remigium alarum* (oarage of wings): ch. 2: 75.

way / Beyond the limits of a vulgar fate,[99] / Beneath the Good how far—but far above the Great' (121–23).[100] 'Beyond the limits of a vulgar fate' falls short of Lucretian and Miltonic voyages beyond 'the flaming bounds of place and time'. This will be a middle—one might say Daedalean—flight, beneath the good, but above the great.

Edward Young

For Edward Young (1683–1765), 'man's destiny is not to pick a middle way between extremes but to soar above them', as David Morris puts it.[101] Young's *magnum opus* is *Night Thoughts* (1742–45), for a century one of the best known and most highly praised poems in English, translated into numerous other European languages. The *Night Thoughts* are sustained by repeated flights of the mind and soul,[102] the path on which the reader, and in particular Young's fall-guy, the backsliding sceptic Lorenzo, is exhorted to follow the poet on his sublime flights of poetry in contemplation of the truths of religion.[103] Samuel Richardson, a close friend of Young, compliments him in a letter: 'Pope's . . . was not the genius to lift our souls to Heaven, had it soared ever so freely, since it soared not in the Christian beam; but there is an eagle, whose eyes pierce through the shades of midnight, that does indeed transport us, and the apotheosis is yours.'[104] In the conclusion to 'Night the First', Young himself modestly laments the fact that Pope, one of his own poetic heroes and here placed in the sublime company of Homer and Milton, had not attempted a lofty flight

99. Cf. Pope, *Essay on Criticism* 154–55: 'From vulgar bounds with brave disorder part, / And snatch a grace beyond the reach of art.'

100. Not aspiring to the moral perfection of 'the good', but superior to those who pride themselves on a worldly greatness. Cf. the Duke of Buckingham on Lord Fairfax: 'How much it is a meaner thing / to be unjustly great than honorably good', cited in Mitford 1814: 54. Lonsdale (1969, ad loc.) cites Pope, *Epitaph on Mr Fenton*: 'A poet blest beyond the poet's fate, / Whom heav'n kept sacred from the proud and great' (3–4).

101. Morris 1972: 153. On Young's 'hallmark spatial idiom', his spatial dimension of 'extravagance', see Irlam 1999: 177.

102. The phrase 'flight of mind' itself occurs at *Night Thoughts* 5.60: 'And being's source, that utmost flight of mind!'

103. Cornford 1989: 10: 'Notwithstanding the bathetic fate of Johnson's winged philosopher, "flight", "winging", "mounting", and "soaring" became in the middle of the eighteenth century the ideal metaphors to describe imaginative and religious aspirations.'

104. Cited in Cornford 1989: 2.

of this kind in his poetry, but confined himself to lower regions in his *Essay on Man* (*Night Thoughts* 1.448–59):[105]

I roll their raptures, but not catch their fire:
Dark, tho' not blind, like thee Maeonides!
Or Milton! Thee; ah could I reach your strain!
Or his who made Maeonides our own.[106]
Man too he sung: immortal man I sing;
Oft bursts my song beyond the bounds of life;
What, now, but immortality can please?
O had he pressed his theme, pursued the track,
Which opens out of darkness into day!
O had he mounted on his wing of fire,
Soared, where I sink, and sung immortal man!
How had it blessed mankind? and rescued me?

Young ranges—expatiates—across the spectrum of classical and Christian traditions of flights of the mind and ascents of the soul, inviting his readers to experience transport, ecstasy and rapture. Fancy, imagination and contemplation are the vehicles for flight and ascent.

Stephen Cornford makes the case that Edward Young's *Night Thoughts* should be 'central to the discussion of the creative imagination in the eighteenth century'.[107] Locally, Young's handling of the flights of fancy and imagination is positive or negative, depending on context, as in Milton (see ch. 4: 189–92). Imagination is able to soar upwards, where thought is halted in bewilderment: 'Of higher scenes be then the call obey'd. / O let me gaze!—Of gazing there's no end. / O let me think!—Thought too is wilder'd here; / In midway flight Imagination tires; / Yet soon reprunes her wing to soar anew' (9.1217–21). But later in the ninth *Night*, imagination's flight is an obstacle to the operations of reason: 'Retire; the world shut out; thy thoughts call home; / Imagination's airy wing repress; / Lock up thy senses; let no passion stir; / Wake all to Reason; let her reign alone' (1441–44). But again, a little later, Fancy is allowed to roam freely in yet another version of the view from above of Cicero's *Dream of Scipio*, looking down from a height achievable only in fancy, or imagination, at the world that we inhabit: 'For now fancy glows, /

105. On *Night Thoughts* as an answer to Pope's *Essay on Man*, see Odell 1973.
106. Referring to Pope's *Iliad*.
107. Cornford 1989: 10.

Fir'd in the vortex of almighty power' (1595–96; for a fuller quotation of the passage, see below: 238–39).

Fancy is licensed to rove beyond cold fact, into the realm of science fiction, and closer to the divine. But, in a twist of the common equation of boundless space with an ocean, this is a flight of fancy that may end in a drowning, as if in a repetition of the rash ambition of Icarus: 'Yet why drown Fancy in such depths as these? / Return, presumptuous rover' (1613–14).

Early in *Night Thoughts*, the fancies of the sleeping soul, flying on Shakespearean and Miltonic wings, although not engaging man's higher faculties, are nevertheless in themselves proof of the soul's upwardly aspiring nature, and so of its immortality (1.92–102):

> While o'er my limbs Sleep's soft dominion spread,
> What though my soul fantastic measures trod[108]
> O'er fairy fields; or mourned along the gloom
> Of pathless woods; or, down the craggy steep
> Hurled headlong, swam with pain the mantled pool;[109]
> Or scaled the cliff; or danced on hollow winds,
> With antic shapes, wild natives of the brain?
> Her ceaseless flight, though devious, speaks her nature.
> Of subtler essence than the trodden clod;
> Active, aërial, towering, unconfined,
> Unfettered with her gross companion's fall.

But a 'flight of fancy' can be just a turn of phrase for something that is not the case: 'Ruin from man is most concealed when near, / And sends the dreadful tidings in the blow. / Is this the flight of fancy? Would it were!' (3.223–25). The fallen fancy and imagination of 'the man of the world', Lorenzo, Young's backsliding didactic addressee in *Night Thoughts*, are associated not with the heights of heaven, but the depths of hell (8.994–1003):

> Imagination is the Paphian shop,
> Where feeble Happiness, like Vulcan, lame,
> Bids foul Ideas, in their dark recess,
> And hot as hell, (which kindled the black fires,)
> With wanton art, those fatal arrows form

108. Cf., perhaps, Milton's 'L'Allegro': 'Come, and trip it as ye go, / On the light fantastic toe' (33–34).

109. Shakespeare, *Tempest* 4.1.182

Which murder all thy time, health, wealth, and fame.
Wouldst thou receive them, other Thoughts there are,
On angel-wing, descending from above,
Which these, with art Divine, would counterwork,
And form celestial armour for thy peace.

'Paphian shop' is in the first instance a brothel, with reference to the birthplace on Cyprus of Venus, but then becomes the subterranean workshop of Venus's husband Vulcan. There, in book 8 of Virgil's *Aeneid*, after being seduced by his wife, Vulcan forges the 'celestial armour' (caelestibus armis; *Aen.* 12.167) which Venus brings down from the sky to her son Aeneas (*Aen.* 8.608–9). In Young, there is a complete disjunction between the death-dealing ideas forged in Imagination's hellish version of Vulcan's 'shop',[110] and the thoughts of a different kind that come down from above and mediate between man and heaven, worked into celestial armour by a heavenly version of Vulcan's 'art divine'. Young here offers the reader an imaginative exercise in creative imitation.

At the beginning of the first *Night*, mankind in this life is introduced as a Platonic prisoner who needs to be released to fly to a heaven of a resolutely Christian nature: 'Prisoner of earth, and pent beneath the moon, / Here pinions all his wishes; winged by Heaven / To fly at infinite; and reach it there, / Where seraphs gather immortality, / On life's fair tree, fast by the throne of God' (1.136–40). Young castigates his old self, when his Reason had not 'yet put forth her wings to reach the skies'; that conceit reaches back ultimately to the *Phaedrus*, but here the image is specifically of a caterpillar in a cocoon, not yet winged as a butterfly (an ancient symbol of the soul): 'How, like a worm, was I wrapped round and round / In silken thought, which reptile Fancy spun, / Till darkened Reason lay quite clouded o'er' (157–59). These are also the wings with which the poet Young will launch himself on his sublime flights of poetry.

The image of the imprisoned soul in need of wings for escape is developed at greater length in the second *Night* (2.339–54):

All feeling of futurity benumbed;
All god-like passion for eternals quenched;
All relish of realities expired;

110. 'Shop' is used of Vulcan's workshop in a poem from Cowley's *The Mistress*, 'The Monopoly' (Waller 1905: 120): 'Not Aetna flames more fierce or constantly, / The sounding shop of Vulcan's smoky art; / Vulcan his shop has placed there, / And Cupid's forge is set up here' (3–6); cf. also Cowley, *The Civil War* 1.385–86 (Pritchard): 'Hampden whose brain like Ætna's shop appear'd, / Where thunder's forg'd, yet no sound outwards heard.'

Renounced all correspondence with the skies;
Our freedom chained; quite wingless our desire;
In sense dark-prisoned all that ought to soar,
Prone to the centre, crawling in the dust;
Dismounted every great and glorious aim;
Embruted every faculty divine;
Heart-buried in the rubbish of the world:
The world, that gulf of souls, immortal souls,
Souls elevate, angelic, winged with fire
To reach the distant skies, and triumph there
On thrones, which shall not mourn their masters changed;
Though we from earth; ethereal they that fell.
Such veneration due, O man, to man.

In this passage, Young uses the image of triumph, implicit in Lucretius's account of Epicurus's flight of the mind, and frequently explicit in late antique poetry on the triumphal ascent of the soul of the martyr or the virtuous Christian. The winged ascent of the soul compensates for a fall, here the fall of the angels who will be replaced on their heavenly thrones by man, earthborn but with a soul of originally divine nature. Man's capacity to triumph on those thrones is the consequence of Christ's sacrifice for man. Man ascends with the resurrected Christ, as Young exultantly proclaims in the fourth *Night*, 'The Christian Triumph' (4.286–92):

The theme, the joy, how then shall man sustain?
O the burst gates! crushed sting! demolished throne!
Last gasp! of vanquished Death. Shout, Earth and Heaven!
This sum of good, to man: whose nature then
Took wing, and mounted with Him from the tomb?
Then, then, I rose; then first humanity
Triumphant passed the crystal ports of light[.]

Elsewhere, Young uses the idea of the liberation of the mind or soul in its flights from the body to polemicize against the free-thinkers of his time (7.1218–30):

Lorenzo! this black brotherhood renounce;
Renounce St. Evremont, and read St. Paul.
Ere rapt by miracle, by reason winged,
His mounting mind made long abode in heav'n.

This is freethinking, unconfined to parts,
To send the soul, on curious travel bent,
Through all the provinces of human thought,
To dart her flight through the whole sphere of man;
Of this vast universe to make the tour;
In each recess of space, and time, at home;
Familiar with their wonders; diving deep;
And, like a prince of boundless int'rests there,
Still most ambitious of the most remote[.]

'This, this is thinking-free' (1242), Young concludes, the freedom of thought to soar and dive, travelling through time as well as space, a pairing that we have seen in Seneca and Cowley, for example. Saint Paul, rapt to the seventh heaven, is opposed to the free-thinking wit and hedonist Charles de Saint-Évremond.

A lengthy passage in 'Night the Ninth' (9.968ff.) chides the Christian reader with a reminder of the true lessons about the nature of the soul taught by the great ancient sages, Aristotle, Plato, Socrates, Cicero, Seneca, who 'took their nightly round through radiant paths / By seraphs trod'.[111] These sages taught the natural affinity between the human soul and the heavens, where the soul recognizes its proper home.

'The soul of man was made to walk the skies' (1018), where she is no stranger, but at home in her place of birth, a teaching at once Platonic-Stoic and Christian: 'Nor as a stranger does she wander there; / But, wonderful herself, through wonder strays; / Contemplating their grandeur, finds her own' (1025–27). The soul 'feels herself at home among the stars; / And, feeling, emulates her country's praise' (1034–35). For Seneca, the Stoic cosmopolitan, the true fatherland of the human mind is not a city, however great, an Ephesus or Alexandria, but the universe itself, the whole vault of heaven ('hoc omne conuexum') containing seas, lands of the earth and the air (*Epistles* 102.21). Man, for Young, is a 'Sky-born, sky-guided, sky-returning race!' (6.418).

The soul is at home in the heavens because it shares in the boundlessness of space. Sublimity is experienced in the mind's own unconstrained expansion in the contemplation of the immensity of space (anticipated in Thomson's 'Summer': see ch. 3: 159): 'That mind immortal loves immortal aims; / That boundless mind affects a boundless space; / That, vast surveys, and the

111. Cf. the 'nightly rounding' (*PL* 4.685) spiritual creatures, whose songs, Adam tells Eve, 'Divide the night, and lift our thoughts to heaven' (688).

sublime of things, / The soul assimilate, and make her great' (9.1010–13). Mind's expansion into boundless space is the meeting of like with like ('assimilate'). Young's matching of the divinely great powers of the mind to the greatness of the celestial phenomena stands in a long tradition that can be traced back at least as far as Manilius's exaltation of the sublimity of the human mind and its capacity to embrace the vastness of the universe, with which the mind is cognate, as taking its origin from the stars, and of which it is a microcosm:[112] 'do not scorn the powers of your mind as if proportionate to the smallness of your breast; its power is boundless' (nec contemne tuas quasi paruo in pectore uires: / quod ualet, immensum est) (*Astron.* 4.923–24). Manilius transfers the Lucretian *immensus* from the universe to the human reason that is capable of comprehending and mastering it (932: 'ratio omnia uincit'). The same equation of the boundlessness of the Lucretian universe with the boundlessness of the immortal human soul is made by the Younger Seneca at *Epistles* 102.21: 'Tell me rather how closely in accord with nature it is to let one's mind reach out into the boundless universe [in immensum mentem suam extendere]! The human soul is a great and noble thing; it permits of no limits except those which can be shared even by the gods [communes et cum deo terminos].' Lucretius's Epicurus establishes a *terminus* (boundary-stone) to the laws of nature through the overthrow of the traditional gods; the Stoic Seneca makes the boundaries of the soul co-extensive with a providential deity. In *An Essay upon the Infinity of Worlds* (1646), the Cambridge Platonist Henry More (1614–87), with his eye very much on the Lucretian Epicurus's wandering through the *immensum* (see ch. 2: 37), uses 'boundless' of his own mind: 'Strange sights do straggle in my restless thoughts, / And lively forms with orient colours clad / Walk in my boundless mind' (stanza 2.1–3); a mind that is capable of 'spread[ing] abroad through endless 'spersed air', 'Measuring th'unbounded heavens and wasteful sky' (stanza 5.2, 6).

112. *Astron.* 4.884–85: 'et capto potimur mundo nostrumque parentem / pars sua perspicimus genitique accedimus astris' (We capture and take control of the heavens; we examine our father, a part of him, and approach the stars from which we were born); 893–95: 'quid mirum, noscere mundum / si possunt homines, quibus est et mundus in ipsis / exemplumque dei quisque est in imagine parua' (What wonder is it, if men are capable of knowing the heavens, men who also contain the heavens in themselves, and when each of us is a model of the divinity in a small likeness.)

Thomas Traherne also exults in 'The capacity of the human imagination to grow with the universe, the capacity of the human soul to be filled yet still to aspire for more beyond.'[113] For example, in 'Nature' (17–22):

My inclinations rais'd me up on high
And guided me to all infinity.
A secret self I had enclosed within,
That was not bounded with my clothes of skin,
Or terminated with my sight, the sphere
Of which was bounded with the heavens here.

In a prose work, Traherne writes, 'Objects are so far from diminishing, that they magnify the faculties of the soul beholding them. . . . The whole hemisphere and the heavens magnify your soul to the wideness of the heavens; all the spaces above the heavens enlarge it wider to their own dimension. And what is without limit makes your conception illimited and endless.'[114]

In *Night Thoughts*, Edward Young paradoxically turns to his purposes the moralizing of ancient philosophers and satirists on the subject of the insatiability and unboundedness of greed and desire (see ch. 2: 58–59). Earthly ambition and avarice are in fact signs of the soul's immortality, and of its true home in the heavens. According to the sentence of the court of Conscience, recorded after the witnesses Ambition and Avarice have been called (*Night Thoughts* 7.511–20):

His [man's] very crimes attest his dignity;
His sateless thirst of pleasure, gold, and fame,
Declares him born for blessings infinite:
What less than infinite makes un-absurd
Passions, which all on earth but more inflames?
Fierce passions, so mismeasured to this scene,
Stretch'd out, like eagles' wings, beyond our nest,
Far, far beyond the worth of all below,
For earth too large, presage a nobler flight,
And evidence our title to the skies.

113. Cited in Nicolson 1950: 177.
114. Cited ibid.

The passions of fallen man will point the way back to the world above, when guided by reason (539–44):

> But these (like that fallen monarch [Nebuchadnezzar] when
> reclaimed)
> When Reason moderates the rein aright,
> Shall re-ascend, remount their former sphere,
> Where once they soared illustrious; ere seduced,
> By wanton Eve's debauch, to stroll on earth,
> And set the sublunary world on fire.

Young here is in line with John Dennis's teaching, that poetry soars up to the heavens when Reason guides the Enthusiastic Passions (see above: 197–99). The contrast between earthly desires that never achieve their goal, and a divine desire that is sated by the unboundedness of itself and of its object, is found earlier in Henry More's opposition between the sinking into the depths of bodily pleasure and the lofty soaring of a self-denying love, in 'Cupid's Conflict' (annexed to *Democritus Platonissans* [1646]) (127–38):

> Who seeks for pleasure in this mortal life
> By diving deep into the body base
> Shall loose true pleasure: but who gainly strive
> Their sinking soul above this bulk to place
> Enlarged delight they certainly shall find
> Unbounded joys to fill their boundless mind.
>
> When I my self from mine own self do quit
> And each thing else; then an all-spreaden Love
> To the vast universe my soul doth fit
> Makes me half equal to all-seeing Jove.
> My mighty wings high stretched then clapping light
> I brush the stars and make them shine more bright.

Young also uses the vastness of space and the view from above to teach lessons about the vanity of earthly ambitions, in the manner of Cicero and Boethius and many later imitators; for example, when Fancy roves in thought over a multiplicity of universes created by God (*Night Thoughts* 9.1597–612):

> Is not this home-creation, in the map
> Of universal Nature, as a speck,

Like fair Britannia in our little ball,
Exceeding fair, and glorious, for its size,
But, elsewhere, far out-measured, far outshone?
In fancy (for the fact beyond us lies)
Canst thou not figure it, an isle, almost
Too small for notice, in the vast of being;
Severed by mighty seas of unbuilt space
From other realms; from ample continents
Of higher life, where nobler natives dwell;
Less northern, less remote from DEITY,
Glowing beneath the line of the Supreme,
Where souls in excellence make haste, put forth
Luxuriant growths; nor the late autumn wait
Of human worth, but ripen soon to gods?

Young vastly expands the view from above in Cowley's 'The Exstasie', where the soaring poet looks down on this earth, on which Britain is but a speck in the sea: 'How small the biggest parts of earth's proud title show! / Where shall I find the noble British land? / Lo, I at last a northern speck espy, / Which in the sea does lie, / And seems a grain o' the sand' (8–12; see ch. 3: 139–40).[115] That vision is scaled up to a whole universe that now appears no bigger than a small and insignificant island in the 'mighty seas of unbuilt space'.[116]

115. Other echoes of Cowley: with *Night Thoughts* 9.620–30 ('Above . . . above . . . above . . .'), cf. Cowley, *Davideis* 1.347ff. (Heaven); with 9.622–27 ('Above the northern nests of feathered snows, / The brew of thunders, and the flaming forge / That forms the crooked lightning; 'bove the caves / Where infant tempests wait their growing wings, / And tune their tender voices to that roar / Which soon, perhaps, shall shake a guilty world'), *Davideis* 1.75–76: 'Beneath the dens where unfledged tempests lie, / And infant winds their tender voices try'; with 9.2016 ('And far, how far, from lambent are the flames!'), Cowley, 'The Exstasie' 24; *Davideis* 3.295.

116. For another example of this ratio of comparative size used to summon up sublime immensity, cf. *Night Thoughts* 6.176–89: 'How shall the stranger man's illumined eye, / In the vast ocean of unbounded space, / Behold an infinite of floating worlds / Divide the crystal waves of ether pure, / In endless voyage, without port! The least / Of these disseminated orbs, how great? / Great as they are, what numbers these surpass, / Huge as Leviathan to that small race, / Those twinkling multitudes of little life, / He swallows unperceived! Stupendous these! / Yet what are these stupendous to the whole? / As particles, as atoms ill-perceived; / As circulating globules in our veins; / So vast the plan. Fecundity Divine!'

But elsewhere the view from above is used to show the marvels of human, and specifically British, arts, as one of a series of 'proofs' of the immortality of the soul, in the rousing finale to the sixth *Night* (6.761–69):

> Come, my ambitious! let us mount together,
> (To mount, Lorenzo never can refuse,)
> And from the clouds, where Pride delights to dwell,
> Look down on earth.—What seest thou? Wond'rous things!
> Terrestrial wonders, that eclipse the skies.
> What lengths of laboured lands! What loaded seas!
> Loaded by man for pleasure, wealth, or war:
> Seas, winds, and planets, into service brought,
> His art acknowledge, and promote his ends[.]

This is a panorama indebted to Virgil's 'laudes Italiae' in *Georgics* 2, which includes an image of the indignant waves raging against Agrippa's monumental harbour works in the Bay of Naples (161–64). Young's Christian God puts the waves in their place (6.791–801):

> Hear, naval thunders rise;
> Britannia's voice! that awes the world to peace.
> How yon enormous mole projecting breaks
> The mid-sea, furious, waves? Their roar amidst,
> Out-speaks the Deity, and says, 'O main!
> Thus far, nor farther; new restraints obey.'
> Earth's disembowelled! measured are the skies!
> Stars are detected in their deep recess!
> Creation widens! vanquished Nature yields!
> Her secrets are extorted! Art prevails!
> What monuments of genius, spirit, power?

No longer a 'speck' in the seas, Britannia now rules the waves and the world.[117] Human achievement, seen in the perspective of greatness rather than insignificance, is here deployed as a proof of the immortality of the soul. It is also a view from above accommodated to the earthbound ambition and pride of Lorenzo ('Look down on . . .').

117. See Young's *Imperium pelagi. A Naval Lyrick: Written in Imitation of Pindar's Spirit. Occasion'd by His Majesty's Return, Sept. 1729. and the Succeeding Peace,* celebrating British commerce, using the 'for thee' formula.

Elsewhere, the recognition of the true grandeur and divinity of man's soul as revealed in its capacity to comprehend the heavens is contrasted with the kind of false apotheosis for which the rulers of the earth aim, in an apostrophe to 'Bourbon' (Louis XV) (9.1056–63):

> Wouldst thou be great, wouldst thou become a god,
> And stick thy deathless name among the stars,[118]
> For mighty conquests on a needle's point?
> Instead of forging chains for foreigners,
> Bastille thy tutor: grandeur all thy aim?
> As yet thou know'st not what it is: how great,
> How glorious then appears the mind of man,
> When in it all the stars and planets roll!

The kind of Bourbon pretension Young has in mind may be exemplified from François Lemoyne's vast ceiling painting of the apotheosis of Hercules in the Salon d'Hercule at Versailles (1736). Young looks for his own apotheosis in the return of his soul to God on his death: 'When shall my Soul her incarnation quit, / And, re-adopted to Thy blest embrace, / Obtain her apotheosis in Thee?' (9.1343–45)

The immensity of Young's celestial spaces, and the thousand world-systems scattered through them, are very definitely post-Newtonian, although Newton is mentioned by name only once in the *Night Thoughts*.[119] Young's blank verse is very definitely post-Miltonic, and Miltonic allusions are scattered through the poem. At points, Young's psychological soaring and sinking replicate Milton's experiences and anxieties: for example, soaring in Milton's wake, before being checked by the thought of eternal damnation: 'Where am I rapt by this triumphant theme, / On Christian joy's exulting wing, above / Th' Aonian mount?[120]—Alas, small cause for joy! / What, if to pain immortal? If extent / Of being, to preclude a close of woe?' (4.301–5). And Miltonic ambition echoes in an invocation to Heaven's King (9.586–93):

> While of Thy works material the supreme
> I dare attempt, assist my daring song;

118. Cf. Cowley, 'The Praise of Pindar': 'Among the stars he sticks his name' (33).

119. 9.1836–37: 'Ye searching, ye Newtonian angels! tell, / Where your great Master 's orb? His planets, where?'

120. *PL* 1.15: 'Above the Aonian mount.'

Loose me from earth's enclosure, from the sun's
Contracted circle set my heart at large;
Eliminate my spirit, give it range
Through provinces of thought yet unexplored;[121]
Teach me, by this stupendous scaffolding,
Creation's golden steps, to climb to Thee.

The manic-depressive Young experiences Miltonic doubts and inhibitions in the 'Relapse' (relapse into grief at death of Narcissa) of the fifth *Night* (5.208–23, 227–46):

Thought borrows light elsewhere; from that first fire,
Fountain of animation! whence descends
Urania, my celestial guest! who deigns
Nightly to visit me,[122] so mean; and now
Conscious, how needful discipline to Man,
From pleasing dalliance with the charms of night,
My wand'ring thought recalls, to what excites
Far other beat of heart; Narcissa's tomb!
 Or is it feeble Nature calls me back?
And breaks my spirit into grief again?
Is it a Stygian vapour in my blood?
A cold, slow puddle, creeping through my veins?
Or is it thus with all men?—Thus with all.
What are we? how unequal? now we soar,
And now we sink;[123] to be the same, transcends
Our present prowess.
. . .
The noblest spirit, fighting her hard fate,
In this damp, dusky region, charged with storms,
But feebly flutters,[124] yet untaught to fly;
Or, flying, short her flight, and sure her fall.
Our utmost strength! when down, to rise again;

121. *PL* 1.16: 'Things unattempted yet in prose or rhyme.'
122. *PL* 7.1ff.: 'Descend from heav'n, Urania . . .'; 28–29: 'yet not alone, while thou / Visitest my slumbers nightly'.
123. Cf. 1.458: 'Soared, where I sink', contrasting Pope's *hypsos* with his own *bathos*.
124. *PL* 2.933 (Satan): 'Fluttering his pennons vain.'

And not to yield, though beaten, all our praise.
Though proud in promise, big in previous thought,
Experience damps our triumph.[125] I, who late,
Emerging from the shadows of the grave,
Where Grief detained me prisoner, mounting high[126]
Threw wide the gates of everlasting day,
And called mankind to glory, shook off pain,
Mortality shook off, in ether pure,
And struck the stars;[127] now feel my spirits fail,[128]
They drop me from the zenith,[129] down I rush,
Like him whom fable fledged with waxen wings,
In sorrow drowned—But not, in sorrow, lost.
How wretched is the man who never mourned?
I dive for precious pearl in sorrow's stream.

Young combines allusion to the fable of Mulciber (Vulcan) hurled down from heaven, to which Milton compares the fall of Lucifer, with explicit reference to the fall of Icarus.[130] It was Daedalus who sorrowed, not the drowned Icarus, but, unlike Daedalus, Young extracts something of value from his loss. Passive sinking becomes an active diving for precious pearls, into which the tears of grief are transformed.[131]

125. *PL* 9.44–46: 'unless an age too late, or cold / Climate, or years damp my intended wing / Depressed'.

126. *Lycidas* 172: 'So Lycidas sunk low, but mounted high'.

127. Horace, *Odes* 1.1.36: 'sublimi feriam sidera uertice' (I shall strike the stars with my head held high).

128. *PL* 2.929–31: 'thence many a league, / As in a cloudy chair, ascending rides / Audacious; but, that seat soon failing'.

129. *PL* 1.740–41: 'and how he fell / From heaven, they fabled, thrown by angry Jove'; 1.744–45: 'and with the setting sun / Dropped from the zenith like a falling star'.

130. For 'Daedalian engin'ry' as the means to a wrong kind of flight, cf. *Night Thoughts* 6.259–62: 'Genius and Art, Ambition's boasted wings, / Our boast but ill deserve. A feeble aid! / Dædalian engin'ry! if these alone / Assist our flight, Fame's flight is Glory's fall.' But Fame's upward striving is also a proof of man's desire for immortality: 'Fame is the shade of immortality' (7.365; varying the topos that glory is the shadow of virtue).

131. Soaring and diving (as opposed to sinking): *Night Thoughts* 4.390–97 (elaborating Psalm 139:8–10: 'If I ascend up into heaven, thou art there: if I make my bed in hell, behold, thou art there. If I take the wings of the morning, and dwell in the uttermost parts of the sea; even there shall thy hand lead me'); 6.462–63: 'What wealth in souls that soar, dive, range around, / Disdaining limit or from place or time'.

The boldest flights come in the last *Night*, the ninth ('The Consolation'), with the most expansive occupying a position that forms a climax for *Night Thoughts* as a whole, at 9.1710–850. Of this passage a late eighteenth-century editor of the poem, Charles Edward de Coetlogon, notes, 'A more sublime and instructive flight of imagination than this, is no where to be found within the compass of human science. The attentive admirer of this work, will follow the author in his celestial travels with increasing pleasure and astonishment through one hundred and forty lines.'[132] The ascent is at once a climb, up regular steps (9.1710–12: 'I . . . climb Night's radiant scale, / From sphere to sphere; the steps by Nature set / For man's ascent'; on steps or ladders of ascent, see ch. 1: 14, 18), and a ride in a flying chariot (1715–16: 'In ardent Contemplation's rapid car, / From earth, as from my barrier,[133] I set out'). Like Cowley in 'The Exstasie', and the soul of Elizabeth Drury in Donne's 'Second Anniversary', the poet ascends through the successive spheres, striking 'into remote; / Where, with his lifted tube, the subtle sage / His artificial airy journey takes, / And to celestial lengthens human sight' (1719–22). Young acknowledges the power of the telescope to liberate the imagination of seventeenth- and eighteenth-century poets (cf. Cowley, 'The Exstasie' 34–35: 'Where I behold distinctly as I pass / The hints of Galileo's glass'). 'Artificial' may hint at Milton's description of Galileo as 'the Tuscan artist' (*PL* 1.288). Young pauses as 'On Nature's Alps I stand, / And see a thousand firmaments beneath! / A thousand systems! as a thousand grains!' (1748–50). He wonders, 'What are the natives of this world sublime?', and imagines asking them questions about famous characters from the biblical past who may have passed this way, in one direction or the other: 'Called here Elijah, in his flaming car? / Passed by you the good Enoch, on his road / To those fair fields,[134] whence Lucifer was hurled; / Who brushed, perhaps, your sphere, in his descent, / Stained your pure crystal ether, or let fall / A short eclipse from his portentous shade?' (1817–22). But questions as to the ultimate destination—'Where is He' (God)—go unanswered, and the flight of the mind halts: 'Here human effort ends; / And leaves me still a stranger to His throne. / Full well it might! I quite mistook my road, / Born in an age more curious than devout' (1849–52). Piety rather than astronomical curiosity is the path to God.

132. de Coetlogon 1793, on *Night Thoughts* 9.1715ff.

133. 'Barrier' refers refers to the *carcer*, or starting-gate, in the ancient circus (*OED* s.v. *barrier*, n. 1e).

134. Cf. *PL* 4.268–69: 'Not that fair field / Of Enna'.

Several hundred lines later, Young calls on familiar topics in order to bring closure to his boundless poem (2170–78):

> Shall I, then, rise in argument and warmth,
> And urge Philander's posthumous advice,
> From topics yet unbroached?
> But, Oh!—I faint!—My spirits fail! Nor strange;
> So long on wing, and in no middle clime;
> To which my great Creator's glory called,
> And calls—but, now, in vain. Sleep's dewy wand
> Has stroked my drooping lids, and promises
> My long arrear of rest[.]

This perfunctory 'failure' of flight is little more than a gesture to let down the curtain on the lengthy flights and expatiations of the poem; but not before a preview of the last curtain of all, in a closing call to Lorenzo (to awake, rather than to indulge in the sleep to which the poet is about to succumb) that incorporates allusion to Alexander Pope, in order to enlist him for the essay on immortal man which, in the epilogue to the first *Night*, Young had regretted that Pope himself did not write (9.2421–34):

> To more than words, to more than worth of tongue,
> Lorenzo! Rise, at this auspicious hour;
> An hour, when Heaven's most intimate with man;
> When, like a falling star, the ray divine
> Glides swift into the bosom of the just;
> And just are all, determined to reclaim;
> Which sets that title high, within thy reach.
> Awake then; thy Philander calls: Awake!
> Thou who shalt wake, when the creation sleeps;
> When, like a taper, all these suns expire;
> When Time, like him of Gaza in his wrath,
> Plucking the pillars that support the world,
> In Nature's ample ruins lies entombed;
> And midnight, universal midnight, reigns.

Young ends with a call to awaken, where Pope had begun his essay on (mortal) man with the same call to his patron: 'Awake, my St. John! leave all meaner things / To low ambition, and the pride of kings' (*Essay on Man* 1.1–2; see above: 202). After invoking a Miltonic closure in the allusion to *Samson*

Agonistes, Young returns in the last line of *Night Thoughts* to Pope, and to the curtain that falls at the end of *The Dunciad* (4.655–56): 'Thy hand, great Anarch! lets the curtain fall; / And universal darkness buries All.'[135] Pope, himself alluding to Milton's 'anarch' Chaos (*PL* 2.988), the anti-ruler of a Lucretian chaos, ends with the anti-creation of the empire of Chaos. Young's universal darkness signals the end of God's created world, the end of created time. Lucretius's presence may be felt more distantly in 'Nature's ample ruins', an image evoked repeatedly by Lucretius as he brings the providential world-picture crashing down about our ears.[136] But for Young, the ruin of Nature is not a return to Chaos, but the prelude to the dawning of Eternity.

Immediately before these closing lines, Young perhaps includes another corrective to Pope, as he sums up his own poetic flight (9.2411–18):

> Thus, darkness aiding intellectual light,
> And sacred silence whispering truths divine,
> And truths divine converting pain to peace,
> My song the midnight raven has outwinged,
> And shot, ambitious of unbounded scenes,
> Beyond the flaming limits of the world,
> Her gloomy flight. But what avails the flight
> Of fancy, when our hearts remain below?

'Beyond the flaming limits of the world' acknowledges the starting point for so much of the tradition that I have been tracing, the Lucretian flight of Epicurus's mind 'extra . . . longe flammantia moenia mundi' (Lucr. 1.72–73). Young may have more particularly in mind Pope's allusion to the Lucretian passage in his dismissal of the extramundane interests of 'He who can all the flaming limits pierce / Of worlds on worlds, that form one universe' (but only if he had access to the manuscript version of *Essay on Man,* at 1.23–24: see above: 204).[137]

135. Pope's 'curtain' appears at *Night Thoughts* 5.131–32: 'There lies our theatre; there sits our judge. / Darkness the curtain drops o'er life's dull scene', introducing however not Chaos, but the reign of Reason and Virtue; 9.1300–302: 'When these strong demonstrations of a God / Shall hide their heads, or tumble from their spheres; / And one eternal curtain cover all.' Cornford (1989 ad loc.) compares Dryden's 'The Last Parting of Hector and Andromache', 116–17: 'The fatal day draws on, when I must fall; / And universal ruin cover all.'

136. Lucretius uses *ruina* in the context of the end of the world at 1.1107, 2.1145, 5.347, 6.607.

137. Although in using 'flaming limits' to translate 'flammantia moenia' (lit. 'flaming walls'), Pope follows Evelyn and Creech in their translations of the Lucretian lines, and also Rochester, 'Satyr against Reason and Mankind': 'The flaming limits of the Universe' (69; see n. 38 above).

Romantic to Victorian

In the rest of this chapter, I will take the story forward into the Romantic and Victorian periods with examples of the flight of the mind in three poets: Anna Letitia Barbauld, Alfred Tennyson and William Wordsworth.

Anna Letitia Barbauld (1743–1825) was a leading writer of early Romanticism, and one who moved in radical circles. She acknowledges the inspiration for the space odyssey of her 'A Summer Evening's Meditation'[138] by taking as epigraph a line from the ninth book of Edward Young's *Night Thoughts*: 'One sun by day, by night ten thousand shine' (*Night Thoughts* 9.748).[139] Milton is also a strong presence in this poem, as he is in Edward Young's flights of the mind. The meditation unfolds as evening falls when the sky has cleared after a storm, and the moon, the evening star Venus, and the stars appear bright in the heavens. It is the eye that is first drawn to wander over the heavenly bodies, with a hint of erotic seduction: 'the skies . . . with mild maiden beams / Of tempered lustre court the cherished eye / To wander o'er their sphere' (3–6). The hint at an ascent through love (on which see ch. 1: 14–17) is repeated at 48–50: '[I]s there not / A tongue in every star, that talks with man, / And woos him to be wise?' This is also the free expatiation of the eye over the spaces above: 'the unsteady eye, / Restless and dazzled, wanders unconfined / O'er all this field of glories; spacious field, / And worthy of the Master [God]' (28–31). Meditation turns to the thought, also with an ancestry going back to Plato, that the soul is of divine origin, the sky its home: 'At this still hour the self-collected soul / Turns inward, and beholds a stranger there / Of high descent, and more than mortal rank; / An embryo God' (53–56).

The 'meditation' is also a mental flight of contemplation: ''Tis now the hour / When Contemplation from her sunless haunts, / . . . / Moves forward; and with radiant finger points / To yon blue concave swelled by breath divine' (17–18, 23–24). Barbauld follows a tradition of contemplative ascent that goes

138. Date of composition unknown, but probably before 1781, as there is no mention of Uranus. Edition and commentary in McCarthy 2019: no. 55. On the poem, see Janowitz 2004: 25–26; Janowitz 2010: 10–11; Brothers 2015: ch. 2, 'Barbauld: "Embryo Systems and Unkindled Suns"'; Browning 2016. Tyrrell 2021 reads Barbauld's engagement with Milton's sublime cosmography in 'A Summer Evening's Meditation' as an assertion of the female poet's command of the cosmos, mediated through the cosmic voyages of the earlier women poets Elizabeth Singer Rowe and Elizabeth Carter.

139. Cf. also Mallet, *The Excursion* 2.4: 'Ten thousand suns blaze forth.'

back to the Middle Ages.[140] It is also a flight of Fancy, a more recent facilitator of flight, on whose wings Barbauld's mind is launched on a more daring journey through space, in another example of the equation of flying and sailing: 'Seized in thought, / On Fancy's wild and roving wing I sail, / From the green borders of the peopled Earth' (71–73). She hurtles through the planets of our solar system, whence 'launch[ed] into the trackless deeps of space' she comes on Edward Young's ten thousand suns that lie beyond, and then arrives at the Chaos through which Milton's Satan passes on his flight from hell.[141] This is also Lucretian territory, since Milton's description of Chaos adopts Lucretius's image of an atomic civil war (Lucr. 2.114–22). Barbauld may well have read Lucretius himself in Latin: she had persuaded her schoolmaster father to teach her Latin and some Greek, and read avidly in his library.[142] Her meditation comes to an end when, in an example of the 'Icarian pattern', the wings of her soul run out of stamina in their flight of fancy (97: 'fancy droops'). In a Miltonic context, Barbauld may allude more specifically to the sudden end to Eve's flight of the mind in her satanically inspired dream, as narrated by Eve in *Paradise Lost* 5 (90–92); from the previous book we know that this happened when Ithuriel's spear revealed Satan 'Squat like a toad, close at the ear of Eve', pouring illusions, fantasms and dreams into the 'organs of her fancy' (*PL* 4.802; see ch. 4: 187).[143]

Any anxiety on Barbauld's part that she may be tempted, like Eve, into a flight too high, is assuaged in the closing lines: 'But now my soul, unused to stretch her powers / In flight so daring, drops her weary wing / And seeks again the known accustomed spot,[144] / Drest up with sun, and shade, and

140. See ch. 1: 17–19.

141. With 93–97 ('To the dread confines of eternal night, / To solitudes of vast unpeopled space, / The deserts of creation, wide and wild; / Where embryo systems and unkindled suns / Sleep in the womb of chaos), cf. *PL* 2.891–96: 'The secrets of the hoary deep, a dark / illimitable ocean . . . / . . . / where eldest Night / And Chaos . . . hold / Eternal anarchy'; 2.898–900: 'For hot, cold, moist, and dry, four champions fierce / . . . to battle bring / Their embyron atoms'; 2.910–11: 'Into this wild abyss, / The womb of nature and perhaps her grave' (with which cf. Lucr. 5.259: '[terra] omniparens eadem rerum commune sepulcrum' ([earth] both the parent of all things and their common grave)).

142. See William McCarthy's *ODNB* article on Barbauld.

143. Adam's disquisition on 'mimic fancy' (*PL* 5.95–116) explains to Eve the likely source of her dream.

144. Brothers sees this as an example of the 'Greater Romantic lyric' (on which see the classic article Abrams 1970), in which the individual is shown on a mental journey confronting the imaginary and then returning to the comfort of the local.

lawns,[145] and streams' (112–14). This is the familiar and comfortable English countryside as Eden, where, unlike Eve, Barbauld will not be tempted to seek unlawful knowledge or pick forbidden fruit, but will rather, herself like a fruit, 'Content and grateful, wait the appointed time, / And ripen for the skies'[146] (118–19).

Since antiquity, flight through the air has been recurrently figured as sailing or rowing over the sea. The flight of the mind is a journey over the unbounded ocean of space, as we have seen on numerous occasions in the preceding chapters. My last two texts in this chapter are famous romantic images of seafaring, literal or figurative, which, I argue, reveal themselves as late-coming heirs to the tradition of flights of the mind.

In the heavily Miltonic section in 'Night the Fifth' of *Night Thoughts*, the 'Relapse', on the inability of the human spirit to sustain a soaring flight, Edward Young contemplates the need to rest content with the second best of never admitting defeat, like a prizefighter who keeps on coming back when knocked to the floor (227–32):

> The noblest spirit, fighting her hard fate,
> In this damp, dusky region, charged with storms,
> But feebly flutters, yet untaught to fly;
> Or, flying, short her flight, and sure her fall.
> Our utmost strength, when down, to rise again;
> And not to yield, though beaten, all our praise.

'Not to yield' are the last words of Tennyson's 'Ulysses' (1833), in lines which also balance an inescapable weakness against a determination to continue striving: 'Made weak by time and fate, but strong in will / To strive, to seek, to find, and not to yield' (69–70). Tennyson himself may have another Miltonic passage in mind: the fallen Satan's defiant assertion of his 'unconquerable will, / And study of revenge, immortal hate, / And courage never to submit or yield' (*PL* 1.106–8).

145. *PL* 4.252: 'lawns' in Eden.

146. Ripening souls: cf. Young, *Night Thoughts* 9.1610–12 (of other universes than our own): 'Where souls in excellence make haste, put forth / Luxuriant growths; nor the late autumn wait / Of human worth, but ripen soon to gods'; 9.1889–92: 'seeds of Reason . . . When grown mature, are gathered for the skies'; Akenside, *Pleasures*: 'Those sacred stores that wait the ripening soul, / In truth's exhaustless bosom.' (243–44).

Tennyson's 'Ulysses' draws on the tradition that in his old age, after return-
ing home to Ithaca and reclaiming his wife and hearth, the archetypal epic
wandering hero did not rest content with this ending to his adventures, but
set off again in quest of new achievements. Ulysses sees no end to the possibili-
ties of human experience: 'Yet all experience is an arch wherethro' / Gleams
that untravelled world whose margin fades / For ever and forever when I
move' (19–21). His desire is always to go beyond, his 'gray spirit yearning in
desire / To follow knowledge like a sinking star, / Beyond the utmost bound
of human thought' (30–32). He calls on his fellow-mariners 'to seek a newer
world . . . for my purpose holds / To sail beyond the sunset, and the baths /
Of all the western stars, until I die' (57–61).

 The suspicion that the shared use in Young and Tennyson of the phrase 'not
to yield', in itself hardly uncommon,[147] is more than coincidental, is reinforced
if we turn to another passage in Young's 'Night the Ninth' in which he contin-
ues his appeal to Heaven's King for assistance with his 'daring song' with an
invitation to Lorenzo to set sail with him on a daring voyage (9.598–619):

> Lorenzo! come, and warm thee: thou, whose heart,
> Whose little heart, is moored within a nook
> Of this obscure terrestrial, anchor weigh:
> Another ocean calls, a nobler port;
> I am thy pilot, I thy prosperous gale:
> Gainful thy voyage through yon azure main;
> Main without tempest, pirate, rock, or shore;
> And whence thou may'st import eternal wealth;
> And leave to beggared minds the pearl and gold.
> Thy travels dost thou boast o'er foreign realms?
> Thou stranger to the world! thy tour begin;
> Thy tour through Nature's universal orb:
> Nature delineates her whole chart at large,
> On soaring souls, that sail among the spheres;
> And man how purblind, if unknown the whole?
> Who circles spacious earth, then travels here,
> Shall own he never was from home before!
> Come, my Prometheus, from thy pointed rock

147. Search for 'not to yield' in LION: × 445 in total, including × 59 in poetry; × 27 in
drama; × 63 in prose; × 159 in EEBO.

Of false ambition if unchained, we'll mount;
We'll, innocently, steal celestial fire,
And kindle our devotion at the stars;
A theft, that shall not chain, but set thee free.

This is a sea-journey through the unbounded ocean of space. The reverse equation of a sea-journey with a figurative flight is found in the immediate source for Tennyson's 'Ulysses', Ulisse's account to Dante in *Inferno* 26 of the 'mad flight' of his last voyage: 'and turning our stern towards the east, we made wings out of our oars for our mad flight, always gaining on the left' (e volta nostra poppa nel mattino, / de' remi facemmo ali al folle volo, / sempre acquistando dal lato mancino) (*Inferno* 26.124–26).[148] Young calls Lorenzo to a journey beyond the known limits of the world, as Tennyson's Ulysses calls on his companions to sail beyond the sunset. Ulysses is in search of a newer world; Young invites Lorenzo to explore a world to which he is a stranger, and whose totality is unknown to him. Both are journeys into freedom: 'A theft, that shall not chain, but set thee free' (*Night Thoughts* 9.619); Ulysses addresses his mariners as 'Souls / That ever . . . opposed / Free hearts, free foreheads' ('Ulysses' 46–49).

In contrast to the romantically unachievable journey of Tennyson's Ulysses, the journey to which Young calls Lorenzo does have a firm goal, 'a nobler port' (9.601). But doubtless part of Young's attraction for the Romantics, as also for the writers of the *Sturm und Drang* movement, was his power to evoke a sense of endless journeying, in a spirit that is as often as melancholy as it is cheerful, in the manner of many of the other physico-theological tours of the universe. In another picture of oceanic space, Young emphasizes its unboundedness, in an account of the banquet of knowledge to be enjoyed in eternity (6.174–80):

From some superior point (where, who can tell?
Suffice it, 'tis a point where gods reside,)
How shall the stranger man's illumined eye,
In the vast ocean of unbounded space,
Behold an infinite of floating worlds

148. On Dante's Ulisse and his reception in Tasso and Milton, and on sailing as flying, see Quint 2014: 67–73. Tennyson's 'Ulysses' draws on traditions of writing about new world explorations going back to Columbus: see Nohrnberg 2009; ibid. 116 for the converse, the celestial explorations of Galileo compared to the sea voyages of Columbus or the Argonauts by Giambatista Manso and by Marino (*Adone* 10.45).

Divide the crystal waves of ether pure,
In endless voyage, without port?

It is the unbounded quality of the space travelling of the *Night Thoughts* to which Young returns as he sums up his poetic flight at the start of the last verse paragraph of 'Night the Ninth': 'My song the midnight raven has outwinged, / And shot, ambitious of unbounded scenes, / Beyond the flaming limits of the world, / Her gloomy flight' (2414–17), in the final iteration of the Lucretian 'beyond' (see above: 246).

From his childhood, Wordsworth was drawn by the lure of the unbounded, as he tells us in *The Prelude* (1805–6) (13.145–52):

I love a public road: few sights there are
That please me more; such object hath had power
O'er my imagination since the dawn
Of childhood, when its disappearing line,
Seen daily afar off, on one bare steep
Beyond the limits which my feet had trod,
Was like a guide into eternity,
At least to things unknown and without bound.

It is not surprising, then, that the theme of the flight of the mind into the boundless punctuates Wordsworth's career from early to late.[149] In his 'Lines Written as a School Exercise at Hawkshead' at the age of fourteen (1784/85), he imitates the tradition of poems in praise of Newton.[150] The personified Power of Education describes the enlightenment of Britannia when 'Science with joy saw Superstition fly / Before the lustre of Religion's eye' (43–44). The scientific reason of Lucretius's Epicurus overcomes a Religio that is synonymous with Superstitio; Britannia's Christian enlightenment drives a wedge between (false) superstition and (true) religion. Among the results is that (71–76)

Fair to the view is sacred Truth displayed.
In all the majesty of light arrayed,
To teach, on rapid wings, the curious soul
To roam from heaven to heaven, from pole to pole,

149. Material collected and discussed in Thomas and Ober 1989.
150. Specifically paraphrasing Francis Fawkes's translation of Halley's Latin poem on Newton (see ch. 3: 153).

From thence to search the mystic cause of things,
And follow Nature to her secret springs[.]

This is a flight that reaches a goal, albeit a hidden one, a 'mystic cause', the 'secret springs' of Nature.

Ten years later, in a draft passage written for, but not eventually published in, 'An Evening Walk' (1794: Wordsworth's first long poem),[151] Wordsworth draws on passages in Akenside's *The Pleasures of Imagination* (1.152–54, 3.384–85), and looks through them to their Lucretian model, extolling

> those to whom the harmonious doors
> Of Science have unbarred celestial stores,[152]
> To whom a burning energy has given
> That other eye which darts thro' earth and heaven,[153]
> Roams through all space and unconfined,
> Explores the illimitable tracts of mind,
>
> . . .
>
> And proud beyond all limits to aspire
> Mounts through the fields of thought on wings of fire.

Here the emphasis is more on the boundless: 'unconfined', and 'illimitable', a word with a history,[154] and one that was to be used to striking effect by Tennyson in his poem 'Lucretius', in a vivid description of the Epicurean atoms and void: 'I saw the flaring atom-streams / And torrents of her myriad universe, / Ruining along the illimitable inane'[155] (38–40). For Wordsworth, the

151. DC MS 10 2v: see Averill 1984: 163. On the 1794 revisions of the poem, see Jump 1986.

152. Cf. Lucr. 1.70–71: 'effringere ut arta / naturae primus portarum claustra cupiret', cited in Kelley 1983: 221.

153. Cf. Shakespeare, *Midsummer Night's Dream* 5.1.12–15: 'The poet's eye, in a fine frenzy rolling, / Doth glance from heaven to earth, from earth to heaven, / And as imagination bodies forth / The forms of things unknown'.

154. *OED*: first citation, Spenser *Hymne of heauenly loue* 57 'the heauens illimitable hight'; then Milton *PL* 2.891–2 'a dark / Illimitable ocean without bound'; 1726 E. Fenton in Pope et al. tr. Homer *Odyssey* V. xx. 75 'Tossed thro' the void, illimitable space'; Thomson, *Summer* 34 'illimitable void'.

155. Tennyson may take it immediately from William Hamilton Drummond, *The First Book of T. Lucretius Carus* (1808): 'Or if it stretch without a term or bound, / A dread illimitable vast profound' (1051–52) (Lucr. 1.957: 'an immensum pateat uasteque profundum'); 'Earth girds the sea, round earth the billows roll; / But nought e'er bounds th' illimitable' (1091–92) (Lucr. 1.987: 'omne quidem uero nil est quod finiat extra'); 'For say, what centre can the fancy

boundlessness is both of the universe and of the mind that aspires to traverse the universe in thought.

In 1814, as the conclusion to his Preface to *The Excursion*, Wordsworth published a passage of poetry that exists in a number of earlier drafts, which he presented as 'taken from the first Book of the Recluse [his projected but unfinished masterwork] . . . as a kind of *Prospectus* of the design and scope of the whole Poem'. Wordsworth places himself as a successor to Milton, as he invokes the Muse of mental flights, Urania, in preparation for his own journeying through the spaces of the 'Mind of Man', more terrifying than the physical spaces of the universe traversed in *Paradise Lost* ('The Prospectus' 23–41):[156]

> 'fit audience let me find though few!'
> So prayed, more gaining than he asked, the Bard,
> Holiest of Men.—Urania, I shall need
> Thy guidance, or a greater Muse, if such
> Descend to earth or dwell in highest heaven!
> For I must tread on shadowy ground, must sink
> Deep—and, aloft ascending, breathe in worlds
> To which the heaven of heavens is but a veil.
> All strength—all terror, single or in bands,
> That ever was put forth in personal form;
> Jehovah—with his thunder, and the choir
> Of shouting Angels, and the empyreal thrones,
> I pass them, unalarmed. Not Chaos, not
> The darkest pit of lowest Erebus,
> Nor aught of blinder vacancy—scooped out
> By help of dreams—can breed such fear and awe
> As fall upon us often when we look
> Into our Minds, into the Mind of Man,
> My haunt, and the main region of my Song.

feign / Within th' illimitable vast inane?' (1157–58) (Lucr. 1.1070–71: 'nam medium nil esse potest . . . infinita').

156. Sitter 1982: 136 notes that Akenside's flight of the soul at *Pleasures* 1.185–211 'suggests and perhaps influences' Wordsworth's 1814 'Prospectus' for *The Recluse*. On the importance of Epicurus's mental flight for the dialogue between Milton and Wordsworth, see Priestman 2012: 410; on Wordsworth and Lucretius, see Kelley 1983; Spiegelmann 1985; Dix 2002.

'The Prospectus' is a major manifesto of Wordsworth's poetic aims.[157] In the passage here quoted, the—by now very familiar—opposition of sinking and soaring is transcended, as Wordsworth aims to go even beyond Milton, in a translation of Milton's theological subject-matter into a Romantic programme of exploration of the Mind of Man. The language of the flight past Jehovah 'with his thunder, and the choir / Of shouting angels', is biblical and Miltonic. But there is a touch of titanism in the assertion that the poet will 'pass them, unalarmed': the reader may be put in mind of Lucretius's Epicurus, who was not deterred by thunder and lightning, taken by unenlightened man as signs of the anger of a personified Superstition, from setting off on a flight of the mind to bring back the truth about Nature (see ch. 2: 36–37). That Lucretian passage was well known to Wordsworth; there is perhaps a correction to it in a line earlier in 'The Prospectus', where Wordsworth lists the things to which he wishes to 'give utterance in numerous Verse. /—Of Truth, of Grandeur, Beauty, Love, and Hope—/ And melancholy Fear subdued by Faith' (13–14). True Faith subdues Fear, where Epicurus had freed mankind from fear by subduing false Religion.

Finally, a very famous passage, which goes back ultimately to the same Lucretian text, from the 1850 *Prelude*, where Wordsworth describes his undergraduate nights in St John's College, Cambridge, looking across the boundary wall to the chapel of Trinity College (*Prelude* 3.58–63):

And from my pillow, looking forth by light
Of moon or favouring stars, I could behold
The antechapel where the statue stood
Of Newton with his prism and silent face,
The marble index of a mind for ever
Voyaging through strange seas of Thought, alone.

The last two lines were added in the 1850 *Prelude*. As Thomas and Ober exhaustively document, they come towards the end of what was by the mid-nineteenth century a long tradition of Newton poems, including by this time a sub-tradition of poems on the statue of Newton in Trinity chapel (see

157. '[T]he manifesto of a central Romantic enterprise against which we can conveniently measure the consonance and divergences in the writings of his contemporaries' (Abrams 1971: 14). The 'Prospectus' is the starting-point for the whole project of Abrams's *Natural Supernaturalism*.

Fig. 3.2).[158] The 'strange seas of Thought' are those travelled by mental astronauts through the Ocean of space, in the standard conflation of seafaring and sky-wandering. It is by the light of the heavenly bodies whose laws were discovered by Newton, and through which his disembodied soul now travels in poems by Thomson and others, that Wordsworth is favoured with the sight of the building that houses the statue. The silent face of Roubiliac's earthbound statue looks upwards towards the heavens, lips slightly parted, in an expression of intellectual rapture. The words 'for ever' play an ecphrastic trick: the marble statue is forever fixed in this pose of scientific exploration, but it is the index of a mind embarked on a journey that will never come to an end, because the seas of thought are boundless. There is no sense of a goal or port, and there is no company: 'alone' is the last word. Newton has become the Romantic solitary wanderer, with whom Wordsworth, the poetic lonely wanderer, strongly identifies.[159] But the lines that describe this icon of originality are embedded in tradition, and it is a strongly classical tradition; the lonely Newton, and Wordsworth, are in company, in the company of those who had preceded them in wanting to be alone: Horace and Manilius, for example, in their unaccompanied ventures into poetic and astronomical space.

158. Wordsworth is perhaps indebted in particular to E. G. Lytton Bulwer [Bulwer-Lytton], 1825 Cambridge Chancellor's Gold Medal, 'Sculpture': 'Lo! where, through cloister'd aisles, the soften'd day / Throws o'er the form a "dim religious" [Milton, 'Il penseroso' 160] ray, / In graven pomp, and marble majesty, / Stands the immortal Wanderer of the sky—/ The sage who, borne on Thought's sublimest car, / Track'd the vague moon, and read the mystic star'. On Wordsworth's debt to Lucretius in these lines, see Kelley 1983: 221–22.

159. So Abbott 2009.

6

Visions of Apotheosis and Glory on Painted Ceilings

IN THE PRECEDING CHAPTERS ON POETIC TEXTS, I have on occasion adduced related or comparative material from the visual representation of upward flight on painted ceilings: the celestial glorification of James I of England on Rubens's ceiling in the Banqueting House at Whitehall, the posthumous realization of his poetic ambition as the young James VI of Scotland's 'Vpon the fyrie heauen to walk at list'; the triumphal procession of the Duke of Marlborough through the skies on the ceilings of Blenheim Palace, the visual equivalent of the hyperbolic verse panegyrics written to celebrate his victories in the War of the Spanish Succession; the heavens that open up to receive the saints in the sacred paintings of Verrio and Laguerre, satirized by Alexander Pope. In this chapter, I take a more detailed look at the representation of flight and elevation to the heavens in the baroque ceiling painting of seventeenth- and early eighteenth-century England.[1] My chief focus will once more be on the use of classical iconography, and on the interaction of pagan classical with Christian. The lines of reception are less direct in the case of painting than in the textual tradition, since very few ceiling paintings from antiquity will have survived down to the Renaissance (at least in non-Christian buildings), and the iconography of early modern ceiling painting is therefore largely constructed on the basis of ancient texts. The visual vocabulary itself of English ceiling painting is for the most part taken over from earlier European models, sacred and secular—Italian, French, Flemish. Many of the

1. For a sympathetic survey of the painted interior in seventeenth- and early eighteenth-century England, with consideration of the reasons why this kind of art has gone out of fashion, see Johns 2013 (also interrogating the label 'baroque').

practitioners of mural and ceiling painting in Britain were indeed continental artists, such as Rubens, Verrio and Laguerre.

Pietro da Cortona's 'Planetary Rooms'

I begin with a continental example of how a variety of classical models may be combined in a complex iconographical programme, Pietro da Cortona's 'Planetary Rooms' in the Pitti Palace in Florence (1641–47; completed 1659–65 by Ciro Ferri). This celebration of the achievements and pretensions of the Medici family had a seminal influence on baroque ceiling paintings across Europe, and on the imagery of royal and princely apotheosis and glorification.[2] Through the five rooms, dedicated to five of the planets, Venus, Apollo, Mars, Jupiter and Saturn,[3] the Medicean prince ascends through the ages of man, from youth to old age. The classical ascent through the spheres, alluded to in Cicero's *Dream of Scipo*, might also remind the Christian viewer of Dante's ascent through the celestial spheres in *Paradiso*. At each stage, the prince is guided by Hercules, the mortal hero who became an immortal god, and was always ready to hand as the model for the historical ruler who aims for the skies (see ch. 2: 77). Already in antiquity Hercules had become the type both for ruler and military conqueror, and for a heroism of virtue and philosophical achievement. The Medicean prince appears in all these roles.

The room of Venus depicts the victory of virtue over sensual love, as Minerva, goddess of wisdom, carries the young prince away from the embrace of Venus, upwards towards Hercules (Fig. 6.1). Hercules is accompanied by Anteros, in the role of Divine or Virtuous Love,[4] bearing the laurel wreath with which the flying prince will be crowned. This is Anteros as an embodiment of the heavenly love which will fuel the upward flight. The rooms of Apollo and Mars contrast contemplative and active lives: in the former the prince is instructed by Apollo (the sun) who points to the celestial globe held up by (probably) Hercules, a lesson in astronomy (Fig. 6.2).[5] Behind the prince is

2. Campbell 1977, esp. 165–83 on the influence of Cortona.

3. The Ptolemaic, not the Galilean, sequence: Campbell 1977: 79–81.

4. Campbell 1977: 92 on Anteros as *Amor virtutis*, Divine or Virtuous Love.

5. But also pointing to the skies which will be the reward for the active life of the ruler, as in the Ciceronian *Dream of Scipio*. In the *Aeneid*, Aeneas raises on his shoulders the great circle of the divinely crafted Shield, emblematic of Roman history, repeating the pose of Atlas, or Hercules, shouldering the heavens (see Hardie 1986: 372–75).

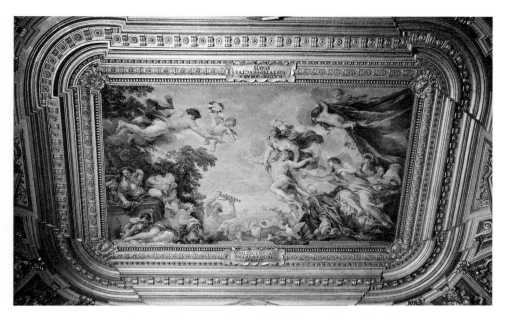

FIGURE 6.1. Pietro da Cortona, ceiling of Sala di Venere, Palazzo Pitti, Florence.
Luisa Ricciarini / Bridgeman Images.

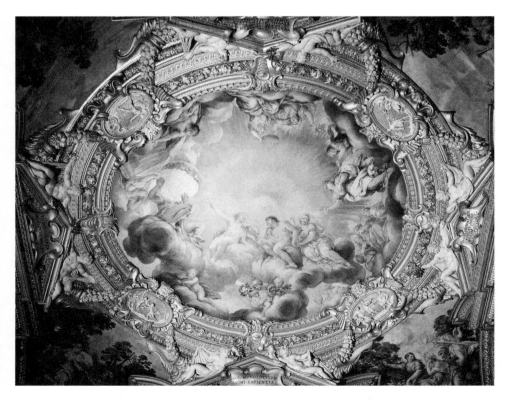

FIGURE 6.2. Pietro da Cortona, ceiling of Sala di Apollo, Palazzo Pitti, Florence.
Luisa Ricciarini / Bridgeman Images.

Fame with her trumpet: Fame, we remember, also elevates her favourites to the skies (ch. 2: 52–53).

Classical and Christian converge in Cortona's use of the schema for church domes devised by Correggio, and popularized by Giovanni Lanfranco in Rome, in which the viewer looks up to the blaze of divine light through circles of clouds populated by denizens of the heavens. (Fig. 6.3). The sunburst at the centre of Cortona's ceiling is easily assimilable to the dazzling brightness of the Christian God. It is a dazzling sublimity; Cortona plays a crucial role in the baroque opening out of space to the vastness of infinity.[6] Two of the inscriptions in the pediments of the lunettes below the central fresco, urging wisdom and moderation on the young prince, are perhaps also intended in part as self-admonition by the artist, a reminder to himself of the risks of sublime flights: 'The sun strengthens, and rain brings forth, flowers; love the golden mean' (flores firmat sol educat imber auream dilige mediocritatem [that is, the Horatian Golden Mean: Odes 2.10.6]); and 'Behold, imitate the sun; you will travel most safely in the middle region' (en imitare solem medio tutissimus ibis [the sun-god's unheeded advice to his son Phaethon in Ovid: Met. 2.137]).

Cortona's most daring di sotto in su (from below upwards) effects are found in the room of Mars, which celebrates the active life in the form of military achievement (Fig. 6.4): Mars hurtles from the heavens towards the prince, who is spearing a crew member tumbling out of an enemy galley. In his left hand, Mars holds his star directly over the prince's head, the promise of an astral destination. Mars and prince together form part of a diagonal that reaches across the Dioscuri, riding on clouds, to the figure of Hercules: Castor and Pollux, like Hercules, are examples of mortals who achieved divinity, showing the way to the earthly ruler. Occupying the centre of the field, however, is not the apotheosed ruler, but the stemma Mediceo, the device of the Medici family, whose six palle (balls) appear almost as six celestial spheres: a visual pun, perhaps, on the 'Medicean Stars', the name given by Galileo to the four major satellites of Jupiter in his Sidereus nuncius (Starry messenger) of 1610;[7] and if so, another rapprochement of princely power and scientific inquiry.

6. Spinosa 1981: 294–98, on Cortona.

7. See Campbell 1977: 145–46. Allusion to the Medicean Stars has also been detected more certainly in Luca Giordano's painting Jupiter and the Apotheosis of the Medici (1682/85), in the Galleria di Luca Giordano, Palazzo Medici Riccardi, in which four members of the family have

The upward momentum of the composition of the ceiling of the room of Mars is balanced by the downward movement of the crew-member of an enemy galley, thrust down by the prince's spear and about to tumble out of the picture space. The group is reminiscent of the schema of Michael casting down the rebel angels. More generally, images of ascent to divinity or glory are often accompanied by the corresponding thrusting or hurling down of the forces of evil, in a dynamic tension between soaring and falling, light and dark, heaven and hell. A grandiose example is Giovanni Battista Gaulli's *Triumph of the Name of Jesus* on the ceiling of the nave of the Church of the Gesù in Rome (unveiled 1679; Fig. 6.5), where the viewer's eye zooms up to the holy name in a burst of light, while, underneath, below the dark undersides of clouds, heretics fall to perdition.

Ascent is also matched by descent in the room of Jupiter in the Pitti Palace (Fig. 6.6). In another circular composition reminiscent of a dome, Hercules has now equipped the prince with his own club as he presents him to his own heavenly father Jupiter. Jupiter's foot rests on his eagle, previously the vehicle for the ascent to heaven of Ganymede, who appears above Jupiter's head, swooping through the vastness of space. In two plasterwork cartouches, Jupiter blasts the Giants with his thunderbolts, and hurls Phaethon from the chariot of the Sun—two classical examples of forced descents which are the penalty for wrong ways of aspiring to heaven.

The ceiling of the final room, of Saturn, the work of Cortona's pupil Ciro Ferri, shows the apotheosis of the Medicean prince, now grey-haired and flying up to Eternity and Glory; Glory, with her trumpet of fame, crowns him. Above, Saturn, with his scythe, sheds the light of his own star on the head of the prince. On earth below, Hercules, who has completed his task of guiding the prince to the heavens, is on the point of his own apotheosis, seated on his funeral pyre. One of the two inscriptions that accompany the fresco of the vault includes the phrase with which Virgil's Apollo confirms the celestial destination of the Trojan prince Iulus and his descendants, 'sic itur ad astra' (this is the path to the stars [*Aen.* 9.641; see ch. 2: 71), suggesting the Medici family's own dynastic pretensions.

stars on their heads: see ch. 2: n. 101. Giordano alludes, presumably, to Cortona's Planetary Rooms in the Pitti Palace on the other side of the Arno.

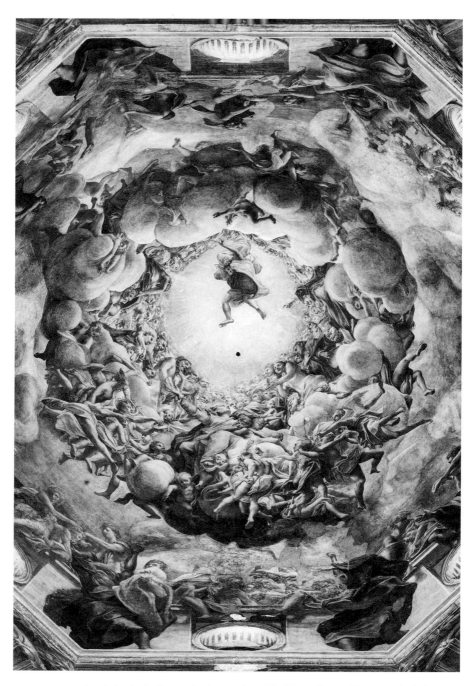

FIGURE 6.3. Antonio da Correggio, *Assumption of the Virgin*, dome of Parma cathedral. Bridgeman Images.

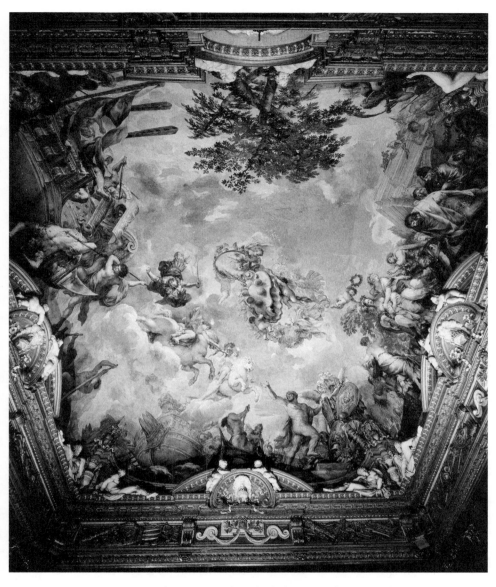

FIGURE 6.4. Pietro da Cortona, ceiling of Sala di Marte, Palazzo Pitti, Florence.
Luisa Ricciarini / Bridgeman Images.

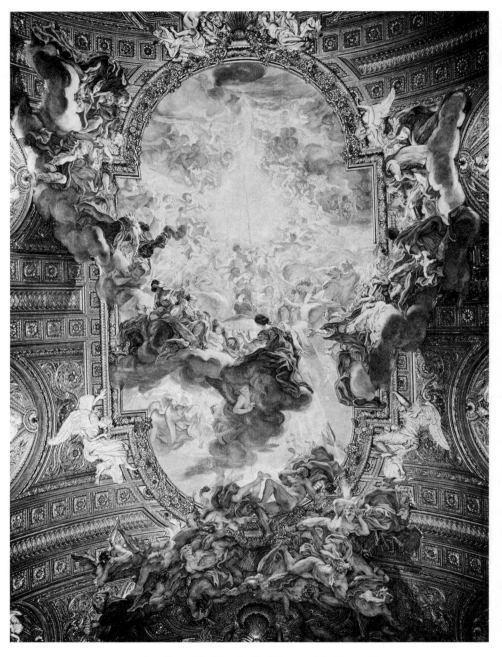

FIGURE 6.5. Giovani Battista Gaulli, *Triumph of the Name of Jesus*,
Church of the Gesù, Rome. Bridgeman Images.

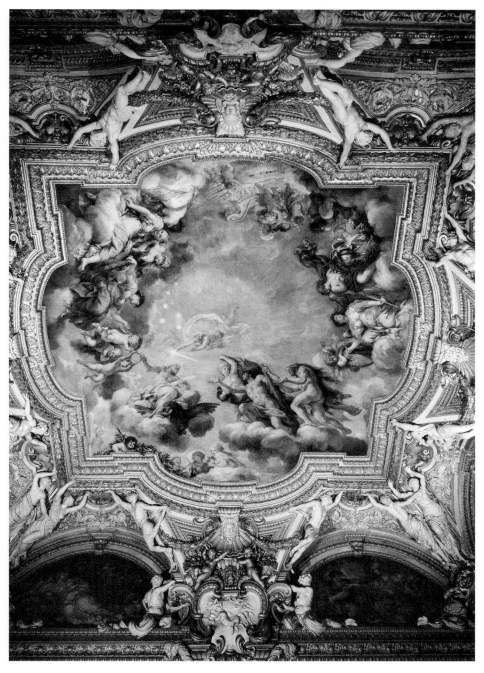

FIGURE 6.6. Pietro da Cortona, ceiling of Sala di Giove, Palazzo Pitti, Florence.
Luisa Ricciarini / Bridgeman Images.

Elizabethan and Early Stuart England.
The Banqueting House, Whitehall

Coming now to England, I shall be looking at images of celestial aspiration on ceiling paintings, many of which have complex iconographical programmes. I focus on selected aspects, with recurrent reference to the classical tradition: first, the use of apotheosis, the translation of the earthly ruler to the heavens, to articulate messages about the relationship between human life on earth and the skies; second, the embedding of narratives of ascent within larger moralized cosmic structures, in a manner comparable both to the epic poems of Virgil and Ovid, and their Renaissance successors, and to the grander examples of continental ceiling painting; third, illusion and fictionality; and finally, the interaction and merging of the classical and the Christian.

The major fashion in Britain for ceiling paintings with images of the heavens, and of ascents to, descents from or journeys through the heavens, begins after the Restoration of 1660, and continues into the first decades of the eighteenth century, up to the time when the baroque in architecture and painting goes out of fashion. The story before the Restoration is of more isolated instances of celestial aspiration depicted on ceilings.

Many of these images are of the apotheosis or glorification of the ruler, or the great nobleman, in the tradition of Roman imperial apotheosis. Before turning to the seventeenth century, a few words are due on the association between the earthly ruler and the heavens in panegyric of Elizabeth I, drawing on both classical and Christian traditions, in imagery that will survive into the seventeenth and early eighteenth centuries. Frances Yates's seminal study 'Queen Elizabeth I as Astraea' explores the use of Golden Age imagery in the imperial legend of Elizabeth.[8] The return of the virgin Astraea is the return of the goddess of justice to earth from heaven, a return that in Virgil's fourth *Eclogue* is synchronized with the descent from the skies of a new ruler (7: 'iam noua progenies caelo demittitur alto'; see ch. 2: 64). Elizabeth is also associated with the sky through her identification with the virgin Diana, goddess of the moon, and, after her death, more daringly with the Virgin Mary.[9] We

8. Yates 1975. On the pervasiveness of the myth of Astraea in Golden Age Spain, see de Armas 1986. On the reception of *Eclogue* 4 in the Italian Renaissance, see Houghton 2019.

9. Yates 1975: 79; 'In the memorial poems the death of Elizabeth becomes a kind of Assumption of the Virgin, followed by a Coronation of the Virgin in heaven', citing a 1603 Cambridge poem: 'Quae fuit in terris Dea, Virgo, Regia virgo / Nunc est in coelis Regia, Virgo, Dea' (The

may remember that the fourth *Eclogue*, the main classical text for the fiction of Astraea, was standardly read as a crypto-Christian prophecy of the birth of Christ.[10]

Turning from Elizabeth I to the time of the Stuarts, one of the most remarkable surviving decorative schemes from the early Stuart period is the mural paintings in the Little Castle at Bolsover Castle, a programme executed probably in 1619–21, and doubtless closely supervised by the castle's owner, William Cavendish, whose character and interests it reflects in complex ways.[11] The various elements of the iconography are derivative of continental models, Netherlandish, French and Italian. Distributed over two floors, the programme traces a path from the bodily world of the humours and the senses, through the defeat of bestial monsters by Hercules, whose labours could be allegorized as the victory of Virtue over the passions, opening the way to the soul's ascent to heaven. Ascending from the first to the second floor, we come from the world of pagan mythology to the Old and New Testament prophets, patriarchs, saints and apostles of the Star Chamber, and the combined classical and Christian virtues in the Marble Closet. The final destination is two private rooms, whose ceilings display contrasting, but not necessarily irreconcilable, visions of heaven. The Heaven Room shows Christ ascending through circles of cherubs and angelic musicians set against clouds (Fig. 6.7). This schema derives ultimately from Correggio's painting of the assumption of the Virgin in the Duomo in Parma (see Fig. 6.3). This Christian model for the final homecoming of the hero is balanced by the ceiling of the Elysium Closet, in which the clouds open to reveal circles of the classical gods and goddesses (Fig. 6.8). This ceiling is based on Primaticcio's design for the Galerie d'Ulysse at Fontainebleau, itself indebted to the ceiling of the Sala dei Giganti in the Palazzo del Te in Mantua (where Primaticcio had been Giulio Romano's assistant: see Fig. 6.35). The frieze round the top of the walls in the Elysium Closet shows Ovidian scenes of passion and lust. Christian and classical versions of heaven.

Timothy Raylor argues that in these two mirroring ceilings, 'Neoplatonism and Ovidianism, the sacred and the profane, the ideal and the actual engage

royal virgin who on earth was goddess and virgin, now in heaven is royal, virgin, goddess). See also Hackett 1995: 213–21, supplementing and qualifying Yates.

10. Houghton 2019: Part 3, 'Religion'.

11. For sustained readings of the programme of the paintings in the Little Castle, see Raylor 1999; Stevens 2017, arguing that the iconography is engaged in a detailed and far-reaching dialogue with the masques of Ben Jonson and with William Cavendish's own literary works.

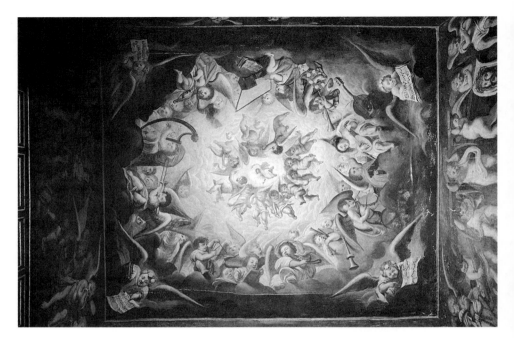

FIGURE 6.7. Ceiling of the Heaven Room, Bolsover Castle. © English Heritage.

in an urbane and sceptical dialogue',[12] and that the iconography reflects the argument embodied in the character of Hercules in Ben Jonson's 1618 masque *Pleasure Reconciled with Virtue*. Crosby Stevens has argued that Ben Jonson himself may have guided the iconography in the Little Castle, the themes of which were picked up in *Love's Welcome at Bolsover*, the masque written by Jonson for the visit of Charles I and Henrietta Maria to Bolsover in 1634, and probably performed inside the Little Castle. If this is so, the ceiling paintings in the Heaven and Elysium rooms are an example, of which we will see others, of the close connection between mural painting and the Stuart masque, in their handling of celestial aspirations.[13]

Biblical and classical intersect in a full-blooded work of the continental baroque that will have struck Londoners in the mid-1630s with the shock of the new as much as the building which it adorns, Inigo Jones's Banqueting House at Whitehall (1619–22), must have astounded by its uncompromising

12. Raylor 1999: 435.

13. The close links between mural painting and the masque is a central and recurrent theme of Hamlett 2020: see index s.v. 'masques'.

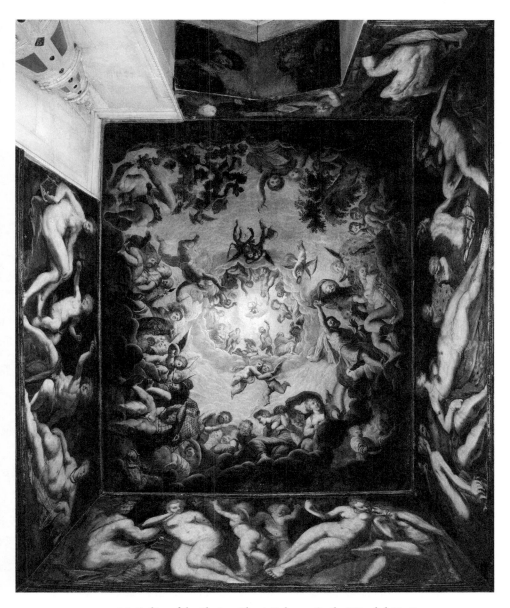

FIGURE 6.8. Ceiling of the Elysium Closet, Bolsover Castle. © English Heritage.

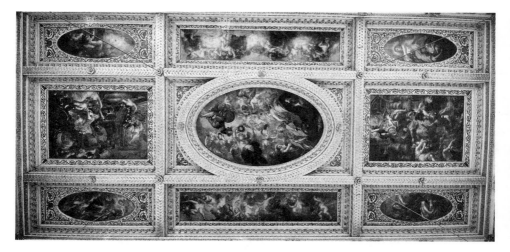

FIGURE 6.9. Peter Paul Rubens, ceiling of the Banqueting House, Whitehall.
© Historic Royal Palaces.

Palladian classicism a decade before. Rubens's ceiling panegyric for James I proclaims Charles I's vision of a monarchical ideology through the celebration of his father (d. 1625) (Fig. 6.9). I will direct my remarks chiefly to the central panel of *The Glorification of James I* (Fig. 6.10),[14] and to the relationship of this skyward journey to the programme, as a whole, of the nine panels that make up the ceiling.

The central panel is busy with twisted flying figures bearing the deceased king upwards from the dark register below his feet towards the celestial brightness that increasingly lights up the clouds over his head, and against which are silhouetted the triumphal and civic crowns of laurel and oak-leaves. There are strong foreshortenings of *di sotto in su*, but little scope for an expansive *cielo aperto* (open sky), a consequence of the division of the ceiling into a number of panels, rather than using the space as a single field, as in the great Roman ceilings of the later seventeenth century.[15] To compensate for this, the eye is drawn upwards by the sequence of the four circles consisting of the following: James's head; the imperial crown, which is being removed from his head after

14. Martin insists (2005) that the central panel should properly be labelled 'King James I brought in triumph to his final account', rather than an 'apotheosis', and he gives to the whole scheme the title 'Glorification of King James I'.

15. The compartmental design of Inigo Jones's ceiling looks rather to Venetian models: see Donovan 2004: 95–96.

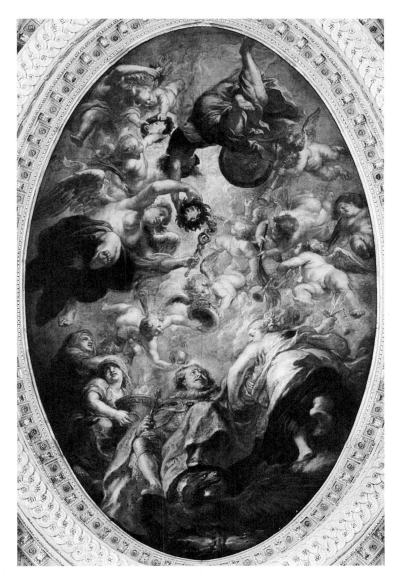

FIGURE 6.10. Peter Paul Rubens, *The Glorification of James I*, Banqueting House, Whitehall. © Historic Royal Palaces.

his death; and the triumphal and civic crowns which are to be laid on his head as he ascends. The sky-reaching fame and triumphal glory of the king are expressed through the four flying putti to the right, bearing two palm-branches and blowing two trumpets.

This tightly unified composition is at the confluence of a number of traditions. The basic scheme of ascent to (and through) the bright clouds of heaven, with swirling *di sotto in su* figures, on a circular or oval field, stands in a tradition of Christian images of ascent, the ascension of Christ or the assumption of the Virgin, and the ascents of saints, a tradition that begins with Correggio's dome paintings in Parma, and then establishes itself in Rome, with Giovanni Lanfranco's dome of Sant'Andrea della Valle (*Assumption of the Virgin*, completed 1627), to spread out across Europe.[16] Christian elements are foregrounded in Rubens's *Glorification* in the personifications of Theology, Piety, and Sacred Justice who flank the king. Of equal weight are the classical symbols of power and triumph. The wings of the thunderbolt-bearing eagle of imperial apotheosis beneath James bear up the globe of the world (*orbis terrarum*); James himself rests one foot on the globe, and the other on one of the eagle's wings. The laurel crown and triumphal palms straddle the classical and the Christian, having already in antiquity been appropriated as attributes of the triumph of the Christian martyr.

The central glorification panel is related to the other two large rectangular panels on the main axis of the hall as the posthumous reward for *The Wise Rule of James I* (Fig. 6.11), and for *The Union of the Crowns of England and Scotland* (Fig. 12). Themes of peace and concord are important in both, as they are in the Virgilian tradition taken in its broadest outline: the *Aeneid* celebrates the *pax Augusta*,[17] achieved after a centuries-long history of Roman warfare, and proclaims a new age of concord after the discord of the near-fatal civil wars of recent decades. The festoons of red and white roses in *The Union of the Crowns* refer to the harmony of the once warring Houses of Lancaster and York, from both of which James was descended, a reminder, ironic given what was soon to happen in Charles I's Britain, of the ending of civil war which had been so central a part of Tudor ideology. Virgil mythologizes Roman civil war as hellish and chthonic, as the renewal of gigantomachy or the eruption of a Fury

16. See Buccheri 2014: ch. 5.

17. Donovan 2004: 123 sees a parallelism between the iconographies of the Whitehall ceiling and the *Ara Pacis Augustae*. Even if Rubens had seen some of the fragments of the *Ara Pacis*, it is unlikely that he could have pieced together its programme.

FIGURE 6.11. Peter Paul Rubens, *The Wise Rule of James I*,
Banqueting House, Whitehall. © Historic Royal Palaces.

from the underworld. This Virgilian deployment of the vertical axis to oppose
good and evil, order and disorder, is paralleled in the Whitehall ceiling (as it
very frequently is in early modern political, as well as religious, allegories). In
the *Wise Rule* panel, at the foot of James's throne, Minerva, wielding her
father's thunderbolt, thrusts Mars downwards, and lower still Mercury, with
the caduceus of peace, points at the fallen, snaky-haired figure of 'Furor'; and
three hydra-like monsters attempt to rise from hell. The original Hydra was
dispatched by Hercules. Hercules himself appears in one of the smaller oval
panels in the four corners of the ceiling, which show gods and a personifica-
tion overcoming Vices. The format of the elongated oval itself dictates a strong
up-and-down composition. Hercules as Heroic Virtue crushes Envy, since
antiquity a close relative of the infernal Furies.

FIGURE 6.12. Peter Paul Rubens, *The Union of the Crowns*,
Banqueting House, Whitehall. © Historic Royal Palaces.

Another celestial touch is the rays of light around the head of the figure,
probably Apollo, who suppresses a demonic Avarice, as he bestows royal lib-
erality, a virtue much prized by James (Fig. 6.13). There is a hint here of the
sun-king, a conceit that has a long history before Louis XIV: in the climactic
scene of the ecphrasis of the Shield of Aeneas in Virgil's *Aeneid*, for example,
where Augustus, seated on the threshold of the temple of Apollo, and vicar for
the sun-god, reviews the peoples of the world who process before him in his
triumphal procession, as the Sun's gaze extends to the whole world (see ch. 2:
77–78). On the Whitehall ceiling, the two long side panels of processions of putti,
including little chariots laden with cornucopias and drawn by animals, celebrate
the happiness brought about by the rule of James. These serve a function,

within the programme as a whole, analogous to the triumph of Augustus at the end of Roman history on the Virgilian Shield. In none of this am I claiming immediate dependence on Virgil on the part of Rubens. But I would say that Rubens is drawing on a Renaissance visual vocabulary that had, over the centuries, been significantly shaped by the Virgilian tradition.

In terms of contemporary contexts and models, the Whitehall ceiling looks both across the Channel and to its very immediate environment. Across the Channel, the classicizing of Rubens's Whitehall ceiling is continuous with the large-scale cycle that the artist put to one side to work on the London commission, the twenty-one canvases of the life of Maria de' Medici, widow of Henri IV, mother and one-time regent of Louis XIII, and mother of Charles I's queen Henrietta Maria. These canvases (now in the Louvre) were designed to be hung vertically on the walls of a gallery in the Luxembourg Palace, and so obey compositional principles different from ceiling paintings, but both schemes articulate comparable visions of the relationship of the earthly ruler to the heavens, and both show an interference between the classical and the Christian.[18]

FIGURE 6.13. Peter Paul Rubens, *Apollo[?] Suppressing Avarice*, Banqueting House, Whitehall. © Historic Royal Palaces.

There are four scenes in the Medici cycle which could be labelled as apotheosis: the first shows the very classicizing apotheosis of Henri IV, in the central painting of the cycle, *The Death of Henri IV and Proclamation of Regency* (Fig. 6.14) (as *The Glorification of James I* is the central panel on the Whitehall ceiling). The assassinated Henri is borne up not by personifications of Christian virtues, but by Jupiter, with his thunderbolt-bearing eagle, and by Saturn, gesturing with his sickle of Time towards the upward path to the immortality of the gods. This upward movement follows the partial arc of the zodiac which encloses the gods, who fade out into a heavenly brightness that captures

18. Stechow 1968: ch. 4, 'The Past and the Present', on the near-identity of the pagan and Christian spheres for Rubens, reacting against the oppressive tendencies of the Counter-Reformation.

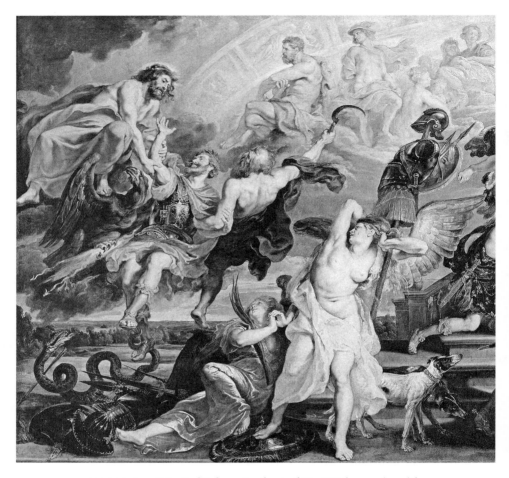

FIGURE 6.14. Peter Paul Rubens, *Apotheosis of Henri IV*, from cycle on life
of Maria de' Medici. Detail. Bridgeman Images.

something of the effect of the illusion of ascent into the bright heavens on a
ceiling or dome painting.[19] Compositionally, the group of Henri, Jupiter and
Saturn alludes to two engravings of skyward launches by Rubens's own master,

19. For apotheosis following immediately on assassination, cf. Ovid's narrative of the death
and stellification of Julius Caesar, *Met.* 15.745–851. Henri IV is taken up to the heavens (and down
to the underworld) in another traditional vehicle in canto 7 of Voltaire's epic *La Henriade*, in a
dream vision in which Saint Louis travels with Henri in a chariot of light, with allusions to
Elijah's chariot of fire and to Astolfo's chariot-flight with Saint John in Ariosto's *Orlando furioso*
(see ch. 2: 102–5).

Otto van Veen, in the latter's *Quinti Horatii Flacci emblemata*: *Virtus immortalis*, which illustrates the power of Virtue to elevate statesman and warrior to immortality; and *A Musis Aeternitas* (Eternity [which comes] from the Muses), which celebrates the power of the poet to eternize his subjects and himself.[20] In the second of these, the laurel-crowned Horace is borne upwards by Time and Fame, an illustration of Horace's own prophecies of his flight upwards in immortal fame, as well as of his assertion of his power to lend immortality to his subjects. Rubens perhaps hints reflexively at his own power as an artist to immortalize.

The last three scenes of apotheosis in the Medici cycle form a closing sequence to the cycle,[21] drawing chiefly on Christian, not pagan, templates. In the penultimate, *The Return of the Mother to her Son* [Louis XIII]' (Fig. 6.15), Maria is 'Maria Assumpta elevated by grace of her now beatifically godlike son'; 'light streams from his head in the shape of a rayed golden crown: thus King of France, Apollo, and, unabashedly, Christ the King.'[22] Upwards movement is balanced by a female Saint Michael-like figure blasting a many-headed leonine Hydra monster down to hell with a thunderbolt.[23] In the final painting, *Time Unveils the Truth*, queen mother and king are seated against a radiant sky, glorified and apotheosed, in a composition that alludes to the coronation of the Virgin.

Much closer to home, Rubens's Whitehall ceiling looks down on the stage for the performance of the Stuart court masque, for which Inigo Jones's Banqueting House was the setting until 1637, when a new timber masquing room was built, so that the Rubens ceiling should not be blackened by the smoke from the hundreds of torches and lamps that provided the lighting effects for the masques. One might think of the Rubens ceiling as the enduring deposit of the successive years of the transient performances of Jacobean and Caroline

20. Reproduced in Millen and Wolf 1989, plates 41–42 (discussed on pp. 127–28); van Veen 1979: 14–15, 158–59.

21. I follow Millen and Wolf (1989), who see the last three canvases, *The Queen Opts for Security*, *The Return of the Mother to Her Son* and *Time Unveils the Truth*, as a threefold sequence of apotheosis.

22. Millen and Wolf 1989: 216.

23. For a later British example of a similar motif, see Queen Anne's coronation medal showing her as Pallas hurling a thunderbolt against the Hydra, symbolizing the war against France: Hawkins 1904–11, 2: 228–29; Edie 1990: 326–28.

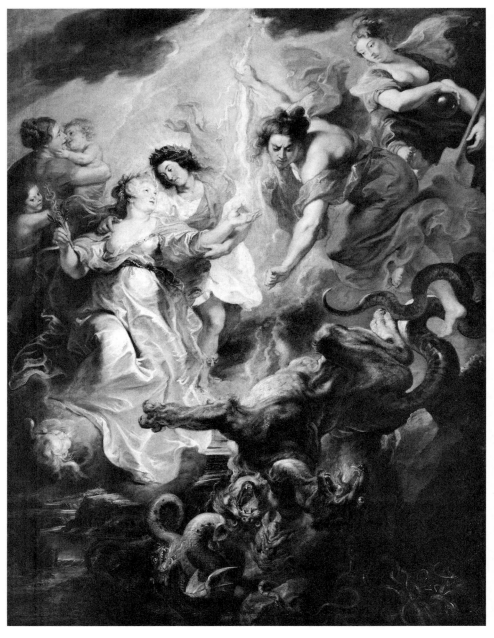

FIGURE 6.15. Peter Paul Rubens, *The Return of the Mother to her Son,* from cycle on life of
Maria de' Medici. Bridgeman Images.

masques, perhaps even as the apotheosis of the masque.[24] Descents from and ascents to heaven were a regular feature of the stage-magic of the masque, delivering a message about the refined and celestial virtues of the royal couple and their court. For example, perhaps the greatest of the Stuart masques, [25] Thomas Carew's 1634 *Coelum Britannicum*, uses the classical motif of catasterism, the stellification of earthly creatures, in a fantasy in which Charles I's British court has become a model for heaven, and the Olympian gods sweep the skies clean of the monstrous constellations of classical mythology, products of the catasterism of Jupiter's rape victims after their metamorphosis into beasts by a jealous Juno, and repopulate the eighth sphere of the heavens with stellified British heroes, greatest and most eminent among which is the star of King Charles. Carew based *Coelum Britannicum* on Giordano Bruno's *Lo spaccio de la bestia trionfante* (The expulsion of the triumphant beast) of 1584, dedicated to Sir Philip Sidney, a channel through which a continental celestial expatiation had reached England fifty years before. (On Giordano Bruno's celestial aspirations, see ch. 3: 126–27).[26]

The Caroline masque is strongly infused with the Neoplatonism fostered by Charles's queen Henrietta Maria,[27] and of this too there may be traces on Rubens's ceiling. Gregory Martin states that 'the young bearer of two torches riding triumphantly on the ram [in one of the Bacchic processions of putti] . . . represents Divine or Platonic Love, the much revered state of the soul to be attained above all else in the Caroline court'—an illustration of the power of

24. Gordon 1975: 50: 'With the imagery of the ceiling we are in the world of the last court masques, a *Triumph of Peace* or a *Salmacida Spolia*.' Strong speculates (1980) that Inigo Jones himself may have have drawn up the programme; on the question of its authorship, see Donovan 2004: 139–47. Orgel and Strong 1973, 1: 71: 'Rubens's allegories of the Stuart monarchy were the most permanent embodiments the age was to produce of the masque's mode of expression. In effect the Banqueting House ceiling made of every action performed within the great hall a symbolic drama about kingship. While the temporal ruler and his subjects carried out the ceremonies of state below, far above, all but indistinguishable, hung the apotheosis of the dynasty and the nation, like Platonic Ideas of which the real court was merely a shadow.' There is a close connection between painting and theatrical design and machinery: see Buccheri 2014 on the influence of stage cloud machinery on painting; Gloton 1965: 30–31 on the parallelism between the union of imaginary and real in ceiling visions of Paradise and in theatre and festival; Bernini, Cortona and the Carracci all worked on stage illusions.

25. The judgement of Orgel and Strong 1973, 1: 15–27, 'The Mechanics of Platonism'.

26. On Bruno and the Stuart masque, see Gatti 1995; on *Coelum Britannicum*, see Hille 2012: 240–51.

27. See Veevers 1989.

love to control base instincts. Martin continues, 'The boys riding the tiger and the lion, the yoking of the lion and bear and their being controlled by reins are motifs that illustrate the power of love to control base instincts.'[28] This is a reflection, ultimately, of the celestial charioteer and his horses in Plato's *Phaedrus* myth.

What kinds of fiction and illusion are we dealing with in works such as the Rubens's Maria de' Medici cycle and the Whitehall ceiling, or the masque *Coelum Britannicum*? The divine right of kings was central to the ideology of the first two Stuart monarchs.[29] James I took seriously his royal godlikeness, and one of his favourite dictums was, 'Kings are called gods.'[30] At the death of James, William Laud said, 'His rest . . . is in Abraham's bosom, and his crown changed into a crown of glory.'[31] That too was presumably spoken with some degree of conviction by a Christian bishop.

When it comes to classical mythology, we can think in terms of the clothing of Christian truths in pagan dress, in line with a long tradition of the accommodation of pagan myth and literature that goes back to late antiquity. Furthermore, mythology is a space of imaginative freedom, in which celestial aspirations can be entertained through a suspension of disbelief, and without fear of the taint of paganism. The cohabitation of pagan fancies and Christian beliefs also goes back to late antiquity, as in, for example, the two versions of the posthumous ascent to the skies of the (very Christian) emperor Theodosius I, discussed in chapter 2 (97–98). The poet Claudian, working within the tradition of Virgil and his epic successors, recounts the catasterism of Theodosius, as he ascends through the planetary spheres to become a 'new star' (*On the Third Consulship of Honorius* 162–83). Saint Ambrose, in his funeral speech for Theodosius, begins with topics of pagan ruler-cult, but quickly modulates into biblical texts, and speaks of Theodosius's exchange of an earthly for a heavenly crown, as he ascends to the celestial Jerusalem. One assumes that Claudian's Christian readers would have taken the catasterism as a flattering fiction, but one that they could, if they wished, translate into a Christian equivalent. Claudian's late antique panegyrical epics were a rich resource for

28. Martin 2011: 169.

29. There is much on the limits of claiming divinity for the earthly ruler, with regard to the praise of Elizabeth I in Spenser's *The Shepheardes Calender*, in Pugh 2016, with particular reference to Spenser's adaptations of the apotheoses in Virgil's fourth and fifth *Eclogues* (on which see ch. 2: 64–66).

30. E.g., in a speech of 1616 in the Star Chamber: 'for Kings sit in the Throne of God, and they themselves are called Gods' (Sommerville 1994: 204).

31. Cited in Gordon 1975: 35.

Renaissance panegyrists, in both texts and images, and enjoyed a higher profile than in more recent times.[32] For example, Claudian's narrative of the apotheosis of Theodosius is translated in John Ogilby's annotation of his *The Entertainment of His Most Excellent Majestie Charles II* (London 1662),[33] an account and description of the cavalcade and triumphal arches erected for the passage of Charles II through the city of London to his coronation. One of the inscriptions on the second arch, to the 'British Neptune' Charles II, read, 'O NIMIUM DILECTE DEO, CUI MILITAT AEQUOR, | ET CONJURATI VENIUNT AD CLASSICA VENTI' (For thee, O Jove's delight, the seas engage, / And mustered winds, drawn up in battle, rage [Ogilby's translation]), an adaptation of some famous lines (95–97) from Claudian's *On the Third Consulship of Honorius*.

Another way of realizing celestial aspirations is through various kinds of identification, role-playing and dressing-up, creating connections with both Christian and pagan figures, and expatiating freely in a world of metaphor and fiction.[34] Thus, in Rubens's representation of royalty, Maria de' Medici and Louis XIII appear in the poses of a coronation of the Virgin; or, on the Whitehall ceiling, James's pose in the panel of *The Union of the Crowns* alludes to the judgement of Solomon. In the court masque, the royal family and members of the court are literally costumed in the parts of gods and personifications. This is a godlikeness through theatrical disguise. Imperial impersonation of the gods goes back to antiquity, particularly in the more private medium of gems and cameos: for example, a gem showing Octavian, the future Augustus, as Neptune driving his chariot of sea horses (Fig. 6.16), a statement of his rule over the waves. Octavian infamously put on a banquet of the twelve gods, at which the guests appeared in the guise of gods and goddesses, Octavian taking the part of Apollo (Suetonius *Aug.* 70). Ben Jonson, drawing on the Suetonian

32. See Saward 1982: 9–12 on the importance of the ancient literary tradition of panegyric for Rubens's iconography; index s.v. 'Claudian'; on the importance of Claudian for seventeenth-century English poetry, see Moul 2016; 2017; 2021.

33. Ogilby 1987: on pp. 34–35 of the facsimile, Claudian, *Cons. Hon. III* 162–74 is quoted and translated as one of the passages documenting the Roman practice of imperial consecration, to illustrate the inscriptions 'DIVO JACOBO' and 'DIVO CAROLO', beneath the statues of James I and Charles I on the first arches erected for Charles II's coronation procession in London. Knowles in Ogilby 1987: 34: 'Claudian is Ogilby's most favoured source.' Ogilby's triumphal arches appear as part of the stage machinery at the end of the first act of *Albion and Albanius* (Knowles in Ogilby 1987: 24 with n. 102).

34. For the equation of earthly court and Olympus in Hellenistic poetry, see Hunter 2003: 93–96.

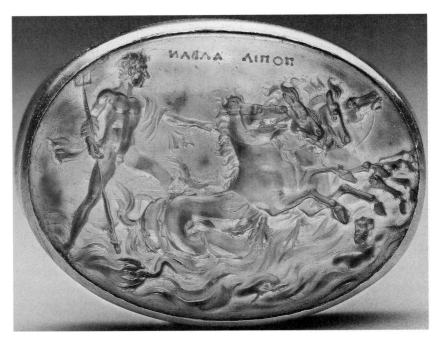

FIGURE 6.16. Oval gem with Octavian as Neptune, mounting a sea-chariot.
© Museum of Fine Arts, Boston.

report, stages a banquet of the gods in his play *Poetaster*, in which Ovid takes the part of Jupiter, and his lover, Augustus's daughter Julia, the part of Juno, with disastrous consequences. More safely, Rubens portrays Henri IV and Maria de' Medici as Jupiter and Juno, in the panel of *Consummation of the Marriage of Henri IV and Marie de' Medici at Lyons* (Fig. 4.2), and royal personages play the parts of the gods in the panel of *The Council of the Gods*, with Louis XIII in the pose of Apollo Belvedere, whose radiate head designates him a sun-king.[35]

Another mythological divine wedding was used as a figure for an earthly union in a (lost) painting by Guido Reni intended for the ceiling of the bed-chamber of the Queen's House at Greenwich, furnished by Henrietta Maria in the mid- to late 1630s. The painting showed Ariadne being presented to Bacchus by Venus; Cupid flies overhead, pointing to the constellation of the Corona Borealis, the product of the catasterism (metamorphosis into a constellation)

35. For the French tradition of court portraiture, see Bardon 1974. There are many examples also in British court portraiture, with sitters in the likeness of a pagan divinity, or even of the Virgin and child: see Solkin 2015: 16–17.

of Ariadne's crown after her union with the god (see ch. 2: 62). The painting, together with the framing cartouches and Latin mottoes, was an allegory for the enduring and fruitful marriage of Henrietta Maria and Charles I.[36]

Henrietta Maria and Charles I take on other divine disguises in Gerrit van Honthorst's (1590–1656) *Apollo and Diana*, painted between April and December 1628 while van Honthorst was working in London for Charles I, and probably commissioned by the Duke of Buckingham, who had visited Paris and seen Rubens's Maria de' Medici cycle (Fig. 6.17).[37] The painting was installed at an unknown location in the Banqueting House at Whitehall. In it, the Duke of Buckingham plays the role of Mercury[38] leading the seven Liberal Arts out of a dark cave in which they have been languishing, and into the light of royal patronage (alluding perhaps to Plato's allegory of the cave). He presents them to Charles I (as Apollo, the god of art and learning) and Henrietta Maria (as Diana, Apollo's sister). The painting is composed as yet another contrast between ascent and descent: Mercury-Buckingham leads the Liberal Arts up into the light towards the royal embodiments of the gods of the sun (symbolized by the circular blaze of the sun on Apollo—Charles's head) and moon (symbolized by the crescent of the moon on Diana—Henrietta-Maria's head), while the enemies of royal enlightenment, perhaps to be identified as Envy and Hate, are thrust downwards into the pit by children with a torch of Knowledge and a trumpet of Fame. Van Honthorst was a Caravaggist, known for his artificially lit scenes; in this case we might think of the artificial lighting of the court masque, another aspect of the self-conscious fictionality of this painting.[39] Honthorst's image of Charles and Henrietta Maria seated on high side by side, in the image of gods, is reflected in the first speech of Mercury in Carew's *Coelum Britannicum*, which announced to the royal couple, first addressed by Mercury as 'Bright glorious twins of love and majesty',[40] the

36. See Higgott 2020. Reni's painting never arrived at Greenwich, and was replaced by Giulio Romano's *Daedalus and Icarus*, also now lost. The ceiling is now decorated with an eighteenth-century painting, *Aurora Dispersing the Shades of Night*.

37. For detailed discussion, see Hille 2012: 228–40.

38. Buckingham (George Villiers) had taken part in the masque *Mercury Vindicated* in 1615.

39. Veevers 1989: 150: 'The painting is conceived in masque-like terms and could stand as an introduction to the masques of the thirties. . . . The vices, like the figures of an anti-masque, are tumbled into the darkness below the throne, and the play of light in the painting connects the central group of the Arts with the Royal group, which reflects light to the heavenly figures above.'

40. One of a number of early modern disproofs of the Ovidian dictum (referring to Jupiter's disguise as a bull to achieve his love for Europa), 'non bene conueniunt nec in una sede moran-tur / maiestas et amor' (Majesty and love do not well agree, nor are they to be found in the same

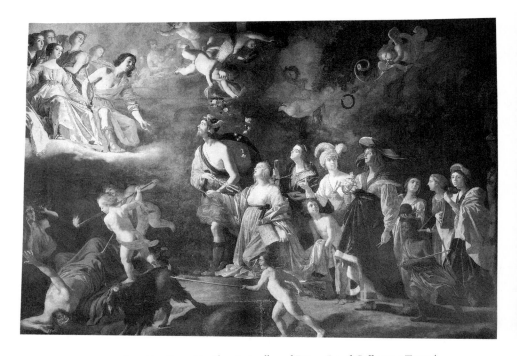

FIGURE 6.17. Gerrit van Honthorst, *Apollo and Diana*. Royal Collection Trust /
© Her Majesty Queen Elizabeth II 2021.

succession of Charles to the 'vacant rooms' of the heavens, purged of the monstrous constellations of classical mythology, with 'Next, by your side, in a triumphant chair, / And crown'd with Ariadne's diadem, / . . . / . . . the fair consort of your heart, and throne.'[41]

Honthorst's painting is satirized in a pamphlet issued to celebrate the assassination of the Duke of Buckingham on 23 August 1628, *Felton Commended* (22–29):

> now in haste
> The cunning Houndhorst must translated be
> To make him the restorer Mercury
> In an heroic painting, when before
> Antwerpian Rubens' best skill made him soar,
> Ravished by heavenly powers into the sky,

place) (*Met.* 2.846–47). 'Twins' comes perilously close to identifying the royal couple as brother and sister, as were Apollo and Diana.

41. Dunlap 1964: 155 (ll. 90–97).

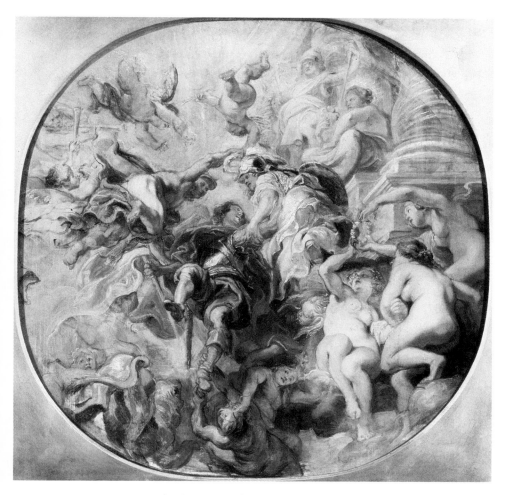

FIGURE 6.18. Peter Paul Rubens, sketch for *The Glorification of the Duke of Buckingham*.
Bridgeman Images.

> Opening and ready him to deify
> In a bright blissful palace, fairy isle.[42]

The reference in lines 26–29 is to Rubens's ceiling painting *The Glorification of the Duke of Buckingham* (c. 1625), in Buckingham's London residence, York House.[43] The artist's oil sketch for the painting (Fig. 6.18) (itself now

42. BL MS Sloane 826, fol. 192r.
43. For a detailed discussion of the painting and preliminary sketches, see Hille 2012: 207–27, arguing that the composition alludes to the elevation of Ganymede to the residence of his lover

destroyed) shows the duke being borne upwards by Minerva and Mercury towards a temple where personifications of Virtue and Honour wait to receive him. Winged putti flutter around him. The composition is echoed in the Banqueting House *Glorification of James I* of a few years later.

The Restoration

An actual theatre is the setting for a theatrical *tour de force* of celestial illusionism, and one with yet another layer of fiction, since this is a modern academic building pretending to be an ancient theatre, the Sheldonian Theatre in Oxford.[44] Robert Streater's *Truth Descending on the Arts and Sciences* was fixed in place in 1669 (Fig. 6.19). Christopher Wren's enormous flat ceiling appears to be nothing more substantial than the thin air of the sky, revealed as the *velarium* (awning) is drawn back by flying putti from the cords that supported it, in reality gilded rods of wood. This is a descent, of Truth, rather than an ascent, but the viewer's eye is drawn upwards, past the circling *enkuklios paideia* of the Arts and Sciences, and up into the sublime and vertiginous space of the opening heavens, as, for example, in the dome paintings of the assumption of the Virgin by Correggio and Lanfranco. The elongated square of the theatre provides space for the counterbalancing downward movement of the expulsion of Envy, Rapine and Ignorance, comparable to the downward fall of the heretics in Gaulli's *Triumph of the Name of Jesus* in the Church of the Gesù (see Fig. 6.5). The Sheldonian ceiling is a version of the flight of the mind, comparable to the philosophical and scientific sky-reachings of a Lucretius or a Manilius; but this is an intellectual revelation and conquest with political overtones, if Anthony Geraghty is right in seeing allusion to the Restoration and the routing of the forces of Cromwell. Geraghty also sees a restoration of the visual idiom of the pre–Civil War Stuart masque: the clouds which support the Arts and Sciences suggest the scenic device of the 'heavens', the bank of cloud on which the seated actors in a masque descended from on high[45]—appropriately enough in a 'theatre'.

Jupiter, so sanitizing and purifying the derogatory use of the image of Ganymede to refer the relationship between James I and his favourite, the 'catamite' Buckingham (on Ganymede, see ch. 2: 72, 89–90).

44. Geraghty 2013.

45. Robert Whitehall wrote an extravagant paean to the ceiling, 'Urania, or, A Description of the Painting of the Top of the Theater at Oxon, as the Artist Lay'd his Design' (London,

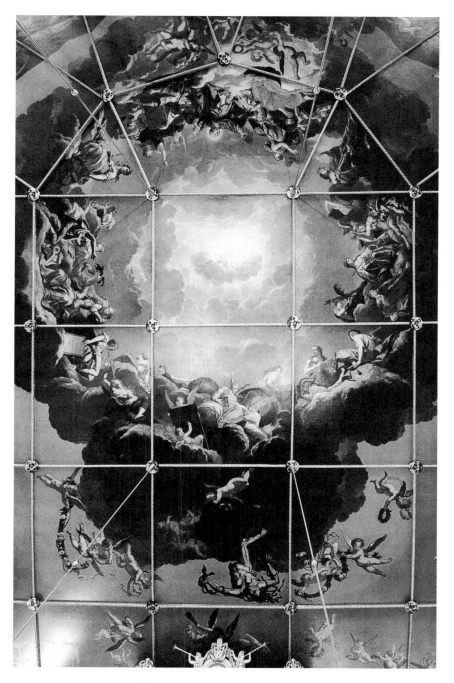

FIGURE 6.19. Robert Streater, *Truth Descending on the Arts and Sciences*, Sheldonian Theatre ceiling. © Photovibe/Greg Smolonski.

The revival by Charles II of the celestial aspirations of his father and grand-father after the Cromwellian interregnum is seen already in a panel from the ceiling of Charles II's bedchamber at Whitehall Palace, painted by John Michael Wright: *Astraea Returns to Earth*, perhaps of 1661 (Fig. 6.20).[46] Justice-Astraea is seated in the heavens between, on her right, the constellation Libra (the scales held by a cherub), and, on her left, a circular portrait of Charles, in the place where Leo should be. Continental and British converge once more: the illusionism of the heavens is in the manner of Pietro da Cortona or Andrea Sacchi, leading baroque painters in Rome, where Wright had spent more than ten years, while the motto on the scroll held by the descending angelic winged messenger, 'Terras Astraea revisit' (Astraea revisits the earth), comes from one of the many reworkings of Virgil's fourth *Eclogue* by panegyrists of Elizabeth I.[47] Wright's painting is a visual equivalent to John Dryden's 'Astraea Redux' of 1660, a panegyric of the newly restored Charles II which also activates memories of the glorious reign of Elizabeth.

David Solkin, in a recent discussion of this painting, sees, in the presence of Charles II *only* in the painted likeness of the medallion portrait supported by putti, a sign of the tentative quality of this resumption of celestial royal panegy-ric—a hesitancy as to the chances of a successful restoration of monarchy.[48] But it is rather, or perhaps as well, a question of the limits of fictionality. It would after all look rather odd if a flesh and blood, adult, Charles II were perched in the clouds, waiting to descend in his return to England. The apotheosis of the great man in image, or in the form of a heraldic device, as in the translation to the skies of the *stemma Mediceo* in the Sala di Marte in the Planetary Rooms of the Pitti Palace, is one way of avoiding the implausibility of bodily elevation to the heav-ens. For example, in one of the grandest late baroque exercises in celestial illu-sionism, Giambattista Tiepolo's fresco *The Four Continents* on the ceiling of the Treppenhaus at Würzburg (1750–53), the personification of Painting looks up to the medallion portrait of Tiepolo's patron, the Prince-Bishop von Greiffenklau, as it is borne up through clouds towards the gods.[49]

1669): 'These to the life are drawn so curiously / That the beholder would become all Eye: / Or at the least an Argus so sublime / A phant'sie makes essayes to Heaven to climb / That future ages must confess they owe / To STREETER more than Michel Angelo' (p. 7).

46. Stevenson and Thomson 1982: 67–69.

47. Verses presented by Robert Twist to Elizabeth in 1597: 'redeunt Saturnia saecla, / ultima caelestum terras Astraea revisit' (Strong 1977: 122).

48. Solkin 2015: 4–5.

49. Discussed by Alpers and Baxandall 1994: 154. Another example of the floating medallion portrait of Charles II, possibly posthumous, is Jacques Parmentier's oil-on-copper painting of

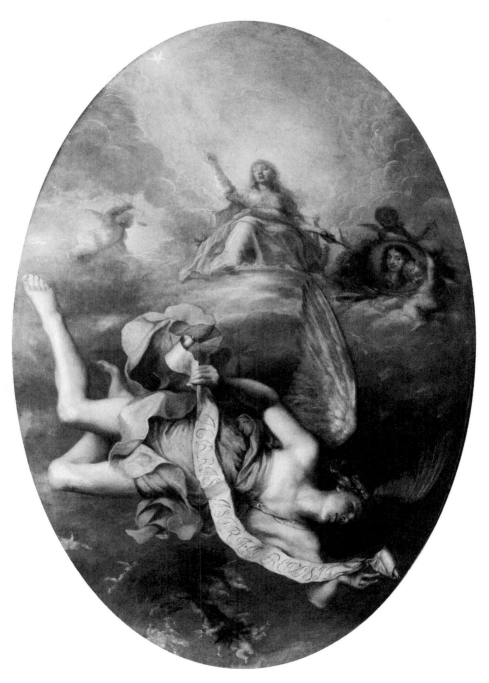

FIGURE 6.20. John Michael Wright, *Astraea Returns to Earth*.
© Nottingham City Museums & Galleries / Bridgeman Images.

Wright's *Astraea Returns to Earth* strays into the surreal in the image, beneath the winged messenger, of a tree carried through the sky by winged putti. This flying oak is the tree in which Charles II was said to have hidden from the Cromwellian troops after the battle of Worcester. The 'Robur Carolinum' (Charles's oak) would be astronomically translated to the skies when in 1679 Edmond Halley identified it as a constellation in the southern sky, located between the constellations of Centaurus and Carina, extending into half of Vela (in the manner of the Alexandrian court astronomer Conon's identification of the constellation of the Lock of Berenice in Callimachus and Catullus: see ch. 2: 62).[50] The dates don't seem to work, but it would be a neat conceit if one constellation, Virgo, were shown about to come down from the heavens, back to earth, while another, Robur Carolinum, is on its way up to the heavens.

For more ambitious images of Charles II in the mode of cosmic kingship, we have to await the arrival in England, in 1672, of the Italian painter Antonio Verrio, who came via Paris where he may have been an assistant to Charles Le Brun, 'first painter' to King Louis XIV. Verrio gave a sample of what he was capable of in *The Sea-Triumph of Charles II* (perhaps 1674) (Fig. 6.21).[51] The king rides in Neptune's chariot. He is paired with, rather than impersonating, the god of the sea (as in the Octavian cameo: Fig. 6.16); indeed, Neptune appears to be in the service of the superior god Charles, enthroned at the top of the pyramidal composition. As well as ruling the waves, Charles's power extends to the heavens: at the top, a trumpet-blowing Fame holds a scroll with the inscription 'imperium Oceano famam qui terminet astris', referring to the man 'Whose Empire Ocean, and whose Fame the Skies / Alone shall bound' (Dryden). This is the climax of the Virgilian Jupiter's prophecy (*Aen.* 1.287) of the greatness of Caesar (Julius or Augustus), one of the most overworked lines of the *Aeneid*.

Verrio's major programme of royal magnification and elevation, most of it now destroyed, was at Windsor, and here Charles II does ride in the skies

an owl-helmeted Minerva on a cloud holding aloft an oval portrait of an armoured Charles II, above a view of Windsor (see Sharpe 2013: 111). Medals were an important medium for propagating the achievements of Louis XIV, and, as Wellington demonstrates (2015), their forms were also incorporated in works of painting and sculpture: see esp. ch. 7, 'Numismatic Resonances: Le Brun's Cycle for the Hall of Mirrors at Versailles'.

50. Information from Wikipedia, entry for 'Robur Carolinum'.

51. See Sharpe 2013: 106–8; Johns 2016: 157–65. Two putti carry a map inscribed with another Virgilian allusion, 'pacatumque reget', from *Ecl.* 4.17: 'pacatumque reget patriis uirtutibus orbem' (he will rule a world pacified by his father's virtues).

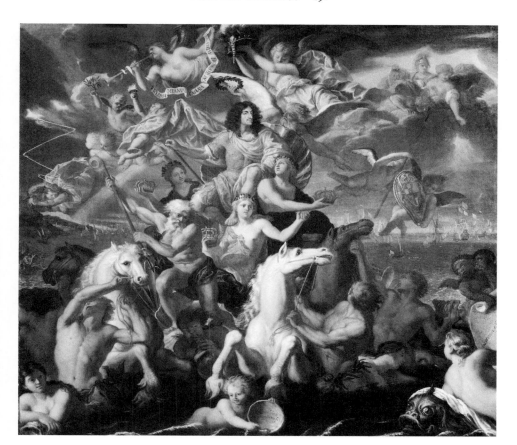

FIGURE 6.21. Antonio Verrio, *The Sea-Triumph of Charles II*. Royal Collection Trust / © Her Majesty Queen Elizabeth II 2021.

in person.[52] The climax of the programme, close in its imagery to that of Thomas Carew's masque *Coelum Britannicum*, was *The Apotheosis of Charles II* in St George's Hall (Fig. 6.22), which was opened to the public in 1684, the same year as the Galerie des Glaces (Hall of Mirrors) at Versailles.[53] Our main evidence for it is now a watercolour and a drawing, both of the early

52. On which see De Giorgi 2009: 105–12; Sharpe 2013: 119–21; Hamlett 2020: 41–50; Strunck 2019 develops the christological iconography of Charles II. For an overview of Verrio's career, see Brett 2009/10.

53. Gibson 1998; see also Johns 2016: 169–72. On the iconography of the Galerie des Glaces, its meanings and functions, see above all Sabatier 1999.

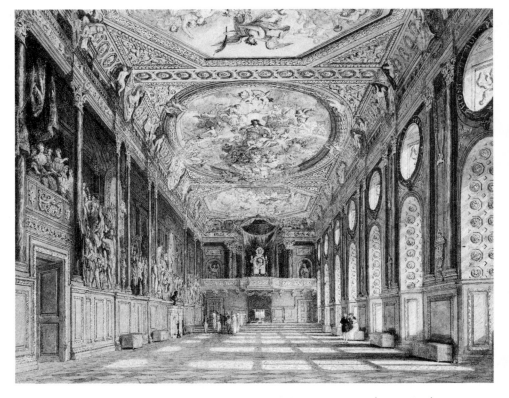

FIGURE 6.22. St George's Hall, Windsor, murals by Antonio Verrio (watercolour).
Royal Collection Trust / © Her Majesty Queen Elizabeth II 2021.

nineteenth century. The iconography has been expertly reconstructed by Katherine Gibson; I shall pick out only those aspects that relate to celestial aspirations. Against a trompe-l'oeil heaven, the king is seated on a rainbow, aligning the justice of the king with that of Christ the Judge,[54] a Christological allegory that was continued in the frescoes in the King's Chapel, whose ceiling bore the *Resurrection of Christ*, in parallel to the *Apotheosis* of the king on the ceiling of St George's Hall. Above the king's head shines the *sidus Carolinum*, the star that shone at Charles II's birth in 1630.[55] The viewer

54. Cf. the 'Rainbow Portrait' of Elizabeth I, possibly also associating the queen with Christ as universal ruler and judge (so Sharpe 2009: 385).

55. The Star Chamber at Windsor bore on its ceiling a representation of the *sidus Carolinum* twelve feet in diameter (Colvin 1976: 317). See also ch. 2: n. 101.

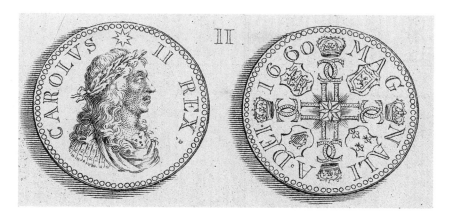

FIGURE 6.23. Medal struck for coronation of Charles II, with the *sidus Carolinum*. *The Works of Edmund Waller* (London, 1730) (p. cxxii and folding plate at rear), detail. By permission of the Master and Fellows, Trinity College, Cambridge.

might think both of the star that shone at the birth of Christ, and of the *sidus Iulium*, the comet that appeared at the death of Julius Caesar and which was taken as a sign of his apotheosis (see ch. 2: 66): a medal struck at the Restoration shows the profile head of Charles with the star above (Fig. 6.23), reminiscent of Augustan coins showing the head of Divus Julius with a star.[56] In St George's Hall, below the king, Justice and four other Virtues triumph over hellish monsters, Rebellion, Faction, Sedition and a seven-headed hydra tumbling downwards. The schematic opposition of good and evil is given a specifically British inflection in the group, behind the throne, of Saint George defeating the dragon.[57]

In *The Restoration of the Monarchy* (mid-1670s), on the ceiling of the King's Withdrawing Room at Windsor (Fig. 6.24),[58] the king rides through the sky in the chariot of the Sun. Here he is privileged passenger, not impersonation, of the Sun, who drives his chariot towards the other Olympian gods, with the Arts and Sciences in the clouds behind. Again, a cosmic contrast between heaven and hell is expressed in a classical vocabulary: as the king soars through the sky towards Olympus, Hercules beats down the forces of evil with his

56. E. Fenton (ed.), *The Works of Edmund Waller, Esq; in Verse and Prose* (London, 1730), cxxii and folding plate at rear.

57. Alluding to Rubens's *Landscape with Saint George and the Dragon* (Royal Collection), in which George bears the features of Charles I.

58. Etching by Peter Vandrebanc (Vanderbank).

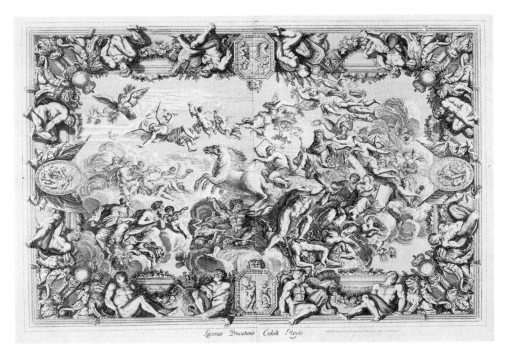

FIGURE 6.24. Peter Vandrebanc, engraving after Antonio Verrio,
The Restoration of Charles II, ceiling of the King's Withdrawing Room, Windsor Castle.
© The Trustees of the British Museum.

club.[59] The composition is very closely related to Le Brun's painting of Louis
XIV's *Passage of the Rhine* in the Galerie des Glaces at Versailles (Fig. 6.25):
surprisingly, the evidence suggests that Le Brun borrowed from Verrio, not
the other way round.[60]

59. Another image of royal victory over a malignant force of evil is the relief on the base of
the Monument to the Great Fire of London, an *Allegory of the Great Fire of London* (Cajus Ga-
briel Cibber, 1671–77), on which Charles II steps on a demon of fire, identified with Envy in a
later engraving (BM 1880, 1113.3869): see Sharpe 2013: 125–26.

60. So Croft-Murray 1954; 1962: 55; followed by Solkin 2015: 10, although De Giorgi suggests
(2009: 106) that Verrio draws on Le Brun (without offering evidence). In *The Passage of the
Rhine*, Louis XIV brandishes the thunderbolt of Jupiter as his chariot charges across the Rhine;
behind the chariot Hercules menaces the river-god of the Rhine with his club. Whether or not
Le Brun borrowed from Verrio, the image of a Jovian Louis hurtling across the river in a chariot
draws on earlier images at Versailles of Apollo, or Louis-as-Apollo, driving the solar chariot,
such as Joseph Werner's painting of Louis XIV as Apollo driving the chariot of sun (1662–67;

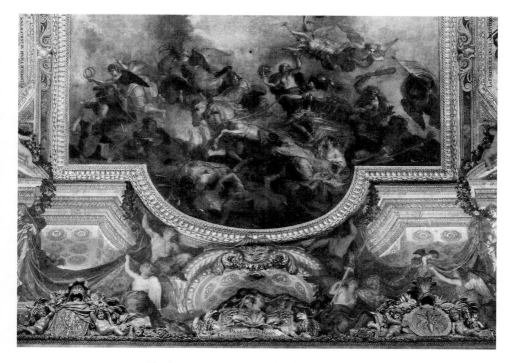

FIGURE 6.25. Charles Le Brun, *Le Passage du Rhin en présence des ennemis, 1672,*
Galerie des Glaces, Versailles. Photo © RMN-Grand Palais (Château de Versailles) /
Gérard Blot/Hervé Lewandowski.

In one of the surviving ceilings by Verrio at Windsor, in the Queen's Audi-
ence Chamber, Charles II's queen Catherine of Braganza also rides in a flying
chariot, travelling towards the Temple of Virtue (Fig. 6.26). Verrio's elevation
of Charles to a panegyrical divinity is clearly emulative of, and, apparently, an
inspiration for, the contemporary imagery of the monarch whom we today
tend to think of as *the* sun-king, Louis XIV.[61]

Palace of Versailles), or a medal of 1661 showing the sun-god in his four-horse chariot, an em-
blem of the king's constant presence in his councils (illustrated in Wellington 2015 at 206). Sa-
batier shows (2016) that the Apolline imagery of Louis as sun-king of the earlier part of his reign
was superseded by a concentration on the image of the king himself as embodiment of the state.
Louis appears elsewhere in a Jovian role in the Galerie des Glaces, in *The Capture of the Town
and Citadel of Ghent in Six Days, 1678,* in which the king, borne aloft by the eagle of Jupiter,
brandishes the thunderbolt.

61. For sun-king imagery in the anonymous text of John Blow's 'Up, Shepherds, Up', prob-
ably performed at Windsor for the birthday of Charles II in 1689, see Pinnock 2015: 202–4.

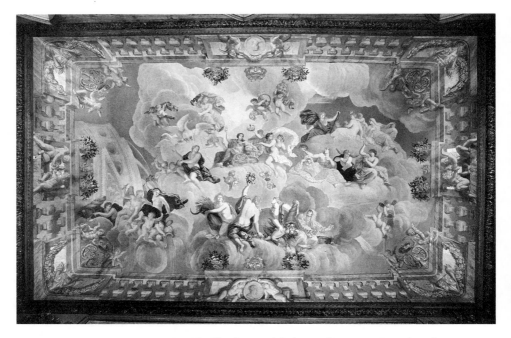

FIGURE 6.26. Antonio Verrio, *The Glorification of Catherine of Braganza*, Queen's Audience Chamber, Windsor. Royal Collection Trust / © Her Majesty Queen Elizabeth II 2021.

Charles's descent from the heavens in the company of Astraea is finally matched, after his death, with his ascent to the sky in Dryden's libretto for *Albion and Albanius*. This is the first full-length English opera to survive, and one which draws on the traditions of the earlier Stuart masque, with its descents and ascents (see above: 279).[62] Furthermore, *Albion and Albanius* and Dryden's opera *King Arthur*, for which *Albion and Albanius* was originally intended as a prologue, are both closely related to the iconography of Verrio's murals at Windsor. The finale to *Albion and Albanius*, added after the death of Charles II in 1685, stages the descent from heaven of Phoebus Apollo to announce that Albion (Charles II) must change his earthly seat for a place in the zodiac: 'Betwixt the Balance and the Maid, / The Just, / August, / And peaceful shade, / Shall shine in Heav'n with beams display'd, / While great Albanius [the Duke of York, and now James II] is on Earth obeyed' (Dryden 1976, p. 51). The place in the constellations is that envisaged by Virgil for the

62. See Hammond 1984.

future apotheosis of Octavian at *Georgics* 1.32–35, between Erigone (Virgo) and the 'Claws' of Scorpio, another name for Libra (see ch. 2: 67). Dryden footnotes the Virgilian source in the epithet 'August', alluding to Octavian's future name 'Augustus'.[63]

The Glorious Revolution. The Painted Hall, Greenwich

Following the accession of William and Mary, after the 'Glorious Revolution' and the strict imposition of the Test Act, the Roman Catholic Verrio lost his post as chief painter to the king, and turned back to his aristocratic patrons. But he returned to royal service, and worked at Hampton Court for William III and Queen Anne between 1700 and 1705. His most ambitious project there, the King's Staircase, is a complex allegorical scheme that deploys a narrative about the possibility of an ascent to heaven in the service of a Williamite political message (Fig. 6.27). It is based closely on an unusual classical text, *The Caesars*, a Menippean, or Lucianic, satire written in Greek by the Roman emperor Julian the Apostate. At the Saturnalia (Greek *Kronia*) the deified Romulus invites the gods and the emperors to a banquet. The gods dine at a table at the zenith of the heavens, while a table is prepared for the emperors just below the moon in the upper air. After the Roman emperors have trooped on, the deified Hercules asks why Alexander the Great has not been invited as well. There follows a contest between five of the emperors and Alexander, in which each argues for his own merits. Marcus Aurelius is the winner, on the basis that he is the wisest.

In Verrio's painting, Alexander the Great, accompanied by a flying Victory, appears to be the winner. Banks of cloud ascend diagonally towards the empty table in the upper sublunary region, on the left from the figure of Alexander,

63. For other visual and textual representations of the apotheosis of Charles II, cf. Parmentier's miniature of the apotheosis of Charles II (n. 49 above); and 'A Paean, or Song of Triumph, on the Translation and Apotheosis of King Charles the Second, by my Ld. R[adcliffe]', in *Examen poeticum, Being the Third Part of Miscellany Poems* ['Tonson's Miscellany'] (London, 1693): 'Good kings are number'd with immortal gods, / When hence translated to the blest abodes; / For princes (truly great) can never die, / They only lay aside mortality; / So Charles the Gracious is not dead, / But to his kindred stars is fled; / There happy, and supremely blest, / With mighty Jove, his sire does feast. / See how with majesty divine, / And dazzling glory, his bright temples shine: / He now an equal god, by gods is crowned, / With golden harps and trumpets sound, / And to his health the nectar-bowl goes round; / Celestial concerts Io-Paean sing / And heavn's grand chorus makes Olympus ring' (pp. 260–61; cited in Gibson 1998).

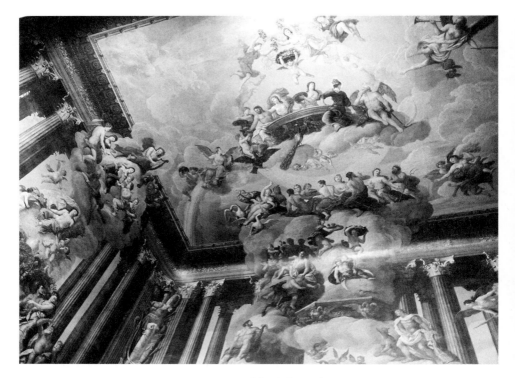

FIGURE 6.27. Antonio Verrio, *Banquet of the Gods*, King's Staircase, Hampton Court.
© Historic Royal Palaces.

and on the right above the group of emperors. The clouds support, on the left, Hercules, the advocate for Alexander, and, on the right, the deified Romulus, the advocate for the emperors. The exact political-allegorical meaning of all the details is debated, but it is clear that Alexander is a figure for William III, whose favourite emblems were the lion and the lion-slaying Hercules.[64]

One effect of taking Julian's *The Caesars* as the text for the programme of the King's Staircase is that the celestial ambition of Alexander and the emperors is limited to the table set out at the summit of the sublunar region, painted at the top of the long wall of the staircase, and cannot aspire to the high table of the Olympian gods, which is painted on the ceiling, against a brilliant blue

64. Edgar Wind's learned article (1939/40) situating the programme of the Verrio painting within a Protestant tradition, associated with the first and third Earls of Shaftesbury, of seeing in Julian a revolutionary figure and a philosophical symbol of emancipation has not been universally accepted. For a recent assessment, see Dolman 2009/10.

sky, and framed by the circle of the zodiac, an example of the banquet of the gods that is a theme of numerous baroque ceilings. This lofty space is beyond the reach of any mortal, be they royal or commoner, who ascends the King's Staircase.[65]

No such textual restraint holds back the iconography of my last example of the celestial aspirations of the British monarchy on a painted ceiling. The ceiling of the Painted Hall of the Royal Hospital at Greenwich exploits, for William and Mary, the unabashed iconography of cosmic kingship that had been used to celebrate the earlier Stuarts (Fig. 6.28). Set within a larger cosmic symbolism, it continues the rivalry with France, and is also implicated in an emulative comparison and contrast between successive occupants of the British throne. Sir James Thornhill's ensemble of interiors in the Painted Hall at Greenwich, the ceiling of the Lower Hall (1707–14) and the ceiling and walls of the Upper Hall (1717–26), celebrates the 'Glorious Revolution' of 1688 and the Protestant monarchy of William and Mary, Queen Anne (1702–14) and the first Hanoverian king, George I. Thornhill pointedly diverts the iconography of the absolutist Stuarts, from James I to James II, to the service of the new, non-absolutist monarchy, one which serves the people of Great Britain.[66]

One has the impression that Thornhill conceived the programme as a kind of corrective *summa* of Stuart iconography of the celestial and cosmic aspirations of the monarch, perhaps even checklisting Elizabethan panegyric in an allusion to Virgil's fourth *Eclogue*.[67] Elizabeth was, after all, born at Greenwich,

65. Staircases to the heavens: Burchard suggests (2016: 228–31) that the sunlight that flooded through the skylight of the Escalier des Ambassadeurs at Versailles had an Apollonian symbolism, and that the ascent of the staircase was simultaneously an ascent towards Apollo-Sun-Louis XIV. Stephan suggests (1997: 79ff.) that the apotheosis of Hercules painted in Prince Eugene of Savoy's staircase (1696–1701) at his Winter Palace in Vienna (arguably erected in response to the Escalier des Ambassadeurs) made of the ascent of the staircase an imitation of the hero's ascent to the celestial sphere.

66. Compare the argument in Williams 1981, that after the constitutional revolution of 1688 poets such as Charles Montagu, Joseph Addison and Matthew Prior found ways of accommodating the verse panegyric tradition of the pre-1688 Stuarts to the new political and social conditions.

67. Elsewhere *Eclogue* 4 is cited: for example, in Kneller's portrait *William III on Horseback* (1701, now at Hampton Court; Stewart 1983: 54): above the king's head a putto holds a scroll bearing the inscription 'Pacatumque reget patriis uirtutibus orbem' (*Ecl.* 4.17): see Sharpe 2013: 415–16; ibid. 436, on a medal of William and Mary, with on the reverse a statue of the king holding a sword and a model of a church, with 'Caelo delabitur alto' (a variation of *Ecl.* 4.7: 'caelo demittitur alto').

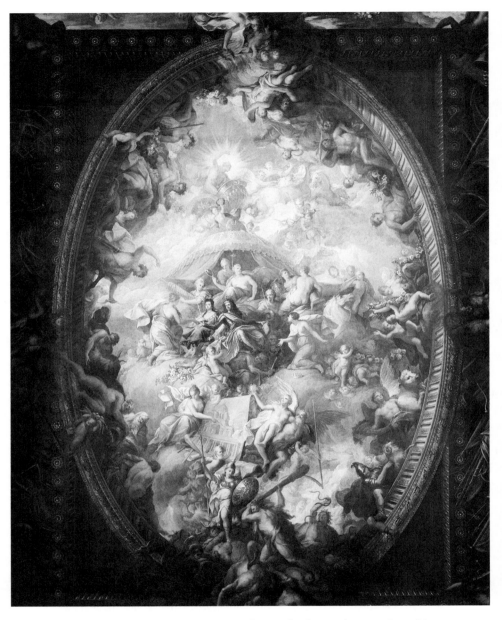

FIGURE 6.28. James Thornhill, *The Glorification of William and Mary*, ceiling of the
Painted Hall, Greenwich. © James Brittain / Bridgeman Images.

and it was an inevitable panegyrical turn to compare Queen Mary, and then Queen Anne, to Elizabeth.[68] In terms of composition and style, Thornhill, like Verrio, is more immediately influenced by the panegyrical schemes for Louis XIV masterminded by Charles Le Brun than by Rubens's work for the English court, which was a continuation of Rubens's own cycle for the earlier French court of Maria de' Medici. The design of the Greenwich ceiling, with its vast central panel, subsidiary panels at either end, and *quadratura* (illusionist architectural painting) effects, is closer to the great Roman ceilings of Cortona (*The Triumph of Divine Providence* in the Palazzo Barberini, 1633–39), Gaulli (*The Triumph of the Name of Jesus* in the Church of the Gesù), and Pozzo (*The Apotheosis of Saint Ignatius* in Sant'Ignazio, 1688–94), than it is to the nine compartments of Rubens's panelled ceiling. It seems likely, however, that Thornhill was engaged in some kind of competitive relationship with Rubens as a royal painter and iconographer.[69] As celebration of royal power, the Painted Hall at Greenwich might have been seen as an alternative to or replacement for the Banqueting House, whose importance will have been lessened after the destruction by fire of most of the Palace of Whitehall in 1698.[70] The Banqueting House had recently played a central role in the accession of William and Mary to the British throne, for it was there that the speaker of the House of Lords made 'a solemn tender of the Crown' to Prince William of Orange and his consort Princess Mary Stuart on 13 February 1689.[71] Furthermore, *The Glorification of William and Mary* decorates the ceiling not of a royal banqueting chamber, but of a space designed as the eating-place of commoners: pensioned heroes of their nation's navy (even if it was in the event deemed too magnificent for that purpose, and never regularly used as such). Queen Mary's conversion, in 1692, of the King Charles wing of Greenwich Palace into a naval hospital may itself make a point about the self-representation of the new constitutional monarchy, in contrast to the monuments of its absolutist

68. Queen Mary compared to Elizabeth I: Williams 2005: 121; Queen Anne compared to Elizabeth: ibid. 137 n. 4 (e.g., by taking over Elizabeth's motto 'Semper eadem'); see also Carretta 1983: 1–19, 'Anne and Elizabeth: The Poet as Historian and Painter in *Windsor Forest*'.

69. See Balakier and Balakier 1995: 82–84 on the baroque oval shared by Rubens and Thornhill, with further speculation on Keplerian and Newtonian planetary ellipses, and William and Mary as the centre of gravity in the Greenwich oval. Balakier and Balakier put forward an extreme reading of the ceiling as Newtonian astronomical allegory, reclaiming the French sun-king metaphor for British purposes.

70. After which the Banqueting House was converted to the Chapel Royal.

71. See Martin 2011: 177.

Stuart predecessor. The grandiose expansion of the Hospital with buildings by Wren, Hawksmoor and Vanbrugh was perhaps seen as a realization of the unrealized designs of Inigo Jones and Wren for Whitehall.

If Thornhill was entering a contest of images with Inigo Jones's great building in Whitehall, the ceiling of the Painted Hall perhaps also referred to the painted ceiling of another Inigo Jones building much closer at hand, the Queen's House at Greenwich, the ceiling of whose main hall was decorated with *Peace Reigning over the Arts and Sciences* by the Caravaggist Orazio Gentileschi, Henrietta Maria's favourite artist (now in Marlborough House in London) (Fig. 6.29).[72] On the central circular field, Muses and Arts are seated on clouds in pronounced *di sotto in su*, with Peace soaring above in the centre, and in a line with Victory beneath her. At either end of Thornhill's ceiling are galleries 'in which are the several Arts and Sciences relating to Navigation',[73] practical arts and sciences of direct use to the British people both in winning naval victories and in the commercial pursuits of peace.

If this is on the right lines, the grand pretensions of the glorification of the constitutional monarchs William and Mary are justified by a contest of images with the ceilings commissioned by Charles I at Whitehall and Charles II at Windsor. For this kind of war of images, one might compare, generally, the image contests engaged in by Octavian and Antony in the years leading up to the battle of Actium, in the course of which Octavian seems to have appropriated for himself Antony's self-identification with Hercules.[74]

William and Mary are placed under a canopy of state in the centre of a brightly lit sky in which we look up to the radiant figure of the sun-god Apollo driving his four white horses on his course through the zodiac, whose signs are represented by the fully modelled figures in the circumference of the oval, above the balustrade painted in *quadratura*. This is a powerful—and traditional—image of *cosmos* and *imperium*. Many years ago, when I was writing my first book, *Virgil's 'Aeneid': Cosmos and Imperium*, I visited the Painted Hall for the first time, and was struck by the parallels between the iconography of Thornhill's ceiling and the patterns I was concerned to analyze in the *Aeneid*. So, good rule and the salvation of the nation are rewarded with a place in the

72. On Laguerre's incorporation of the Gentileschi ceiling into the iconography of his celebration of the Duke of Marlborough at Marlborough House, see Hamlett 2016: 201.

73. According to Thornhill's own 'An Explanation of the Painting in the Royal Hospital at Greenwich' (?1730), sold for 6*d* by the porter of the Hospital.

74. See Zanker 1988.

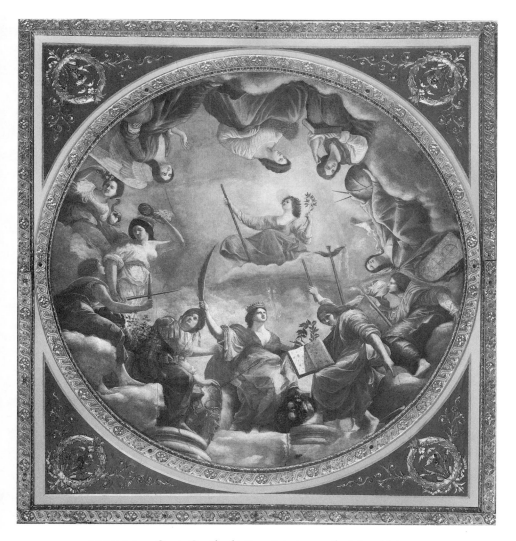

FIGURE 6.29. Orazio Gentileschi, *Peace Reigning over the Arts and Sciences*,
originally on ceiling of the Queen's House, Greenwich. Royal Collection Trust /
© Her Majesty Queen Elizabeth II 2021.

sky. The rulers are associated with the sun-god: on the Virgilian Shield of Ae-
neas, Augustus is seated on the threshold of the gleaming temple of Apollo, as
a sun-king (see ch. 2: 77–78). Thornhill's radiant Apollo may be a polemical
allusion to the most famous sun-king, Louis XIV, whose French have been
defeated by British armies. This is a contest of images not just between William

and Mary and the earlier Stuart monarchs, but also between British and French glorifications of kingship.

Virgil's epic and Thornhill's Greenwich ceiling each contain a narrative of war leading to peace: in the two painted galleries at either end of the ceiling of the Lower Hall are the sterns of a British man of war and a captured Spanish ship, alluding to British naval victories; and it was at the sea-battle of Actium, one of the climactic images in Virgil's survey of Roman history on the Shield of Aeneas in *Aeneid* 8, that Octavian/Augustus decisively defeated Antony and Cleopatra. In Richard Steele's description of the central image of the Greenwich ceiling, 'King William presents peace and liberty to Europe, and tramples on tyranny . . . expressed by a French personage'.[75] The brightness of the sun-god, at the upper end of the oval, making his orderly journey round the circuit of the zodiac, is contrasted with the dark and turbulent scene at the bottom end, where Pallas and Hercules destroy Calumny, Detraction and Envy and other vices,[76] 'which seem to fall to Earth, the place of their natural Abode', as Richard Steele puts it, but who we might rather think of as being cast deeper still, into the pit of hell. Compare the enforced fall of demons and vices in the baroque ceilings of churches in Rome, and in Streater's Sheldonian ceiling; and, in the *Aeneid*, compare the recurrent allusions to the Olympian gods' defeat of Titans and Giants, or Hercules's gigantomachic vanquishing of the monster Cacus in *Aeneid* 8.[77] The cosmic allegory is reinforced by the presence

<hr />

75. Richard Steele, *The Lover*, Tuesday 11 May 1714: the description has the Virgilian epigraph 'Animum picturâ pascit' (He feeds his mind on the picture) (*Aen.* 1.464).

76. Hercules's presence is all but inevitable in such contexts (see ch. 2: 77–78); for William III as Hercules, see Baxter 1992.

77. For examples of Virgilian plots and images of hellish disturbance overcome, cf. Pope, *Windsor-Forest* 412–20 (consequent on peaceful British naval empire, alluding to *Aen.* 1.294–96; *Geo.* 3.37–39): 'In brazen bonds shall barb'rous Discord dwell: / Gigantic Pride, pale Terror, gloomy Care, / And mad Ambition, shall attend her there: / There purple Vengeance bath'd in gore retires, / Her weapons blunted, and extinct her fires: / There hateful Envy her own snakes shall feel, / And Persecution mourn her broken wheel: / There Faction roar, Rebellion bite her chain, / And gasping Furies thirst for blood in vain' (see Carretta 1983: 12–18 for an extended comparison of the textual and visual programmes of *Windsor-Forest* and the Greenwich ceiling). John Dennis's *A Poem on the Battel of Ramellies, in Five Books* deploys a Virgilian-Cowleyan-Miltonic machinery of an assembly of devils called by a very Miltonic Satan, followed by the descent of Discord disguised as the mistress Maintenon to Louis XIV; order is restored when 'Thus Discord and the Gaul were forc'd to yield / To Marlb'rough and to Union's Sacred Pow'r'. For an example of the highly Virgilian image of Gigantomachy for the defeat of the enemy, cf. John Hughes, *The House of Nassau* (London, 1702), a panegyrical ode on the death

in the four great angles of, in the words of Thornhill's 'Explanation', 'the four Elements, Fire, Air, Earth, and Water, . . . offering their various productions to King William and Queen Mary'. At one end of the oval, an epic Fame 'descends, sounding the praise of the royal pair'.[78]

But this is a cosmos obedient to the rulers in specifically British ways. Virgil's *Aeneid* opens with a violent storm that threatens to shipwreck the hero Aeneas, and from which he is saved by the intervention of Neptune, whose calming of the waves is also an image of the Roman statesman's ability to control political disorder. Britannia's rule over the waves is of a more literal kind. Entry to the Painted Hall is under a dome on which are painted the four winds, disposed around, at the centre, 'a compass, with its proper points duly bearing' (in Thornhill's words). The compass, and the visual containment within the circle of the cupola, form a prefatory image of Britannia's power over wind and wave. Britain commands the seas through her military and mercantile navies, and she commands the skies through the genius of her scientists, whose observations and discoveries are in turn put to the service of Britannia's rule over the waves. In front of the Naval Hospital flows the Thames, highway for warships and merchantmen, and behind it rises the hill on which sits the Royal Greenwich Observatory. This is a place where the sea meets the heavens, and British trade meets British science, providing a ceiling over the heads of the heroes who have defended the British empire. John Flamsteed, the first astronomer royal, is depicted on the ceiling, in the gallery at the lower end of the hall, to the right of the stern of the Spanish galley, demonstrating his mastery of the heavens as he 'holds the construction of the great eclipse which happened April the 22nd, 1715'. Flamsteed is assisted by his disciple Thomas Weston 'in making observations, with a large quadrant . . . of the moon's descent upon the Severn', calculations to predict, and so master, the dangerous Severn Bore (Fig. 6.30).

of William III: 'That glory to a mighty Queen remains, / To triumph o'er th' extinguished foe. / She shall supply the Thunderer's place; / As Pallas from th' aetherial plains / Warr'd on the Giants impious race, / And laid their huge demolish'd works in smoky Ruins low. / Then ANNE's shall rival Great ELIZA's reign, / And William's genius with a grateful smile / Look down, and bless this happy Isle, / And peace restor'd shall wear her olive crown again.' (402–11).

78. For a textual analogue to the cosmic symbolism of the ceiling, cf. Thomas Shadwell, *Congratulatory Poem on His Highness, the Prince of Orange His Coming into England* (1689), where the Revolution is figured as cosmogony: 'When undistinguish'd in the mighty mass, / And in stagnation universal matter was / . . . Let there be light, th' almighty fiat run; / No sooner 'twas pronounc'd, but it was done' (cited in Williams 2005: 98).

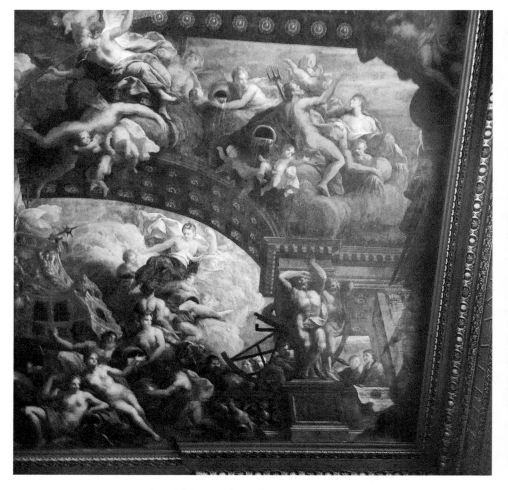

FIGURE 6.30. James Thornhill, lower gallery of the ceiling of the Painted Hall, Greenwich. Photo Philip Hardie.

On the left side of the gallery are three figures who embody a genealogy of the new astronomy culminating in Isaac Newton: Tycho Brahe, Copernicus, and 'an old philosopher pointing to some remarkable mathematical figures of the incomparable Sir Isaac Newton'. One might compare (generally) the association in Manilius's *Astronomica* of intellectual control of the sky, and the deified Augustus's rule over the heavens (1.799–804); or Ovid's conceit connecting imperial apotheosis and astronomy in the person of Julius Caesar, at *Fasti* 3.159–60 (Julius Caesar): 'he wished to learn in advance about the heavens promised to

him, and not enter as a stranger god mansions unknown to him' (promissumque sibi uoluit praenoscere caelum / nec deus ignotas hospes inire domos).

A Newtonian cosmos is also one of predictable regularity, in which the heavenly bodies are kept in their places, and the powers even of a sun-king are bounded. One of the most important of the poems written in honour of Newton on his death in 1727 is 'The Newtonian System of the World' by Jean-Théophile Desaguliers, a colleague of Newton's, addressed to George II.[79] In this poem, Desaguliers spins out of Newton's gravitational model an allegory of constitutional monarchy. The rousing climax (180–88) celebrates 'the people's joys' at a time

> When majesty diffusive rays imparts,
> And kindles zeal in all the British hearts,
> When all the powers of the throne we see
> Exerted, to maintain our liberty:
> When ministers within their orbits move,
> Honour their king, and shew each other love:
> When all distinctions cease, except it be
> Who shall the most excel in loyalty[.][80]

So far this has been a comparative study of *cosmos* and *imperium* in the *Aeneid* and the Greenwich ceiling. When we move from the Lower Hall to the Upper Hall, Virgilian references become explicit. This is another scheme

79. See Boutin 1999; also Nicolson 1946: 135–36.

80. On Desaguliers and political metaphor see (briefly) Williams 2005: 187; Connell 2016: 192; Robertson 2020: 62. Connell uses the term 'cosmic whiggism' of this kind of thing (187–97, 'Cosmic Whiggism in *The Seasons*'). Examples of the political metaphor of heavenly bodies in Young's *Night Thoughts*: 9.698–705, on the political lessons of the heavenly bodies: 'The planets of each system represent / Kind neighbours; mutual amity prevails; / Sweet interchange of rays, received, return'd; / Enlightening, and enlighten'd! All, at once, / Attracting, and attracted! Patriot-like, / None sins against the welfare of the whole; / But their reciprocal, unselfish aid / Affords an emblem of millennial love'; 9.1158–67: 'More obvious ends to pass, are not these stars / The seats majestic, proud imperial thrones, / On which angelic delegates of Heaven, / At certain periods, as the Sovereign nods, / Discharge high trusts of vengeance or of love; / To clothe, in outward grandeur, grand design, / And acts most solemn still more solemnize? / Ye Citizens of air! what ardent thanks, / What full effusion of the grateful heart, / Is due from man indulged in such a sight!' Cf. also Pope, *Essay on Man* 2.65–66 (man if not guided by Reason's comparing balance): 'Or, meteor-like, flame lawless thro' the void, / Destroying others, by himself destroy'd'. On the application of Newtonian physics to the moral and political worlds, see McKillop 1942: 34–36.

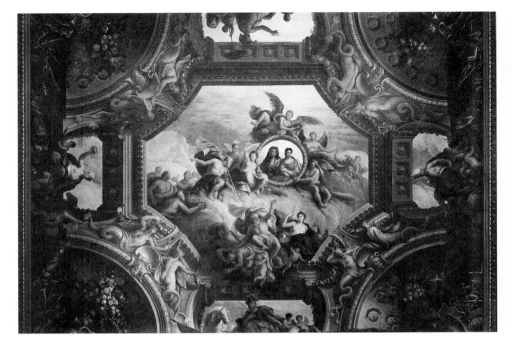

FIGURE 6.31. James Thornhill, ceiling, Upper Hall, Greenwich.
© James Brittain / Bridgeman Images.

which combines *cosmos* and *imperium* with figurative apotheosis. This time, the rulers borne in the sky, on the ceiling of the Upper Hall, are Queen Anne and Prince George of Denmark, but in artistic representation rather than bodily presence, in another example of the device of the medallion portrait, supported by Hercules (Virtue Heroic) and Concord Conjugal, seated on rolling clouds, with clear skies expanding above (Fig. 6.31). Neptune is shown surrendering his trident to (the portrait of) Prince George, lord high admiral of the British seas, possibly an allusion to Verrio's *Sea-Triumph of Charles II*. In the covings of the ceiling are the four 'quarters' (continents) of the world, Europe, Asia, Africa and America, 'admiring our maritime power'.[81] Below, 'Juno or the air, with Aeolus, god of the winds, are commanding a calm'. This is an

81. The four continents (or quarters of the globe) are a frequent feature in visual panegyrical programmes, pointing to the worldwide pretensions of the power celebrated: for example, Verrio's ceiling in the King's Presence Chamber at Windsor depicted a portrait of Charles,

inversion of the first episode of the *Aeneid* in which Juno persuades Aeolus to unleash the storm winds against Aeneas and his ships. This is a Juno now obedient to her husband Jupiter, reflecting the conjugal concord of Anne and George. The poses of the winds shown in shadow beneath Aeolus are reminiscent of the familiar image of vices or devils cast down from the heavens: for example, the group of Hercules and Pallas casting down vices in the Upper Hall—henceforth the winds will be confined to their subterranean cavern. The group of Aeolus and the winds also refers back to the very beginning of the iconographic programme, the paintings in the cupola at the entrance to the Lower Hall of a compass, with the four winds arranged around it in orderly fashion according to the four points of the compass.

Descent of a more benevolent kind is represented on the 'Great Front' (back wall) of the Upper Hall (Fig. 6.32), which shows the descent of Mercury,[82] pointing up to the Virgilian motto in the frieze 'Iam noua progenies caelo', referring to the descent of the mysterious child in Virgil's fourth *Eclogue* (7). Below, a curtain is drawn to reveal George I sitting and leaning on a terrestrial, not a celestial, globe. Providence descends to put a sceptre in his hands, and above George is another figure of returning descent, Astraea with the scales, and another motto from *Eclogue* 4: 'Iam redit et uirgo' (6). Various members of the royal family appear in the persons of mythological figures. At the top of the composition is a figure holding a pyramid, signifying stability or the glory of princes (according to the 'Explanation'), but also a sky-aspiring symbol of fame and immortality. This allegorical pyramid is balanced by a real building, the dome of St Paul's, now the actual completed building, in contrast to the plan, or Platonic idea, of the cupola of the Hospital that is unrolled in the heaven of the Lower Hall. St Paul's itself is a symbol of return and restoration after the Great Fire. Trompe l'oeil curtained steps descend to the real-world Upper Hall, whither we have ascended from the Lower Hall. Finally, we come upon the painter Thornhill, creator of this fantasy world, and gatekeeper

surrounded by palm-fronds, displayed by Mercury to the four quarters of the globe. In general, see Poeschl 1985.

82. Cf. the flying figure of Mercury, the messenger of royal *renommée*, linking the two sides of the central panel in the Galerie des Glaces, *Le roi gouverne par lui-même*, and *Faste des puissances voisines de la France*. Above Louis to the left is the chariot of Apollo, preceded by Aurora and Daybreak (a child with a star over his head), coming from the heights of the clouds to illuminate 'les grands actions' of Louis (*Mercure galant*, December 1684).

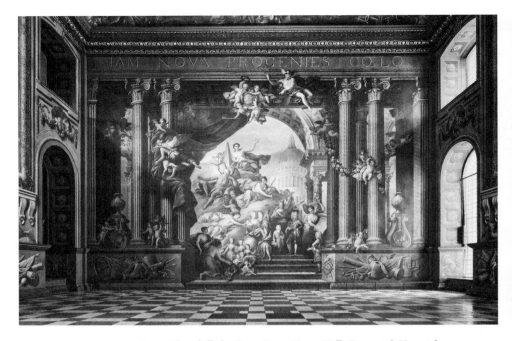

FIGURE 6.32. James Thornhill, the Great Front, Upper Hall, Greenwich Hospital.
© James Brittain.

between the worlds of reality and art. Thornhill looks outwards to the viewer, his right hand held in an elegant gesture to invite us into his imaginary world. The side walls of the Upper Hall are also about grounding and landing, with their balancing scenes in *grisaille* of the landings in England of William of Orange (at Torbay in 1688) and George of Hanover (at Greenwich in 1714).

Richard Johns convincingly reads the programme of the Upper Hall as reflecting on the ending of an age when British monarchs could appropriately be celebrated in the grandiose, and sublime, forms of baroque apotheosis:

The conventions of bodily deportment, gesture and dress that inform this image of the king and his family belong not to the celestial world of baroque allegory, but to the earthbound, interior realm of dynastic family portraiture . . . [but] by turning to the conventions of portraiture as the best way of asserting the Hanoverian presence in the final scene at Greenwich, Thornhill [also] anticipated the decline of the kind of theatrical decoration that he had painted on the lower hall ceiling twenty years earlier. Once the image of monarchy had descended from the ceiling, grounded by

the certainty of a healthy progeny on earth, there was neither the need nor the opportunity for it to return. Thornhill had done his job.[83]

There is other evidence that an investment in the sacral nature of kingship still mattered for Queen Anne, but not for her Hanoverian successor.[84]

Country Houses

By the 1720s, the fashion for baroque mural and ceiling painting was waning not just in royal palaces and foundations, but more generally across Britain, as more restrained modes of decorative scheme accompanied the switch in architectural fashion from the baroque to the Palladian neoclassical. Pope satirizes the pretentious ceiling paintings of Verrio and Laguerre in his 'Epistle' to Lord Burlington (1731), the high priest of the Palladian movement (see ch. 5: 205). But prior to this seismic shift in taste, the classical vocabulary of celestial aspirations had been liberally splashed across the ceilings of the houses of the aristocracy and the wealthy. I end this chapter with a selection.[85]

The skies open, and the gods await, to receive the apotheosis of heroes ancient and modern. The apotheosis of Hercules is very popular in late baroque art both on the continent (notably in François le Moyne's work for Louis XV in the Salon d'Hercule at Versailles (1736)) and in Britain. The Dutch artist Jacob Jacobsz de Wet II's *Apotheosis of Hercules* (1675) was commissioned by Sir William Bruce for King Charles II's bedchamber at the Palace of Holyroodhouse in Edinburgh (Fig. 6.33). Model for a king, Hercules is also the model for a national hero, the Duke of Marlborough, in Thornhill's unrealized design for the apotheosis of Hercules for the ceiling of the Saloon at Blenheim Palace. In the event that ceiling was decorated with Laguerre's *Allegory of War and Peace*, in which the duke is seen stepping into a chariot to be borne

83. Johns 2004: 197, 205.

84. Smith 2009: 148: Anne's reign 'contained a strongly sacral element, one which links it to Charles II's and James II's monarchy—and severs it from George I's'. Verrio painted an *Apotheosis of Anne* as Astraea-Virgo on the ceiling of the queen's drawing-room at Hampton Court. See also Collins 1989; Burke 1992: ch. 9, 'The Crisis of Representations'. Williams concludes (1981: 67) that by 1714 'the unabashed mythologizing of earlier political verse had been thoroughly and explicitly discredited' (cited in Sharpe 2009: 36 in connection with the decline of the sacralization of representations of the monarch).

85. The starting-point for a survey of subjects on ceilings is still the catalogues in Croft-Murray 1962; 1970.

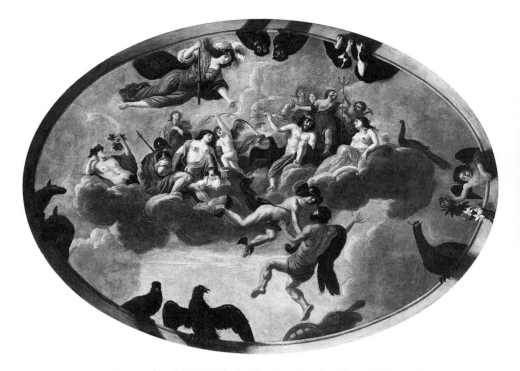

FIGURE 6.33. Jacobsz de Wet II, *The Apotheosis of Hercules*, Palace of Holyroodhouse.
Royal Collection Trust / © Her Majesty Queen Elizabeth II 2021.

aloft into the clouds (see Fig. 5.1). The eagle of Jupiter flies over his head, and
Peace clutches at the duke's right arm to restrain his further use of the sword.[86]
Hercules now has a merely supporting role, raising his club to subdue the
duke's enemies.[87] Verrio painted the labours and apotheosis of Hercules in the
'Great Room Above' in Montagu House, the London home (on the site of
what is now the British Museum) of Ralph Montagu, ambassador at the
French court. Montagu was responsible for inviting Verrio to England, and so
a major figure in the importation of continental tastes across the Channel. The
apotheosis of Hercules and his union on Olympus with Hebe, goddess of

86. The figure of Peace restraining the arm of Louis XIV as he wields his baton of command,
and the arm of an allegorical figure wielding a sword, appear on a sketch by Le Brun for a tap-
estry with the subject of 'Louis XIV subjecting a town': see Sabatier 1999: 279–81.

87. On the appropriation of the panegyrical imagery of Louis XIV for the celebration of the
Duke of Marlborough, see Wellington 2016.

youth, is the subject of the ceiling of the Great Hall of Montagu's country home, Boughton House, painted by Louis Chéron (c. 1705–7). Other ceilings at Boughton House show Ovidian mythological scenes unfolding against clouds opening out into the unbounded spaces of blue skies.[88]

The apotheosis of Romulus, for which the main source is Ovid's account in *Metamorphoses* 14 (see ch. 2: 79), is the subject of a sketch by Thornhill,[89] and of Verrio's ceiling in the Second George Room at Burghley House, in which Romulus is presented by his father Mars to Jupiter, who is accompanied by Ganymede and by the eagle which was the vehicle for Ganymede's elevation to heaven.[90] Hercules with his club and his wife Hebe sit nearby on a cloud: as in Ovid, Hercules's apotheosis has shown the way for later Roman apotheoses. 'Sic uirtus euehit ardens' (Thus blazing virtue raises [the hero] upwards) is inscribed on a scroll held by Mercury (a motto on one of the Alexander the Great tapestries designed by Le Brun for Louis XIV).

The apotheosis of Romulus's wife Hersilia, also narrated by Ovid (*Met.* 14.829–51), was painted by Thornhill in the Sabine Room at Chatsworth. Hersilia, faithful to her Roman husband, as opposed to her own Sabine family, has been read here as alluding to Queen Mary, loyal to her Protestant husband William II, as opposed to her father, the Catholic James II. The apotheosis of Julius Caesar, meanwhile, is the subject on the ceiling of the Painted Hall at Chatsworth, painted by Laguerre (Fig. 6.34).[91] Laguerre closely follows Ovid's account of the catasterism of Caesar in *Metamorphoses* 15: the bodily form of Caesar has just escaped from the embrace of Venus, seated in her swan-drawn carriage, and the transformation of his soul into a star is indicated by the bright star on his head, as Mercury presents the new god to Jupiter. Added to the Ovidian scene is the contrast, common in ceiling paintings, between the upwards motion of the apotheosis or glorification of the hero or saint, and the downwards motion of figures of evil thrust from the skies: Minerva and Justice drive out the naked bodies of the assassins and the figure of Envy; elsewhere in the pictorial field, Hercules brings down his club on other evil-doers and the Hydra, aided by Perseus brandishing the head of Medusa. But, as Richard Johns points out, any simple panegyrical equation (William Cavendish, first

88. See Marandet 2017.

89. Possibly for Hewell Grange; see Hamlett 2013.

90. *The Rape of Ganymede* is the central painting, by Verrio, on the ceiling of the Queen's Closet at Ham House.

91. Johns forthcoming.

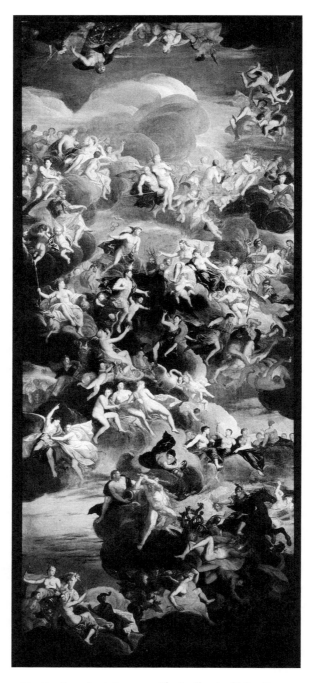

FIGURE 6.34. Louis Laguerre, *The Apotheosis of Julius Caesar* (ceiling in the Painted Hall, Chatsworth). © The Devonshire Collections, Chatsworth. Reproduced by permission of Chatsworth Settlement Trustees.

duke of Devonshire, or King William, as the hero rewarded with a place in the skies for virtuous deeds) is complicated by the sight that confronts the viewer who ascends the staircase to look back at the Hall, and sees the gruesome scene on the far wall of the murder of Caesar, at the base of the statue of Pompey the Great (which does not figure in the Ovidian narrative), prompting, perhaps, thoughts of the justified killing of a tyrant who had destroyed Roman liberty with the defeat of Pompey. The assassination is presided over by the figures of Pluto, Death aiming a spear at Caesar and the three Fates cutting the thread of his life, hinting at another destination than the heavens for the dead Caesar—the underworld.[92]

The wedding banquet on Olympus of Cupid and Psyche (see ch. 2: 35) is a frequent subject for paintings, usually on ceilings, in Renaissance and early modern Europe, offering a vista upwards from our earthbound existence into the bright heavens populated by the gods, and giving flesh to the fantasy that, like Cupid and Psyche, we might escape the cares and ordeals of our terrestrial lives to feast with the gods.[93] Famous examples include Raphael's painting on the ceiling of the Loggia of Cupid and Psyche in the Villa Farnesina, Rome (1517–18), and Giulio Romano's fresco in the Sala di Psiche, in the Palazzo del Te in Mantua. The Sala di Psiche forms a contrasting pair with the virtuoso trompe l'oeil Sala dei Giganti at the opposite corner of the garden façade: right and wrong ways of attempting to ascend to the heavens, each with a figure of Jupiter at the centre, respectively welcoming Psyche to heaven, and blasting down the monstrous Giants with thunderbolts (Fig. 6.35).[94] Cupid and Psyche

92. Cf. Lucan's savage comment on the effects of the battle of Pharsalus at *Civil War* 7.457–59: 'Civil war shall make deified emperors the equals of gods, and Rome will deck out spirits of the dead with thunderbolts and radiate crowns and stars, and in the temples of the gods will swear by shades', revealing the falsehood of the ideology of imperial apotheosis. But it might be noted that the presence of the Fates, at least, could be read as in line with the Ovidian account, as illustration of the references to the inviolable decrees of the Fates at *Met.* 15.780–81, 808–9.

93. For an example of the illusionistic invitation to the viewer, expressed in the language of rapture and amazement of the 'Whig sublime', see Thomas Tickell's description of Verrio's murals at Lowther Castle, painted in 1693 for John Lowther, first viscount Lonsdale, in his poem *Oxford* (1706) (addressed to the second viscount Lonsdale): 'Such art as this adorns your Lowther's Hall, / Where feasting gods carouse upon the wall, / The nectar, which creating paint supplies, / Intoxicates each pleas'd spectator's eyes, / Who view, amaz'd, the figures heav'nly fair, / And think they breath the true Elysian air, / With strokes so bold, great Verrio's hand has drawn / The gods in dwellings, brighter than their own' (cited in Hamlett 2020: 89).

94. Hartt 1958, 1: 126–40, 152–58. On the sublime imagery of the Sala dei Giganti, with its ceiling showing the gods assembled in the clouds under a Pantheon-like dome, a composition indebted to Correggio's church domes in Parma, see Etlin 2012: 254–58.

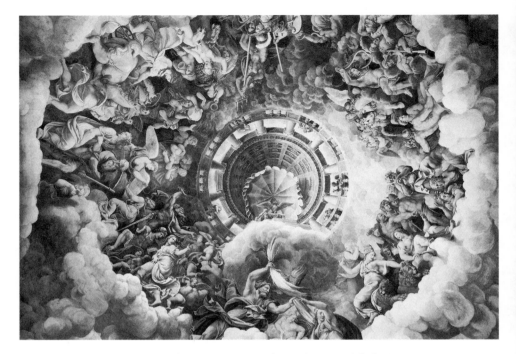

FIGURE 6.35. Giulio Romano, *Jupiter Blasting the Giants*, Sala dei Giganti, Palazzo del Te, Mantua. Photo © Raffaello Bencini / Bridgeman Images.

on Olympus is also a popular subject in England. Psyche's welcome in heaven is the subject of a sketch by Rubens (c. 1621–22), in which Mercury guides Psyche upwards to the throne of Jupiter, at whose feet Cupid, on bended knee, awaits his bride. The pronounced *di sotto in su* foreshortening suggests that this is a sketch for a ceiling painting, possibly an early design for the ceiling of the Banqueting House in Whitehall, in connection with the proposed match between the future Charles I and the Infanta of Spain.[95] The reception in heaven of Cupid and Psyche was painted by Verrio on the ceiling of the Great Drawing Room at Burghley House, and by Thornhill on the ceiling of the hall at Stoke Edith.

Even more popular than this subject of a mortal who is finally blessed with elevation to the company of the gods was that of Phaethon, a mortal who fell to earth through his presumption in aspiring to the skies (also a popular subject in the France of Louis XIV).[96] Scenes are taken from the beginning

95. See Donovan 2004: 117–18.
96. Bardon 1957: 406–7; Néraudau 1982: 326–27.

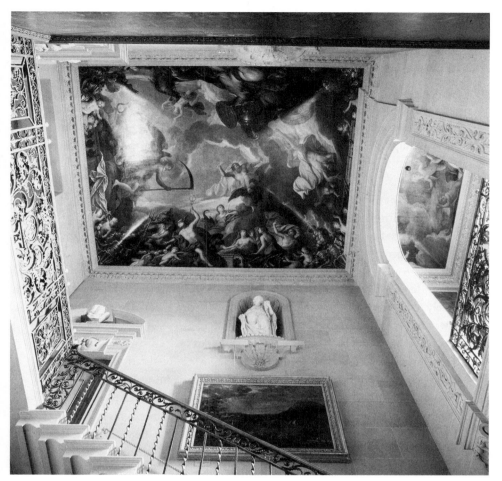

FIGURE 6.36. James Thornhill, *The Fall of Phaethon* (ceiling in the West Stairs, Chatsworth).
© The Devonshire Collections, Chatsworth. Reproduced by permission of
Chatsworth Settlement Trustees.

and ending of the story. On the ceiling of the Queen's Great Staircase at Windsor, Verrio depicted the Sun giving Phaethon permission to drive his chariot; scenes of the metamorphosis of Cycnus and of the Heliades, the sisters of Phaethon, below, showed the aftermath of Phaethon's disastrous fall. At Chatsworth, Laguerre depicted the Sun anointing the face of Phaethon to protect him from the solar heat (Ovid, *Met.* 2.122–23); on the ceiling of the west stairs at Chatsworth, Thornhill painted the fall of Phaethon (Fig. 6.36). The subject was also painted by Antonio Pellegrini on the dome at Castle

Howard (now replaced by a modern copy after a fire). Political allegory may be present: Kerry Downes detected comment by the Williamite third earl of Carlisle on the absolutist ambitions of Charles II, James II and Louis XIV. This is contested by Charles Saumurez Smith, who sees in it rather the general humanist lesson on the folly of all human endeavour.[97] Saumurez Smith points out that an anti-autocratic message is unlikely in the paintings commissioned by the Francophile Ralph Montagu for Montagu House from Charles de La Fosse (a pupil of Le Brun, who had painted Apollo in his chariot in the King's Apartments at Versailles): in the saloon, Phaethon was shown driving the chariot of the Sun, while his fall was depicted in the anteroom.[98] The political application of the story of Phaethon was not uncommon, in the right context, in seventeenth-century England: for example, in the case of the medal struck for the coronation of William and Mary, showing Phaethon blasted by Jupiter, with the legend 'NE TOTVS ABSVMATVR' (That the whole [world] should not be consumed) (Fig. 6.37).[99] But in the case of ceiling paintings one should not underestimate the motivation of the aesthetic challenge of creating a sub-limely terrifying image of a chariot and its rider hurtling down from the ceiling towards the viewer (see ch. 5: 217).

That other Ovidian flying over-reacher, Icarus (see ch. 2: 83), is a less fre-quent subject. He is found, however, in a major pre-Restoration scheme, the ceilings of the Single and Double Cube Rooms at Wilton House, commis-sioned for Philip Herbert, fourth earl of Pembroke, in the late 1640s.[100] On the ceiling of the Single Cube Room, Icarus plunges downwards as his feathers fall away in the heat of the sun, watched helplessly by his father Daedalus, who continues to fly strongly on his own massive and firmly fixed wings. The ceiling of the Double Cube Room displays three scenes from the life of Perseus. In the two smaller panels, at either end, Perseus is shown with the winged horse Pegasus. In the earlier episode, Perseus holds the head of Medusa, from a drop of whose blood Pegasus has just been born, and the horse rears up beside Perseus, wings extended. In the second panel, Perseus comes to the rescue of Andromeda in a version in which he flies on Pegasus (rather than winged san-dals). The fall of Icarus contrasts with Perseus's control of the winged horse,

97. Downes 1977: 33; Saumurez Smith 1990: 105–8.

98. On the other hand, another ceiling at Montagu House bore a scene of the fall of the Giants, a common political image (Croft-Murray 1962: 249).

99. On the politics of mural paintings of the Phaethon story, see Hamlett 2020: 98–102.

100. For detailed discussion, including of the continental models for the paintings, and of connections between the ceiling paintings and the masque, see Hamlett 2020: 20–28.

FIGURE 6.37. Jan Roettiers, medal commemorating the coronation of William and Mary, showing the fall of Phaethon. Royal Collection Trust / © Her Majesty Queen Elizabeth II 2021.

for whose generation he has been responsible through his mastering and killing of the Gorgon. Political meanings have been read out of the sequence of the two ceilings, pertaining to the Earl of Pembroke's detachment from the cause of the king and alliance with that of Parliament: 'The murals at Wilton were clearly inspired by the Banqueting House.'[101] If so, one of the points of contact is the use of ceiling spaces to propagate ideological and political messages though images of ascent and descent.[102]

101. Ibid.: 21.

102. Ibid.: 37 n. 48 refers to Goldberg 1983: 104–7 on Daedalus and Icarus in seventeenth-century art. On the reception of the story of Daedalus and Icarus, see also Rudd 1988.

Epilogue

IN BRITAIN, the fashion for large-scale figurative wall and ceiling painting was over by about 1740, but ceilings continued to open up to the heavens in other countries, in schemes both sacred and secular. The use of the pictorial vocabulary of apotheosis survived longer in the republican United States, in the monumental *Apotheosis of George Washington* on the dome of the rotunda of the Capitol in Washington by the Italian painter Constantino Brumidi (completed 1865), steeped in the traditions of the Italian Renaissance and baroque. Brumidi uses a heavily classical iconography to celebrate the agricultural and industrial progress of the United States. In keeping with the long tradition whereby virtuous ascent is balanced by the driving downwards of forces of evil and disorder, an American Athena, accompanied by the thunderbolt-bearing American eagle, tramples on the latter, including Discord in the likeness of the Confederate president Jefferson Davis.[1]

In England, the classicizing language of apotheosis was revived for large panel paintings celebrating Nelson, after his death in the moment of victory at the battle of Trafalgar: Benjamin West's *Immortality of Nelson*,[2] and Scott Pierre Nicolas Legrand's *Apotheosis of Nelson*,[3] both in the National Maritime Museum, Greenwich. The vertical thrust is particularly emphatic in Legrand's painting, in which Nelson is borne upwards from the dark smoke of battle, towards a blaze of light, by Neptune and angels. Above Neptune, Fame holds a crown of stars over Nelson's head, hinting at catasterism. At the top, the Olympian gods Mars, Minerva and Hercules are enthroned on clouds, presided over by Jupiter and his eagle. A curious example of the panegyrical use

1. See Ahrens 1973/74.
2. https://collections.rmg.co.uk/collections/objects/14378.html (accessed 29 July 2021).
3. https://collections.rmg.co.uk/collections/objects/14379.html (accessed 29 July 2021).

of apotheosis from late Hanoverian Britain is a small panel painting of the *Apotheosis of George III and the Royal Family*, now in Wimpole Hall, Cambridgeshire, and dated 1829.[4] The unknown artist of this not very distinguished piece was perhaps prompted by Robert Southey's *A Vision of Judgement* (1821), which narrates the reception of George III (d. 29 January 1820) into celestial bliss, welcomed into heaven by his predecessors on the British throne, after meeting the soul of George Washington at the gate of heaven. The two Georges agree that 'Thou and I are free from offence', while others are blamed for the 'foul arts of faction and falsehood' that resulted in the loss of the American colonies. Southey's poem was mercilessly burlesqued in Byron's *The Vision of Judgement* (1822).

These are late outcrops. In English poetry, in contrast to painting, there is no abrupt falling away in the production of texts of celestial aspiration. As is demonstrated by the concluding examples in chapter 5—works by Anna Letitia Barbauld, Tennyson and Wordsworth—flights of the mind continue into the Romantic and Victorian periods. The vertical contrast between soaring and diving, or soaring and sinking, presents itself easily to frame the aspirations and anxieties of the Romantic poet. M. H. Abrams's classic study of the Romantic imagination *Natural Supernaturalism* takes as its point of departure Wordsworth's 'Prospectus for *The Recluse*', in which the poet positions himself as a successor to Milton's ascents and descents, which themselves retrace long traditions of both classical and biblical models (see ch. 5: 254–55). The closing section of Abrams's book is entitled 'The Eagle and the Abyss'.[5] Here he discusses Wordsworth's imagery in *The Prelude* of glances into the abyss and mountain-climbing, both literal and figurative, in a dialectic of hope and despair. From disillusion the poet and his companion are 'reconciled . . . to realities' by the view of the Vale of Chamouni, including the small birds and '[t]he eagle soar[ing] in his element' (*Prelude* 6.463). Abrams finds the same imagery of mountain-climbing, abysses and soaring eagle in Friedrich Schiller's *Der Spaziergang* (1795), a central text of German Romanticism, and one which, for Abrams, encapsulates much of what his long book has had to say about the Romantic imagination. Another soaring spirit of Romanticism is Euphorion, the child of Faust and Helen in Goethe's *Faust*, Part 2, Act 3.[6] Euphorion

4. Reproduction and catalogue entry at http://www.nationaltrustcollections.org.uk/object /207797 (accessed 29 July 2021).

5. Abrams 1971: 448–62.

6. According to Ptolemaios Chennos, an Alexandrian grammarian of imperial date, Euphorion was the winged son of Helen and Achilles, who was knocked down to earth by Zeus.

climbs higher and higher up a mountain, and hurls himself into the air in the attempt to fly and take part in a war that he sees raging below, but plunges to the ground, as the Chorus cries out 'Icarus, Icarus!' (9901). Elsewhere, Goethe identifies Euphorion as Byron, and the war as that of Greek independence. Goethe may have meant to warn against an uncontrolled and euphoric Romantic titanism.[7]

Nor, when we look back in time from the period covered centrally in this book, the late sixteenth to the earlier nineteenth century, is it difficult to find medieval examples of poetry of celestial aspiration, indebted to classical as well as to the ubiquitous biblical exemplars. The towering monument of Dante's *Commedia* stands in a tradition of long medieval poems on philosophical and theological journeys to the heavens, of which Alan of Lille's *Anticlaudianus* (1181–84), which Dante certainly knew, is the outstanding example. In this personification allegory, Prudence undertakes a journey to heaven to ask God for a soul for the perfect man which Nature wishes to construct. Prudence's journey is in a flying chariot, put together by Concord, and drawn by five horses, that is, the five senses. The final stages of her ascent are only made possible by the aid of Theology and Faith. The *Anticlaudianus* is an influence not just on Dante's ascent in the *Commedia*, but also on Geoffrey's parodic ascent in *The House of Fame*.

Enough has been said to make the point that my selection in this book is only a part of a more continuous history of its themes. All periodizations are leaky, and the restriction of a study to just one nation and its literature and art is also partial, especially for centuries when English literature was so open to continental influences. Nevertheless, I repeat my opening claims: firstly, that the poetry and painting of the period here focused upon is characterized by a particularly marked attraction to themes and images of celestial aspiration; and, secondly, that in these centuries this attraction finds expression in large part through intensive intertextual dialogue with classical models, of a kind that becomes more tenuous and less self-conscious as we move through the nineteenth century towards modernity.

Dreams and fancies of elevation from the earth are probably a constant of human psychology. I end on a contemporary note, with an example of the conceit of the flight of the mind, written by a mind unusually imprisoned in an earthbound body. In his last book, Stephen Hawking described himself

7. See Rudd 1988: 48. I am grateful to David Quint for drawing my attention to Goethe's Euphorion.

as 'travelling across the universe by using my mind and the laws of physics. I have been to the furthest reaches of our galaxy, travelled into a black hole and gone back to the beginning of time'.[8] Hawking was perhaps not unaware that mental space-flight was often attributed to Newton, whose statue in Trinity College chapel stands a few hundred yards from Hawking's own Cambridge college.

8. Hawking 2018: 21.

BIBLIOGRAPHY

Abbott, R. (2009) 'Cambridge Ideas—Strange Seas of Thought', 1 October, https://www.youtube.com/watch?v=U5bZwpgxjNI (accessed 29 July 2021).

Abrams, M. H. (1920) 'Structure and Style in the Greater Romantic Lyric', in F. W. Hilles and H. Bloom (eds), *From Sensibility to Romanticism: Essays Presented to Frederick A. Pottle*. New York: 527–60.

Abrams, M. H. (1971) *Natural Supernaturalism: Tradition and Revolution in Romantic Literature*. New York.

Ahrens, K. (1973/74) 'Constantino Brumidi's *Apotheosis of George Washington* in the Rotunda of the United States Capitol', *Records of the Columbia Historical Society, Washington, DC* 49: 187–208.

Albury, W. R. (1978) 'Halley's Ode on the *Principia* of Newton and the Epicurean Revival in England', *Journal of Historical Ideas* 39: 24–43.

Allen, D. C. (1970) *The Harmonious Vision: Studies in Milton's Poetry*. Baltimore.

Allott, K. (ed.) (1948) *The Poems of William Habington* (with introduction and commentary). Liverpool.

Alpers, S., and Baxandall, M. (1994) *Tiepolo and the Pictorial Intelligence*. New Haven, CT.

Arnold, Matthew (1879) *Mixed Essays* (2nd edn). London.

Ascoli, A. R. (1987) *Ariosto's Bitter Harmony: Crisis and Evasion in the Italian Renaissance*. Princeton, NJ.

Ashfield, A. and P. de Bolla (eds) (1996) *The Sublime: A Reader in British Eighteenth-Century Aesthetic Culture*. Cambridge.

Auger, P. (2019) *Du Bartas' Legacy in England and Scotland*. Oxford.

Averill, J. (ed.) (1984) *'An Evening Walk' by William Wordsworth* (The Cornell Wordsworth). Ithaca, NY.

Bachelard, G. (1943) *L'Air et les songes: Essai sur l'imagination du movement*. Paris.

Balakier, A. S. and J. J. Balakier (1995) *The Spatial Infinite at Greenwich in Works by Christopher Wren, James Thornhill, and James Thomson: The Newton Connection*. Lewiston, NY.

Baldwin Smith, E. (1956) *Architectural Symbolism of Imperial Rome and the Middle Ages*. Princeton, NJ.

Banks, K. (2008) *Cosmos and Image in the Renaissance: French Love Lyric and Natural-Philosophical Poetry*. London.

Barber, T. (ed.) (2020) *British Baroque: Power and Illusion* (Tate Britain exhibition catalogue). London.

Barchiesi, A. (ed.) (2005) *Ovidio: 'Metamorfosi'*, vol. 1: *Libri I–II*. Rome.

Barchiesi, A. (2009) 'Phaethon and the Monsters', in P. Hardie (ed.), *Paradox and the Marvellous in Augustan Literature and Culture*. Oxford: 163–88.

Bardon, F. (1974) *Le Portrait mythologique à la cour de France sous Henri IV et Louis XIII*. Paris.

Bardon, H. (1957) 'Ovide et le grand roi', *Les Études classiques* 25: 401–16.

Barkan, L. (1991) *Transuming Passion: Ganymede and the Erotics of Humanism*. Stanford, CA.

Barlow, R. D. (1973) 'Robert Burton's Cosmic Voyage', *Journal of the History of Ideas* 34: 291–302.

Barr, W. (1952) 'A Commentary on the Panegyrics of Claudian on the Third and Fourth Consulates of Honorius'. Dissertation, University of London.

Bate, J. (2019) *How the Classics Made Shakespeare*. Princeton, NJ.

Baxter, S. (1992) 'William as Hercules: The Implications of Court Culture', in L. Schwoerer (ed.), *The Revolution of 1689: Changing Perspectives*. Cambridge: 95–106.

Beard, M. and J. Henderson (1998) 'The Emperor's New Body: Ascension from Rome', in M. Wyke (ed.), *Parchments of Gender. Deciphering the Bodies of Antiquity*. Oxford: 191–219.

Beard, M., J. North and S. Price (1998) *Religions of Rome* (2 vols). Cambridge.

Beauchamp, T. L. (ed.) (2000) *The Clarendon Edition of the Works of David Hume: 'An Enquiry concerning Human Understanding'*. Oxford.

Bennett, J. S (1989). *Reviving Liberty: Radical Christian Humanism in Milton's Great Poems*. Cambridge, MA.

Berger, R. W. (1993) *The Palace of the Sun: The Louvre of Louis XIV*. University Park, PA.

Bickermann, E. (1929) 'Die römische Kaiserapotheose', *Archiv für Religionswissensachaft* 27: 1–34.

Birrell, T. A. (1956) 'Sarbiewski, Watts and the Later Metaphysical Tradition', *English Studies* 37: 125–32.

Bolton, J.D.P. (1962) *Aristeas of Proconnesus*. Oxford.

Borris, K. (1990) 'Allegory in *Paradise Lost*: Satan's Cosmic Journey', *Milton Studies* 26: 101–33.

Borris, K. (2017) *Visionary Spenser and the Poetics of Early Modern Platonism*. Oxford.

Bottrall, M. (1950) 'The Baroque Element in Milton', *English Miscellany* 1: 31–42.

Bousset, W. (1901) 'Die Himmelsreise der Seele', *Archiv für Religionswissenschaft* 4: 136–69, 229–73.

Boutin, P. (1999) *Jean-Théophile Desaguliers: Un huguenot, philosophe et jurist, en politique. Traduction et commentaires de 'The Newtonian System of the World. The Best Model of Government'*. Paris.

Branham, R. B. (1989) *Unruly Eloquence: Lucian and the Comedy of Traditions*. Cambridge, MA.

Bremmer, J. N. (2014) 'Descents to Hell and Ascents to Heaven in Apocalyptic Literature', in J. J. Collins (ed.), *The Oxford Handbook of Apocalyptic Literature*. Oxford: 340–57.

Brena, F. (1999) 'Osservazioni al libro IX del *Bellum civile*, in P. Esposito and L. Nicastri (eds), *Interpretare Lucano: Miscellanea di studi*. Naples: 275–301.

Brett, C. (2009/10) 'Antonio Verrio (c. 1636–1707). His Career and Surviving Work', *British Art Journal* 10.3: 4–17.

Brothers, D. W. (2015) *The Romantic Imagination and Astronomy: On All Sides Infinity*. Basingstoke.

Brown, J. P. R. (2009) 'Donne and the *Sidereus Nuncius*: Astronomy, Method and Metaphor in 1611'. PhD thesis, University of Toronto.

Brown, R. (1987) 'The Palace of the Sun in Ovid's *Metamorphoses*, in M. Whitby, P. Hardie and M. Whitby (eds), Homo viator*: Classical Essays for John Bramble*. Bristol: 211–20.

Browning, R. (2016) 'Anna Letitia Barbauld's "A Summer Evening's Meditation" and the Cosmic Voyage since *Paradise Lost*', *Journal of Eighteenth-Century Studies* 39: 395–412.

Bruno, Giordano (1879–91) *Opera latine conscripta*, ed. F. Tocco and G. Vitelli (8 vols). Naples.

Buccheri, A. (2014) *The Spectacle of Clouds, 1439–1650: Italian Art and Theatre*. Farnham.

Buchanan, George (1586) *Sphaera quinque libris descripta*. Herborn (Hesse).

Buchheit, V. (1971) 'Epikurs Triumph des Geistes (Lucr. 1.62–79)', *Hermes* 99: 303–23.

Burchard, W. (2016) *The Sovereign Artist. Charles Le Brun and the Image of Louis XIV*. London.

Burke, Edmund (1958) *A Philosophical Enquiry into the Origin of Our Ideas of the Sublime and the Beautiful*, ed. J. T. Boulton. London.

Burke, P. (1992) *The Fabrication of Louis XIV*. New Haven, CT.

Burrow, C. (2019) *Imitating Authors. Plato to Futurity*. Oxford.

Burrow, C., S. Harrison, M. McLaughlin and E. Tarantino (eds), (2021) *Imitative Series and Clusters from Classical to Early Modern Literature*. Berlin.

Burton, Robert (1989–2000) *The Anatomy of Melancholy*, ed. T. C. Faulkner, N. K. Kiessling and R. L. Blair (6 vols). Oxford.

Butler, G. F. (2005) 'Milton's Meeting with Galileo: A Reconsideration', *Milton Quarterly* 39: 132–39.

Butler, M. (2008) *The Stuart Court Masque and Political Culture*. Cambridge.

Buxton, B. (2014) 'A New Reading of the Belvedere Altar', *American Journal of Archaeology* 118: 91–111.

Buxton, R.G.A. (1980) 'Blindness and Limits: Sophokles and the Logic of Myth', *Journal of Hellenic Studies* 100: 22–37.

Byard, M. M. (1978) 'Divine Wisdom—Urania', *Milton Quarterly* 12: 134–37.

Cahn, W. (1989) 'Ascending to and Descending from Heaven: Ladder Themes in Early Medieval Art', in *Santi e demoni nell'alto medioevo occidentale (secoli V–XI)*, vol. 2 (Atti delle settimane di studio del Centro italiano di studi sull'alto Medioevo [7–13 April 1988]). Spoleto: 697–724.

Cameron, A. (1970) *Claudian: Poetry and Propaganda at the Court of Honorius*. Oxford.

Cameron, A. (2011) *The Last Pagans of Rome*. Oxford.

Campbell, L. B. (1935) 'The Christian Muse', *The Huntington Library Bulletin* 8: 29–70.

Campbell, L. B. (1959) *Divine Poetry and Drama in Sixteenth-Century England*. Cambridge.

Campbell, M. (1977) *Pietro da Cortona at the Pitti Palace: A Study of the Planetary Rooms and Related Projects*. Princeton, NJ.

Capelle, W. (1912) 'Μετέωρος—μετεωρολογία', *Philologus* 71: 414–48.

Carey, J. and A. Fowler (eds) (1968) *The Poems of John Milton*. London.

Carretta, V. (1983) *The Snarling Muse: Verbal and Visual Political Satire from Pope to Churchill*. Philadelphia.

Casanova-Robin, H. (2019) 'Poétique des apothéoses dans les *Métamorphoses*: Un transitoire paradoxal?', in H. Casanova-Robin and G. Sauron (eds), *Ovide, le transitoire et l'éphémère: Une exception à l'âge augustéen?* Paris: 69–88.

Cavarzere, A. (1996) *Sul limitare. Il 'motto' e la poesia di Orazio.* Bologna.

Cerri, G. (ed. and trans.)) (1999) *Parmenide di Elea: 'Poema sulla natura'.* Milan.

Chalker, J. (1969) *The English Georgic: A Study in the Development of a Form.* London.

Champlin, E (2003). *Nero.* Cambridge, MA.

Cheney, P. (1993) *Spenser's Famous Flight: A Renaissance Idea of a Literary Career.* Toronto.

Cheney, P. (2009) *Marlowe's Republican Authorship: Lucan, Liberty, and the Sublime.* Basingstoke.

Cheney, P. (2018) *English Authorship and the Early Modern Sublime.* Cambridge.

Chignell, A. and M. C. Halteman (2012) 'Religion and the Sublime', in T. M. Costelloe (ed.), *The Sublime: From Antiquity to the Present.* Cambridge: 183–202.

Chomarat, J. (ed. and trans.) (1996) *Palingène (Pier Angelo Manzolli, dit Marzello Palingenio Stellato: 'Le Zodiaque de la vie' (Zodiacus vitae) XII Livres.* Geneva.

Clark, J. R. (1970) *Form and Frenzy in Swift's 'Tale of a Tub'.* Ithaca.

Clucas, S. (1990) 'Giordano Bruno's *Degli eroici furori* and Fulke Greville's *Caelica*', *Renaissance Studies* 4: 201–27.

Clymer, L. (2005) 'Philosophical Tours of the Universe in British Poetry, 1700–1729, or, The Soaring Muse', in M. Ciavolella and P. Coleman (eds), *Culture and Authority in the Baroque.* Toronto: 30–62.

Cobb, Samuel (1700) *Poetae Britannici: A Poem.* London.

Cohen, M. (1986) 'The Whig Sublime and James Thomson', *English Language Notes* 24: 27–35.

Cole, S. (2013) *Cicero and the Rise of Deification at Rome.* Cambridge.

Coleman, K. M. (ed.) (1988) *Statius Silvae IV.* Oxford.

Colie, R. L. (1957) 'Thomas Traherne and the Infinite: The Ethical Compromise', *Huntington Library Quarterly* 21.1: 69–82.

Collins, C. (1984), 'Milton's Early Cosmos and the Fall of Mulciber', *Milton Studies* 19: 37–52.

Collins, S. L. (1989) *From Divine Cosmos to Sovereign State: An Intellectual History of Consciousness and the Idea of Order in Renaissance England.* New York.

Colvin, H. (1976) *The History of the King's Works*, vol. 5: *1660–1782.* London.

Connell, P. (2016) *Secular Chains: Poetry and the Politics of Religion from Milton to Pope.* Oxford.

Conti, Natale (1979) *Mythologiae, sive Explicationis Fabularum Libri Decem* [Padua, 1616 (repr.)], ed. S. Orgel. New York.

Cope, J. I. (1962) *The Metaphoric Structure of 'Paradise Lost'.* Baltimore.

Cornford, S. (ed.) (1989) *Edward Young: 'Night Thoughts'.* Cambridge.

Cosgrove, D. (2001) *Apollo's Eye: A Cartographic Genealogy of the Earth in the Western Imagination.* Baltimore.

Cottegnies, L. (2016) 'Michel de Marolles's 1650 French Translation of Lucretius and Its Reception in England', in Norbrook, Harrison and Hardie (eds) (2016): 161–89.

Courcelle, P. (1958) 'La postérité chrétienne du *Songe de Scipion*', *Revue des études latines* 36: 205–34.

Courcelle, P. (1967) 'La vision cosmique de saint Benoît', *Revue des études augustinennes et patristiques* 13.1–2: 97–117.

Courcelle, P. (1972) 'Flügel (Flug) der Seele I', *Reallexikon für Antike und Christentum* 8: 29–65.

Crabbe, A. (1981) 'Anamnesis and Mythology in the *De consolatione philosophiae*', in L. Obortello (ed.), *Atti [del] Congresso internazionale di studi boeziani (Pavia, 5–8 ottobre 1980)*. Rome: 311–25.

Creech, Thomas (1697) *The Five Books of M. Manilius: Containing a System of the Ancient Astronomy and Astrology, together with the Philosophy of the Stoicks. Done into English Verse, with Notes*. London.

Croft-Murray, E. (1954) 'A Drawing by Charles Le Brun for the *Passage du Rhin* in the *Grand Galerie* at Versailles', *British Museum Quarterly* 19: 58–59.

Croft-Murray, E. (1962) *Decorative Painting in England 1537–1837*, vol. 1: *Early Tudor to Sir James Thornhill*. London.

Croft-Murray, E. (1970) *Decorative painting in England 1537–1837*, vol. 2: *The Eighteenth and Early Nineteenth Centuries*. London.

Cumming, W. P. (1931) 'The Influence of Ovid's *Metamorphoses* on Spenser's "Mutabilitie Cantos"', *Studies in Philology* 28: 241–56.

Cumont, F. (1917) 'L'aigle funéraire des Syriens et l'apothéose des empereurs', in Cumont, *Études syriennes*. Paris: 35–118 [expanded version of *Revue de l'histoire des religions* 62 (1910) 119–64]

Cumont, F. (1942) *Recherches sur le symbolisme funéraire des romains*. Paris.

Curran, J. (2000) *Pagan City and Christian Capital: Rome in the Fourth Century*. Oxford.

Davidson, P. (2007) *The Universal Baroque*. Manchester.

Davies, P.J.E. (2000) *Death and the Emperor: Roman Imperial Funerary Monuments from Augustus to Marcus Aurelius*. Cambridge.

Davies, S. (1983) *Images of Kingship in 'Paradise Lost'*. Columbia, MS.

Davies, S., and W. B. Hunter (1988) 'Milton's Urania: "The meaning, not the name I call"', *Studies in English Literature 1500–1900* 28: 95–111.

Dean-Otting, M. (1984) *Heavenly Journeys: A Study of the Motif in Hellenistic Jewish Literature*. Frankfurt.

de Armas, F. A. (1986) *The Return of Astraea: An Astral-Imperial Myth in Calderón*. Lexington, KY.

de Coetlogon, C. E. (ed.) (1793) *Night Thoughts on Life, Death & Immortality, by Edward Young, with Notes Critical and Illustrative by. To Which is Prefixed The Life of the Author*. London.

de Jong, I. (2018) 'The View from the Mountain (*oroskopia*) in Greek and Latin Literature', *The Cambridge Classical Journal* 64: 23–48.

de Jong, I.J.F. (2019) 'From Oroskopia to Ouranoskopia in Greek and Latin epic', *Symbolae Osloenses* 93: 12–36.

Derham, William (1713) *Physico-Theology: or, A Demonstration of the Being and Attributes of God from His Works of Creation*. London.

Dewar, M. (ed.) (1996) *Claudian Panegyricus de sexto consulatu Honorii Augusti*. Oxford.

De Giorgi, R. (2009) '*Couleur, couleur!' Antonio Verrio: Un pittore in Europa tra Seicento e Settecento*. Florence.

Di Gregorio, L. (2010). 'L'Hermes di Eratostene.' *Aevum* 84: 69–144.

Dix, R. (1996) (ed.) *The Poetical Works of Mark Akenside*. Cranbury, NJ.

Dix, R. (2002) 'Wordsworth and Lucretius: The Psychological Impact of Creech's Translation', *English Language Notes* 39: 25–33.

Dodd, E. S. and C. Gorman (eds) (2016) *Thomas Traherne and Seventeenth-Century Thought*. Cambridge.

Dodds, E. R. (1968) *The Greeks and the Irrational*. Berkeley, CA.

Dolman, B. (2009/10) 'Antonio Verrio and the Royal Image at Hampton Court', *British Art Journal* 10.3: 18–28.

Domenicucci, P. (1989) 'I "Capretti" di Virgilio: Note sul catasterismo de Giulio Cesare', in M. A. Cervellera and D. Liuzzi (eds), *L'astronomia a Roma nell'età augustea*. Lecce: 91–106.

Donno, E. S. (ed.) (1963) *Elizabethan Minor Epics*. New York.

Donovan, F. (2004) *Rubens and England*. New Haven, CT.

Doran, R. (2015) *The Theory of the Sublime from Longinus to Kant*. Cambridge.

Downes, K. (1977) *Vanbrugh*. London.

Drew Griffith, R. (1995) 'Catullus' *Coma Berenices* and Aeneas' farewell to Dido', *Transactions of the American Philological Association* 125: 47–59.

Dryden, John (1976) *The Works of John Dryden*, vol. 15: *Plays: 'Albion and Ascanius', 'Don Sebastian', 'Amphitryon'*, ed. E. Miner and G. R. Guffey. Berkeley, CA.

Du Bartas, Guillaume (2011) *La Sepmaine, ou, Création du monde*, ed. S. Arnaud-Seigle et al. (3 vols). Paris.

Dunbar, N. (ed.) (1995) *Aristophanes: 'Birds'*. Oxford.

Dunlap, R. (ed.) (1964) *The Poems of Thomas Carew with His Masque 'Coelum Britannicum'*. Oxford.

DuQuesnay, I.M.LeM. (1976/77) 'Virgil's Fifth *Eclogue*', *Proceedings of the Virgil Society* 16: 18–41 [= P. Hardie (ed.) (1999). *Virgil: Critical Assessments*, vol. 1: 351–84]

Duret, L. (1988) 'Néron-Phaéthon, ou La témérité sublime', *Revue des études latines* 66: 139–55.

Edgecombe, R. S. (1994) *Leigh Hunt and the Poetry of Fancy*. Madison, WI.

Edie, C. A. (1990) 'The Public Face of Royal Ritual: Sermons, Medals and Civic Ceremony in Later Stuart Coronations', *Huntington Library Quarterly* 53: 311–36.

Eigeldinger, M. (1973) 'Le mythe d'Icare dans la poésie française du XVIe siècle', *Cahiers de l'Association internationale des études françaises* 25: 261–80.

Ellenzweig, S. (2014) '*Paradise Lost* and the Secret of Lucretian Sufficiency', *Modern Language Quarterly* 75: 385–409.

England, R. (1979) *The Baroque Ceiling Paintings in the Churches of Rome 1600–1750: A Bibliography*. Hildesheim.

Erler, M. (2002) 'Epicurus as *deus mortalis*: *homoiosis theoi* and Epicurean Self-Cultivation', in D. Frede and A. Laks (eds), *Traditions of Theology: Studies in Hellenistic Theology, Its Background and Aftermath*. Leiden: 159–81.

Etlin, R. A. (2012) 'Architecture and the Sublime', in T. M. Costelloe (ed.), *The Sublime: From Antiquity to the Present*. Cambridge: 230–73.

Ettenhuber, K. (2007) 'Hyperbole: Exceeding Similitude', in S. Adamson, G. Alexander and K. Ettenhuber (eds), *Renaissance Figures of Speech*. Cambridge: 197–213.

Evelyn, John (1656) *An Essay on the First Book of T. Lucretius Carus 'De rerum natura'*. London.

Ewart, W. M. (1853) 'Pope and Buchanan', *Notes & Queries*, series 1, vol. 7: 570.

Fabian, B. (1973) 'Edmond Halleys Encomium auf Isaac Newton: Zur Wirkungsgeschichte von Lukrez', in K. Heitmann and E. Schroeder (eds), *Renatae litterae: Studien zum Nachleben der Antike und zur europäischen Renaissance: August Buck zum 60. Geburtstag*. Frankfurt: 273–90.

Fabian, B. (1979) 'Pope and Lucretius: Observations on "An Essay on Man"', *Modern Language Review* 74: 524–37.

Fairchild, H. N. (1939) *Religious Trends in English Poetry*, vol. 1: *1700–1740: Protestantism and the Cult of Sentiment*. New York.

Fallon, S. M. (1994) 'Intention and its Limits in *Paradise Lost*: The Case of Bellerophon', in D. T. Benet and M. Lieb (eds), *Literary Milton: Text, Pretext, Context*. Pittsburgh: 161–79.

Fantazzi, C. (ed.) (2004) *Angelo Poliziano: 'Silvae'*. Cambridge, MA.

Fara, P. and D. Money (2004) 'Isaac Newton and Augustan Anglo-Latin Poetry', *Journal of the History and Philosophy of Science* 23: 549–71.

Fenton, E. (ed.) (1730) *The Works of Edmund Waller, Esq; in Verse and Prose*. London.

Festugière, A. J. (1949) *La Révélation d'Hermès Trismégiste*, vol. 2: *Le Dieu cosmique* (3rd edn). Paris.

Finney, C. L. (1924) 'Drayton's *Endimion and Phoebe* and Keats's *Endymion*', *PMLA* 39.4: 805–13.

Fish, S. (1967) *Surprised by Sin: The Reader in 'Paradise Lost'*. London.

Fitzgerald, W. (1984) 'Aeneas, Daedalus and the Labyrinth', *Arethusa* 17: 51–65.

Fitzgerald, W. (1987) *Agonistic Poetry: The Pindaric Mode in Pindar, Horace, Hölderlin, and the English Ode*. Berkeley, CA.

Flammini, G. (1993) 'L'apoteosi di Cesare tra mito e realtà: Ovid, *Met.* 15.745–851', in D. Poli (ed.), *La cultura in Cesare. Atti del convegno internazionale di studi (Macerata-Matelica, 30 aprile–4 maggio 1990)*, vol. 2. Rome: 733–49.

Fontaine, J. (1982) 'Les images virgiliennes de l'ascension céleste dans la poésie latine chrétienne', in *Gedenkschrift für Alfred Stuiber* (*Jahrbuch für Antike und Christentum*, Ergänzungsband 9). Münster: 55–67.

Fordoński, K. and P. Urbański(eds) (2008) *Casimir Britannicus: English Translations, Paraphrases, and Emulations of the Poetry of Maciej Kazimierz Sarbiewski*. London.

Foster, K. (1985) 'Dante and Two Friars: *Paradiso* XI–XII', *New Blackfriars* 66: 480–96.

Fowler, A. (1996) *Time's Purpled Masquers: Stars and the Afterlife in Renaissance English Literature*. Oxford.

Fowler, A. (ed.) (1997) *Milton: 'Paradise Lost'* (2nd edn). London.

Fowler, D. (2002) *Lucretius on Atomic Motion: A Commentary on 'De rerum natura' 2.1–332*. Oxford.

Freud, S. (1920) *A General Introduction to Psychoanalysis*. New York.

Frye, R. M. (1978) *Milton's Imagery and the Visual Arts: Iconographic Tradition in the Epic Poems*. Princeton, NJ.

Garrison, J. D. (1975) *Dryden and the Tradition of Panegyric*. Berkeley, CA.

Gascoigne, J. (1988) 'From Bentley to the Victorians: The Rise and Fall of British Newtonian Natural Theology', *Science in Context* 2: 219–56.

Gatti, H. (1995) 'Giordano Bruno and the Stuart Court Masques', *Renaissance Quarterly* 48: 809–42.

Gee, E. (2009) 'Borrowed Plumage: Literary Metamorphosis in George Buchanan's *De sphaera*', in P. Ford and R.P.H. Green (eds), *George Buchanan: Poet and Dramatist*. Swansea: 35–57.

Geraghty, A. (2013) *The Sheldonian Theatre: Architecture and Learning in Seventeenth-Century Oxford*. New Haven, CT.

Gibbons, T. (1780) *Memoirs of the Rev. Isaac Watts, D.D.* London.

Gibson, K. (1998) 'The Decoration of St George's Hall, Windsor, for Charles II: "Too resplendent bright for subjects' eyes"', *Apollo: The International Magazine of the Arts*, no. 435: 30–40.

Gibson, W. S. (1989) *'Mirror of the Earth': The World Landscape of the Sixteenth Century*. Princeton, NJ.

Gildenhard, I. (2004) 'Confronting the Beast: From Virgil's Cacus to the Dragons of Cornelis von Haarlem', *Proceedings of the Virgil Society* 25: 27–48.

Gillespie, S. (2001) *Shakespeare's Books: A Dictionary of Shakespeare's Sources*. London.

Glenn, J. R. (ed.) (1987) *A Critical Edition of Alexander Ross's 1647 'Mystagogus poeticus, or, the Muses Interpreter'*. New York.

Gloton, M. C. (1965) *Trompe-l'oeil et décor plafonnant dans les églises romaines de l'âge baroque*. Rome.

Goldberg, J. (1983) *James I and the Politics of Literature: Jonson, Donne, and Their Contemporaries*. Baltimore.

Gömöri, G. (2011) '"The Polish Swan Triumphant": The English Reception of Maciej Kazimierz Sarbiewski in the Seventeenth Century', *Modern Language Review* 106: 814–33.

Gordon, D. J. (1975) 'Rubens and the Whitehall Ceiling', in S. Orgel (ed.), *The Renaissance Imagination*. Berkeley, CA: 24–50.

Graf, F. (2004) 'The Bridge and the Ladder: Narrow Passages in Late Antique Visions', in R. S. Boustant and A. Y. Reed (eds), *Heavenly Realms and Earthly Realities in Late Antique Religions*. Cambridge: 19–33.

Greene, T. M. (1963) *The Descent from Heaven: A Study in Epic Continuity*. New Haven, CT.

Griffin, D. (1986) *Regaining Paradise: Milton and the Eighteenth Century*. Cambridge.

Grimal, P. (1949) 'La "Ve Églogue" et le culte de César', in *Mélanges d'archéologie et d'histoire offerts à Charles Picard*. Paris: 406–19.

Guillou, E. (1963) *Versailles, le palais du soleil*. Paris.

Haan, E. (1993) 'From Helicon to Heaven: Milton's Urania and Vida', *Renaissance Studies* 7: 86–107.

Hackett, H. (1995) *Virgin Mother Maiden Queen: Elizabeth I and the Cult of the Virgin Mary*. Basingstoke.

Hadot, P. (1995) *Philosophy as a Way of Life: Spiritual Exercises from Socrates to Foucault*, trans. M. Chase. Oxford.

Halleran, M. R. (ed.) (1995) *Euripides: 'Hippolytus'*. Warminster.

Halliwell, S. (2008) *Greek Laughter: A Study of Cultural Psychology from Homer to Early Christianity*. Cambridge.

Halliwell, S. (2011) *Between Ecstasy and Truth: Interpretations of Greek Poetics from Homer to Longinus*. Oxford.

Halperin, D. J. (1988) *The Faces of the Chariot: Early Jewish Responses to Ezekiel's Vision*. Tübingen.

Hamilton, A. C. (ed.) (1977) *Spenser: 'The Faerie Queene'*. London.

Hamlett, L. (2012) 'The Longinian Sublime: Effect and Affect in "Baroque" British Visual Culture', in C. van Eck, S. Bussels, M. Delbeke and J. Pieters (eds), *Translations of the Sublime: The Early Modern Reception and Dissemination of Longinus' 'Peri Hupsous' in Rhetoric, the Visual Arts, Architecture and the Theatre*. Leiden: 187–220.

Hamlett, L. (2013) 'Sublime Effect: James Thornhill's *A Ceiling and Wall Decoration* and *The Apotheosis of Romulus: Sketch for a Ceiling Decoration* and Peter Paul Rubens's *Apotheosis of*

James I', in N. Llewellyn and C. Riding (eds), *The Art of the Sublime* (Tate Research publication), https://www.tate.org.uk/art/research-publications/the-sublime/lydia-hamlett -sublime-effect-james-thornhills-a-ceiling-and-wall-decoration-and-the-r1140518 (accessed 29 July 2021).

Hamlett, L. (2016) 'Rupture through Realism: Sarah Churchill and Louis Laguerre's Murals at Marlborough House', in M. Hallett, M. Myrone and N. Llewellyn (eds), *Court, Country, City: British Art and Architecture, 1660–1735*. New Haven, CT.

Hamlett, L. (2020) *Mural Painting in Britain 1630–1730: Experiencing Histories*. London.

Hammond, P. (1984) 'Dryden's *Albion and Albanius*: The Apotheosis of Charles II', in Lindley (ed.) (1984): 169–83.

Hammond, P. (2017) *Milton's Complex Words: Essays on the Conceptual Structure of 'Paradise Lost'*. Oxford.

Hardie, P. (1986) *Virgil's 'Aeneid': Cosmos and Imperium*. Oxford.

Hardie, P. (1997) 'Questions of Authority: The Invention of Tradition in Ovid *Metamorphoses* 15', in T. Habinek and A. Schiesaro (eds), *The Roman Cultural Revolution*. Cambridge: 182–98.

Hardie, P. (2002) 'Another look at Ganymede', in T. P. Wiseman (ed.), *Classics in Progress: Essays on Ancient Greece and Rome*. Oxford: 333–61.

Hardie, P. (2006) 'Virgil's Ptolemaic Relations', *The Journal of Roman Studies* 96: 25–41.

Hardie, P. (2009) *Lucretian Receptions: History, the Sublime, Knowledge*. Cambridge.

Hardie, P. (2012) *Rumour and Renown. Representations of Fama in Western Literature*. Cambridge.

Hardie, P. (ed.) (2015) *Ovidio: 'Metamorfosi'*, vol. 6: *Libri XIII–XV*. Rome.

Hardie, P. (2016) 'Reflections of Lucretius in Late Antique and Early Modern Biblical and Scientific Poetry: Providence and the Sublime', in J. Lezra and L. Blake (eds), *Lucretius and Modernity. Epicurean Encounters across Time and Disciplines*. London: 187–202.

Hardie, P. (2018) 'The Vertical Axis in Classical and Post-Classical Epic', in S. Finkmann, A. Behrendt and A. Walter (eds), *Antike Erzähl- und Deutungsmuster. Zwischen Exemplarität und Transformation: Festschrift für Christiane Reitz zum 65. Geburtstag*. Berlin: 219–37.

Hardie, P. (2019) 'Generic Dialogue and the Sublime in Cowley: Epic, Didactic, Pindaric', in P. Major (ed.), *Royalists and Royalism in 17th-Century Literature: Exploring Abraham Cowley*: New York: 71–92.

Hardie, P. (2020a) 'Ovidian Exile, Presence, and Metamorphosis in Late Antique Latin Poetry', in M. Möller (ed.), *Excessive Writing: Ovids Exildichtung*. Heidelberg: 123–35.

Hardie, P. (2020b) 'Flying with the Immortals: Reaching for the Sky in Classical and Renaissance Poetics', in S. Pugh (ed.), *Conversations: Classical and Renaissance Intertextuality*, Manchester: 31–54.

Hardie, P. (forthcoming) 'Cicero and Lucretius on Deifying the Great Man'.

Harrison, S. J. (1996) '*Aeneid* 1.286: Julius Caesar or Augustus?', *Papers of the Leeds International Latin Seminar* 9: 127–33.

Harrison, S. J. (2000) *Apuleius: A Latin Sophist*. Oxford.

Harrison, S. J. (2017) *Horace: 'Odes II'*. Cambridge.

Hart, C. (1988) *Images of Flight*. Berkeley, CA.

Hartt, F. (1958) *Giulio Romano* (2 vols). New Haven, CT.

Haskell, Y. (1998a) 'Renaissance Didactic Latin Poetry on the Stars: Wonder, Myth and Science', *Renaissance Studies* 12: 495–522.

Haskell, Y. (1998b) 'The Masculine Muse: Form and Content in the Latin Didactic Poetry of Palingenius and Bruno', in C. Atherton (ed.), *Form and Content in Didactic Poetry*. Bari: 117–44.

Haskell, Y. (1999) 'Between Fact and Fiction: The Renaissance Didactic Poetry of Fracastoro, Palingenio and Valvasone', in Y. Haskell and P. Hardie (eds), *Poets and Teachers: Latin Didactic Poetry and the Didactic Authority of the Latin Poet from the Renaissance to the Present*. Bari: 77–103.

Haskell, Y. (2016) 'Poetic Flights or Retreats? Latin Lucretian Poems in Sixteenth-Century Italy', in Norbrook, Harrison and Hardie (eds) (2016): 91–121.

Haskell, Y. (2017) 'Conjuring with the Classics. Neo-Latin poets and Their Pagan Familiars', in V. Moul (ed.), *A Guide to Neo-Latin Literature*. Cambridge: 17–34.

Hassel, R. C., Jr (1971) 'Donne's *Ignatius His Conclave* and the New Astronomy', *Modern Philology* 68: 329–37.

Havens, R. D. (1922) *The Influence of Milton on English Poetry*. Cambridge, MA.

Hawking, S. (2018) *Brief Answers to the Big Questions*. London.

Hawkins, P. S. (1984) '"By gradual scale sublimed": Dante's Benedict and Contemplative Ascent', in T. G. Verdon (ed.), *Monasticism and the Arts*. Syracuse, NY: 254–69.

Hawkins, F. A. (1904–11) *Medallic Illustrations of the History of Great Britain and Ireland to the Death of George II* (19 vols). London.

Healy, T. S. (ed.) (1969) *John Donne: 'Ignatius His Conclave'*. Oxford.

Hebel, J. W. (ed.) (1925) *'Endimion and Phoebe: Ideas Latmus', by Michael Drayton* [1535 (repr.)]. Stratford-upon-Avon.

Hebel, J. W. (ed.) (1931–41) *The Works of Michael Drayton* (5 vols). Oxford.

Hecquet-Noti, N. (ed.) (1999) *Avit de Vienne: 'Histoire spirituelle'*, vol. 1: *Chants I–III*. Paris.

Heninger, S. K. (1960) 'The Sun-King Analogy in *Richard II*', *Shakespeare Quarterly* 11: 319–27.

Higgott, G. (2020) '"Mutual fruitfulness": A Nuptial Allegory on Queen Henrietta Maria's Bedchamber Ceiling at the Queen's House, Greenwich', in M.-C. Canova-Green and S. Wolfson (eds), *The Wedding of Charles I and Henrietta Maria, 1625: Celebrations and Controversy*. Turnhout: 295–320.

Hille, C. (2012) *Visions of the Courtly Body: The Patronage of George Villiers, First Duke of Buckingham, and the Triumph of Painting at the Stuart Court*. Berlin.

Hillier, R. (1993) *Arator on the Acts of the Apostles: A Baptismal Commentary*. Oxford.

Hils, George (1646) *The Odes of Casimire. Translated by G. H.* London.

Himmelfarb, M. (1993) *Ascent to Heaven in Jewish and Christian Apocalypses*. New York.

Hoefmans, M. (1994) 'Myth into Reality: The Metamorphosis of Daedalus and Icarus (Ovid, *Metamorphoses*, VIII, 183–235)', *L'Antiqité classique* 63: 137–160.

Hooker, E. N. (ed.) (1939) *The Critical Works of John Dennis*, vol. 1. Baltimore.

Hopkins, D. (2007) 'The English Voices of Lucretius from Lucy Hutchinson to John Mason Good', in S. Gillespie and P. Hardie (eds), *The Cambridge Companion to Lucretius*. Cambridge: 254–73.

Horn, R. D. (1975) *Marlborough, a Survey: Panegyrics, Satires, and Biographical Writings, 1688–1788*. Folkestone.

Houghton, L. (2019) *Virgil's Fourth 'Eclogue' in the Italian Renaissance*. Cambridge.

Howe, P. P. (ed.) (1930) *The Complete Works of William Hazlitt*, vol. 5. London.

Hoxby, B. and A. B. Coiro (eds) (2016) *Milton and the Long Restoration*. Oxford.

Hoyles, J. (1971) *The Waning of the Renaissance 1640–1740: Studies in the Thought and Poetry of Henry More, John Norris and Isaac Watts*. The Hague.

Hunter, R. L. (ed.) (1989) *Apollonius of Rhodes: 'Argonautica', Book 3*. Cambridge.

Hunter, R. L. (ed.) (2003) *Theocritus: 'Encomium of Ptolemy Philadelphus'*. Berkeley, CA.

Hunter, R. L. (2012) *Plato and the Traditions of Ancient Literature: The Silent Stream*. Cambridge.

Hunter, R. L. (2018) *The Measure of Homer: The Ancient Reception of the Iliad and the Odyssey*. Cambridge.

Iliffe, R. (2017) *Priest of Nature: The Religious Worlds of Isaac Newton*. Oxford.

Inglesfield, R. (1990) 'James Thomson, Aaron Hill, and the Poetic "Sublime"', *Journal for Eighteenth-Century Studies* 9: 141–56.

Irlam, S. (1999) *Elations: The Poetics of Enthusiasm in Eighteenth-Century Britain*. Stanford, CA.

Jacob, C. (1984) 'Dédale géographe: Regard et voyage aériens en Grèce', in J. Lallot (ed.), *LALIES 3: Actes des sessions de linguistique et de littérature (Aussois, 1–6 septembre 1981)*. Paris: 147–64.

Janowitz, A. (2004) *Women Romantic Poets. Anna Barbauld and Mary Robinson*. Tavistock.

Janowitz, A. (2010) 'The Sublime Plurality of Worlds: Lucretius in the Eighteenth Century', (*Tate Papers* issue 13), https://www.tate.org.uk/art/research-publications/the-sublime/anne-janowitz-the-sublime-plurality-of-worlds-lucretius-in-thesup-supeighteenth-century-r1138670 (accessed 29 July 2021).

Jeanneret, M. (2012) *Versailles, ordre et chaos*. Paris.

Johns, R. (2004) 'James Thornhill and Decorative Painting in England after 1688'. PhD thesis, University of York.

Johns, R. (2012) '"The British Caesar": John Churchill, 1st Duke of Marlborough, and the Visual Arts', in J. B. Hattendorf, A. J. Veenendaal, Jr and R. van Hövell tot Westerflier (eds), *Marlborough: Soldier and Diplomat* (Protagonists of History in International History, vol. 2). Zutphen: 320–55.

Johns, R. (2013) '"Those Wilder Sorts of Painting": The Painted Interior in the Age of Antonio Verrio', in D. Arnold and D. P. Corbett (eds), *A Companion to British Art, 1600 to the Present*. Malden, MA: 79–104.

Johns, R. (2016) 'Antonio Verrio and the Triumph of Painting at the Restoration Court', in M. Hallett, N. Llewellyn and M. Myrone (eds), *Court, Country, City: British Art and Architecture, 1660–1735*. New Haven, CT: 153–76.

Johns, R. (forthcoming) '"The Head is Put Where the Feet Should Be": Julius Caesar as Hero and Villain at Chatsworth'.

Jones, R. M. (1926) 'Posidonius and the Flight of the Mind through the Universe'. *Classical Philology* 21: 97–113.

Jones, W. P. (1966) *The Rhetoric of Science: A Study of Scientific Ideas and Imagery in Eighteenth-Century English Poetry*. London.

Jonson, Ben (2012) *The Cambridge Edition of the Works of Ben Jonson*, ed. D. Bevington, M. Butler and I. Donaldson (7 vols). Cambridge.

Jump, H. (1986) '"That Other Eye": Wordsworth's 1794 Revisions of "An Evening Walk" ', *The Wordsworth Circle* 17.3: 156–63.

Kant, I. (1987) *Critique of Judgment*, trans. W. S. Pluhar. Indianapolis.

Kant, I. (2000) *Critique of the Power of Judgment*, trans. P. Guyer and E. Matthews. Cambridge.

Kantorowicz, E. (1963) 'Oriens Augusti—Lever du roi', *Dumbarton Oaks Papers* 17: 117–77.

Karr, D. (2017) 'Notes on the Study of Merkabah Mysticism and Hekhalot Literature in English', *Jewish Studies* 52: 35–112

Keller, L. (1974) *Palingène, Ronsard, Du Bartas: Trois études sur la poésie cosmologique de la Renaissance*. Bern.

Kelley, P. (1983) 'Wordsworth and Lucretius' *De rerum natura*', *Notes & Queries* 30: 219–22.

Kennedy, D. F. (1983) 'Shades of Meaning: Virgil, *Eclogue* 10, 75–7', *Liverpool Classical Monthly* 8: 124.

Kenney, E. J. (ed.) (1990) *Apuleius: 'Cupid and Psyche'*. Cambridge.

Kenney, E. J. (ed.) (2011) *Ovidio: 'Metamorfosi'*, vol. 4: *Libri VII–IX*. Rome.

Kerrigan, W. (1975) 'The Heretical Milton: From Assumption to Mortalism', *English Literary Renaissance* 5: 125–66.

Kilgour, M. (2012) *Milton and the Metamorphosis of Ovid*. Oxford.

King, J. N. (2001) 'Spenser's Religion', in A. Hadfield (ed.), *The Cambridge Companion to Spenser*. Cambridge: 200–216.

Kirstein, R. (ed.) (2000) *Paulinus Nolanus: 'Carmen 17'*. Basel.

Knowles, J. (2012), 'Introduction' to Ben Jonson, *News from the New World* in Jonson (2012), vol. 5: 425–28.

Koortbojian, M. (2013) *The Divinization of Caesar and Augustus: Precedents, Consequences, Implications*. Cambridge.

Koppenfels, W. von (2007) *Der andere Blick, oder das Vermächtnis des Menippos: Paradoxe Perspektiven in der europäischen Literatur*. Munich.

Kraszewski, C. S. (2006) 'Maciej Kazimierz Sarbiewski: The Christian Horace in England', *Polish Review*, 61: 15–40.

Labriola, A. C. (1978) 'The Titans and the Giants: *Paradise Lost* and the Tradition of the Renaissance Ovid', *Milton Quarterly* 12.1: 9–16.

Landolfi, L. (2003) *'Integra prata': Manilio, i proemi*. Bologna.

Lane-Fox, R. (2015) *Augustine: Conversions to Confessions*. London.

Lascelles, M. (1972) 'The Rider on the Winged Horse', in Lascelles, *Notions and Facts: Collected Criticism and Research*. Oxford: 1–28.

Leonard, J. T. (2013) *Faithful Labourers: A Reception History of 'Paradise Lost'* (2 vols). Oxford.

Leranbaum, M. (1977) *Alexander Pope's 'Opus Magnum', 1729–1744*. Oxford.

Levin, H. (1961) *Christopher Marlowe: The Overreacher*. London.

Lewalski, B. K. (1973) *Donne's 'Anniversaries' and the Poetry of Praise: The Creation of a Symbolic Mode*. Princeton, NJ.

Lewalski, B. K. (1979) *Protestant Poetics and the Seventeenth-Century Religious Lyric*. Princeton, NJ.

Lewalski, B. K. and E. Haan (eds) (2012) *The Complete Works of John Milton*, vol. 3: *The Shorter Poems*. Oxford.

Lieb, M. (1999) 'Encoding the Occult: Milton and the Traditions of "Merkabah" Speculation in the Renaissance', *Milton Studies* 37: 42–88.

Lieberg, G. (1970) 'Apotheose und Unsterblichkeit in Ovids Metamorphosen', in M. Albrecht and E. Heck (eds), *Silvae: Festschrift für Ernst Zinn zum 60. Geburtstag*. Tübingen: 125–35.

Liebeschuetz, J.H.W.G. (ed. and trans., with C. Hill) (2005) *Ambrose of Milan: Political Letters and Speeches*. Liverpool.

Lindley, D. (ed.) (1984) *The Court Masque*. Manchester.

Lohfink, G. (1971) *Die Himmelfahrt Jesu: Untersuchungen zu den Himmelfahrts- und Erhöhungstexten bei Lukas*. Munich.

Lonsdale, R. (ed.) (1969) *The Poems of Thomas Gray, William Collins, Oliver Goldsmith*. London.

Lonsdale, R. (ed.) (2006) *Samuel Johnson: 'The Lives of the Most Eminent English Poets: With Critical Observations on Their Works'* (4 vols). Oxford.

Lovatt, H. (2013) *The Epic Gaze: Vision, Gender and Narrative in Ancient Epic*. Cambridge.

Lucasini, C. M. and C. Moreschini (eds) (2012) *Hermias Alexandrinus: 'In Platonis Phaedrum scholia'*. Berlin.

Luck-Huyse, K. (1997) *Der Traum vom Fliegen in der Antike*. Stuttgart.

MacCaffrey, I. G. (1959) *'Paradise Lost' as 'Myth'*. Cambridge, MA.

MacCormack, S. (1981) *Art and Ceremony in Late Antiquity*. Berkeley, CA.

Mack, M. (ed.) (1950) *Alexander Pope: 'An Essay on Man'*. London.

Mack, M. (ed.) (1967) *Alexander Pope: 'The Iliad of Homer, Books I–IX'*. London.

Madec, G. (1988) 'Ascensio, ascensus', in *Augustinus-Lexikon* 1.3: cols 466–75 [repr. in Madec, *Petites études Augustiniennes* (Paris, 1994) 137–49]

Maguire, J. P. (1939) 'The Sources of Pseudo-Aristotle *De mundo*', *Yale Classical Studies* 6: 111–67.

Major, P. (2020) 'Sacred and Secular in Cowley's *Essays*', in P. Major (ed.), *Royalists and Royalism in 17th-Century Literature: Exploring Abraham Cowley*. New York: 202–28.

Mallet, David (1728) *'The Excursion': A Poem: In Two Books* London.

Manley, F. (ed.) (1963) *John Donne: The 'Anniversaries'*. Baltimore.

Marandet, F. (2017) 'Louis Chéron (1660–1725) à Boughton House: Nouvelles réflexions sur la genèse et la signification du décor peint de "Mister Charron"', *British Art Journal* 18: 48–56.

Marsh, D. (1998) *Lucian and the Latins: Humor and Humanism in the Early Renaissance*. Ann Arbor, MI.

Marshall, M. F. (ed.) (1987) *The Poetry of Elizabeth Singer Rowe (1674–1737)*. Lewiston, NY.

Martin, C. G. (1996), '"Boundless the Deep": Milton, Pascal, and the Theology of Relative Space', *English Literary History* 63: 45–78.

Martin, G. (2005) *Rubens: The Ceiling Decoration of the Banqueting Hall*, ed. A. Balis (2 vols). London.

Martin, G. (2011) *Rubens in London: Art and Diplomacy*. London.

Martin, J. R. (1954) *The Illustration of the Heavenly Ladder of John Climacus*. Princeton, NJ.

Martindale, C. (2012) 'Milton's Classicism', in D. Hopkins and C. Martindale (eds), *The Oxford History of Classical Reception in English Literature*, vol. 3: *1660–1790*. Oxford: 53–90.

Martz, L. L. (1954) *The Poetry of Meditation: A Study in English Religious Literature*. New Haven, CT.

Mayor, J.E.B. (ed.) (1889) *Thirteen Satires of Juvenal* (4th edn, revised; 2 vols). London.

McCabe, R. A. (ed.) (1999) *Edmund Spenser: The Shorter Poems*. London.

McCabe, R. A. (2015) 'Spenser', in P. Cheney and P. Hardie (eds), *The Oxford History of Classical Reception in English Literature*, vol. 2: *1558–1660*. Oxford: 557–78.

McCarthy, W. (ed.) (2019) *The Collected Works of Anna Letitia Barbauld*, vol. 1: *The Poems, Revised*. Oxford.

McKillop, A. D. (1942) *The Background of Thomson's 'Seasons'*. Minneapolis.

McKillop, A. D. (ed.) (1961) *James Thomson:'The Castle of Indolence' and Other Poems*. Lawrence, KA.

Meister, F. J. (2020) *Greek Praise Poetry and the Rhetoric of Divinity*. Oxford.

Merrix, R. P. (1987) 'The Phaëton Allusion in *Richard II*: The Search for Identity', *English Literary Renaissance* 17: 277–87.

Millen, R. F. and R. E. Wolf (1989) *Heroic Deeds and Mystic Figures: A New Reading of Rubens' 'Life of Maria de' Medici'*. Princeton, NJ.

Milton, John (1931–38) *The Works*, ed. F. A. Patterson et al. (18 vols). New York.

Milton, John (1953–82) *The Complete Prose Works of John Milton*, gen. ed. D. M. Wolfe (8 vols). New Haven, CT.

Mitford, J. (ed.) (1814) *The Poems of Thomas Gray, with Critical Notes*. London.

Money, D. (2006) 'Aspects of the Reception of Sarbiewski in England', in P. Urbański (ed.), *Pietas Humanistica: Neo-Latin Religious Poetry in Poland in European Context*. Frankfurt: 157–87.

Morgan, L. (1999) *Patterns of Redemption in Virgil's 'Georgics'*. Cambridge.

Morillo, J. D. (2001) *Uneasy Feelings: Literature, the Passions and Class, from Neoclassicism to Romanticism*. New York.

Morris, D. B. (1972) *The Religious Sublime: Christian Poetry and Critical Tradition in 18th-Century England*. Lexington, KY.

Moshenska, J. (2014) *Feeling Pleasures: The Sense of Touch in Renaissance England*. Oxford.

Moul, V. (2016) 'Revising the Siege of York: From Royalist to Cromwellian in Payne Fisher's "Marston Moor"', *The Seventeenth Century* 31: 311–31

Moul, V. (2017) 'Andrew Marvell and Payne Fisher', *Review of English Studies* 68: 524–48.

Moul, V. (2019) 'The Date of Marvell's *Hortus*', *The Seventeenth Century* 34: 329–51.

Moul, V. (2021) 'England's Stilicho: Claudian's Political Poetry in Early Modern England', *International Journal of the Classical Tradition* 28: 23–50.

Mühl, M. (1958) 'Des Herakles Himmelfahrt', *Rheinisches Museum für Philologie* 101: 106–34.

Nadar, Félix (2015) *When I Was a Photographer*, transl. E. Cadava and L. Theodoratou. Cambridge, MA.

Naiden, J. R. (1952) *The 'Sphaera' of George Buchanan* (privately printed).

Narducci, E. (2001) 'Pompeo in cielo (*Pharsalia* IX 1–24; 186–217), un verso di Dante (*Parad.* XXII 135) e il senso delle allusioni a Lucano in due epigrammi di Marziale (IX 34; XI 5)', *Museum Helveticum* 58: 70–92.

Narducci, E. (2002) *La provvidenza crudele: Lucano e la distruzione dei miti augustei*. Pisa.

Nelis, D. (2008) 'Caesar, the Circus and the Charioteer in Vergil's *Georgics*', in J. Nelis-Clément and J.-M. Roddaz (eds), *Le cirque romain et son image*. Pessac: 497–520.

Néraudau, J.-P. (1982) 'Ovide au château de Versailles', in R. Chevallier (ed.), *Colloque présence d'Ovide*. Paris: 323–43.

Néraudau, J.-P. (1986) *L'Olympe du roi-soleil, ou, Comment la mythologie et l'Antiquité furent mises au service de l'idéologie monarchique sous Louis XIV à travers la literature, la peinture, la musique, les fêtes, la sculpture, l'architecture et les jardins, à Vaux-le-Vicomte, Meudon, St Cloud, Sceaux, Marly, St Germain et Versailles*. Paris.

Newcomb, Thomas (1723) 'The Last Judgment of Men and Angels': A Poem in Twelve Books: After the Manner of Milton. London.

Nicolson, M. H. (1946) Newton Demands the Muse: Newton's Opticks and the 18ᵗʰ Century Poets. Princeton, NJ.

Nicolson, M. H. (1948) Voyages to the Moon. New York.

Nicolson, M. H. (1950) The Breaking of the Circle: Studies in the Effect of the 'New Science' upon Seventeenth-Century Poetry. Evanston, IL.

Nicolson, M. H. (1956) 'Milton and the Telescope', in Nicolson, Science and Imagination. Ithaca, NY: 80–109.

Nicolson, M. H. (1959) Mountain Gloom and Mountain Glory: The Development of the Aesthetics of the Infinite. Ithaca, NY.

Nisbet, R.G.M. (1995) Collected Papers on Latin Literature, ed. S. J. Harrison. Oxford.

Nisbet, R.G.M. and M. Hubbard (1970) A Commentary on Horace, 'Odes', Book I. Oxford.

Nisbet, R.G.M. and M. Hubbard (1978) A Commentary on Horace, 'Odes', Book II. Oxford.

Nixon, C.E.V. and B. Saylor Rodgers (eds and trans.) (1994) In Praise of Later Roman Emperors: The 'Panegyrici latini'. Berkeley, CA.

Noggle, J. (2001) The Skeptical Sublime: Aesthetic Ideology in Pope and the Tory Satirists. New York.

Nohrnberg, J. (2009) 'Eight Reflections of Tennyson's "Ulysses"', Victorian Poetry 47: 101–50.

Norbrook, D. (1999) Writing the English Republic: Poetry, Rhetoric and Politics 1627–1660. Cambridge.

Norbrook, D. (2013) 'Milton, Lucy Hutchinson, and the Lucretian Sublime', in N. Llewellyn and C. Riding (eds), The Art of the Sublime (Tate Research publication), http://www.tate.org.uk/art/research-publications/the-sublime/david-norbrook-milton-lucy-hutchinson-and-the-lucretian-sublime-r1138669 (accessed 29 July 2021).

Norbrook, D., S. Harrison and P. Hardie (eds) (2016) Lucretius and the Early Modern. Oxford.

Norman, N. J. (2009) 'Imperial Triumph and Apotheosis: The Arch of Titus in Rome', in A. Counts and S. Tuck (eds), Koine: Mediterranean Studies in Honour of R. Ross. Oxford: 41–53.

Norton, D. F. and M. J. Norton (eds) (2007) The Clarendon Edition of the Works of David Hume: 'A Treatise of Human Nature', vol. 1: The Texts. Oxford.

O'Daly, G. (1991) The Poetry of Boethius. London.

Odell, Daniel W. (1972) 'Young's Night Thoughts as an Answer to Pope's Essay on Man', Studies in English Literature 1500–1900 12: 481–501.

Ogilby, John (1987) The entertainment of His Most Excellent Majestie Charles II in his passage through the city of London to his coronation (facsimile edn with introduction by R. Knowles). Binghamton, NY.

O'Hara, J. J. (1990) Death and the Optimistic Prophecy. Princeton, NJ.

Olson, S. D. (ed.) (1998) Aristophanes: 'Peace'. Oxford.

Olszynka, A. (2006) 'Das Motiv des Fliegens bei Horaz (Carm. 2, 20), Kochanowski (Pieśni 2, 24) und Sarbiewski (Lyr. 1, 10; 2, 5 und 4, 32)', in E. Schäfer (ed.), Sarbiewski: Der polnische Horaz. Tübingen: 83–94.

Orgel, S. and R. Strong (1973) Inigo Jones: The Theatre of the Stuart Court. (2 vols). London.

Padel, R. (1974) '"Imagery of the Elsewhere": Two Choral Odes of Euripides', Classical Quarterly 24: 227–41.

Palme, P. (1957) Triumph of Peace: A Study of the Whitehall Banqueting House. London.

Pandey, N. B. (2013) 'Caesar's Comet, the Julian Star, and the Invention of Augustus', *Transactions of the American Philological Association* 143: 403–47.

Pantin, I. (1995) *La Poésie du ciel dans la seconde moitié du seizième siècle*. Geneva.

Patrides, C. A. (1962) 'Renaissance Interpretations of Jacob's Ladder', *Theologische Zeitschrift* 18: 411–18.

Patten, T. (2012) 'The Purification of Love: Heavenly Ascent from Plato to Dante', *Intermountain West Journal of Religious Studies* 4.1, https://digitalcommons.usu.edu/imwjournal/vol4/iss1/2 (accessed 29 July 2021).

Pease, A. S. (ed.) (1955–58) *Marcus Tullius Cicero: 'De natura deorum'* (2 vols). Cambridge, MA.

Pellegrini, A. M. (1943) 'Bruno, Sidney, and Spenser', *Studies in Philology* 40: 128–44.

Pelling, C.B.R. (ed.) (1988) *Plutarch: 'Life of Antony'*. Cambridge.

Pemberton, Henry (1738) *Observations on Poetry, Especially the Epic: Occasioned by the Late Poem upon Leonidas*. London.

Petersmann, M. (1976) 'Die Apotheosen in den Metamorphosen Ovids'. Dissertation, University of Graz.

Petronella, V. F. (1984) 'Double Ecstasy in Drayton's *Endimion and Phoebe*', *Studies in English Literature 1500–1900* 24: 87–104.

Pinnock, A. (2012) '*Deus ex machina*: A Royal Witness to the Court Origin of Purcell's *Dido and Aeneas*', *Early Music* 40: 265–78.

Pinnock, A. (2015) 'Which Genial Day? More on the Court Origin of Purcell's *Dido and Aeneas*, with a Shortlist of Dates for its Possible Performance before King Charles II', *Early Music* 43: 199–212.

Pinto, Vivian de Sola (1935) 'Isaac Watts and the Adventurous Muse', *Essays and Studies* 20: 86–107.

Poensgen, T. (1969) *Die Deckenmalerei in italienischen Kirchen*. Berlin.

Poeschl, S. (1985) *Studien zur Ikonographie der Erdteile in der Kunst des 16.-18. Jahrhunderts*. Munich.

Porter, J. (2007) 'Lucretius and the Sublime', in S. Gillespie and P. Hardie (eds), *The Cambridge Companion to Lucretius*. Cambridge: 167–84.

Porter, J. I. (2016) *The Sublime in Antiquity*. Cambridge.

Praz, M. (1964) 'Baroque in England', *Modern Philology* 61: 169–79.

Prescott, A. L. (1978) *French Poets and the English Renaissance: Studies in Fame and Transformation*. New Haven, CT.

Price, S. (1987) 'From Noble Funerals to Divine Cult: The Consecration of Roman Emperors', in D. Cannadine and S. Price (eds), *Rituals of Royalty: Power and Ceremonial in Traditional Societies*. Cambridge: 56–105.

Priestman, M. (2012) 'Didactic and Scientific Poetry', in D. Hopkins and C. Martindale (eds), *The Oxford History of the Reception of Classical Literature*, vol. 3: *1660–1790*. Oxford: 401–25.

Pugh, S. (2016) *Spenser and Virgil: The Pastoral Poems*. Manchester.

Putnam, M.C.J. (1986) *Artifices of Eternity: Horace's Fourth Book of Odes*. Ithaca, NY.

Putnam, M.C.J. (1998) *Virgil's Epic Designs: Ecphrasis in the 'Aeneid'*. New Haven, CT.

Quint, D. (1977) 'Astolfo's Voyage to the Moon', *Yale Italian Studies* 1: 398–409.

Quint, D. (1983) *Origin and Originality in Renaissance Literature: Versions of the Source*. New Haven, CT.

Quint, D. (1993) *Epic and Empire: Politics and Generic Form from Virgil to Milton*. Princeton, NJ.

Quint, D. (2014) *Inside 'Paradise Lost'*. Princeton, NJ.

Ramachandran, A. (2015) *The Worldmakers: Global Imagining in Early Modern Europe*. Chicago.

Raylor, T. (1999) '"Pleasure Reconciled with Virtue": William Cavendish, Ben Jonson, and the Decorative Scheme of Bolsover Castle', *Renaissance Quarterly* 52: 402–39.

Rebeggiani, S. (2018) *The Fragility of Power: Statius, Domitian and the Politics of the Thebaid*. Oxford.

Reeves, E. (2014) *Evening News: Optics, Astronomy, and Journalism in Early Modern Europe*. Philadelphia.

Reiss, T. J. (1980) *Tragedy and Truth: Studies in the Development of a Renaissance and Neoclassical Discourse*. New Haven, CT.

Revard, S. P. (2001) *Pindar and the Renaissance Hymn-Ode: 1450–1700*. Tempe, AZ.

Ricks, C. (2002) *Allusion to the Poets*. Oxford.

Ridgely, B. S. (1963) 'The Cosmic Voyage in French Sixteenth-Century Learned Poetry', *Studies in the Renaissance* 10: 136–62.

Robertson, R. (2020) *The Enlightenment: The Pursuit of Happiness 1680–1790*. London.

Roche, P. (ed.) (2009) *Lucan: 'De bello ciuili', Book 1*. Oxford.

Røstvig, M.-S. (1954a) 'Casimire Sarbiewski and the English Ode', *Studies in Philology* 3: 443–60.

Røstvig, M.-S. (1954b) 'Benlowes, Marvell, and the Divine Casimire', *Huntington Library Quarterly* 18: 13–35.

Røstvig, M.-S. (1962) *The Happy Man: Studies in the Metamorphoses of a Classical Ideal* (2nd edn; 2 vols). Oslo.

Roston, M. (1980) *Milton and the Baroque*. London.

Rougier, L. (1959) *La Religion astrale des Pythagoriciens*. Paris.

Rublack, U. (2015) *The Astronomer and the Witch: Kepler's Fight for his Mother*. Oxford.

Rudd, N. (1988) 'Daedalus and Icarus (ii): From the Renaissance to the Present Day', in C. Martindale (ed.), *Ovid Renewed: Ovidian Influences on Literature and Art from the Middle Ages to the Twentieth Century*. Cambridge: 37–53.

Russell, D. A. (ed.) (1964) *'Longinus': 'On the Sublime'*. Oxford.

Rutherford, I. (2001) *Pindar's Paeans: A Reading of the Fragments with a Survey of the Genre*. Oxford.

Rutherford, R. B. (1989) *The Meditations of Marcus Aurelius: A Study*. Oxford.

Sabatier, G. (1999) *Versailles, ou, La Figure du roi*. Paris.

Sabatier, G. (2016) *Versailles, ou, La Disgrâce d'Apollon*. Rennes.

Sabbatino, P. (2004) *'A l'infinito m'ergo': Giordano Bruno e il volo del moderno Ulisse*. Florence.

Saintsbury, G. (1905) *Minor Poets of the Caroline Period*, vol. 1. Oxford.

Salzman, M. R. (1998) 'Deification in the *Fasti* and the *Metamorphoses*', in C. Deroux (ed.), *Studies in Latin Literature and Roman History*, vol. 9 (Collection Latomus 244). Brussels: 313–44.

Sambrook, J. (ed.) (1981) *James Thomson: 'The Seasons'*. Oxford.

Sambrook, J. (ed.) (1986) *James Thomson: 'Liberty', 'The Castle of Indolence', and Other Poems*. Oxford.

Sambrook, J. (1991) *James Thomson, 1700–1748: A Life*. Oxford.

Sambrook, J. (2014) *The Life of the English Poet Leonard Welsted (1688–1747): The Culture and Politics of Britain's Eighteenth-Century Literary Wars*. Lewiston, NY.

Santagata, M. (ed.) (2004) *Francesco Petrarca, Canzoniere* (updated edn). Milan.

Saumarez Smith, C. (1990) *The Building of Castle Howard*. London.

Saunders, T. (2008) *Bucolic Ecology: Virgil's 'Eclogues' and the Environmental Literary Tradition*. London.

Saward, S. (1982) *The Golden Age of Marie de' Medici*. Ann Arbor, MI.

Schaar, C. (1977) '"Each Stair Mysteriously Was Meant"', *English Studies* 58: 408–10.

Schiesaro, A. (2014) '*Materiam superabat opus*: Lucretius Metamorphosed', *Journal of Roman Studies* 104: 73–104.

Schiesaro, A. (2020) 'Lucretius' Apocalyptic Imagination', *Materiali e discussioni per l'analisi dei testi classici* 84: 27–93.

Scholem, G. G. (1965) *Jewish Gnosticism, Merkabah Mysticism, and Talmudic Tradition*, (2nd edn). New York.

Schrade, H. (1928/29) 'Zur Ikonographie der Himmelfahrt Christi', *Vorträge der Bibliothek Warburg*: 66–190.

Scodel, J. (2010) 'Lyric', in G. Braden, R. Cummings and S. Gillespie (eds), *The Oxford History of Literary Translation in English*, vol. 2: *1550–1660*. Oxford: 212–47.

Scott, J. B. (1991) *Images of Nepotism: The Painted Ceilings of Palazzo Barberini*. Princeton, NJ.

Scott, W. (ed.) (1924–36) *Hermes Trismegistus: 'Hermetica'* (4 vols). Oxford.

Seck, F. (ed.) (2018) *Johannes Kepler: 'Sämtliche Gedichte'*. Hildesheim.

Segal, A. F. (1980) 'Heavenly Ascent in Hellenistic Judaism, Early Christianity and Their Environment', *Aufstieg und Niedergang der römischen Welt* 23.2: 1333–94.

Segal, C. (2001) 'Intertextuality and Immortality: Ovid, Pythagoras and Lucretius in *Metamorphoses* 15', *Materiali e discussioni per l'analisi dei testi classici* 46: 63–109.

Shakespeare, William (2007) *Complete Works* (The RSC Shakespeare), ed. J. Bate and E. Rasmussen. Basingstoke.

Sharpe, K. (2009) *Selling the Tudor Monarchy: Authority and Image in Sixteenth-Century England*. New Haven, CT.

Sharpe, K. (2013) *Rebranding Rule: The Restoration and Revolution Monarchy, 1660–1714*. New Haven, CT.

Sharrock, A. (1994) *Seduction and Repetition in Ovid's 'Ars amatoria'*. Cambridge.

Shawcross, J. T. (1991) *John Milton and Influence: Presence in Literature, History and Culture*. Pittsburgh.

Sherburne, Edward (1675) '*The Sphere' of Marcus Manilius Made an English Poem*. London.

Shifflett, A. (1998) *Stoicism, Politics, and Literature in the Age of Milton: War and Peace Reconciled*. Cambridge.

Sitter, J. E. (1982) *Literary Loneliness in Mid-Eighteenth-Century England*. Ithaca, NY.

Slaveva-Griffin, S. (2003) 'Of Gods, Philosophers, and Charioteers: Content and Form in Parmenides' 'Proem' and Plato's *Phaedrus*', *Transactions of the American Philological Association* 133: 227–53.

Smith, H. (2009) '"Last of all the Heavenly Birth": Queen Anne and Sacral Queenship', *Parliamentary History* 28.1: 137–49.

Smith, N. (1994) *Literature and Revolution in England, 1640–1660*. New Haven, CT.

Smith, N. (ed.) (2003) *The Poems of Andrew Marvell*. Harlow.

Solkin, D. H. (2015) *Art in Britain 1660–1815*. New Haven.

Sommerville, J. P. (ed.) (1994) *King James VI and I: Political Writings*. Cambridge.

Spiegelmann, W. (1985) 'Some Lucretian Elements in Wordsworth', *Comparative Literature* 37: 27–49.

Spinosa, N. (1981) 'Spazio infinito e decorazione barocca', in F. Zeri (ed.), *Storia dell'arte italiana, Parte seconda: Dal Medioevo al Novecento*, vol. 2: *Dal Cinquecento all'Ottocento, 1: Cinquecento e Seicento*. Turin: 275–343.

Spurgeon, C. (1935) *Shakespeare's Imagery and What It Tells Us*. Cambridge.

St Clair, A. (1964) 'The Apotheosis Diptych', *The Art Bulletin* 46.2: 205–11.

Stanwood, P. G. (1963) 'St Teresa and Joseph Beaumont's *Psyche*', *Journal of English and Germanic Philology* 62: 533–50.

Steadman, J. M. (1972) *Disembodied Laughter: Troilus and the Apotheosis Tradition*. Berkeley, CA.

Steadman, J. M. (1984) '*Paradise Lost* and the Apotheosis Tradition', in Steadman, *Milton's Biblical and Classical Imagery*. Pittsburgh: 167–89.

Stechow, W. (1968) *Rubens and the Classical Tradition* (Martin Classical Lectures). Cambridge, MA.

Stephan, P. (1997) '"Ruinam praecedit Superbia": Der Sieg der Virtus über die Hybris in den Bildprogrammen des Prinzen Eugen von Savoyen', *Belvedere, Zeitschrift für bildende Kunst* 3: 62–87.

Stevens, C. (2017) '"Oh, to make boards speak! There is a task": Understanding the Iconography of the Applied Paintings at Bolsover Castle', *Early Modern Literary Studies* 19.2, https://extra.shu.ac.uk/emls/journal/index.php/emls/article/view/339 (accessed 29 July 2021).

Stevens, P. (1985) *Imagination and the Presence of Shakespeare in 'Paradise Lost'*. Madison, WI.

Stevenson, S. and D. Thomson (1982) *John Michael Wright: The King's Painter*. Edinburgh.

Stewart, D. D. (2016) 'Angel Bodies to Whig Souls: Blank Verse after Blenheim', in Hoxby and Coiro (eds) (2016): 204–23.

Stewart, S. (1970) *The Expanded Voice: The Art of Thomas Traherne*. San Marino.

Stewart, J. D. (1983) *Sir Godfrey Kneller and the English Baroque Portrait*. Oxford.

Strong, E. S. (1915) *Apotheosis and Afterlife: Three Lectures on Certain Phases of Art and Religion in the Roman Empire*. London.

Strong, R. (1977) *The Cult of Elizabeth: Elizabethan Portraiture and Pageantry*. London.

Strong, R. (1980) *Britannia triumphans: Inigo Jones, Rubens, and Whitehall Palace* (12th Walter Neurath Memorial Lecture). London.

Strunck, C. (2019) 'Throne and Altar: Antonio Verrio's Decoration of the Royal Chapel and St George's Hall at Windsor Castle (1680–1683)', in C. Strunck (ed.), *Kulturelle Transfers: Zwischen Grossbritannien und dem Kontinent 1680–1968*. Petersberg: 9–19.

Sutherland, J. (ed.) (1953) *Alexander Pope: 'The Dunciad'* (revised edn). London.

Sylvester, Josuah (1979) *The Divine Weeks and Works of Guillaume de Saluste, sieur du Bartas, Translated by Josuah Sylvester*, ed. S. Snyder (2 vols). Oxford.

Tarrant, R. J. (ed.) (2012) *Virgil: 'Aeneid', Book XII*. Cambridge.

Taylor, B. (2020) *Lucretius and the Language of Nature*. Oxford.

Taylor, G. C. (1934) *Milton's Use of Du Bartas*. Cambridge, MA.

Taylor, L. R. (1931) *The Divinity of the Roman Emperor*. Middletown, CT.

Terry, R. (2005) *Mock-Heroic from Butler to Cowper: An English Genre and Discourse.* Aldershot.

Teskey, G. (2015) *The Poetry of John Milton.* Cambridge, MA.

Thomas, W. K. and W. U. Ober (1989) *A Mind for Ever Voyaging: Wordsworth at Work Portraying Newton and Science.* Edmonton.

Thompson, E.N.S. (1919) 'Milton's Knowledge of Geography', *Studies in Philology* 16: 148–71.

Tillotson, G. (ed.) (1954) *Alexander Pope: 'The Rape of the Lock' and Other Poems* (revised edn). London.

Treip, M. A. (1991) '"Celestial Patronage": Allegorical Ceiling Cycles of the 1630s and the Iconography of Milton's Muse', in M. di Cesare (ed.), *Milton in Italy: Contexts, Images, Contradictions.* Binghamton, NY: 237–79.

Tucker, B. (ed.) (1996) *The Poetry of Laetitia Pilkington (1712–1750) and Constantia Grierson (1706–1733).* Lewiston, NY.

Turcan, R. (1959) 'L'âme-oiseau et l'eschatologie orphique', *Revue de l'histoire des religions* 155: 33–40.

Tyrrell, T. R. (2021) '"Soaring in the High Region of Her Fancies": The Female Poet and the Cosmic Voyage', in M. Green and S. Al-Akhras (eds), *Women (Re)writing Milton.* London: 60–80.

van Veen, Otto (1979) *Horatii emblemata Antwerp 1612* (facsimile). New York.

Veevers, E. (1989) *Images of Love and Religion: Queen Henrietta Maria and Court Entertainments.* Cambridge.

Vessey, M. (2015) 'Classicism and Christianity', in P. Cheney and P. Hardie (eds), *The Oxford History of Classical Reception in English Literature*, vol. 2: *1558–1660.* Oxford: 103–28.

Volk, K. (2002) *The Poetics of Latin Didactic: Lucretius, Vergil, Ovid, Manilius.* Oxford.

Volk, K. (2004) '"Heavenly steps": Manilius 4.119–121 and Its Background', in R. S. Boustant and A. Y. Reed (eds), *Heavenly Realms and Earthly Realities in Late Antique Religions.* Cambridge: 34–46.

Volk, K. (ed.) (2008) *Vergil's 'Georgics'* (Oxford Readings in Classical Studies). Oxford.

Waith, E. M. (1962) *The Herculean Hero in Marlowe, Chapman, Shakespeare and Dryden.* London.

Waller, A. R. (ed.) (1905) *Abraham Cowley: Poems.* Cambridge.

Wallerstein, R. (1961) *Studies in Seventeenth-Century Poetic.* Madison, WI.

Warnlof, J. J. (1973) 'The Influence of Giordano Bruno on the Writings of Sir Philip Sidney'. PhD thesis, Texas A&M University.

Warren, J. (2000) 'Epicurean Immortality', *Oxford Studies in Ancient Philosophy* 18: 231–61.

Watts, Isaac (1706) *Horae lyricae: Poems, Chiefly of the Lyric Kind, in Two Books.* London.

Watts, Isaac (1709) *Horae lyricae: Poems, Chiefly of the Lyric Kind, in Three Books.* London.

Watts, Isaac (1721) *Sermons on Various Subjects.* London.

Weinstock, S. (1971) *Divus Julius.* Oxford.

Wellington, R. (2015) *Antiquarianism and the Visual Histories of Louis XIV: Artifacts for a Future Past.* Farnham.

Wellington, R. (2016) 'A Reflection of the Sun: The Duke of Marlborough in the Image of Louis XIV', *The Court Historian* 21: 125–39.

West, D. (1993) 'On Serial Narration and on the Julian Star', *Proceedings of the Virgil Society* 21: 1–16.

White, P. (ed.) (2019) *Augustine: 'Confessions', Books V–IX*. Cambridge.

Whitney, Geffrey (1586) *A Choice of Emblemes*. Leiden.

Whittington, L. (forthcoming) *Antiquity Made Whole: Completion and the Classical Past in Renaissance Literary Culture*. Baltimore.

Wick, C. (ed.) (2004) *M. Annaeus Lucanus: 'Bellum civile', Liber IX; Einleitung, Text und Übersetzung* (2 vols). Munich.

Wickkiser, B. L. (1999) 'Famous Last Words: Putting Ovid's Sphragis into the *Metamorphoses*', *Materiali e discussioni per l'analisi dei testi classici* 42: 113–42.

Williams, A. (2005) *Poetry and the Creation of a Whig Literary Culture 1681–1714*. Oxford.

Williams, A. S. (1981) 'Panegyric Decorum in the Reigns of William III and Anne', *Journal of British Studies* 21: 56–67.

Williams, G. D. (2012) *The Cosmic Viewpoint: A Study of Seneca's 'Natural Questions'*. Oxford.

Williams, M. F. (2003) 'The *sidus Iulium*, the Divinity of Men, and the Golden Age in Virgil's *Aeneid*', *Leeds International Classical Studies* 2: 1–29.

Wills, J. (1998) 'Divided Allusion: Virgil and the *Coma Berenices*', *Harvard Studies in Classical Philology* 98: 277–305.

Wind, E. (1939/40) 'Julian the Apostate at Hampton Court', *Journal of the Warburg and Courtauld Institutes* 3: 127–37.

Yates, F. (1936) *A Study of 'Love's Labours Lost'*. Cambridge.

Yates, F. (1943) 'The Emblematic Conceit in Giordano Bruno's *Degli eroici furori* and in the Elizabethan Sonnet Sequences', *Journal of the Warburg and Courtauld Institutes* 6: 101–21.

Yates, F. (1975) 'Queen Elizabeth I as Astraea', in Yates, *Astraea: The Imperial Theme in the Sixteenth Century*. London: 29–87.

Yunis, H. (ed.) (2011) *Plato: 'Phaedrus'*. Cambridge.

Zanker, P. (1988) *The Power of Images in the Age of Augustus* (trans. A. Shapiro). Ann Arbor, MI.

Zetzel, J.E.G. (ed.) (1995) *Cicero: 'De re publica': Selections*. Cambridge.

Ziolkowski, J. M. and M.C.J. Putnam (2008) *The Virgilian Tradition: The First Fifteen Hundred Years*. New Haven, CT.

INDEX OF PASSAGES DISCUSSED

GENERAL INDEX

A NOTE ON THE TYPE

This book has been composed in Arno, an Old-style serif typeface in the classic Venetian tradition, designed by Robert Slimbach at Adobe.